AHMANSON · MURPHY
FINE ARTS IMPRINT

THE AHMANSON FOUNDATION

has endowed this imprint

to honor the memory of

FRANKLIN D. MURPHY

who for half a century

served arts and letters,

beauty and learning, in

equal measure by shaping

with a brilliant devotion

those institutions upon

which they rely.

The publisher gratefully acknowledges the generous contribution to this book provided by the Richard and Harriett Gold Endowment Fund in Arts and Humanities.

MAKING IT NEW

MAKING

UNIVERSITY OF CALIFORNIA PRESS
Berkeley Los Angeles London

WILLIAMS COLLEGE MUSEUM OF ART
Williamstown, Massachusetts

IT NEW

THE ART AND STYLE OF SARA AND GERALD MURPHY

EDITED BY DEBORAH ROTHSCHILD

THIS BOOK SERVES AS THE CATALOGUE FOR THE
EXHIBITION *MAKING IT NEW: THE ART AND STYLE OF
SARA AND GERALD MURPHY*

WILLIAMS COLLEGE MUSEUM OF ART
Williamstown, Massachusetts | July 8–November 11, 2007

YALE UNIVERSITY ART GALLERY
New Haven, Connecticut | February 26–May 4, 2008

DALLAS MUSEUM OF ART
Dallas, Texas | June 8–September 14, 2008

NATIONAL
ENDOWMENT
FOR THE
HUMANITIES

This exhibition has been made possible in part by the National
Endowment for the Humanities: great ideas brought to life, the Terra
Foundation for American Art, the Getty Foundation, and the Dedalus
Foundation, Inc.

Any views, findings, conclusions, or recommendations expressed in
this exhibition do not necessarily represent those of the National
Endowment for the Humanities.

University of California Press, one of the most distinguished university
presses in the United States, enriches lives around the world by
advancing scholarship in the humanities, social sciences, and natural
sciences. Its activities are supported by the UC Press Foundation
and by philanthropic contributions from individuals and institutions.
For more information, visit www.ucpress.edu.

University of California Press
Berkeley and Los Angeles, California

University of California Press, Ltd.
London, England

Williams College Museum of Art
Williamstown, Massachusetts

Title page: The Mad Beach Party, La Garoupe beach, Antibes, July
1923, photographed by François Biondo (se p. 154).

Library of Congress Cataloging-in-Publication Data

Making it new : the art and style of Sara and Gerald Murphy / edited
by Deborah Rothschild.
 p. cm. — (Ahmanson-Murphy fine arts book)
 Issued in connection with an exhibition held July 8–Nov. 11, 2007,
Williams College Museum of Art, Feb. 26–May 4, 2008, Yale University
Art Gallery, and June 8–Sept. 14, 2008, Dallas Museum of Art.
 Includes bibliographical references and index.
 ISBN 978-0-520-25238-7 (cloth : alk. paper) — ISBN 978-0-520-
25240-0 (pbk. : alk. paper)
 1. Murphy, Gerald, 1888–1964—Exhibitions. 2. Murphy, Sara—
Exhibitions. 3. Murphy, Gerald, 1888-1964—Friends and associates—
Exhibitions. 4. Arts, Modern—20th century—Exhibitions.
I. Williams College. Museum of Art. II. Yale University Art
Gallery. III. Dallas Museum of Art.
 ND237.M895A4 2007
 759.13—dc22
 [B] 2007011568

Manufactured in Canada

16 15 14 13 12 11 10 09 08 07
10 9 8 7 6 5 4 3 2

The paper used in this publication meets the minimum requirements
of ANSI/NISO Z39.48-1992 (R 1997) (*Permanence of Paper*).

CONTENTS

When describing Sara and Gerald Murphy, the quality most frequently noted by both friends and biographers is their generosity of spirit. Their desire to share with the world the talents of the extraordinary circle of individuals whom they embraced seems truly inexhaustible. What is equally remarkable was the Murphys' ability to identify these individuals when their creative expression was only on the cusp of making itself present, often in forms that were as yet uncharted territory. The Murphys had that rare capacity to recognize the new and to encourage it wholeheartedly and fearlessly. Being in their company, as the title of this catalogue and the accompanying exhibition suggest, meant being an active agent in making the world anew, that is to say, fully inhabiting the idealism that was all that came to be known as "the modern."

The breadth of the Murphys' contributions to the cultural history of modernism is impressive. In presenting the Murphys' lives and their brilliant artistic circle, the Williams College Museum of Art has endeavored to capture the couple's dynamism, complexity, and joie de vivre by weaving their personal story together with their involvement in the avant-garde art, music, dance, and literature of their time. They engaged in spirited conversations with such legendary figures as Pablo Picasso, Ernest Hemingway, F. Scott Fitzgerald, and Igor Stravinsky. The Murphys' enthusiasm, as well as their openness to diverse art forms, made them compelling to their contemporaries and continues to be inspiring today. Placing art in such a broad context has, for many years, been the hallmark of our exhibitions. Located on one of the country's premiere liberal arts campuses, the museum draws upon the interest and expertise of faculty across the disciplines and the college's commitment to ensuring the arts are central to the texture of undergraduate education.

We are deeply grateful to President Morton Owen Schapiro and the Office of the Provost for their support of our work as a teaching museum and of *Making It New: The Art and Style of Sara and Gerald Murphy* in particular. The passion and dedication to meticulous scholarship of Deborah Rothschild, Senior Curator of Modern and Contemporary Art, informs every detail of the exhibition and its catalogue. We thank her for energetically and single-mindedly pursuing her vision for this project, which we hope will both transform knowledge in the field and introduce the general public to the unparalleled richness of the Murphys' world. Dr. Rothschild's vision was supported by members of the Murphy family and those who remember Gerald and Sara as well as by the lenders to the exhibition. Without all of them this undertaking would have been impossible, and we are sincerely grateful for their sharing of memories, mementos, and significant works of art.

We thank the Getty Foundation for providing the research grant that enabled Dr. Rothschild to move this project forward. The National Endowment for the Hu-

manities awarded the museum major support, which has enabled us invite a remarkable range of scholars to add depth and breadth to our understanding of the Murphys and their milieu, and we thank the NEH program officers for working with our staff to help realize the potential of an exhibition focused on this amazing couple. The Terra Foundation for American Art has generously supported the transatlantic perspective of this project, and we thank them for, once again, enthusiastically participating in our work. We also thank the Dedalus Foundation for its contribution.

It is appropriate that the exhibition will travel to the Yale University Art Gallery, since Gerald graduated from Yale in 1912. Recently, Yale acquired one of Gerald's seven extant paintings, *Bibliothèque* (*Library*, 1926–27), and we are grateful to Director Jock Reynolds for agreeing to conserve and lend this and other important works to the exhibition. We also thank the museum staff for its encouragement of this exhibition.

Director Jack Lane at the Dallas Museum of Art has been similarly generous, agreeing to lend several paintings, including two of the rare Gerald Murphy paintings, to the exhibition. That the exhibition will go to Dallas is also apt, for the Dallas Museum for Contemporary Arts was, in 1960, the first to include Gerald Murphy's work in a major exhibition, *American Genius in Review No. 1*, and its director at the time, Douglas MacAgy, was the first to write critically about Gerald in *Art in America*.

Finally, I would like to thank the staff of the Williams College Museum of Art, who have shown the same generosity of spirit that characterized the Murphys by working tirelessly in support of the museum's mission to bring compelling exhibitions and challenging ideas to the Berkshires and beyond.

LISA G. CORRIN
Class of 1956 Director
Williams College Museum of Art

Sara and Gerald Murphy were all about friendship. They had a knack for building relationships and for bringing people together. How fitting then that this project has afforded the opportunity to meet talented and fascinating individuals, make new friends, and renew ties with old ones.

Generosity must be built into the Murphys' DNA because Honoria Murphy Donnelly's children—Laura, John, and William—all have an abundance of gracious open-heartedness. Laura and John allowed me to work in their homes for days at a time and made me feel welcome in the process. They facilitated research by writing letters to libraries and museums, shipping boxes of archives to the Williams College Museum of Art, and answering innumerable queries. Much new material has come to light as the result of their kindness and largesse.

I first learned about Sara and Gerald Murphy in Paris in 1981 when, in the course of researching my dissertation on Pablo Picasso's designs for Sergei Diaghilev's Russian Ballet, I had the opportunity to interview Boris Kochno, Diaghilev's *régisseur* from 1921 to 1929. He was a curmudgeonly, reclusive soul by this time and had very little positive to say about anyone. However, at the end of one interview he offered, "You're American, why don't you write about Sara and Gerald Murphy?" He proceeded with a humorous account of the perfectly groomed Murphys wielding large broomlike brushes as they painted sets and later broke bread with the bois-

terous Russian work crew. He said what I have since come across countless times, that the Murphys were "ideal people."

After completing my dissertation I went on to other projects and did not think about Sara and Gerald Murphy again until 1999, when someone I met at a dinner party mentioned several times that I *had* to read Amanda Vaill's biography, *Everybody Was So Young*. The recommendation stayed with me because the stranger was so insistent. When I eventually picked up the book in 2003, I saw why—from the first page I was hooked by her marvelous telling of the Murphys' lives and extraordinary friendships. It occurred to me that Sara and Gerald as the nexus of a brilliant constellation of friends would be an excellent subject for a cross-disciplinary exhibition encompassing art, literature, theater, and music –a perfect fit for a college museum with a mandate to reach across fields of study. Before going further with the idea, I contacted Amanda Vaill, who was as captivating and generous in person as one would assume from her writing. She gave me lists of possible works to include and names of people to contact that have remained the core of this book's accompanying exhibition. In the course of this project we have become friends, and, if nothing else, I am grateful to Sara and Gerald for "introducing" me to Amanda.

Before proceeding with the project, it was necessary to ascertain if we could borrow Gerald Murphy's seven

surviving paintings for the exhibition. Two key works reside in the Dallas Museum of Art, and I called Jack Lane, its Director, and a Williams alumnus, who listened carefully and asked tough questions that forced me to articulate the project's focus, what I hoped to accomplish, and why Williams should host such an exhibition. That conversation and his subsequent support have been critical. John Elderfield, Chief Curator of Painting and Sculpture at the Museum of Modern Art in New York; Cora Rosevear, Associate Curator at MoMA; and Adam Weinberg, Director of the Whitney Museum of American Art, were similarly helpful and generous. Myron Kunin, a collector of early modern American art and founder of the Curtis Galleries, also agreed to lend, and I am indebted to him and his helpful registrar, Jenny Sponberg. In 2006 the Yale University Art Gallery acquired *Bibliothèque (Library)*. Director extraordinaire Jock Reynolds was immediately receptive to loaning the work and put me in touch with the Curator of American Paintings and Sculpture, Helen Cooper. We had a marvelous rapport from the beginning, and it has been a joy to work with Helen and the rest of the Yale University Art Gallery staff, including Robin Jaffee Frank, Jenny Chan, Lynne Addison, Clarkson Crolius, and Janet Miller. Similarly, in addition to Jack Lane and Dorothy Kosinski, Barbara Thomas Lemmon Curator of European Art at the Dallas Museum of Art, we owe thanks to Tamara Wootton-Bonner, Heather MacDonald, and Marci Driggers Caslin at the Dallas Museum of Art. Schatzie and George Lee, visitors to Williamstown from Dallas in the summer, were wonderful allies, and I am indebted to Schatzie for sending important information my way. We are delighted that the exhibition is traveling to both Dallas and Yale, which each have deep connections to the Murphys. Further, we are grateful to both museums for the additional loans they are supplying.

Our heartfelt gratitude goes to the other lenders—institutions, private individuals, and galleries—whose sacrifice in parting with works in their collections by Picasso, Juan Gris, Fernand Léger and others has made this exhibition possible. In the United States we are exceedingly grateful to Doreen Bolger, Director of the Baltimore Museum of Art, and her staff, including Curators Darsie Alexander and Katy Rothkopf, for lending major works at a cost to their own programs. Similarly, Graham Beal, Director of the Detroit Institute of Arts, came through for us with a difficult loan. We are thankful to him and to Curators MaryAnn Wilkinson and Alan Darr for pleading

our cause. At the Rhode Island School of Design, Museum of Art, we thank Director Hope Alswang and Curator Maureen O'Brien. Through Maureen, we learned of a virtually unknown portrait of Sara Murphy by William James Jr., and it was wonderful to share the excitement of this "find" and to discover more about the painting with her. Raphaela Platow, Chief Curator at the Rose Art Museum of Brandeis University, has been supportive from an early stage. Jill Meredith, former Director and Chief Curator at the Mead Art Museum; Stephen Fisher, Collections Manager at the Mead; and Professor Stanley Rabinowitz, Director of the Amherst Center for Russian Culture, have generously loaned works by Natalia Goncharova and Mikhail Larionov. We would like to extend our gratitude to Lynn Gumpert, Director of the Grey Art Gallery, New York University; William Griswold, Director of the Minneapolis Institute of Arts; Malcolm Rogers, Director, and Tom Rassieur, Assistant Curator in the Department of Prints and Drawings, at the Museum of Fine Arts, Boston; Willard Holmes, former Director of the Wadsworth Atheneum, Hartford; Fredric Woodbridge Wilson, Curator of the Harvard Theatre Collection; Sonia Dingilian Loan Administrator, and Michelle Potter, Curator, Jerome Robbins Dance Division, New York Public Library; and Richard Warren, Curator, Historical Sound Recordings Collection and American Musical Theater Collection, Yale Music Library. We are especially grateful to Patricia C. Willis, Curator of the Yale Collection of American Literature, and her colleagues Ellen Doon, Nancy Kuhl, and Julia Clark-Spohn of the Beinecke Rare Book and Manuscript Library at Yale University.

Overseas institutions have been equally supportive and generous to us, and we would like to extend our gratitude to the following lenders: Madame Maeght and her assistant Véronique de Lavenne of the Galerie Maeght, Paris; Erik Näslund, Director of the Dansmuseet, Stockholm; Marina Picasso of the Marina Picasso Collection; Jan Krugier, along with Evelyne Ferlay, of Galerie Jan Krugier et Cie, Geneva; and Ingrid Mattison, Head of Music Library and Archives, and Helena Iggander, both at the Royal Swedish Opera. We thank Millicent Hodson and Kenneth Archer for giving permission to borrow the recording of their reconstruction of the ballet *Within the Quota* from the Royal Swedish Opera. At the Musée Picasso in Paris we are grateful to Director Anne Baldassari and at the Picasso Administration, to Claude Picasso.

We wish also to acknowledge the generosity of private collectors: Lori and Art Benton; Richard Lee Brennan (who also helped with research and access to his family archives); Peter Davenport; James DeWoody; Michèle and Marc Ivasilevitch of A&C Projects; William Mac-Leish; Iveta and Tamaz Manasherov, courtesy A&C Projects; Olivia Mattis and Kenneth Wayne; James Moody; Sally and Lydia Robinson; Timothy and Marian Seldes; and Dr. and Mrs. Jeffrey Zissu, courtesy Gary Snyder Fine Art.

The research for this project was launched with a 2004–5 Curatorial Research Fellowship from the Getty Foundation, which enabled me to travel abroad. I would like to thank Nancy Micklewright, Program Officer, and the Getty for their support. A planning grant from the National Endowment for the Humanities enabled me to continue archival research in the United States and supported two advisory meetings where Murphy experts, including the contributors to this catalogue, the art historian Wanda Corn, the installation designer Amy Reichert, and Marianna Adams of the Institute for Learning Innovation advised on content and interpretation. Adams, with the assistance of Molly Polk of Williamstown, conducted visitor research. A second award for the implementation of the exhibition from the National Endowment for the Humanities made it possible to create the show we envisioned. We are grateful to NEH Chairman Bruce Cole and the panelists for their support and constructive comments. Senior Program Officer David Martz has been a pleasure to work with. We thank him for his considered advice and encouragement. The Terra Foundation for American Art provided major support for this project. We want to express our profound gratitude to Elizabeth Glassman, Director, and other members of the Terra for their advice and help. Finally the Dedalus Foundation also awarded the museum a grant in aid.

In addition to Amanda Vaill, we are most fortunate to have distinguished contributors to this publication. Sara and Gerald delighted in discovering and promoting nascent talent. Time has shown that they were all but flawless in their judgment. Calvin Tomkins was one of their "finds." In a letter from July 23, 1961, Sara told him that as a writer he "would go far—very far," and indeed he has. Considered a living literary treasure, he endows every subject about which he writes with insight and artistry. Similarly, William Jay Smith knew the Murphys firsthand, and they also singled out his talent, prophesizing a distinguished career in arts and letters.

Linda Patterson Miller's book *Letters from the Lost Generation* achieves the daunting task of allowing the protagonists of the Murphys' circle to tell their story in their own words. She weaves together primary documents seamlessly and in a fashion that totally engrosses the reader. She continues to bring to light fascinating new material here. I am also indebted to Linda for sharing transcripts and tapes of interviews she conducted from 1979 to 1982 with key players in our narrative.

Dorothy Kosinski, a curator and art historian of singular depth and wisdom, was a classmate of mine at the Institute of Fine Arts many years ago. It has been wonderful to reconnect with her on this project and to be reminded of her excellence and lucidity as a scholar as well as her thoughtfulness and kindness as a colleague. Similarly, Ken Silver and I met in the 1980s through our mutual interest in Picasso. It is always a joy to be in his stimulating, brilliant presence. I am thrilled that this project has afforded me the opportunity to work with him. I am grateful to the art critic and polymath Geoff Young for introducing me to Trevor Winkfield, a gifted artist in his own right, who early on championed the significance of Gerald Murphy as an artist. Olivia Mattis and Kenneth Wayne filled out the scope of this publication by shining light on the critical importance of music in the Murphys' life and by placing Villa America in the context of the art scene in the Riviera.

Both Marian Seldes and William MacLeish, who knew the Murphys well, have been absolutely wonderful in giving time, information, and objects. Possessed of a larger-than-life graciousness and refinement that I associate with the Murphys, Ms. Seldes and Mr. MacLeish made the epoch and the people about whom I was reading vivid and real.

In spring of 2003 I had the pleasure of meeting Wanda Corn during her tenure as a Clark Visiting Professor at Williams. Her groundbreaking work on twentieth-century modernism and transatlantic crosscurrents and her understanding of Gerald Murphy in this context have been pivotal to this project and its emphasis on the Murphys as modernists. I am also grateful for her good fellowship, practical advice, introductions, and general support.

The great John Richardson has also been the most generous of colleagues and a delight to talk with. He not only shared his vast knowledge of Picasso, the Murphys,

and their friends, but also something less tangible—a profound understanding of Picasso's thinking. Between Mr. Richardson and my late, revered mentor, Robert Rosenblum, it seems a direct line into Picasso's elusive and complex psyche has been channeled. Both Mr. Richardson and his collaborator on the monumental Picasso biography, Marilyn McCully, have been unfailingly helpful. I thank them most warmly.

Over the years there are two colleagues upon whom I have come to depend. I cannot imagine undertaking a large project without the involvement of architect, scholar, and exhibition designer Amy Reichert and editor Brenda Neimand. Amy's initial design for the installation at Williams, along with the intellectual model that informed it, has been a guiding principle. Similarly, Brenda Neimand, who read and reworked my essay before it was turned over to University of California Press, clarified half-formed ideas and vastly improved the entire manuscript, lending it a cohesiveness that it originally lacked.

I've been exceptionally lucky in working with Deborah Kirshman at University of California Press, yet another kindred spirit, who, as acquisitions editor, provided encouragement, skillful guidance, and a sure grasp of the possibilities of this publication. Sue Heinemann has been the most efficient, able, and patient of editors. She unified the ten essays individually and as a group—no easy task. Jennifer Knox White copyedited the text and Nicole Hayward designed these pages. I know I speak on behalf of all the essayists in thanking them unreservedly. We would also like to extend deep thanks to Robert Panzer of VAGA for being so very generous with rights and reproductions.

Three directors of the Williams College Museum of Art have been involved with this exhibition. Linda Shearer first supported the idea of a show about the Murphys as artists and muses. In keeping with her democratic leadership—always informed by respect for the opinions and talents of others—Linda gave me free rein in developing the project. Marion Goethals, who was Acting Director in 2005, continued this laissez-faire approach and allowed me the time to work on the Murphys without too many other responsibilities. Lisa Corrin, currently Director, has overseen the most stressful period of organization, encompassing grant applications, catalogue production, and loan negotiations, and she has been an invaluable ally. I am grateful for her aid with difficult loans. Her high-

wattage personal energy and delight in a challenge have been inspiring.

This book and exhibition could not have come into being without the careful and conscientious attention of Kathryn Price (Williams M.A. '02), Assistant Curator at the Williams College Museum of Art, who has been a co-curator rather than an assistant in the year she has devoted to this project. I cannot adequately express my gratitude to Katie for bearing the brunt of the many organizational tasks that go along with a complex project such as this one. The exhibition, with loans of approximately 90 works of fine art and some 300 pieces of ephemera, as well as the publication with nearly 260 illustrations and 10 authors, could not have been realized without her diligence, professionalism, and competence—she is a tireless worker, a lovely person, and an exceptional curator. Hideyo Okamura, the gifted Exhibition Designer and Chief Preparator at the Williams College Museum of Art, has been another indispensable colleague. A talented artist, he infused Amy Reichert's initial design with his own inventiveness and brilliance. In addition to his sure eye and skill, it is always a pleasure to work with Hideyo, who embodies dedication and grace under pressure. Gregory Smith, the son of one of our essayists, William Jay Smith, has a special place in this project. His work on preparing the actual installation with Hideyo is much appreciated.

Diane Hart, Director of Museum Registration, is a consummate professional, on whom I have relied for many years. As always, she orchestrated the myriad details of a complex loan show with great proficiency and thoroughness. Suzanne Silitch, Director of Public Relations and External Affairs, is another standout in a staff of outstanding pros. Her drive and engagement, her eagerness to take on anything and everything, make her the perfect representative and go-to person for the museum. She is a tremendous asset and a delight to work with. Stefanie Spray Jandl, the Andrew W. Mellon Foundation Associate Curator for Academic Programs, in addition to being a treasured friend and confidant, is someone with whom I have collaborated on many projects. As always, she worked hard and thoughtfully to involve various faculty and departments within the college with *Making It New*. She was ably aided by Elizabeth Gallerani, Mellon Foundation Academic Programs Assistant. Cynthia Way, Director of Education and Visitor Experience, along with Emily Schreiner, Coordinator of Education Programs,

created a wonderful array of activities for school-age students, including a "Family Festival" with a "world tour" Murphy-style "stopping" at the Riviera, Paris, and New York. Cynthia also worked on an ambitious program for the public schools, initiated by Rebecca Hayes, our Education Director in 2005. A team of three dedicated teachers from Greenwich High School in Greenwich, New York—Gail Hathaway (English), Tim Kelleher (history), and Naomi Meyer (art)—worked with Cynthia to develop a high school curriculum using the exhibition to further students' understanding of modern art, literature, and history. With the art teacher serving as a "visiting artist," art activities are integrated into English and history classes, making these subjects more accessible. Finally Cynthia and Emily aided Program Coordinator Lisa Clark in organizing an "un-symposium," where performances of jazz and dances of the 1920s punctuated lively talks and demonstrations. Lisa, with the help of Margot Weller (Williams '07) designed the timeline for the exhibition installation. Cynthia Way, also applied her considerable editing skills to reading manuscripts and label copy, and to writing wall text for children.

Melissa Cirone, former Director of Communications, did an exceptional job as grant writer in the earlier stages of this project. William Blaauw, Director of Membership and Events, arranged the gala opening as well as countless receptions in conjunction with the Murphy project with great flair. Dee Dee Lewis, Budget Administrator, has given unstintingly of her time and expertise. She was always ready to help on a variety of fronts. Similarly Amy Tatro, Assistant to the Director, and Judy Pellerin, Secretary, have been of incalculable support, cheerfully carrying out countless requests. Allison Mondel, Museum Shop Manager; Christine Maher, Shop Assistant; Rachel Tassone, Associate Registrar; and Museum Security Officers Michele Alice, John Anderson, Robert Kove, and Jason Wandrei have all played a large part in the realization and monitoring of this complex exhibition. Finally, at the museum, I would like to offer thanks to John Stomberg, Deputy Director and Senior Curator for Exhibitions, who has dealt with the administrative problems with abiding good humor and a spirit of expansive fellowship and diplomacy. I am grateful for all he "made happen."

Throughout the gestation of this project I have been fortunate to have a group of dedicated assistants. Jessica Fripp (Williams M.A. '05) worked for over a year on the project. Her exceptional skill as a researcher and writer were an immeasurable asset, and everything I asked her to do was done perfectly. I extend heartfelt thanks to her for her diligence and devotion. Amelia Kahl Avdič (Williams '04) and Miranda Routh (Williams '03, M.A. '06) were interns from the graduate program in art history who worked full time and with great zeal in consecutive summers and organized and photographed twenty-five boxes of archives from the Murphy estate. Williams College is known for its first-rate graduate program in the history of art, and I can attest to the fact that the master of arts candidates are second to none. Graduate student interns who contributed vastly to the project during the school year were Hannah Blumenthal ('06), Dina Deitsch ('04), Stephanie Schumann ('08), and Yao Wu ('07). Aura Davies, a young friend, helped in the early stage of sifting through archives in East Hampton. Williams undergraduates Liz Kantack ('09), Mia Michelson-Bartlett ('08), and Margot Weller ('07), as well as Melissa St. Pierre, also worked with resourcefulness and energy. Summer volunteers Amanda Bell, Mary Burr (Williams '08), Erin Gerrity, and Julia Kleederman helped immensely on all fronts.

The filmmaker and artist Perry Hall created the documentary film that is such a critical element of the exhibition. It was a pleasure to work with Terri Marlowe and Curtis Cates of BBQ Productions, who videotaped an interview with Marian Seldes. We are also grateful to Joshua Field of Orbit Visual Communications for the design materials he has generated and to Anne Edgar of Anne Edgar Associates for sharing her expertise in public relations.

In addition to the lenders to the exhibition, the following librarians and archivists have been most helpful: Robert Volz at the Chapin Rare Book Library; Jo-Ann Irace, Alison O'Grady, and Christine Menard at Williams College; Karen Bucky at the Clark Art Institute; Susan Wrynn, Hemingway Curator, and James Hill and Laurie Austin, Audiovisual Archives, at the John Fitzgerald Kennedy Presidential Library; Nicholas Scheetz, Manuscripts Librarian, at the Lauinger Library, Georgetown University; Stephen Z. Nonack, William D. Hacker Head of Reader Services, and Stanley Ellis Cushing, Curator of Rare Books, at the Boston Athenaeum; Earle Havens, acting Keeper, and Roberta Zonghi, former Keeper (now Public Service Projects Manager), from the Department of Rare Books, Manuscripts, and Special Collections,

Boston Public Library; Ryan Hendrickson, Assistant Director for Manuscripts, and Maria Morelli, Archivist, at the Howard Gotlieb Archival Research Center, Boston University; Kathleen L. Rawlins, Assistant Director of Cambridge (Mass.) Historical Commission; Barbara S. Meloni, Public Services Archivist, at the Harvard University Archives; Mary Daniels, Special Collections Librarian, at the Frances Loeb Library, Harvard Design School; Irina Klyagin, Project Archivist, at the Houghton Library, Harvard University; William Robinson, Maida and George Abrams Curator of Drawings, Fogg Art Museum; Kristin Parker, Archivist, at the Isabella Stewart Gardner Museum; Linda Hocking, Curator of Library and Archives, and N. Gregory Koldys, Research Assistant, at the Litchfield (Conn.) Historical Society; Donald Yacovone, former Senior Associate Editor, Massachusetts Historical Society (currently Research Manager, W. E. B. Du Bois Institute for African and African American Research, Harvard University); and Peter Rawson, Archivist, and Nighat Saliemi, former Archivist, at the Hotchkiss School Archives. Also the librarians at the Library of Congress, the Columbia University Rare Book and Manuscript Library, the Dance Collection at the New York Public Library, and the Rare Books and Special Collections at Princeton University

In Europe, I would like to thank Chief Curator Christian Derouet at the Musée national d'art moderne, Centre Georges Pompidou; Chief Librarian Didier Schulmann at the Bibliothèque Kandinsky; Dominique Dupuis-Labbé, Lawrence Madeline, Sylvie Fresnault, and especially Jeanne Sudour at the Musée Picasso; Brigitte Hedel-Samson and Nelly Maillard at the Musée national Fernand Léger, Biot; Sophie Lévy at the Musée d'art américain, Giverny; Claude Billaud at the Bibliothèque historique de la ville de Paris; Pascal Hamon at the Ministre de culture; Bernard Ruiz-Picasso and Cécile Godefroy at the Fundación Almine Berbard Ruiz-Picasso para el arte; Michèle Ausser at the Samir Traboulsi Collection in Paris; Mme. Froissard at the Archives Cap d'Antibes; as well as Jacques Livet, Michelle O'Brien and Jean-Louis Vibert-Guigue, Laure de Margerie and Olivier Meslay, and Lisa Tate Tortoli and Jane Prenn in Antibes.

We are delighted that the Williamstown Theatre Festival has commissioned a play as a complement to our exhibition. I am tremendously grateful to Roger Rees, Director of the Festival, for spearheading this idea and to former Board President Ira Lapidus for initiating the idea. The playwright Crispin Whittell has miraculously woven fact into a funny and engaging work of art that captures exactly the dynamics of love and jealousy that swirled around the Murphys' circle at Villa America.

Since 1973, when we became close friends at the Institute of Fine Arts, I have admired the art historian Kathryn Greenthal's perceptiveness and humanistic approach to life and art. Although we had kept in touch over the years, this project brought us together in a way reminiscent of the old days. Kathy has been instrumental in researching, writing, advising, translating, and caring as much about this project as I have. In the spring of 2005 we traveled together to Paris and the Riviera, where we spent every day in libraries and archives. She uncovered much new material there and in Boston, where she wrote the section on the Murphys' Cambridge years that is incorporated into my essay. Once again I am indebted to Sara and Gerald, this time for serving as the catalyst to renew deep ties with a cherished friend and benefit from her intelligence, humor, and wisdom. Another dear friend, Paulette O' Brien, joined us for the Côte d'Azur leg of our travels. As a French native she was an immeasurable help. Paulette also aided in researching (even traveling to old warehouses in Parisian suburbs in search of lost Murphy paintings), translating, and facilitating introductions. Game to take on anything and everything from her base in Paris, she is a true inspiration as someone who lives life fully and joyfully, much like Sara Murphy.

I am also indebted to the following for helping in a variety of ways. At the top of the list is Darra Goldstein, a sounding board, advisor, and problem solver at every stage of this project. Her always-there willingness to listen, take on my tribulations as if they were her own, and offer concrete help is the very definition of friendship. She and Lois Torf, another treasured friend, read and constructively critiqued the essay published here. I want also to single out Phyllis Tuchman—among the most open-handed persons I know—for continually being on the lookout for potential loans and ways to enrich the exhibition. Others who have contributed in a variety of ways are Maggie Adler, Deanna and Norman Alpher, Debra Balken, Robert and Ilona Bell, Joan Benjamin, Pamela and Philippe Besnard, Adela Betancourt, Philip Clapp, Lisa Cohen, Dean Crawford, Mary and Robert Crowell, Charles Duncan, Michael Glier, Susan Gold, Eva Grudin, Mark Haxthausen, Jacqueline Humphries and Tony Oursler, Michèle and Marc Ivasilevitch, Christine Kondoleon

and Frederick Whitman, Carolyn Lanchner, Michael J. Lewis, Jacqueline and David Manning, Michael Nelson, Darryle Pollack, Judy and Larry Raab, James and Nancy Reinish, Eyal Rimmon and Pamela Nathenson, Douglass Shand-Tucci, Olga Shevchenko, David L. Smith, Carol Stegeman, and particularly Susana Leval, Leyla Rouhi, and Lesley Wellman. Dottie and Fred Rudolf, living exemplars of Murphy style and graciousness, have been wonderfully supportive.

No doubt the greatest gift from the family-centered Murphys has been the hours spent discussing them and their intimates with my own family. My sons, Adam and Aaron, and my husband, David, became involved in this project to a surprising degree. All three not only read and critiqued the essay published here, but immersed themselves in the Murphy literature as well as relevant works by Fitzgerald and Hemingway. Adam and Aaron helped with research and were the catalyst for new ways of thinking about Sara and Gerald. It is hard to describe the gratification one feels in having such discussions with beings who not too long ago needed their noses wiped and pants zipped. Finally, how to express in this litany of heartfelt thanks, the one I feel most deeply? To my husband, David, I am profoundly grateful. Over twenty-seven years he has always been there—bolstering, advising, and sacrificing good-naturedly. His unfailing support makes everything possible. He is the best of friends.

DEBORAH ROTHSCHILD
Senior Curator of Modern and Contemporary Art
Williams College Museum of Art

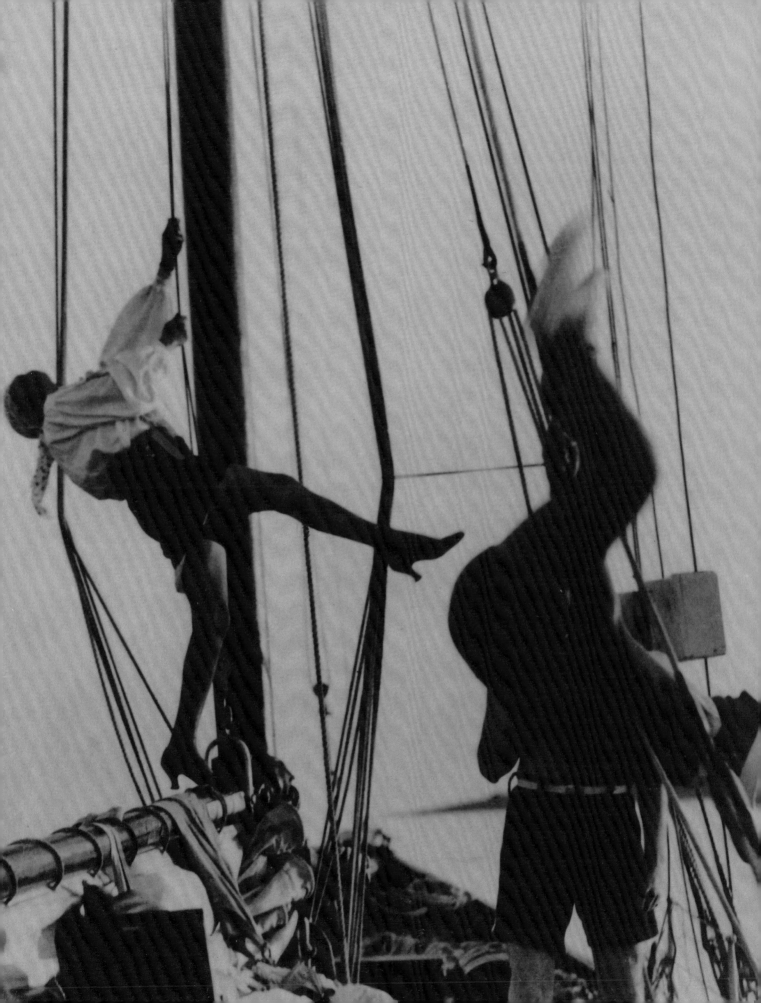

"**D**ay by day make it new / Yet again make it new!"[1] Ezra Pound's charge to his generation sums up Sara and Gerald Murphy's philosophy and achievement. They not only pioneered a modern way of living but also elevated into an art form the notion of making each day "new." Archibald MacLeish called them *the* representative figures of their age" because, as transatlantic avant-gardes, they epitomized the many expatriates who flourished amid the artistic ferment in France during the 1920s.[2]

When the Murphys and their young children arrived in France in 1921, Europe was just beginning to recover from the senseless devastation brought about by the Great War, which had decimated a generation of youth and shattered established values and ideals. Europe welcomed spirited young people from the United States and elsewhere, who found that many cities, especially Paris, offered an open milieu for unfettered expression. The anything-goes atmosphere fostered invention and the exchange of ideas, and art, literature, music, and theater thrived. "Every day was different and there was always something exciting going on," reminisced Gerald, citing a menu of balls, exhibitions, theatricals, manifestations, nightclubs, and cafés.[3]

It is not surprising that Sara and Gerald Murphy were among those drawn to Europe after the war. From the beginning of their marriage in 1915, they were determined to blaze a path that diverged from the expectations of their families and the constricted, snobbish, socially elite world into which they were born. It was critical to Gerald—unusual in those times—that he and Sara be equal partners in creating an existence anchored by "the real issues of life: home, children, work, friends, nature" and "not things."[4] In 1919 he declared to Sara: "What we are doing is fresh, new, and alive."[5]

Gerald, who began to study art only after arriving in Paris, is increasingly recognized as a significant painter even though he produced just a small body of work. Moreover, as a couple, the Murphys were conceptual/performance artists *avant la lettre*. They expended great effort, although it never seemed forced or calculated, to make each moment original and meaningful. One friend noted that even the most mundane act—the way Gerald prepared a cocktail, or a walk from the Murphys' house to the beach—was somehow transformed into a memorable event: "He was a very exciting person to be around because there was always something new about everything he did and the way he perceived things was fresh."[6] The Murphys' life became an artistic exercise, informed by discipline, a keen sense of pleasure, and aesthetic complexity.

In addition to creating art, Sara and Gerald served as

Sara Murphy, Philip Barry (partially hidden), and Gerald Murphy on the *Weatherbird*, c. 1932.

muses to some of the major figures of twentieth-century arts and letters. John O'Hara wrote to Gerald in 1962: "All your friends wanted to capture Gerald and Sara and their life—the life, the way of life."[7] The Murphys are best known as the models for Dick and Nicole Diver in F. Scott Fitzgerald's *Tender Is the Night,* but they also inspired other novels, short stories, poems, paintings, plays, articles, memoirs, and biographies. Many literary friends recalled their time in the Murphys' company as the best moments in their lives. In part this was because, as Linda Patterson Miller notes in her essay here, for a brief period Sara and Gerald personified an aspect of the main literary theme of the era, a kind of dream life—life as we would like it to be—which stands in sharp contrast to life as it really is.

The Murphys were also in some sense patrons of the arts. Although they never asked for works of art or favors in return, they actively supported the careers of such "unknowns" at the time as Ernest Hemingway, Fernand Léger, Cole Porter, John Dos Passos, Archibald MacLeish, and Dorothy Parker. In addition to advice and encouragement, the Murphys offered introductions and financial assistance. They championed new art forms well past the 1920s, continuing to sustain artist-friends even after the Depression devastated their fortunes. That the Murphys' circle of friends in France included so many talents who were to emerge as artistic giants was no coincidence. Sara and Gerald were not only uncannily attuned to the future; they were also people of sophisticated and ecumenical taste. They were at once open to everything and exceedingly choosy, and they paid close attention to the things and especially the people they cared about.

The very broadness of the Murphys' interests—encompassing music, dance, art, literature, and poetry (not to mention gardening, design, and cuisine)—calls for responses from experts in a variety of disciplines. Like Cubist art of the period, which often filters the same scene through multiple, overlying views, the ten essays included here each address a different aspect of the Murphys' lives, friends, art, and influence, thereby offering a fuller, more nuanced, and multiperspectival understanding of who they were and what their place in history is. There is inevitably some overlap in such an interdisciplinary approach, with certain key events, reactions, and personal characteristics reiterated and at times contradicted from essay to essay.

Calvin Tomkins introduces us to the Murphys, whom he met when they and his young family both lived at Snedens Landing in the late 1950s. In time they became close friends, and Sara and Gerald opened up to Tomkins in a way they did with few other people during their long lives. Privy to hours of reminiscing by the Murphys, Tomkins experienced "the freshness and excitement of early modernism in the 1920s." His profile of the Murphys, "Living Well Is the Best Revenge," first appeared in the *New Yorker* in 1962 and was later expanded into a book. In his essay "Remembering Gerald and Sara," Tomkins conveys the Murphys' "utterly captivating" charm, as well as Gerald's wistfulness about his unfinished career as an artist.

My essay offers an overview of Sara and Gerald's lives, with a particular emphasis on the 1920s and 1930s. I draw largely on their own words or those of friends and family, often from unpublished letters, diaries, and interviews. Gerald is the focus of most of the essays in this book, largely because he was the one who consciously invented and realized "a private vision of paradise, imbued with warmth, beauty, intellect and taste."[8] But none of this would have been possible without Sara. She was Gerald's model for all that was best in life. I have tried to convey through her letters her contribution to their partnership and her warmth, love of life, and originality.[9] Much of the Murphys' story is about friendship, and Sara lavished an almost maternal warmth and attentiveness on the people she loved. My essay also offers an analysis of Gerald's small body of work. His paintings represent a particularly American response to the modern school of Paris and, like many Cubist and Surrealist works, contain coded or hidden references.

In "The Murphy Closet and the Murphy Bed," Kenneth E. Silver, an expert on French art and culture of the early twentieth century, examines Gerald Murphy's impeccable style in light of conflicts about his sexual orientation. Silver brings insight and compassion to understanding Murphy's struggle to repress and hide leanings that were unacceptable at the time. The manner in which concealment "helped to shape the life he led and the art he made" is explored through Gerald's self-presentation: from his literal costumes (for fancy dress balls) to his daily clothes (business and casual attire) to, ironically, his nudism—a penchant for which is apparent in many photographs. Silver decodes Gerald Murphy's lost self-portrait of 1928 as "a portrait of the artist as a gay man looking out from the closet" and compares it to the work of Jasper Johns.

Related to Silver's thesis is Amanda Vaill's consideration of Gerald Murphy's theatrical impulses. Murphy's interest in all forms of theater, she argues, offered a means of disguise from uncomfortable truths, since "in the theater concealment is normative and unconventional behavior unexceptional." Vaill, the Murphys' most thorough and engaging biographer, discusses Gerald and Sara's interactions in 1920s Paris with the revolutionary Kamerny Theater of Moscow and Diaghilev's Ballets Russes; Gerald's collaboration with Cole Porter on *Within the Quota* for the Ballets Suédois; and back in America, his last excursion into theater, the ballet *Ghost Town,* created in 1939 for Sergei Denham's Ballet Russe de Monte Carlo. She also discusses MacLeish's play *J.B.,* making the case (as Linda Patterson Miller does in regard to Hemingway's *For Whom the Bell Tolls*) that this literary work by a close friend referred to a period of estrangement in the Murphys' marriage, after tragic loss, which was followed by reconciliation and a strengthening of their relationship.

Trevor Winkfield brings both an artist's and a writer's eye to his analysis of Gerald Murphy's notebook, which contains entries for forty-two possible pictures (plus one for a "construction in frame")—only a small number of which were completed. Winkfield places Gerald's work in context and enables us to see how "Paris made him a great American painter." Through careful analysis of the notebook, which he dubs *The Artist's Eye* or *A Spy's Manual,* Winkfield identifies the formal inventiveness, intellectual rigor, and sharp eye for observing and transforming "slivers of minutiae" that mark Gerald's art. The notebook, a treasure trove of ideas, provides insight into the workings of Gerald's imagination and supplies us with hints of what he was thinking about as he sat down to paint.

In her essay, Linda Patterson Miller, author of *Letters from the Lost Generation: Gerald and Sara Murphy and Friends* (2002), examines the work of writers who used the Murphys as subjects either in memoirs or fiction. Chief among these literary figures are F. Scott Fitzgerald, Archibald MacLeish, John Dos Passos, Philip Barry, and Ernest Hemingway. Patterson Miller's extensive knowledge of the correspondence between the Murphys and their friends, as well as her familiarity with external events and the inner workings of this cast of characters, informs her understanding of the literature that grew out of their friendships. She uncovers, too, the literary equivalent of the Cubist use of coded imagery.

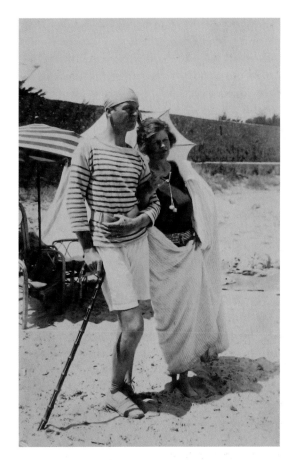

Gerald and Sara on La Garoupe beach, Antibes, summer 1926.
GERALD AND SARA MURPHY PAPERS, BEINECKE LIBRARY, YALE

In *"Les Enfants du Jazz,"* Olivia Mattis, a musicologist who specializes in the links between music and art in the twentieth century, discusses the central place of music in the Murphys' lives and the key, often behind-the-scenes role the couple played in promoting new or then-forgotten forms such as jazz, African American spirituals, and American and Spanish folk music. Their collection of scores and recordings influenced and aided composers from Virgil Thomson and Nicolas Nabokov to Richard Rodgers and Cole Porter, serving as the basis for two motion picture soundtracks and two ballet scores. Besides collecting and promoting all kinds of music, they also performed new as well as unfamiliar songs and dances for a broad network of friends ranging from Isabella Stewart Gardner to Erik Satie. Mattis touches on the head-spinning number of musical personalities involved with the Murphys as she offers the first examination of this vital aspect of their lives.

Like Calvin Tomkins, the poet William Jay Smith presents a firsthand account of the Murphys. He met Gerald and Sara Murphy in 1954 through the novelist Dawn Powell, who had shown them Smith's small book of visual poetry entitled *Typewriter Birds*. Gerald was so taken with the book that he contacted Smith about buying it in quantity. In addition to personal recollection, Smith interprets two paintings by Murphy through the lens of poetry, seeing in them the depiction of "the triumph of time and death" manifested as visual or concrete poems.

The curator and art historian Kenneth Wayne looks at the Côte d'Azur arts community of the 1920s, viewing the Murphys and their Villa America in the context of three other artistic villas and châteaux on the Riviera: Villa Noailles, Picabia's Château de Mai, and the Château de Clavary. He describes the differences among these artistic enclaves, whose guests included many of the Murphys' friends and at times the Murphys themselves.

Dorothy Kosinski, the Dallas Museum of Art's Barbara Thomas Lemmon Curator of European Art, traces Gerald Murphy's critical fortunes as an artist. She touches on his early fame in Paris in the 1920s and the anonymity that followed until 1960, when he was "plucked from obscurity by the fledgling Dallas Museum for Contemporary Arts." The museum's new director, Douglas MacAgy showed five of Murphy's paintings in a group exhibition entitled *American Genius in Review No. 1.* In the course of questioning why MacAgy mounted a show that resurrected forgotten artists, Kosinski revisits the political forces at work in Dallas and the nation during the McCarthy years. She concludes that MacAgy's exhibition was an attempt to defy the cultural conservatism that assailed Dallas in the 1950s and to counter assertions that identified modern art with communism and anti-Americanism.

The essays in this volume strive for a balanced portrait of Sara and Gerald Murphy, plumbing the dark side of their lives as well as shedding light on the multiple ways they served as models for the best that life could be. The writer Donald Ogden Stewart summarizes the impression they made on many: "Once upon a time there was a prince and a princess, that's exactly how a description of the Murphys should begin. They were both rich, he was handsome; she was beautiful; they had three golden children. They loved each other, they enjoyed their own company and they had the gift of making life enchant-

ingly pleasurable for those who were fortunate enough to be their friends."[10] Even after tragedy struck and financial reversals undermined their way of life, they continued, as Calvin Tomkins has noted, "to live at the highest level of sensitivity to cultural and natural stimuli."[11] They also demonstrated respect for every person's dignity and could not abide prejudice or injustice. Early on they championed jazz and African American music as art forms, deploring the demeaning minstrel shows popular at the time. In later years they came to the aid and defense of friends persecuted during the McCarthy era (Paul Draper, Dashiell Hammett, Barry Adler) or banned from restricted communities (Lillian Hellman). Their invention was the creation of an environment based on goodwill, simplicity, domesticity, friendship, and "living well." This way of life laid the groundwork for much that we still look upon as modern. Their lesson for today is the value they placed in, as Sara put it, "the simplest, bottomest things."[12] Such sentiments constituted a worldview that was to prove particularly compatible with the nascent modernist movement. By the time the progressive group L'Esprit Nouveau declared in their October 1920 manifesto, "There is a new spirit. . . . A great period is just beginning,"[13] Sara and Gerald were already "making it new."

NOTES

1 Ezra Pound, *Cantos LII–LXXI* (Norfolk, CT: New Directions, 1940), 11 (Canto LIII).

2 *Those Paris Years: A Conversation between Archibald MacLeish and Samuel Hazo,* videocassette (University Park: Penn State Audio-Visual Service, 1987).

3 Gerald and Sara Murphy, audiotape interview by Calvin Tomkins, c. 1960. I am grateful to Calvin Tomkins for allowing me to quote from these tapes.

4 Gerald Murphy, letter to Sara Murphy, November 12, 1916. Unless otherwise noted, all correspondence between Sara and Gerald is in the Honoria Murphy Donnelly Collection.

5 Gerald, letter to Sara, June 9, 1919.

6 Fanny Myers Brennan, interview by Linda Patterson Miller, June 22, 1981. I am grateful to Linda Patterson Miller for sharing with me the tapes and transcripts of the many interviews she conducted.

7 John O'Hara, letter to Gerald Murphy, 1962, Honoria Murphy Donnelly Collection.

8 William Rubin with the collaboration of Carolyn Lanchner,

The Paintings of Gerald Murphy (New York: Museum of Modern Art, 1974), 10.

9 Gerald certainly appreciated these qualities. As late as 1936, he wrote to Sara: "I wonder if anyone who wants as much feeling of life as you do,—ever really gets it. . . . You certainly have always given it to people. People talk of you with emotional gratitude." Gerald, letter to Sara, April 18, 1936, quoted in Linda Patterson Miller, ed., *Letters from the Lost Generation: Gerald and Sara Murphy and Friends,* ex-

panded edition (Gainesville: University Press of Florida, 2002), 164.

10 Donald Ogden Stewart, *By a Stroke of Luck! An Autobiography* (New York: Paddington Press/Two Continents, 1975), 117.

11 Calvin Tomkins, conversation with the author, May 19, 2004.

12 Sara, letter to Gerald, 1915.

13 Le Corbusier, in *L'Esprit Nouveau* (October 1920).

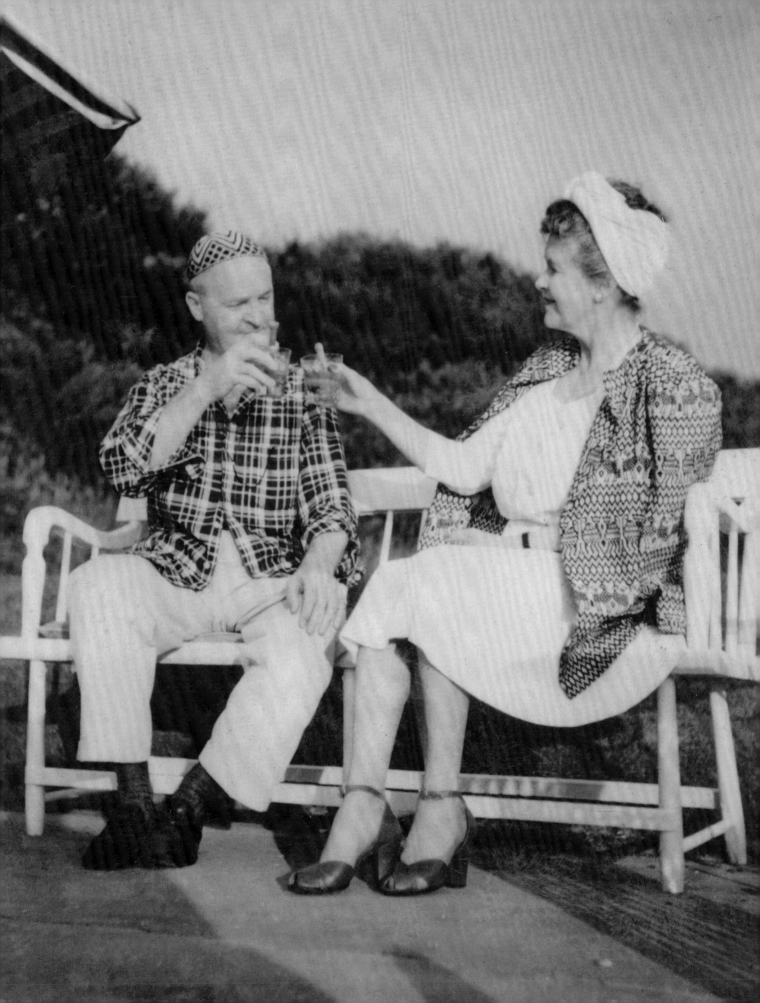

REMEMBERING GERALD AND SARA

CALVIN TOMKINS

When I met Gerald and Sara Murphy, in the late 1950s, they lived in a pre-Revolutionary stone house on the west bank of the Hudson River, about twelve miles north of the George Washington Bridge. To the other residents of this small and highly self-regarding community, called Snedens Landing, the Murphys were glamorous but unknown. It was said that they had lived in Paris in the 1920s, and had known F. Scott Fitzgerald and Ernest Hemingway and other luminaries of that golden era, but the details were hazy. Once a year, in June, the Murphys invited a sizeable number of their neighbors to a garden party. Aside from that, they kept mostly to themselves, and the friends who occasionally visited them were not from Snedens.

Their property was close to ours, and one spring day, a year or so after my wife and I had moved in, our five-year-old daughter and her three-year-old sister saw Gerald and Sara out gardening and wandered over. We followed, apologies ready, but Gerald waved them aside. He was highly amused by Susan, the three-year-old, who had taken a look at his sandals and said, "What are you doing with your bare feet on?" The friendship that began that sunny afternoon always struck me as being somewhat miraculous. A week or so later, we savored

Gerald's champagne cocktails on their second-story front porch; they were made according to a secret recipe that included, in Gerald's mock-serious phrase, "the juice of a few flowers." I recall Sara's saying that you must always look *up*, into the trees, when you sip champagne. Over the next few months, they took us to the theater, and to lunch at the Bird and Bottle, a good restaurant on the other side of the river; Gerald drove us in his vintage black Pontiac, which had a searchlight mounted on the roof to distinguish it from all the other black cars in parking lots and garages. They gave us the full-cast recording of the Gertrude Stein–Virgil Thomson opera *Four Saints in Three Acts*, because, Gerald said, "It really belongs to you." Tied up to their little dock on the river was a mahogany rowboat, which they never used. A friend had urged them to buy it because it was "a gentleman's boat," and for Gerald that was too absurd to resist.

Hemingway and Fitzgerald were demigods to me then, and pretty soon I began asking questions about the decade in Paris when the Murphys had been close to both of them. Gerald's natural gift for storytelling, complemented and sometimes corrected by Sara's memory of exact detail, opened up for me the freshness and excitement of early modernism in the 1920s—something that my close readings of Hemingway and Fitzgerald had not done. Gerald also talked about Pablo Picasso, Fernand Léger, Sergei Diaghilev, Jean Cocteau, Igor Stravinsky, and others—they seemed to have known every-

body who had counted in the culture of the period. He and Sara described how they had volunteered to help re-paint the Diaghilev stage sets that had been worn out through overuse, and I learned that they both had studied painting in Paris with Natalia Goncharova. For some reason, though, even after I began tape-recording our conversations with the idea of writing about the Murphys, Gerald's career as a modern painter didn't come up. When I began interviewing some of their old friends, John Dos Passos wrote me a letter saying that, although a profile of the Murphys seemed to him an impossible task, "The one thing that would take the curse off the project from my point of view would be the writer's interest in Gerald as a painter." I was just starting to write about art and artists for the *New Yorker* then, but Dos Passos's suggestion failed to register with me. In my *New Yorker* profile on the Murphys, which came out in 1962, there is only one paragraph on Gerald's painting.

The reason, I suppose, is that Gerald himself made so little of it. When I asked him once why he had stopped painting, he said that he felt his painting was not first-rate, "and the world is filled with second-rate painting." He never suggested I look at the two pictures of his that were hanging (as I learned much later) in the guest suite upstairs, or the two others that were rolled up in the attic—all four of which are now in major museums, including the Museum of Modern Art and the Whitney Museum of American Art in New York. Stranger still, he barely mentioned that five of his pictures were about to be in a group show of "forgotten" artists at the Dallas Museum for Contemporary Arts, called *American Genius in Review No. 1*. Gerald never went to Dallas to see the show, and neither did I.

Now, of course, it's clear that he didn't think his painting was second-rate—not at the time he was doing it, anyway. "Before I die I'm going to do one picture which will be hitched up to the universe at some point," he wrote to Hemingway in 1927. "I can feel it now and work quietly." He painted for two more years, and then, abruptly, he stopped, and for three decades he appears to have avoided thinking about it. The Dallas exhibition, organized by Douglas MacAgy in 1960, and MacAgy's 1963 essay on Murphy in *Art in America*, brought the work back into focus for him, and also brought it to the attention of some very influential people. One of them was Alfred H. Barr, Jr., who told Gerald, when they met in 1964, that he found his work valuable aesthetically and

would like it to be shown at the Museum of Modern Art. Gerald's later comment on this was characteristically self-mocking: "I've been discovered. What does one wear?" By then, I had become much more interested in Murphy as an artist. On a trip to Europe, I tried, unsuccessfully, to track down two of his missing paintings, the eighteen-foot-tall *Boatdeck* and the much smaller *Portrait*. We kept in touch, and Gerald talked to me a little—not much—about his work and the recognition it was starting to receive. The Corcoran Gallery of Art in Washington, D.C., wanted to give him a one-man show. "Alas, I find myself unable to rise to all this and am temporizing," he wrote me. In the end he turned them down. Gerald questioned me closely about Robert Rauschenberg, John Cage, and Marcel Duchamp, all of whom I was writing about or planning to write about; their approach to art making, with its use of chance and everyday materials, was fascinating to him. "Painting in the USA seems a series of epidemics," he wrote. "Think of the slow process of accretion in Braque's work! Surely someone must be working silently and independently somewhere who will emerge, having distilled visually the essence of the age he lives in. O to be young again! And yet Uccello, a mathematician, started painting at 60!"

Gerald and Sara sold their Snedens house in 1963 and retreated to East Hampton, where they lived in a small cottage (they named it La Petite Hutte), which was all that remained of the six-hundred-acre beachfront estate that Sara's father had once owned. Most of our conversations now were by mail. "Sapphire-and-diamond ocean today," was a typical opening. The house, which they had built themselves, had two small bedrooms and a large living room with a cathedral ceiling and an enormous window facing the ocean, in which Gerald swam for a mile every day in season, up the beach and back. He wrote to me on lined yellow legal paper, graph paper, or small notepads in subtle shades of gray or beige, and when he reached the bottom of the paper, his neat, careful handwriting would often continue up the right margin, across the top, and down the left side. His written reflections were useful when I was writing *Living Well Is the Best Revenge*, an expanded version of the *New Yorker* profile in book form, with an added chapter on Gerald's paintings. But much of the information he gave to me and to MacAgy turned out to be wrong. He said that *Razor* was his first painting, when it was actually the fourth, and he was vague about titles and dates, and about what had

happened to the lost or missing pictures. (Only seven have survived, out of a total of fourteen.) "All of that," he wrote to me, "is as if in a sealed chamber of the past and has somehow become unreal. I was alive those seven years that I was painting. . . . It seems to me now like a truncated tree, something to be eternally unfinished."

The immediate cause of his giving up painting was never in doubt. Patrick, the youngest of the Murphys' three children, the one their friends all said was "more Gerald than Gerald," became very ill in 1929, with what proved to be tuberculosis. The entire Murphy family moved from their home in the south of France to a sanitarium in the Swiss Alps, where they spent the next eighteen months. Their close friend Dorothy Parker visited them there, and wrote, in an anguished letter to their mutual friend Robert Benchley: "Patrick's treatment will take two years, they say. Gerald has absolutely isolated himself with him—does every single thing for him. . . . he is simply pouring his vitality into Patrick, in the endeavor to make him not sick." The losing battle for Patrick's life took seven years, during which their robustly healthy older son, Baoth, died quite suddenly of spinal meningitis. By then, the Murphy family had moved back to the United States, where Gerald took over his father's business, Mark Cross ("this monument to the nonessential," as he called it), pulling the store out of bankruptcy because several other members of his family were dependent on it, living a very different sort of life. "There is something about being struck *twice* by lightning in the same place," he wrote to me, years later. "The ship foundered, was refloated, set sail again, but not on the same course, nor for the same port."

No one who has lost two sons should be required to give reasons for future life decisions, and yet I sometimes wonder why Gerald never painted again. Dorothy Parker, in her letter to Benchley, referred to "that morbid, turned-in thing that began with his giving up his painting and refusing to have it mentioned." Thirty years later, when my conversations with him began, there was no sense of a morbid refusal to discuss the subject; he just seemed to think it was of minor interest. In the last two years of his life, though, after the MacAgy show and the *New Yorker* profile, that too-brief, long-buried commitment to making art resurfaced in his mind, and I believe he was reconciled to it. Some sort of reconciliation was needed, because Gerald had come to think that life and art were incompatible. "Either a good life and lousy work, or good work and a lousy life," as his friend Léger used to say. The Murphys—Gerald quite consciously, Sara more intuitively—had made a very impressive stab at turning their own life into a work of art during the decade they spent in France. Their friends all remarked on it and marveled at it; Fitzgerald even used their life as the basis for his novel *Tender Is the Night*. At first, when Gerald became fully engaged in his own development as an artist, this had seemed to pose no threat to the life they shared with their children and their friends, but tensions and strains may well have existed beneath that magical surface. When tragedy struck them, not once but twice, the darker side of Gerald's Irish nature seems to have assigned guilt and demanded punishment. Did he blame himself for the self-indulgence that serious art requires? I think perhaps he did.

Gerald's last letter to me is dated, in his usual style, "15:viii:64." He was dying of cancer, but what concerned him was an urgent conviction that I should drop what I was doing and write fiction. "You need the feeling," he said, "that there exists a work of considerable proportion lying near you always in your mind, which is yours and no one else's. It should be your secret terrain. Everything there is yours and you add to it daily. . . . The feeling at the end of the day, of having brought it forth. 'This morning it did not exist.'" Gerald had been there, and he knew.

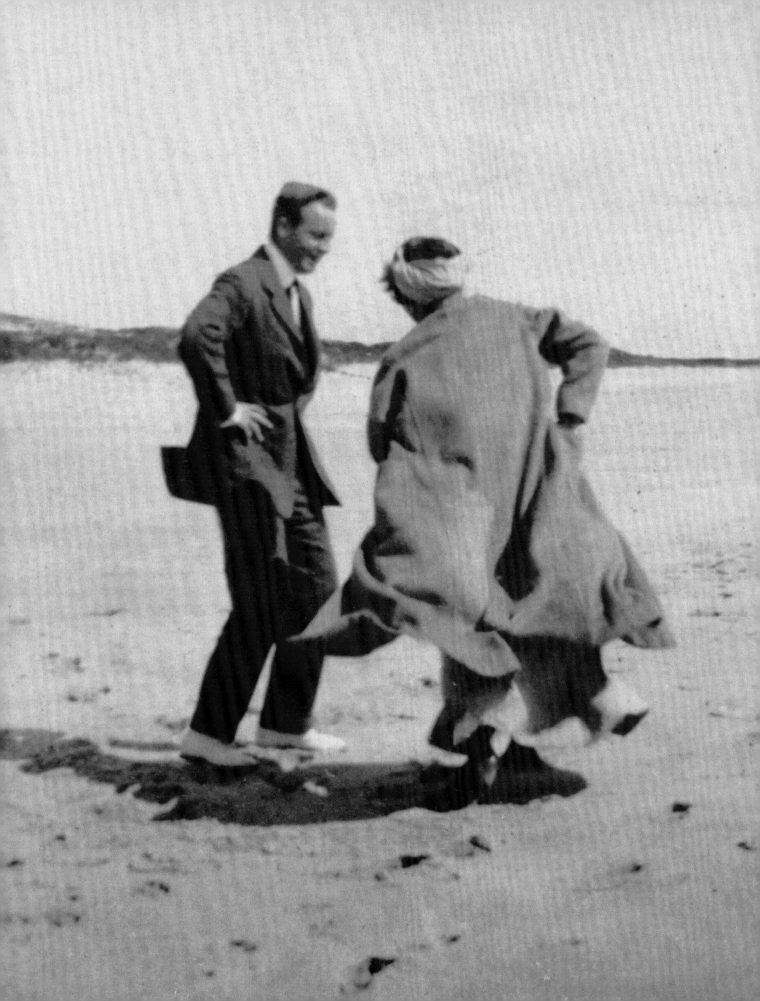

MASTERS OF THE ART OF LIVING

DEBORAH ROTHSCHILD

Person after person—English, French, American, everybody—met them
and came away saying that these people really are masters in the art of living.

ARCHIBALD MACLEISH, ON GERALD AND SARA MURPHY

Gerald Murphy once explained that his remarkable life with his wife, Sara Wiborg Murphy, "was the unconscious creation of two persons who were opposites, except that [we] both reacted to most things aesthetically and . . . those reactions were applied to the life [we] were leading—and not being led by."[1] The marriage between Gerald—who meticulously planned, intellectualized, and expended great effort in order to make each moment a beautiful event—and Sara—who lived intuitively and impulsively—produced a unique alchemy, by which their daily life became an artistic venture. Together, they created a distinctly modern, elegant style of living that ranged over art, literature, music, theater, fashion, design, gardening, child rearing, and entertaining.

Virtually no one who shared the pleasure of their company ever forgot the experience, and years later many still puzzled over what made this luminous couple so enchanting. In the simplest terms, they were privileged Americans who moved to France with their three young children in the 1920s. Gerald became a painter of meticulous, dispassionate canvases, usually depicting small objects enlarged to colossal size, which were praised as original and very American. Sara's love of life, together with her originality, serenity, and singular beauty, inspired

Pablo Picasso and Ernest Hemingway, and both Murphys were the source for F. Scott Fitzgerald's protagonists Dick and Nicole Diver in *Tender Is the Night*. As up-to-date, aesthetically adventurous Americans, Sara and Gerald charmed and fascinated war-weary Europeans. Igor Stravinsky said: "The Murphys were among the first Americans I ever met and they gave me the most agreeable impression of the United States."[2]

Beyond that, it is more difficult to pin down the Murphys' "irresistible pleasingness,"[3] which seemed to cast a spell over an international circle of artists, writers, musicians, dancers, and other friends. The writer and critic Brendan Gill noted that Gerald and Sara delighted "in life's simplest best" and that they had a knack for transforming any space they inhabited into something Murphyesque, by which he means not only unconventional, modern, and elegant, but also possessed of a kind of distinction stemming from some true emotion—an emotion transcending the desire to please.[4] What Gill describes is the creative force that goes into making a work of art, and that is precisely what the Murphys applied to the fleeting, everyday business of living. Gerald once told Fitzgerald that only the invented part of life had any meaning.[5] He and Sara consciously constructed a life so perfect that, for a brief period, it became the calm center of a universe of talented and creative artists. The Murphys' ideal world, so modern in its apparent simplicity and ease and its delight in family, friends, and nature, soon

Detail from photograph of Gerald and Sara Murphy dancing on the beach at East Hampton, c. 1915 (see p. 25).

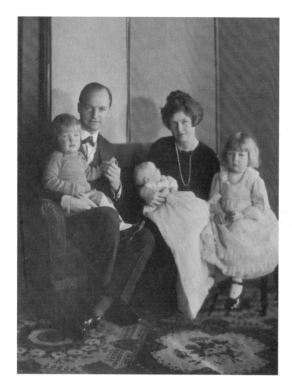

The Murphy family in Cambridge, Massachusetts, winter 1920–21.
Left to right: Baoth, Gerald, Patrick, Sara, and Honoria.

found its way not only into art and novels, but also into poetry (Archibald MacLeish), plays (Philip Barry), and memoirs (John Dos Passos). For these artists and others, the life the Murphys invented came as close to perfection as any of them would find in the real world.

FAMILY BACKGROUND

The three beautiful Miss Wiborgs, originally of Cincinnati, were the sensation of the season. These daughters of Mrs Frank Wiborg took London by storm. They were always seen together and had been in demand at the smartest parties.
UNDATED NEWSPAPER CLIPPING INSERTED INTO
FRANK WIBORG'S 1913 DIARY

The Wiborg Family

Sara Wiborg Murphy was born into the American Dream. Her father, Francis (Frank) Bestow Wiborg (1855–1930), whose beginnings were modest, had made a fortune by the time she was born. In the diaries he kept from 1867 until 1914, Frank Wiborg included not only his thoughts

on business but also articles, calling cards, menus, pictures, letters, political ephemera, and even prophylactics, providing a fascinating record of a time when America's fortunes were booming.[6] Mirroring the rapid growth of the country, Wiborg himself grew from a relatively unsophisticated country boy, left fatherless at age ten, into a worldly titan of industry in the span of twenty years.

He was born in Fulton, Illinois, to Henry Paulinus Wiborg, a Norwegian deckhand on a steamship, and Susan Bestow.[7] Henry died in 1866,[8] and Frank developed a work ethic in his teens. He sold newspapers while attending school, graduating from the Chickering Institute in Cincinnati in 1875. The next year he is listed as a clerk at Captain J. W. Pillsbury's ticket office in the Grand Hotel. A clipping in his 1878 diary announces that "the handsome man about town who is ex-ticket agent of Cincinnati is now established in the printing ink and varnish business." Lee Ault had seen his potential and made Frank a junior partner. The Ault and Wiborg Company grew rapidly, producing quality inks prized by lithographers at home and abroad. Their clients included the publishers Scribner's, Lippincott, and Harper's, as well as artists such as Henri de Toulouse-Lautrec, who in 1896 was commissioned by Wiborg to produce an advertising poster for the company.

Wiborg's station in life was given a dramatic boost with his marriage in 1882 to the wealthy and pedigreed Adeline Sherman of Des Moines, whose uncles were Civil War General William Tecumseh Sherman and Senator John Sherman of the eponymous antitrust act. His marriage gained Wiborg entrée into society and politics, but undoubtedly he would have succeeded in business on his own, as his diaries reveal him to have been intensely ambitious and a tireless worker. Wiborg was the epitome of the take-charge, powerful alpha male of nineteenth-century America. He was one of the earliest proponents of changing from coal to gas and oil fuel, a farsighted view in 1890, and in his book *A Commercial Traveler in South America,* published in 1905, he scolded his countrymen for not seeing the potential of South American resources to enrich American coffers. Wiborg's political ambitions were rewarded by President William Howard Taft, who named him assistant secretary of commerce in 1908.

Adeline Moulton Sherman Wiborg (1859–1917) left no journals, and thus she must be reconstructed from her husband's diaries, her few surviving letters to him and

Frank Wiborg's journal, 1912.
GERALD AND SARA MURPHY PAPERS, BEINECKE LIBRARY, YALE

their three daughters, as well as accounts from the society pages of Des Moines and Cincinnati newspapers, which in her youth noted her beauty, generosity, graciousness, and equestrian abilities, and later her talents as a decorator, hostess, and society matron. Adeline first appears in Frank Wiborg's journal on June 3, 1880, after he met her while she was visiting her cousin in Glendale, a suburb of Cincinnati. It is delightful to read Frank's entries, usually so gruff and businesslike, as he fell in love. On November 29, 1880, visiting Adeline in Des Moines, he wrote: "Miss S. is a perfect little lady." She is mentioned with increasing frequency throughout 1881, as on March 26—"Miss S. has complete possession of me"—and on May 13: "Busy all day attending to my business, but could hardly think of anything but Addie." After more than a year of heady infatuation, they married on April 26, 1882. Frank's diary entry reads: "Des Moines. This is a never-to-be-forgotten day. The most eventful and happiest one of my life[,] the day Addie Sherman becomes my wife." An account of the wedding in the *Des Moines Register* of April 29, 1882, reads: "Nearly all the citizens of Des Moines know of how much real truth and absolute worth this young wife is possessed."[9]

After the couple's honeymoon—a grand tour of Eu-

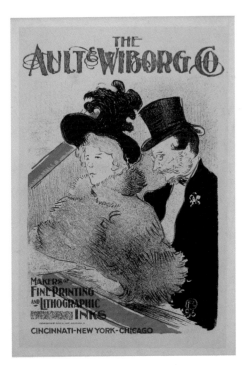

Henri de Toulouse-Lautrec, *Au Concert* (poster for the Ault & Wiborg Co.), 1896. Color lithograph, 19 × 14 in.
MUSEUM OF FINE ARTS, BOSTON, BEQUEST OF LEE M. FRIEDMAN, 1958

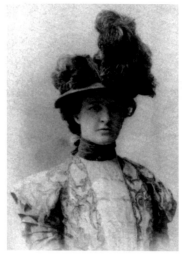

Adeline and Frank Wiborg, c. 1882.

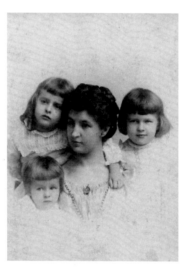

The three Wiborg sisters with their parents, c. 1891. Sara at far right in both.

A gathering of the Sherman family at the home of Major Hoyt Sherman, Sara's maternal grandfather, Des Moines, late 1870s. Sara's mother, Adeline Sherman, sits alone on the lower step. Sara's granduncle John Sherman, who served as both a senator and as secretary of the treasury, stands to the left of the pillar. Her granduncle William Tecumseh Sherman, the renowned Civil War general, is the second man to the right of the pillar. Hoyt Sherman is second to the right of him.

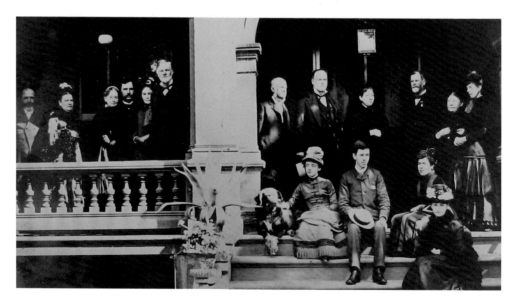

rope—Frank returned to his usual preoccupation with printing ink. Without any previous mention of a pregnancy, he inscribed the top of the diary page for November 7, 1883: "Sara Sherman Wiborg Born," and noted that "after an awful struggle at 7:15 a little girl baby arrives—I never experienced such great relief." Although Frank's diary continued to focus primarily on business after this point, he did give space to social rounds made with Addie and to time spent with Sara. On the couple's second anniversary, he touchingly noted: "If I can only have the rest of my life as happy as the last two years have been I'll be satisfied. I love Addie incomparably more now than when we were married two years ago." When, on January 28, 1887, another daughter was born, he noted in his diary: "This the day our little girl Mary Hoyt is born." He then confided: "Thought and hoped we would have a boy this time." A third daughter, Olga, was born on February 6, 1889. Later in life, Sara would write that even though Frank wanted sons, he "became resigned to girls . . . and was *always wonderful* to his three daughters."[10]

Although Frank Wiborg's business kept the family rooted to Cincinnati for much of the year, they often spent time at the shore. Frank loved swimming and sailing, and as his fortunes grew he looked for a second home by the sea. In July 1888 the family visited Newport, Rhode Island. Frank's diary entry of July 23 reads: "Very interested in Newport—a lovely place—but costs a fortune to live there." The next day he ferried over to Namagansett, Long Island. Thereafter the family summered on the less fashionable Long Island, where Frank began buying property. By 1900 he owned six hundred acres in East Hampton, most of which he gradually sold at a significant profit after the train line was extended to the area and it became a desirable summer destination. He retained eighty acres, however, and built a large estate, known as the Dunes. Completed in 1912, it consisted of a thirty-room mansion with a living room measuring forty-two by seventy feet, as well as stables, a working farm, a dairy, various fruit groves, and a sunken Italian garden.

In the meantime, beginning in 1895 with a family trip to Paris, London, and Egypt, the Wiborgs added extensive travel to their daughters' education. By 1897 Adeline Wiborg's social aspirations for her daughters were taking precedence over her attachment to her husband. She began living abroad with the girls for long periods

Sara and Hoytie Wiborg in a studio photograph taken at the shore, c. 1889.

Sara Wiborg, drawing of Amagansett, 1900. Frank Wiborg kept this drawing in his journal for the year 1900.

BOTH IMAGES GERALD AND SARA MURPHY PAPERS, BEINECKE LIBRARY, YALE

in order to prepare them for entry into European society. Sara, Hoytie, and Olga learned German, French, and Italian; they had singing lessons and played instruments; they rode horses and (then newly invented) bicycles; and they visited the theater or attended parties nearly every evening. In 1899, after a six-month separation, Frank Wiborg joined his family in Berlin. Together, they visited Bayreuth, attending Richard Wagner's Ring Cycle ("The children understand all the motifs and the language perfectly," Frank notes), and were guests of Kaiser Wilhelm II at Charlottenburg Palace. (A newspaper clipping inserted into Frank's diary tells us that Prince Hohenlohe, charmed by the three girls during a transatlantic cross-

TOP LEFT AND RIGHT The Dunes, the
Wiborgs' estate in East Hampton, Long
Island, c. 1915.

RIGHT "The Three Beautiful Misses
Wiborg," 1909. Left to right: Hoytie,
Sara, and Olga.

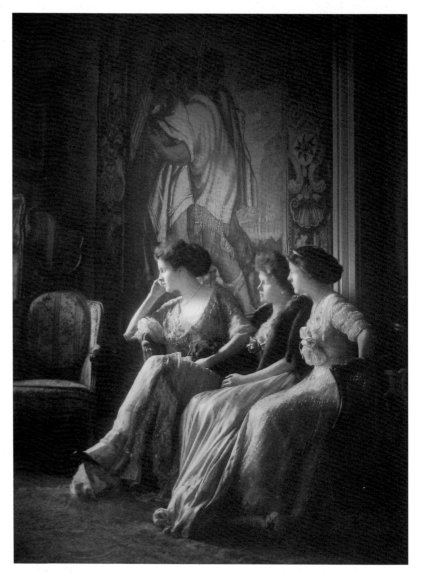

Sara Wiborg, c. 1905.

Surviving ephemera from 1905 to 1914 chronicle the Wiborg family's travels and lifestyle. Frank's diaries are stuffed with newspaper and magazine articles about his trips and achievements and those of his wife and daughters. Charles Dana Gibson described them in one article as epitomizing the ideal beauty of the day, the Gibson Girl,[12] and numerous clippings reported that Sara and her sisters sat for paintings and photographs. The young women were celebrated in society columns for their cleverness, looks, and talent, one column even noting that their fine singing at a certain event had caused them to be mistaken for professional performers.[13] In another, Olga was deemed by Lord Camoys "the most beautiful girl I have met." The same article ended: "All the Wiborg girls are extremely pretty, Miss Sara's chic, Miss Hoytie's dark artistic beauty and Miss Olga's delicate fairness making them a very lovely trio notable in any company."[14] Frank was clearly proud of his daughters, but he also complained of their laziness and spending habits.

Sara "came out" to society with a masked ball at the Cincinnati Country Club on December 30, 1905, entering the ballroom held aloft in a sedan chair. In 1907 Adeline achieved one of her goals when Sara and Hoytie were presented at the Court of Saint James to Edward VII and Queen Alexandra. (Olga was presented in 1909.) In 1911 Adeline and her daughters attended the coronation of King George V.

Photographs also document the Wiborgs' travels. One album, for example, depicts the family's automobile tours of the châteaux of France in 1904 and 1909. Commentary on the latter trip appears in Sara's and Hoytie's journals. Typically, in their diary entries, Sara saw the humor in the multiple flat tires, rainstorms (cars were open-topped then), accidents, and delays—and even in an episode of food poisoning—while Hoytie remained im-

ing the previous year, had invited them to meet and dine with the kaiser.[11]) But Frank was miserable throughout the two-month stay in Europe. He did not like his wife's friends or her enthrallment with aristocratic society. In his diary, he recorded nearly daily arguments with Adeline, who wanted to remain in Germany. On July 4 he wrote: "Things are not very happy with us here. . . . Perhaps I have made a mistake by leaving my family too long in Europe." His entry for July 20 noted: "Fretful row—Adeline is bound that she will stay in Berlin, and I don't care for it. Why she will give up all we have at home for this sort of life is beyond my comprehension." But Adeline had goals for her three daughters: it was necessary for them to become sufficiently refined and accomplished if they were to be accepted by—and perhaps marry into—European society.

Sara (with an unidentified man) at the Grand Prix, Paris, 1909, from the photo album of the Wiborgs' second automobile tour of France.

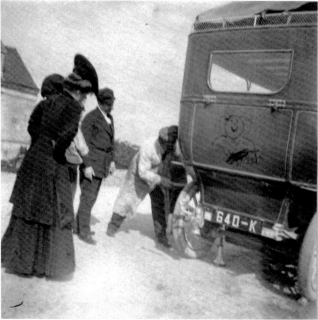

Images from a photo album documenting the Wiborg family's second automobile tour of the châteaux of France of May 1909. **LEFT** Olga wears the checked suit and Hoytie sits beside her. **RIGHT** Sara, dressed in black, is seen from behind; Frank Wiborg is the man in the black suit. On September 12, 1904, during the first automobile tour, Sara wrote in her travel journal: "Tire burst—arrived in Tours reduced to perfect pulps after being on the road for 17 hours. The next morning we got up with a feeling of general repulsion for automobiles."

GERALD AND SARA MURPHY PAPERS, BEINECKE LIBRARY, YALE

perious and put out. The second trip ended with a visit to the Grand Prix in Paris, where Sara was photographed smiling and wearing a lavish hat. Other images from 1905 through 1913 show the sisters romping with unidentified dandies on imposing estates in Headfort, Ireland; Podiebrad, Moravia; and Santa Barbara, California.

Over his wife's protests, Frank insisted the family stay in the United States during the 1912 season, and on May 15 Adeline wrote him a scolding letter:

Dear F., I still regret not going over to London—Many reasons. Keeping girls up to things and alert to intelligent things in life is one. How would you like to have Hoytie or Sara marry someone like Monroe Robinson or such because he is always about and cheerful and no one else amuses them or Olga some *pig* like Bob Breeze. . . . Heaven forbid these girls shall ever take "make shifts" just because they don't care very much or see *different* kinds of people. *Think* it over. I do all the time.[15]

The next year Adeline prevailed and was back with her daughters in London, hosting a "Vegetable Ball" at the Ritz Hotel. The ball was a highlight of the social season. Guests from the ranks of the British nobility competed

in a "rag time potato race" and were given garden vegetables brought in on a wheelbarrow as party favors, causing "gales of laughter."[16] During this stay in London, Sara met members of Sergei Diaghilev's Ballets Russes and attended a performance of Stravinsky's revolutionary atonal modern ballet *Le Sacre du printemps (The Rite of Spring)*. She was so enchanted with the Russian company that for her birthday her sisters gave her an original watercolor by Léon Bakst, the designer of lush sets for Diaghilev.[17]

In February 1914 the entire family toured India and Ceylon, where they rode elephants and attended balls. On the return voyage, Frank caught his daughters smoking—which was considered an indecent activity for women at that time. He wrote in his diary: "To my great disappointment all three of our girls were smoking cigarettes. . . . This [is] a great shock to me and makes me feel that the entire trip has been spoiled." The next day he continues: "The girls' smoking cigarettes incident passes, but it has left a hurt with me—I don't like being disobeyed."

In between traveling and living abroad, Sara pursued

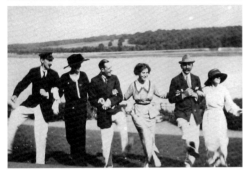

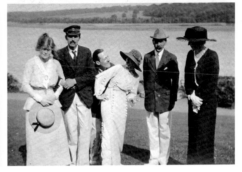

The photographs at left, from one of the Wiborg family's albums, were taken on the Isle of Anglesey, Wales, August 17, 1913. Adeline Wiborg and her daughters toured Scotland, Ireland, and Wales with a group of friends, including Geoffrey Thomas Taylor, Marquess of Headfort, and his wife, Rosie Boote (the former Gaiety Girl). They also stayed with the Taylors at their home in Headfort, Ireland. The man holding Sara's arm in the bottom right photo appears frequently with her in photo albums from this period. In her diary, she records spending a good deal of time with "Geoffrey H" in London, Headfort, and Vichy, France in 1913; however, she may be referring to Geoffrey Taylor, who was the Marquess of Headfort, not the gentleman in the photographs.

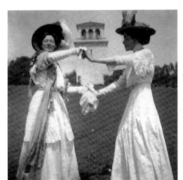

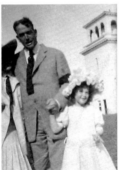

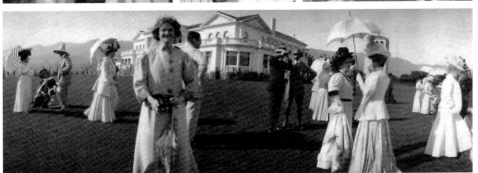

Images from a Wiborg family album documenting a trip to Santa Barbara, California, April 1908. A newspaper clipping inserted in Frank Wiborg's 1908 journal reads: "Mrs. Wiborg and her daughters leave next week for Santa Barbara where they will be the guests of Mrs. William Miller Graham at her home Bessoiguardos . . . a white marble Italian villa on a cliff overlooking the sea. The Atlantic Squadron under Admiral Evans will be anchored and the Flower Pageant will be revived for the occasion." In the bottom photograph, Sara faces the photographer, holding a camera and parasol with the villa in the background.

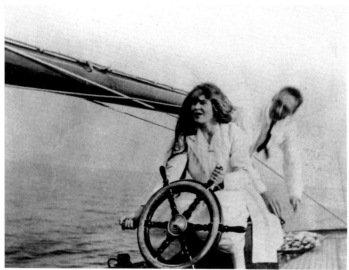

Page from Sara's sketchbook, Hyde Park, London, 1901.

Sara sailing in Gardiner's Bay, Long Island, c. 1910.

her talent for drawing by taking classes at the Art Students League in New York and instruction with William Merritt Chase. Her sketchbooks are filled with sensitively rendered still lifes, studies of studio models, and portrait sketches, but she seemed to be filling time rather than answering a true calling. Despite every advantage—wealth, beauty, talent, wit, and culture—a melancholic emptiness pervades the diary she kept between 1910 and 1914. She frequently complained of being "frightfully depressed" and "feeling low" or "rottenly," a moodiness that seems strikingly out of character with the contentment, optimism, and love of gaiety that she projected in later years. But as she approached the age of thirty, she seemed at loose ends and to be pulled by opposing forces: possessed of "modern" sensibilities, she was independent-minded and unconventional in her thinking, and she had an impulsive, fearless streak that would stay with her throughout her life.[18] Family and friends would later admire this quality in her, but at this point in time she was still shackled by Victorian restrictions and repressed by her parents' expectations. Sara had, after all, been groomed to behave as a showpiece—one of Mrs. Wiborg's beautiful and accomplished daughters—and to snare an aristocratic husband.

The Murphy Family

Gerald Murphy's father, Patrick Francis Murphy (1858–1931), also left behind a written record: hundreds of five-by-three-inch notebooks completely filled with writing. Unfortunately for the biographer, they offer not one personal word about him or his family. Rather, they present a dizzying array of musings about history, literature, and human nature, sprinkled liberally with quotes, adages, and witticisms to be used in the after-dinner speeches for which he was famous. These notebooks and additional loose sheets also contain advertising copy for the Mark Cross company, his luxury goods business. Patrick Murphy wrote his own advertisements—clever, long-winded pieces that often employed wordplay, such as: "Cross purposes: to make the Cross TradeMark the Hall Mark of quality" or "Cross gloves are trumps—when you wear them you hold the best hand."

Patrick Murphy, like Frank Wiborg, was of enterprising immigrant stock. He began his career at seventeen working for the Boston saddler Mark W. Cross. In time, he convinced the owner to manufacture other leather products and eventually bought the establishment when

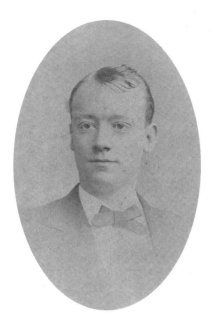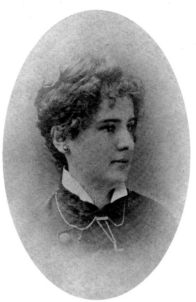

Patrick Francis Murphy (c. 1884)
and Anna Ryan Murphy (1884).

his former employer died, moving the business to New York City in the 1890s. Shrewd in spotting trends, Patrick Murphy branched out of saddles and harnesses just as people were trading in their horses and carriages for automobiles. He understood the new consumer culture's need for novelty and introduced into the American marketplace products such as thermoses, driving gloves, wristwatches, and cocktail shakers. Mark Cross, which Gerald would later dub a "monument to the nonessential," excelled in finding and importing from Europe those luxury items that conferred class and status.

Gerald, who was born in Boston on March 26, 1888, seems to have inherited, and exceeded, his father's talent for trend-setting, as well as his wit, love of wordplay, and gift for being amusing and entertaining. Both were agile and graceful—father and son could execute handstands and Irish jigs. Yet like Frank Wiborg, Patrick Murphy was a hardheaded businessman who viewed his offspring as coddled and weak. At times, he was demeaning and vindictive to his two sons. In adulthood, both Gerald and his elder brother, Frederick (1886–1924), would battle a pervasive sense of inadequacy, along with a need to prove themselves. Gerald also had a precocious, much younger sister, Esther (1898–1962), who as a child won debates and successfully argued political issues with adults. However, her early promise as a scholar was never fulfilled. Though she dazzled listeners with her wit and

Mark Cross advertisement, c. 1910.

knowledge, she would never produce the historical biographies she planned to write.[19]

We know very little about Gerald Murphy's mother, née Anna Ryan (1858–1932). Unlike Adeline Sherman, she did not come from a prominent family, but was of recent immigrant parentage. We have only one photograph of her as a young woman (above); otherwise, we come upon her fully formed and formidable, a devout Catholic and a tough-minded woman. Her many letters to the headmaster of the Hotchkiss School in Lakeville,

Connecticut, during Gerald's years of attendance there (from September 1903 to June 1907) reveal her to be disparaging and hard on her son, while at the same time relentless in pleading his case. She writes in a letter of April 28, 1905: "from the report sent to me in Europe it seemed as though Gerald was making use of what modicum of intelligence he had left to see how low a stand[ard] he could arrive at. I gave him a sharp talking to. . . . Gerald's besetting sin is inattention."[20] Other letters similarly denigrate her son, but when told he had to repeat a year, she replied: "I positively refuse to accept your decision about Gerald as final."

Gerald's academic struggles are laid bare in his Hotchkiss student file. There are three formal notices warning of impending failure in mathematics (a subject that would challenge him throughout his life). These note a "lack of ability to carry out mathematical reasoning processes" and a "natural inaptitude for math and consequent failure to get the fundamentals." Reverend H. G. Buehler, the school's headmaster, summed up Gerald's relation to academia as follows: "Our only trouble with Gerald Murphy was his scholarship, especially in Mathematics, in which he was very discouraging. He had the reputation here of being a wit and a rather attractive ladies' man with very pleasant manners."[21] Anna Murphy's ulti-

matum to the school notwithstanding, Gerald spent an extra year at prep school as well as a summer being tutored before he was accepted into the class of 1912 at Yale.

FRIENDSHIP, MARRIAGE, AND A LIFE ON EQUAL FOOTING

Why is it? Any mention of some important exhibition, concert, book,—editorial,—philosophy—is at once allied with effeminacy of taste. . . . I long for someone, with whom, as I walk the links, I can discuss, without conscious effort,—and with unembarrassed security the things that do not smack of the pavement. . . . I maintain that a man can enjoy a poem of Keats, a watercolor of Bakst—and still have red blood in his veins. GERALD MURPHY, LETTER TO SARA WIBORG, APRIL 9, 1914

I believe in you so. Our new life is but one thing: your ideals and principles and character organized and put into actuality by me. GERALD MURPHY, LETTER TO SARA MURPHY, JULY 21, 1919

Gerald Murphy was sixteen years old when he met Sara Wiborg at a party in East Hampton in 1904. Sara, twenty-one at the time, certainly did not view the boy as a potential suitor. Rather, he tagged along on outings that his older brother, Fred, shared with the Wiborg sisters and their friends. The group basked in the sun, bathed in the ocean, picnicked on the beach, played games, exercised, and horsed around. Gerald turns up frequently in Sara's diary of 1910 to 1914, due to his family's amicable relations with the Wiborgs. From their summer place in Southhampton, he and his family would often visit the Dunes for lunch or tea, or to play golf, swim, or sail. Sometimes the Murphys stayed at the Dunes for the weekend. Gerald helped Sara garden or paint furniture, and they read aloud together. The Wiborgs and their way of life clearly enchanted him. "Surely the place has a spell," he wrote to Sara on June 10, 1914. In many ways, the Dunes, with its lovely grounds, farmhouses, and groves, would serve as a model for Villa America, Gerald and Sara's future home in Antibes, just as the "summer in the Hamptons" way of life they experienced during these years would serve as the model for their life on the Riviera, where it would appear strikingly modern and new.

As he matured, Gerald no doubt saw Sara as unat-

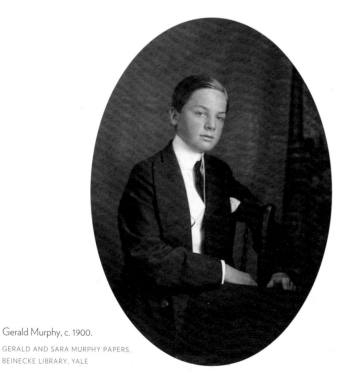

Gerald Murphy, c. 1900.
GERALD AND SARA MURPHY PAPERS,
BEINECKE LIBRARY, YALE

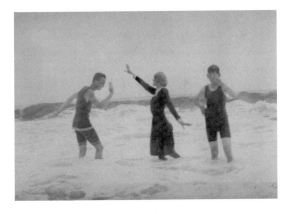

The beach at East Hampton, New York. **LEFT** c. 1915; Gerald is on the left. **BELOW LEFT** c. 1915; Sara is reclining in the lounge chair to the far left, while Gerald stands at right. **BELOW RIGHT** Wiborg family, and friends, c. 1910; Sara is seated second from left. The Murphys later imported the East Hampton beach life to Antibes.

tainable, not only for her beauty and well-traveled sophistication, but for her inbred ease and confidence. She was at home in her skin in a way that he was not—and never would be. Though F. Scott Fitzgerald would later view Gerald as the embodiment of the leisured, moneyed class, they in fact shared a common "lace-curtain Irish" Catholic background. Murphy, who had always been adept at performance and disguise, simply acquired a high-born Anglo-Saxon Protestant veneer—helped, presumably, by his marriage to the real thing.

Self-invention became a way of life for Gerald—something he raised to an art form. The creation extended to the constructed perfection of family, homes, dress, ways of entertaining, and being in the world. To a large extent he used the Wiborgs as his prototype. His reinvention of self was motivated by class issues, but perhaps also by personal ones. Beginning in his fifteenth year, Gerald be-

came aware of what he would later call "a defect," which he was "all too adept" at concealing. Most probably this "defect" referred to sexual ambivalence, as well as to feelings of emotional emptiness.[22] He would look to Sara on both counts to help him appear to be the man he wished to be rather than the one he really was.

In a confessional letter to Archibald MacLeish written in 1931, Gerald spoke of his defect and described the self-doubt that lay beneath the charismatic public persona of his youth: "Eight years of school and college, after my too willing distortion of myself into the likeness of popularity and success, I was left with little confidence in the shell that I had inhabited as another person."[23] Indeed, he was voted leading "social light" and "wittiest" at Hotchkiss and later Yale, and by the time of his Yale graduation, he had also been named "best dressed" and a "thorough gent."[24] As a college senior, he was elected to

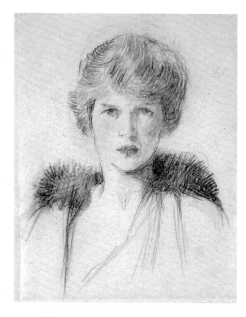

Letter in a bottle, from Gerald to Sara, February 11, 1915.

Sara Wiborg, *Self-Portrait*, c. 1915, sent with a letter to Gerald Murphy.

BOTH IMAGES GERALD AND SARA MURPHY PAPERS, BEINECKE LIBRARY, YALE

the Pundits and the Elizabethans—two literary clubs—as well as to Yale's most exclusive secret society, Skull and Bones. Yet he had an abiding dislike for being a joiner of any group. In later years he would write that he was uncomfortable in clubs, societies, and associations (including religious institutions) and that part of his attraction to Sara was her independent streak—the fact that "she went her own way."[25]

After graduation, Gerald began working for his father at Mark Cross. When World War I broke out in 1914, Sara was en route home from an extended trip with her family to Europe and India. She had not seen Gerald—whom she called "Jerry Berry" or "fat face" and had always treated like a younger cousin—for nine months. They had corresponded in the intervening time, and their knowledge of each other had deepened. Upon meeting again, their relationship changed. They had disclosed shared feelings of emptiness and found that the other had filled this void. The letters between them in the following years sowed the seeds of the life they would invent together in the 1920s. Gerald wrote to Sara nearly daily—sometimes several times a day—in 1915, passionately reiterating his adulation and admiration: "I think that probably you are made of pure gold and each bone of pearl,—with liquid jewels running in veins of silver—because you're so precious to me." He also repeatedly declared his feelings of unworthiness and alluded often to his "weakness." His agonies reached a fever pitch in a letter he sealed in a bottle and tied with a green ribbon, in which he declared: "Let this commemorate the pain and tears of this night. The pain and tears of a man who cried out in his effort to take to his heart the woman who means to him not only all that is beautiful, all that is pure in life, but life itself."

This letter and other correspondence indicate that during this time Gerald confided in Sara his struggle to rid himself of an attraction to men as well as his passionate physical desire for her. For her part, Sara, nearing thirty-two, seems not to have been thrown by Gerald's confessions. Rather, she appears happy to have found a kindred spirit, a man—unlike the boorish, spoiled boys she was used to—who valued the same things she did and who, above all, valued her originality and independent spirit instead of trying to stifle them. Further, Gerald had immense magnetism and charm. Fitzgerald captured this in the character of Dick Diver in *Tender Is the Night:* "He seemed kind and charming—his voice promised that he

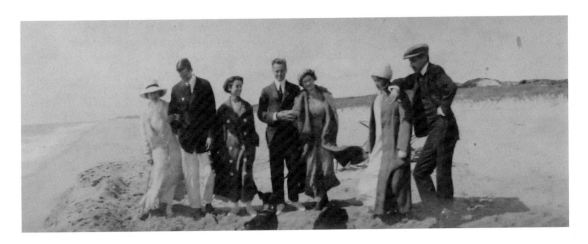

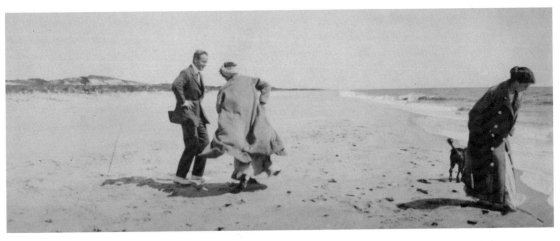

The beach at East Hampton, c. 1915.
TOP Gerald and Sara (center) with friends at the time of their engagement. BOTTOM Gerald and Sara dancing.

would take care of her, and that a little later he would open up new worlds for her, unroll an endless succession of magnificent possibilities."[26] Sara basked in Gerald's attentive adoration. In an undated letter of 1915, she declared: "Your care of me,—and amazing tenderness when you think I feel the least bit seedy,—*touches* me in a way I'll never be able to express. There has never been anything as beautiful to me. . . . I love you beyond belief."

In their letters, both Gerald and Sara expressed a desire to live simply in nature. Sara also confessed her abiding feeling that she was incomplete without Gerald. In an undated letter from 1915, she wrote:

I shall never forget these last 24 hours. You and I outdoors have been in such close touch. . . . Spirit is lacking without you—the things are there—but not the key to open them with. I *never dreamt* I'd find someone whom the *same* things would delight. . . . We will always be able to get the most ecstatic joy out of the simplest, bottomest things—the earth and all the elements are our friends. The manmade and artificial—whether it be things, places, laws, or people—will always give us a feeling of amused—sometimes perplexed—contempt. You are in my inmost heart and mind and soul—where I never thought I would be able to let anyone go.

On March 3, 1915, they became engaged, despite parental disapproval on both sides. (Patrick Murphy, with typical scorn, told Gerald that he "did not deserve to be married."[27]) Photos from that summer show Gerald and Sara dancing on the beach at East Hampton and

Sara's engagement photograph, which appeared on the cover of *Town and Country*, October 20, 1915. A notice of the engagement appeared inside.

cavorting with friends. An engagement announcement appeared in the October issue of *Town and Country*, and the couple was married in a small ceremony on the afternoon of December 30, 1915, in the drawing room of the Wiborgs' home at 40 Fifth Avenue in Manhattan.

After a January honeymoon in Panama, with stopovers in the Caribbean, Gerald and Sara moved into a house at 50 West Eleventh Street in New York. Gerald resumed work for his perpetually displeased father at Mark Cross. There is little correspondence between Gerald and Sara from this period, now that they were living together; however, in the few letters that survive, we find, along with domestic minutiae, the same notes that were sounded in the earlier correspondence. Gerald continued to express his ardent love and regard for Sara, as well as feelings of weakness, or what he called "some cursed thing in me," lamenting "if only it took some other form!"[28] The

letters also reveal their shared, fresh vision of the future, "given entirely to the *real* issues of life: home, children, work, friends, nature."[29]

On November 22, 1917, eight months after the United States entered World War I, Gerald lost patience with the time needed to secure an officer's commission and enlisted in the army as a private. He was shipped off to Ground Officers' Training School in Fort Kelly, Texas, on December 30, eleven days after his daughter, Honoria Adeline, was born. The flood of letters between Sara and Gerald began again, and in the surviving letters we witness Sara's delight in motherhood and the feeling of completeness Gerald gained from his new family. Passionate declarations of love were exchanged daily, and their thoughts on the distinctive life they wished to create together—the seeds of which had been planted during their courtship and would blossom in the 1920s—now firmly took root. Gerald's letters to Sara were effusive: "More and more I realize the beauty and rarity of our life: one feels rather like not even mentioning its preciousness. How grateful to God I am: our future seems to me like a walking thro [sic] sunlit rooms full of music, and fields of flowers and birds. It is poignant with something—Don't you feel so?" And later: "It gives me such courage now to think of us established as a little family. I believe so in us—it is my creed—we can do anything with ourselves."[30]

Photographs from this period, taken while Gerald was on leave, show Sara and Gerald to be completely enthralled with their new role as parents. A miniature letter, measuring just over two inches high, written by Gerald

Gerald (on leave from the army) and Sara with Honoria, 1918.

ALL PHOTOS GERALD AND SARA MURPHY PAPERS, BEINECKE LIBRARY, YALE

Miniature letter from Gerald to the one-
year-old Honoria, 1918. Shown at actual size.

in the guise of a favorite playmate to one-year-old Hono-
ria, exemplifies his involvement as a father and his will-
ingness to lavish time and effort on enchantment. The
letter is enclosed in a tiny envelope with a minuscule dot
of sealing wax and a make-believe stamp with a micro-
scopic cancellation mark on it. The complex games and
imaginative play he loved to orchestrate, and their con-
comitant perfectionism, were key to Gerald's personal-
ity; he would go to elaborate extremes in entertaining
friends and family—especially children.

In February 1917 Gerald was accepted into flight-
training school in Columbus, Ohio, and after passing his
exams was assigned as a second lieutenant to the 838th
Aero Squadron, ending up in Mineola, Long Island. Just
as he was close to having his wish to be sent overseas re-
alized, however, Germany surrendered and the war
ended. Upon his return home, Gerald decided not to go
back to working for his father at Mark Cross. Instead, he
followed a long-standing interest in plants and gardens
by enrolling at the Harvard School of Landscape Archi-
tecture, beginning classes in early June 1919. Before
that, however, on May 13, a son, Baoth Wiborg Murphy,
was born in New York. Gerald rejoiced: "We have a son!

I can't believe it yet."[31] Wiborg and Murphy père were
equally euphoric. Sara reported to Gerald: "The grand-
papas did a lot of handshaking and yelling—Hoytie says
Father takes on as though he had given birth to a son
himself."[32]

Having put behind him the wearisome days at Mark
Cross, Gerald took up residence at the Brattle Inn at 48
Brattle Street in Cambridge, Massachusetts. Just after
arriving, he wrote to Sara: "I shall never learn to be away
from you. . . . Things have changed so. My delight in the
inanimate things of life was so keen a year ago. As I rode
along today I was attracted only by that which repre-
sented life itself as a whole. Surely life—and the living of
it—is greatest."[33] While Sara and the children summered
at the Dunes, Gerald plunged into his coursework in land-
scape topography and summer trees and shrubs.[34] He
enjoyed tasks such as laying out and surveying the pond
at Harvard's Botanic Garden, as well as surveying the uni-
versity's observatory grounds and the Governor's Gar-
den at Milton (today called Governor Hutchinson's
Field). He found the work "absorbing."[35]

Gerald's new career focus was part of a larger plan for
him and Sara. He envisioned for them a pared-down
recasting of the Wiborgs' way of life, and, more signifi-
cantly, his expectations were for a joint venture, with Sara
as an equal partner. He hoped that once his family was
reunited in Cambridge, Sara would be able to take
courses along the same line as his.[36] He wrote to her on
June 9, 1919: "We are now trying to make possible a fu-
ture which will mean that when we wake up in the morn-
ing *the* question and work of the day will *belong* to *both*
of us. *Think* what this means!! To be able to work *together*
over the *same* thing. What husbands and wives can do
this?! Think of our being able to add to all that we already
share—the very work of our hands and brains. The idea
is thrilling to me."

Aside from his studies, Gerald spent time searching
for a house to rent for the family. Sara dispelled his doubt
about a suitable place, expressing what was to be her life-
long creed: "No matter how 'ugly' *any* house is that we
live in—we can make it *seem* beautiful—with sun, + open
fires—+ babies—I defy any house to seem gloomy—+
nothing—not gloomy—is really ugly—is it?"[37] The anec-
dotes they wrote each other when they were apart, de-
tailing stories about their babies and discussing child rear-
ing, reveal the powerful and joyful intimacy they shared
during these blissful and productive years. For example,

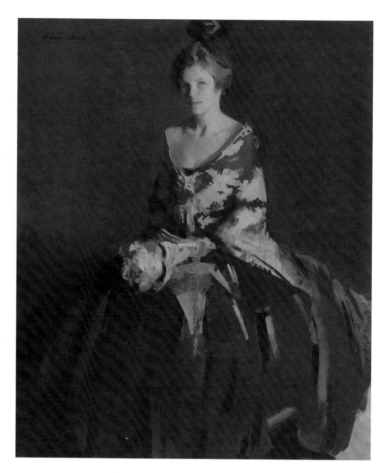

Gerald with Baoth at the Glebe, the
Murphys' summer home in Litchfield,
Connecticut, 1920.

GERALD AND SARA MURPHY PAPERS,
BEINECKE LIBRARY, YALE

William James Jr., *Portrait of Mrs. Gerald
Murphy*, 1921. Oil on canvas, 60 ¼ × 50 ½ in.

MUSEUM OF ART, RHODE ISLAND SCHOOL OF
DESIGN. GIFT OF MRS. GUSTAV RADEKE AND
MR. WILLIAM T. ALDRICH

in letter dated June 22, 1919, Gerald took a firm stand
against spanking, which Sara had been urged to use on
Honoria, who was entering her "terrible twos": "There is
something so *coarse* to me about the reasoning that di-
rects a parent to *inflict pain* in order to have a child's sense
of *fear* aroused by association with doing certain things,"
he wrote. "I should never want to be the one to instill fear
in any child's heart. . . . I may be wrong but I am instinc-
tively against physical punishment. . . . It is not for noth-
ing that I feel always the same ugly horror when I recall
the times that I was punished. It can't be right." In another
letter, dated July 31, 1919, Sara wrote: "The boy [Baoth]
is really getting so good looking, such an eager clever
little face, that melts or rather spreads into the most hu-
morous, infectious smile. I just now said to Mary 'How
good looking he is growing'—and a smile broke out all
over his face—as though he had heard. We both laughed

so." She ended the letter: "Heavens how I miss you. Life
isn't much to me without you by me."[38]

In the fall, the family moved into leased quarters at 149
Brattle Street, and Gerald registered for classes such as
Principles of Landscape Architecture and Elementary
Drafting. He had his most telling success in courses on
the nature and management of various kinds of flora—
trees, shrubs, and herbaceous plants—and on the choices
involved in planting design. Detailed descriptions of
various trees and flowers are scattered throughout his
correspondence.

Instead of going to East Hampton the following sum-
mer, the family passed the months of June, July, and Au-
gust of 1920 in the Glebe, a Greek Revival house on
North Street in Litchfield, Connecticut. After their re-
turn to Cambridge, to a different address, at 4 Willard
Street, their second son, Patrick Francis Murphy II, was

born on October 18. Gerald's uneasiness about his perceived "defect" was somewhat relieved by the birth of each of his children; his indisputable pleasure in parenting filled the emotional void of his earlier years and validated his masculinity. The life he and Sara created in Cambridge, far from the meddling of their relatives, solidified their family and strengthened their resolve to do things *their* way.

During this period, Gerald and Sara became involved in the cultural life of Cambridge and Boston. They were frequent guests of the poet and polymath Amy Lowell (whom Gerald described in a letter to Sara dated July 11, 1919, as a Bostonian George Sand) and also came to know the painter John Singer Sargent, the collector Isabella Stewart Gardner, and members of the illustrious James family—one of whom, the artist William James Jr., painted a portrait of Sara wearing a Spanish shawl. In the end, due very likely to a busy schedule and domestic responsibilities, Sara did not take classes, and Gerald's second year at Harvard was devoted largely to trying to finish work in courses that had not been completed. Bracketed grades were noted for most of his classes in 1919–20, meaning that a mark was given provisionally, with one requirement or another not having been met.[39] Gerald was not satisfied with the direction in which the landscape architecture program was heading, with its growing emphasis on town planning and engineering and its concomitant need for mathematical skills.[40] Even at the beginning of his training, in a letter to Sara dated June 3, 1919, he had admitted: "The work is very hard. . . . I happen to have a blind-spot for mathematics of even the simplest type; unhappily I have indulged it thro-out school and college—and now it returns to haunt me,—what irony." In fact, he appears to have dropped Landscape Architecture 10, which treated the principles of city planning (for which some math skills were surely a prerequisite), since it is crossed out on his transcript. In the remarks section of his record, there is this comment: "work interrupted no marks expects to begin again Feb. 1922."[41] Perhaps feeling that a break from the classroom would refresh him and allow him to resume his studies with greater concentration, and seeing an opportunity to visit the splendid gardens of Europe (a desire that had long been unfulfilled due to the war), Gerald, along with Sara and the children, sailed for England on June 11, 1921. They had no clear idea how long they would be abroad.

MAKING ART AND MAKING FRIENDS IN PARIS

Our experience in Europe would never have been what it was if Sara had not already had a knowledge of the mode of life of the interesting people of all the European capitals. . . . When she showed me what it was we both elaborated on a technique which she already knew. I organized, executed, and sometimes colored it. GERALD MURPHY, LETTER TO CALVIN TOMKINS, JANUARY 3, 1962

Although it all took place in France it was all somehow an American experience.
GERALD MURPHY TO CALVIN TOMKINS, 1962

"I had never seen the gardens of France and England, and our idea at first was to go over and visit the gardens," Gerald told Calvin Tomkins in an audiotaped interview in 1960. But for whatever reason, the great and stately gardens did not inspire. Things had changed drastically since the Great War, and the enchanting world Sara remembered now appeared outdated and overly formal. She summarized: "It just didn't seem to fill the bill."[42]

With the end of the war, America's standing in Europe had shifted. As Fitzgerald wrote: "We were the most powerful nation. Who could tell us any longer what was fashionable and what was fun?"[43] Whereas Americans had once looked across the Atlantic for the latest ideas and fashions, the situation was now reversed: many Europeans admired American style and no longer viewed the United States as a backwater, but as an exciting modern nation—a place of engineering feats and innovations like skyscrapers, suspension bridges, cars, planes, electric appliances, and mass-produced goods, as well as a source of cultural imports such as jazz, cocktails, movies, and comic strips.

The Murphys epitomized modern America in their taste, informality, and up-to-date stylishness.[44] They were at the forefront of a revolution in manners and morals that picked up speed in the United States as the 1920s roared on.[45] Young people no longer cared if they were proper and respectable, but instead wanted to be modern and sophisticated. Sara Murphy was all of these things: well versed in the rules of decorum, she had also been smoking cigarettes, drinking alcohol in mixed company, driving in cars, and speaking her mind frankly since well before 1920. Gerald's talent as a tastemaker, with "his

unerring sense of the scene"[46] and knowledge of the newest gadgets and goods (they were apparently the first people in France to have a waffle iron), contributed to the impression that the couple exemplified a quintessentially American modernity. Fitzgerald captured this in *Tender Is the Night*, describing the young movie star Rosemary Hoyt's reaction to Nicole and Dick Diver: "Rosemary examined their appurtenances—four large parasols that made a canopy of shade, a portable bathhouse for dressing, a pneumatic rubber horse, new things that Rosemary had never seen, from the first burst of luxury manufacturing after the War, and probably in the hands of the first purchasers" (see below and p. 49).[47]

Although at first Gerald and Sara were so disappointed with the European estates and gardens that they decided to cut their stay abroad short, they soon changed their minds. Not long after their arrival in Paris on September 3, 1921, they found that old friends were living there, including Gerald's Yale companion Cole Porter and his wife, Linda, and that there was a lot going on that mirrored their interests. Gerald would later tell Tomkins:

It's hard to explain why, but all the Americans that were in Paris . . . the ones we knew were married and had children . . . were taking this first trip to Europe after the war and were drawn together by the fact that they had the same interests and were enjoying the same things. And those things did not go on any other where. . . . The activity in Paris in the modern movement was so constant. There was either an exhibition or two, or there was a

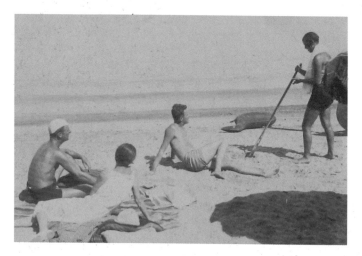

Gerald (at far left) on La Garoupe beach, Antibes, 1926. Note the pneumatic rubber horse.

A gala at Le Boeuf sur le Toit, Paris, 1922.

remarkable concert of new music, or the Dadaists were having a manifestation, or there was a costume ball over in Montparnasse, or a premiere of a new play—there was always something and every day was different. The cafés were really where you got your news, and there were new restaurants and bistros that you discovered.[48]

Three years after the trauma of World War I, weary of politics and Great Causes, Paris had assumed an "anything goes" atmosphere that Gerald and Sara readily embraced. The Dadaists' "serious fun," which shocked the establishment, was but one demonstration of a general nose-thumbing at authority and a desire to let loose. The Murphys were absorbed into this milieu, where bohemian artists, writers, and intellectuals mingled with the titled and the wealthy. They became part of a circle that included French natives as well as expatriates from Russia, Spain, Ireland, and the United States, all drawn to Paris by a feeling that here they could, as Ezra Pound put it, "make it new."[49] There were evenings at Jean Cocteau's jazz nightclub, Le Boeuf sur le Toit; concerts by Les Six, a group of modern musicians; émigré balls at the Bal Bullier; and theme parties given by the wealthy aesthete and art patron Comte Étienne de Beaumont.

The Ballets Russes, which Sara had admired since seeing the company perform Stravinsky's *Le Sacre du printemps* in 1913, was still a nexus of progressive theater, art, and music. The Murphys became enmeshed in this privileged circle—which included Stravinsky, Erik Satie,

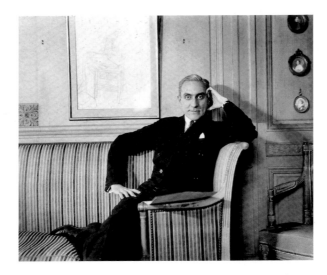

Comte Étienne de Beaumont, c. 1930,
photographed by Thérèse Bonney.

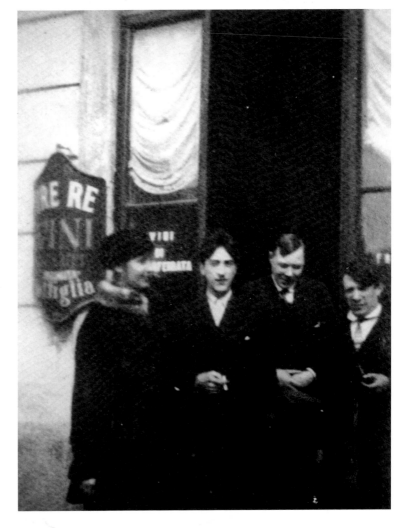

Mikhail Larionov, *Sketch of Serge Diaghilev, Igor
Stravinsky, and Serge Prokofiev*, c. 1918. Pencil on
paper, 17 × 13 ⅛ in.

Natalia Goncharova, Jean Cocteau, Mikhail
Larionov, and Pablo Picasso, c. 1917.

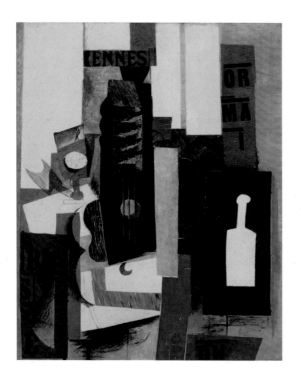

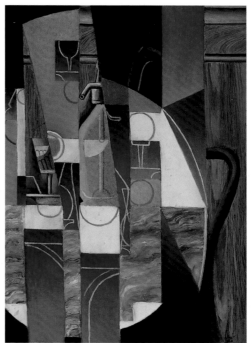

TOP LEFT Pablo Picasso, *Glass, Guitar, and Bottle*, 1913. Oil, pasted paper, gesso, and pencil on canvas, 25 ¾ × 21 ⅛ in.

THE MUSEUM OF MODERN ART, NEW YORK, THE SIDNEY AND HARRIET JANIS COLLECTION

TOP RIGHT Juan Gris, *The Siphon*, 1913. Oil on canvas, 31 ⅝ × 23 ⅝ in.

THE ROSE ART MUSEUM, BRANDEIS UNIVERSITY, GIFT OF EDGAR KAUFMANN, JR.

RIGHT Jean Metzinger, *The Harbor (Le Port)*, 1916–17? Oil on canvas, 33 ½ × 39 ½ in.

DALLAS MUSEUM OF ART, GIFT OF THE SARA LEE CORPORATION

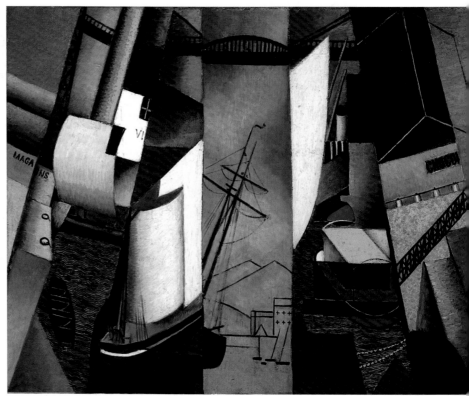

Francis Poulenc, and others—through a chance encounter with modern painting. Gerald later described the event to Tomkins:

The story of our introduction to the Russian Ballet is as simple as I was walking down the rue de la Boétie and saw in the window of Rosenberg's gallery pictures of Picasso and [Georges] Braque, [André] Derain and Juan Gris and was astounded that there could be paintings of that kind. I had never seen modern paintings and immediately I said to Sara, "If this is painting, then this is what I want to do."

In searching for someone with whom we could study, we were led to Natalia Goncharova, who had been designing sets and scenery, and her husband also, [Mikhail] Larionov, for Diaghilev. And Sara and I and Hester Pickman [a friend from Cambridge] went and arranged to get criticism from Goncharova every morning, and we went to her studio on the rue Jacob and painted and designed things. She led us and explained to us the elements of modern painting. It was quite remarkable because she started absolutely abstract; we were not allowed to paint any-

thing recognizable. And Larionov used to come in also and criticize. Through her, we went and worked at the atelier of the Russian Ballet where they painted all the scenery, in Belleville [a district on the outskirts of Paris]. You see, Diaghilev had told Goncharova to ask us to work without pay.

Gerald and Sara were invited to help refurbish worn-out sets from previous productions based on the artists' drawings or maquettes. Sara told Tomkins: "It was an extraordinary opportunity for us." Gerald continued: "There we met Braque and Derain, and Picasso, who came in and criticized the scenery that we were working on."[50]

Boris Kochno, who became Diaghilev's secretary in 1921, described the piquant picture the "well-laundered" Murphys made as they worked congenially alongside the paint-splattered crew, wielding long-handled brushes, like brooms, to apply color to gigantic stage flats and drop curtains, with Sara wearing her green high heels and ever-present pearls and Gerald sporting pressed and stylishly fitted overalls.[51] Gerald was taught to climb up thirty-foot

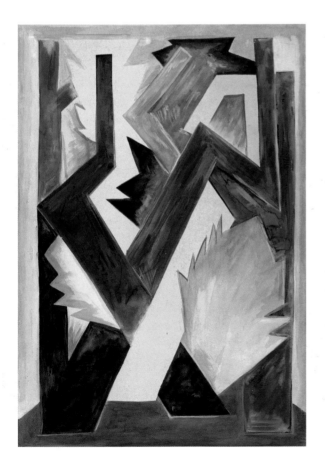

ABOVE Vladimir and Violette Polunin working on a backdrop designed by Picasso for the Ballets Russes production *Le Tricorne*, Covent Garden, London, 1919, using the method of scene painting that was taught to the Murphys.
MUSÉE PICASSO, PARIS

LEFT Natalia Goncharova, *Composition Cubo-Futuriste*, c. 1916. Gouache on paper, 19 5/8 × 12 3/4 in.
MEAD ART MUSEUM, AMHERST COLLEGE, GIFT OF THOMAS P. WHITNEY (CLASS OF 1937)

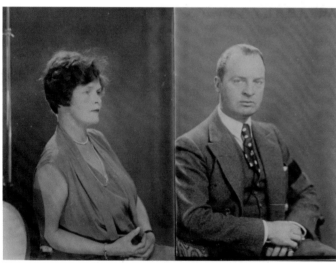

RIGHT Man Ray, *Mrs. Cole Porter,* proof from the series "Mrs. Cole Porter," c. 1924.

BELOW Man Ray, *The Murphy Family: Sara and Gerald Murphy,* 1924.

BOTH PHOTOS MUSÉE NATIONAL D'ART MODERNE, CENTRE GEORGES POMPIDOU, PARIS

RIGHT Sara Murphy, *Honoria,* c. 1926. Pencil on paper, 7 × 6 ¾ in.

GERALD AND SARA MURPHY PAPERS, BEINECKE LIBRARY, YALE

ladders to get the proper perspective on the large-scale canvases used for stage décor.

In a short time, the Murphys were considered part of the Ballets Russes family, not only providing free labor to the company, but also attending the company's rehearsals and premieres. "The odd part of it is anybody who was interested immediately became a kind of a member of it," Gerald explained to Tomkins.[52] In reality, of course, not just anyone would have been welcome; the Murphys' cultural awareness, social grace, and cosmopolitan savoir faire qualified them for entrée. This acceptance into the fold brought with it an ever-widening circle of friends. Through Picasso, for example, the Murphys came to know the American photographer Man Ray, to whom they would send relatives and friends to sit for portraits, including Frank Wiborg, Gerard Lambert (the Listerine heir and an old friend of Sara's), and possibly also Linda Porter.[53] The Murphys themselves, looking the epitome of 1920s chic, posed for Man Ray in 1924. Gerald wears a black armband, signifying mourning for his brother, Fred, whose long struggle with illness due to wounds suffered in World War I had come to an end on May 23 of that year.[54]

During the six months of daily art lessons with Goncharova, from the fall of 1921 until the spring of 1922, Gerald realized he was ready to pursue painting in earnest. In keeping with the plan he had formulated during their courtship and early married years, he expected that Sara would join him in an artistic partnership, much like Goncharova and Larionov's. However, Sara either did not have the time or did not share Gerald's inclination, and apparently remained content to make a few sketches and watercolors now and then, adhering to a premodern style. Gerald, on the other hand, had found his calling. He located a rickety but picturesque studio with thirty-foot-high ceilings at 69, rue de Froidevaux, and with the technical assistance of Vladimir Orloff, a young Russian who had worked for Diaghilev in Belleville, began to create paintings on a giant scale (perhaps a holdover from his experience painting huge theater sets).[55]

When Gerald wrote later about seeing the work that inspired him to be a painter that October day in 1921, he could not remember the pictures themselves, but rather a kaleidoscope of color and form: "There was a shock of recognition which put me into an entirely new orbit."[56] Although he mentioned Rosenberg's gallery to Tomkins, neither of the Rosenberg brothers—Léonce and Paul,

Le Corbusier, *Still Life*, 1920. Oil on canvas, 31 ⅞ × 39 ¼ in.
THE MUSEUM OF MODERN ART, NEW YORK, VAN GOGH PURCHASE FUND

both of whom were art dealers—featured Cubist works in the fall of 1921. It is more likely that Gerald saw the vernissage for the sale of the dealer Daniel-Henry Kahnweiler's inventory, which was on view at a number of galleries. But no matter where he saw the paintings, what is clear is that the style of the work that galvanized him was Cubism. Pioneered by Picasso and Braque in the years around 1908, Cubism was not only a radical form of painting; it also represented a new way of experiencing the world, one tied to the fractured character and staccato pace of modern urban life. Gerald responded immediately to this new kind of picture making, which did not mirror reality but instead shifted, broke apart, and realigned it in unexpected ways. He understood that the Cubist artists were of their time in a profound way, reflecting the uncertain new mechanized age the world had entered.

When Gerald began to paint his large canvases, they were not nonobjective, the form of painting taught to him by Goncharova. Rather, they were simplifications of recognizable objects that assimilated Cubist influences. Gerald adopted the gridlike order that underlies even the most free-flowing Cubist composition, and appropriated the large areas of light and dark that form a loose checkerboard across the painting's surface. The influence of Picasso's *Harlequin* (1918, the Pulitzer Collection, St. Louis) or *Three Musicians* (1921, the Museum of Mod-

ern Art, New York), for example, is clearly seen in Gerald's *Razor* (1924), in the combination of realistic detail with flat areas of color; the severe red, yellow, gray, and black color scheme; and the use of stippling on the razor's shaft (seen also on the vest in *Harlequin*). Through Sara's art-collecting sister, Hoytie, the Murphys knew Paul Rosenberg, who catered to a wealthy clientele and owned Picasso's *Three Musicians*. Léonce Rosenberg, whom the Murphys met in the winter of 1921–22, owned *Harlequin*, and it is likely that they saw this painting, as well as other works by Picasso, Fernand Léger, Gris, Braque, Jean Metzinger, Francis Picabia, Le Corbusier, and Amédée Ozenfant, at Rosenberg's Galerie de L'Effort Moderne. The Murphys also subscribed to Rosenberg's *Bulletin de L'Effort Moderne* (Gerald's paintings *Boatdeck* and *Razor* were featured in the April 1924 and October 1926 issues).[57] These and other connections offered further exposure to Cubism and its offshoots. Gerald did not mimic the work of other artists, however. Rather, he assimilated not only Cubism and Purism, but also Dada and Surrealism, as well as American folk art, advertising, and graphic design, to create works that were entirely original.

Paintings for the Mechanical Age

The first pictures Gerald made in 1922 and 1923 are lost, but we know that he showed four works in the 1923 Salon des Indépendants, "a sort of artistic international

clearing house" that technically accepted all entries and that year displayed more than six thousand objects, covering the walls and floors of seventy rooms of the Grand Palais.[58] Murphy submitted two oil paintings, *Turbines* and *Engine Room* (submitted under the title *Pression*), as well as a watercolor entitled *Taxi* and a pencil drawing called *Crystals* (*Crystaux*). (All four works are now lost, and no images survive of the latter two.) Gerald's brother, Fred, wrote to their mother on February 23, 1923: "Gerald's pictures in the salons, depicting a futurist idea of the power of machinery, are an enormous success, and the painter has had several requests for photographs of his work and of himself." The caption to a photo of *Turbines* in the June 1923 issue of the magazine *Shadowland* reads: "Gerald Murphy's cubistic studies of machinery were the center of attraction for the critics on Varnishing Day." Indeed, compared to the other Salon works illustrated in the same issue, *Turbines* looks advanced.

Both of Gerald's Salon paintings seem to owe much to Goncharova, Picabia, and Léger in their Cubist-derived compositions, in which the picture field is uniformly activated and a certain mechanical-age dynamism and muscularity reign. Both are images of hard metal machinery that appear to represent actual mechanisms but are, in fact, fictional compositions of sometimes real parts. The large center form in *Turbines,* for example, is a 5203 or 5204 stainless-steel ball bearing manufactured by the Swedish firm SKF. Measuring about two inches in real life, it suggests Gerald's penchant for treating small objects on a grand scale in his paintings.[59]

At the time of the 1923 Salon, Gerald and Sara were living on the quai des Grands-Augustins, in an apartment they had decorated in an ultramodern style: the parquet floors were painted black, the walls were stark white, and the only "art" was an eighteen-inch-diameter SKF ball bearing—the largest made—mounted to rotate on a black pedestal set atop an ebony piano. Gerald quipped that he would rather have a real ball bearing than a Rodin that might turn out to be a fake.[60] Like many moderns in the 1920s—such as the Italian Futurists, the Bauhaus artists, and friends like Léger and Blaise Cendrars—Murphy responded to the ball bearing as pure form and as one of the great beauties of the mechanical age.[61] In his painting, however, Gerald may also have been reacting to the Dada artists' frequent use of machinery and found objects as ironic metaphors for human sexuality. William Rubin, who organized the an exhibition of Mur-

phy's work at the Museum of Modern Art, New York, in 1974, asserted that "the kind of Dadaist irony and analogies to human anatomy (more particularly sexual functions) which such works [Picabia's machine parodies] embodied were entirely alien to Murphy's detached and meditative, if no less fascinated, involvement with the motif."[62] Yet the rod bisecting the ball bearing in *Turbines*—a fictional arrangement, since the rod would impede the ball bearing's function—can clearly carry such allusions. True, the Dadaist's irony is missing, but Murphy's detachment is questionable.

Engine Room was inspired by a visit to the engine room of an ocean liner during a transatlantic crossing. The echoing circles and precise arcs of the machine's cogs, wheels, and pistons, and the misspelled name of the engine's manufacturer, again recall Dada tropes. But here, too, there is no irony or frivolity. In the surviving reproduction, the sharp contrasts of dark and light create a mysterious space of lower depths that are beautiful but melancholy.

Murphy continued the ocean liner theme in his next painting, begun in 1923. *Boatdeck,* a giant depiction of the smokestacks and funnels of an ocean liner (the *Paris* and the *Aquitania* were his models), was rendered in a flat, posterlike style, in dark red for the smokestacks, white for the ventilators, and gray and black. These solid, saturated color fields, informed by Synthetic Cubism, looked like the work of graphic artists such as Cassandre, but predate Cassandre's posters by ten years. Gerald used the methods he had learned from working on the Ballets Russes scenery, as a letter from Fred Murphy to his mother indicates: "Here's yet another clipping about Gerald's picture. Before I left Paris I saw its early beginnings: it's a huge canvas: he was painting it from the dizzy heights of a flimsy stepladder. At that time it had only been sketched in: evidently the bright colors they speak of came later. Whatever the value of the painting it has doubtless received the most attention."[63]

At eighteen feet high and twelve feet wide, *Boatdeck* (now lost) was the scandal of the February 1924 Salon des Indépendants. If Gerald, just a little over a year before, had "never seen anything like" Cubism, now the Parisian art world could say the same for *Boatdeck*.[64] The president of the Société des Artistes Indépendants, Paul Signac, tried to keep it out of the Salon, claiming that it was "architectural drawing" rather than fine art. Finally included in the exhibition, *Boatdeck* drew large crowds and

Gerald Murphy, *Boatdeck*, 1924 (lost). Oil on canvas, 18 × 12 ft.

The ocean liner *Aquitania,* photographed by Richard E. Myers in March 1929.

a great deal of press. In photographs of the exhibition (see p. 137), the other paintings look fussy and old-fashioned beside *Boatdeck*'s monumental, pared-down simplicity. Gerald was photographed in front of his painting by the Paris edition of the *New York Herald Tribune* and was interviewed by several journals. To one interviewer, he commented, tongue in cheek, that he was "truly sorry to have caused such a bother with my little picture." To another, he declared: "If they think my picture is too big, I think the other pictures are too small. After all, it is the Grand Palais."[65]

Amanda Vaill, author of *Everybody Was So Young,* suggests that there may have been a personal subtext to the painting, even though there was nothing personal about its presentation: "this was, after all, the sort of liner that was bringing [Gerald's] countrymen to France by the thousands."[66] Perhaps the ocean liner referred to the Murphys' status as *transatlantiques,* crisscrossing the ocean and cross-pollinating American and French culture, attitudes, and goods with each voyage.

Exemplars of Style

The true dandy was not the most foppishly dressed, the most stylish, the most flash-mannered; he was primarily an artist of talent. FRONT FLAP OF WILLARD CONNELY'S *COUNT D'ORSAY: THE DANDY OF DANDIES* (1952), CUT OUT AND KEPT BY GERALD MURPHY IN BOX OF SAYINGS AND QUOTES

Gerald Murphy's *Boatdeck* drew attention to his talents as a visual artist, but as Ellen Barry, a friend of the Murphys, later commented, Gerald was always an artist—only

"at first he was an artist without an art."[67] Indeed, the modern, mechanically precise style that marked his paintings also characterized the man. Before he took up painting, Gerald had developed a contemporary, meticulously honed aesthetic that he applied to the ephemeral business of living. In dress, he used his body as an armature for severe Constructivist assemblages comparable to works by Léger, El Lissitsky, or Sonia Delaunay, prompting the art historian Wanda Corn to describe him as "a walking machine age abstraction." For example, his clothing would be entirely monochrome, with just a dash of color at the pocket, and he would carry his belongings in a square of brightly colored fabric, so as not to disturb the strict line of his suit.[68]

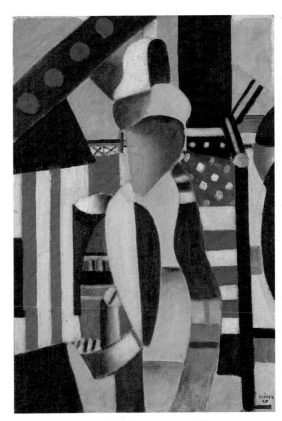

Fernand Léger, *Man with Hat*, 1920. Oil on canvas, 21 ¾ × 15 in.
THE BALTIMORE MUSEUM OF ART, GIFT OF CARY ROSS

Gerald in Venice, 1923.
GERALD AND SARA MURPHY PAPERS, BEINECKE LIBRARY, YALE

For her part, Sara added warmth, comfort, and unconventional touches. She wore pearls for all occasions, even sunbathing, and dressed in a style that had nothing to do with fashion, favoring long, flowing dresses at a time when skimpy was "in." The décors she created were infused with unusual details—for example, she lined the windowsills of her apartment with mirrors to bring in more light, placed stalks of celery in vases, and upholstered her modern furniture in material used to line men's vests. Ellen Barry recalled: "She had a wonderful gift for making the places they lived in special . . . [creating] a marvelous atmosphere with wonderful food and drink, loads of flowers (Sara couldn't be in a room without flowers), the gramophone playing the latest music, and a menagerie of animals."[69] Archibald MacLeish captured what Honoria would call her "exquisite talent for making a residence the embodiment of herself" in his poem "Sketch for a Portrait of Mme. G___M___," which begins: "'Her room' you'd say—and wonder why you called it / Hers."[70] While MacLeish's poem is more

refined, the ode "To Sara," written by Richard Myers (who, with his wife, Alice Lee, became close friends of Sara and Gerald in the 1930s), sums up her talents, interests, and warmth with a sense of fun that seems to suit her to a tee:

I've got a favorite lady
Whose familiar name is Sadie
And whose talents have excited many blurbs.
She's not so very staid-y
And sings songs a little shady
And her plats du jour are full of fancy herbs.

Her house is full of color
Making dull ones look much duller
And she only lets the gayest people call.
Her ankles are the slenderest,
Her beefsteaks are the tenderest,
And her smile just simply can't be beat at all.

Her garden is a miracle
And people get hysterical
For her flower arrangements just delight the eye;
And if she gets in a pickle
And hasn't got a nickel
She could ruin in a minute, Constance Spry.

Her meals are so delirious
It strikes me as mysterious
That any one can rise up from the table.
She can dance like Argentina,
Or even La Zorina,
And could be an ornament to any playbill.

She has a little puppy,
Who is cuter than a guppy,
And he thinks she is the Empress of the world
And he isn't far from wrong,
For who loves her—loves her long,
And her friendship is as priceless as a pearl.

They can cut away her stones
They can break her dainty bones,
They can cut her into tiny little pieces—
But if the surgeon's art
Leaves her nothing but her heart
She'll have love enough to pauperize King Croesus.[71]

In Paris, Sara and Gerald were able to fulfill their ambition to make a life "'loaded and fragrant' with everything that is beautiful."[72] Moving from the United States had allowed them, in many ways, to wipe the slate clean.

Gone were the frills and furbelows, the stuffed and heavy furnishings of their youth, and the Mission furniture of their first homes. According to Vaill, the sleek, pared-down style of their Left Bank apartment was considered so groundbreaking it was practically a tourist attraction.[73] The editor of the *Dial,* Gilbert Seldes, brought writer friends Donald Ogden Stewart and John Dos Passos to the apartment; they brought the Barrys and Archibald and Ada MacLeish, who in turn brought James Joyce. Gerald later noted that Joyce sat at the piano and "composed himself to his Irish repertoire."[74] Fred Murphy described the apartment in a letter to his mother:

Gerald's little apartment at 23 quai des Grands-Augustins is also a great success. They've put no money into the décor. The white walls are bare.... The apartment comprises only a tiny dining room, a double bed room, a strictly modern bath and a larger sitting room which juts out the third floor allowing a view down the Seine.... Enclosed is a sketch. The place costs $500 a year.... On a top floor adjoining a glass roof-house where Gerald works are rooms for the children and two servants rooms, so they are self contained. The house was a tenement when they went in, but Sara by dint of her taste and ingenuity has reclaimed it where necessary, but leaving the old winding stairs and other features that lend interest to the "installation." It took nerve to do it, but the success of the venture is indicated by the numberless inquiries offered for renting it at several times the price originally invested. Papa is well-pleased with it. We dined there last night and enjoyed it hugely. Everything is very simple, and good, and economical.

Detail of a letter from Fred Murphy to his mother, February 22/23, 1923, with a drawing of Sara and Gerald's apartment on the quai des Grands-Augustins, Paris.

Sara and Gerald's life in Paris was as modern and trend-setting as their dress and living quarters. By 1923, they had become deeply involved in the international community of avant-garde artists in Paris, not only working alongside them, but also supporting them and partying with them—at the same time contributing their own special creativity. Fred Murphy, again in the February 22/23 letter to his mother, described the 1923 Grand Bal des Artistes Travesti/Transmental, a charity event to benefit exiled Russian artists: "Tomorrow night the Bal Bullier takes place—it is got up for needy artists and is a great event for all Paris. Gerald has been commissioned to decorate the six large boxes set aside for the American contingent and while I haven't seen the result I hear it is very original."[75] Gerald was probably invited to design the American booths by Goncharova and Larionov, two of the ball's organizers. Goncharova designed the event's poster, and Larionov not only created the sixteen-page program and "ticket," but also served as bartender for the four-day benefit. According to one review, "Tout-Paris" was there, and the doors had to be closed when more than a thousand people filled the hall.[76] The list of participating artists, poets, composers, and supporters reads like a who's who of the international avant-garde: Picasso, Picabia, Derain, Braque, Gris, Henri Matisse, Constantin Brancusi, Jules Pascin, Robert and Sonia Delaunay, Tristan Tzara, Cocteau, Pound, Satie, Stravinsky, Sergei Prokofiev, and Diaghilev are just a few. Most people wore costumes (Léger was "disguised" as a locomotive, and the Japanese painter Foujita, nude and covered with blue lotus tattoos, was carried on in a gold cage). There was live music, including an American jazz band, dancing, singing, poetry readings, and more. One report claimed that the ball had broken new ground in terms of gaiety and being *"plus moderne, plus '1923.'"*[77]

Gerald Murphy is the only American in the list of fifty artists who created booths for the ball, which were designed to represent many nations. Sadly, no photographs or films of the installations have come to light.[78] Apparently Gerald's construction, comprised of boxes transformed into recognizable New York buildings ("an important group of extraordinary houses and skyscrapers surmounted by blinking electric signs"), was a success.[79]

The Murphys found the community of Russian expatriates who had converged upon Paris in the wake of the 1917 Revolution stimulating and congenial. In addition to Ballets Russes rehearsals, Sara and Gerald attended

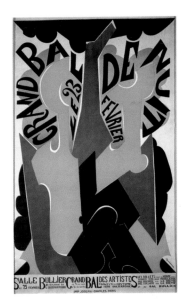

Natalia Goncharova, *Grand Bal de nuit*, February 1923. Color lithograph, sheet: 47 ¼ × 28 ⅞ in.

every performance of Alexander Tairov's progressive Kamerny Theater during the troupe's March 1923 tour. Cocteau and others considered Tairov more radical than Diaghilev (who went to each of the Kamerny Theater's productions with Goncharova, Larionov, and his choreographer, Bronislava Nijinska, in tow). The Kamerny Theater's stage sets may also have been a source for some of the ideas Gerald described in his notebook. In one entry, he outlines a plan for a set: "plank run-way coming down in profile onto stage from inside iron girder structure . . . different level platforms, stairs, etc." This type of multileveled scaffolding was used in Tairov's various productions, including *L'Orage* and *The Man Who Was Thursday*.[80]

Although he was busy with his own paintings, Gerald continued to help with décor for the Ballets Russes, having been promoted to working on scenery for new productions.[81] Dos Passos, in his memoir *The Best Times*, recalls Goncharova designing the sets for Stravinsky's *Les Noces*: "When the time came to paint the scenery Goncharova found herself shorthanded. Gerald offered to help. . . . I went along. We spent a week in a loft near the Place des Combats heating up gluepots, mixing paint, mostly white and dark brown, and spreading it on vast odd shapes of canvas spread out on the floor." Noting that he had never seen such disorganized chaos, Dos Passos comments that at the time he could not see how the scenery would ever be finished, but "in some miraculous way everything fell into place. . . . The production was magnificent."[82]

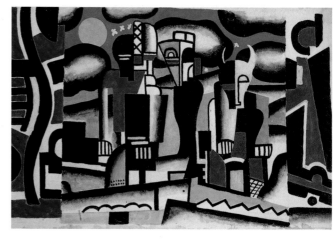

ABOVE LEFT Natalia Goncharova, design for the set: Part One, Scenes 1 and 3, *Les Noces (The Wedding)*, 1923. Graphite and tempera on paper, 26 ½ × 38 ¾ in.
WADSWORTH ATHENEUM MUSEUM OF ART, HARTFORD, THE ELLA GALLUP SUMNER AND MARY CATLIN SUMNER COLLECTION FUND

ABOVE RIGHT Fernand Léger, set design with three god-like figures for *La Création du monde*, 1923. Graphite, watercolor, gouache, and India ink on paper, 16 ½ × 25 in.
DANSMUSEET, STOCKHOLM

LEFT *Les Noces*, rehearsal photograph taken on the roof of the Théâtre de Monte Carlo before the première in Paris in 1923.
STRAVINSKY-DIAGHILEV FOUNDATION COLLECTION, HARVARD THEATRE COLLECTION, HOUGHTON LIBRARY, HARVARD UNIVERSITY

Indeed, first-night audiences dubbed the production a masterpiece. Stravinsky's ballet was not a romantic celebration of wedlock, but rather, a somber meditation on the loss of individuality to communal will: the loveless couple unite in order to procreate for the state. The theme of relentless conformity was buttressed by Goncharova's austere set and costumes (all the dancers, even the bride and groom, were dressed in the same simple brown-and-white clothing). Nijinska's stylized choreography similarly echoed the grim, mechanized, cogs-in-the-machine-of-state theme.

In addition to helping with the scenery for *Les Noces*, Gerald, with Sara, attended all the rehearsals, and they were so swept up in the ballet that they hosted a famous party on a barge on the Seine on July 1, 1923, to celebrate the première. Almost everyone associated with the Parisian vanguard attended, and the party lasted until 5 A.M. Aside from verbal and written accounts, only an

invitation and a reproduction of the menu signed by many of the guests survive (see p. 169).[83]

The period around 1923 was a particularly productive one for Gerald. His newfound friendships and contacts had led not only to total immersion in the avant-garde art scene, but also to theatrical commissions. The actress Mrs. Patrick Campbell, a great friend of Sara and her mother, appears to have asked Gerald to do a poster for a George Bernard Shaw play she was producing. In a letter dated April 30, 1924, Fred Murphy wrote to his mother, reporting on a recent visit to the Murphys' home his wife, Noel, had made: "She saw a poster he [Gerald] was doing for Mrs. Patrick Campbell's production of *Caesar and Cleopatra* and she avers the drawing was really excellent. I knew he'd learned how to paint but I've not yet seen any work of his setting out his drawing."[84]

Among the most important friendships to blossom during this time was that with Léger, whom Gerald and

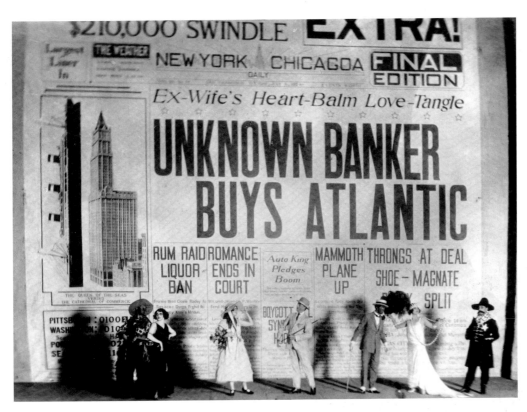

Gerald Murphy, backdrop and costumes for *Within the Quota* (shown in performance), 1923.
GERALD AND SARA MURPHY PAPERS, BEINECKE LIBRARY, YALE

Sara had met at Diaghliev's studio. Gerald later called the modernist painter "an apostle, a mentor, a teacher" and credited the Frenchman with helping him see the beauty of humble objects detached from their context. In the spring of 1923, Léger was working on the décor for a new African-inspired ballet, *La Création du monde,* with music by Darius Milhaud and a scenario by the novelist and poet Blaise Cendrars, for the Ballets Suédois. The founder and director of the Swedish dance company, Rolf de Maré, had been challenging Diaghilev's monopoly of avant-garde ballet since 1920 and wanted to commission an "American" ballet. Léger suggested to him that Gerald Murphy would be the ideal person to create an "authentic" conception and design.[85] Gerald agreed to the commission and took as his subject immigration; it was a topical issue because legislation enacted by Congress to limit relocation to the United States was stirring debate on both sides of the Atlantic and hordes of foreigners were pouring into France. He called his ballet *Within the Quota.*

When de Maré asked Gerald to suggest an American composer to write the score for the ballet, Gerald turned to his old Yale friend Cole Porter. Porter was not yet famous—his first real success was to come in 1928 with *Paris,* the musical that featured "Let's Do It, Let's Fall in Love." Porter's score for *Within the Quota* mixes jazz with orchestral music and "modern" noises such as taxi horns and fairground calliopes, an approach to composition that had been introduced by Satie and Cocteau in the ballet *Parade* in 1917 and continued by Stravinsky, Milhaud, John Alden Carpenter, and Georges Antheil, among others.

Gerald's stage set for *Within the Quota,* which he painted himself, was a masterful parody of popular journalism's hyperbolic headlines, with a nod to Dada typography and pastiche.[86] In keeping with his style of vastly magnifying small objects, he created a giant blowup of a fictional American newspaper's front page, featuring stories that were both topical and autobiographical: the headlines wittily referred to American capitalists and their insatiable acquisitiveness ("Unknown Banker Buys Atlantic," recalling his father-in-law, perhaps); there were also jabs at Prohibition, which Sara and

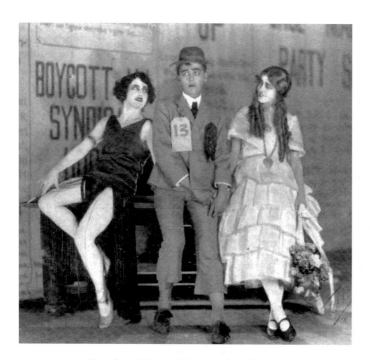

Ebon Strandin (as Jazz Baby), Jean Börlin (as Immigrant),
and Edith Bonsdorfl (as Sweetheart of the World) in *Within the
Quota*, 1923.

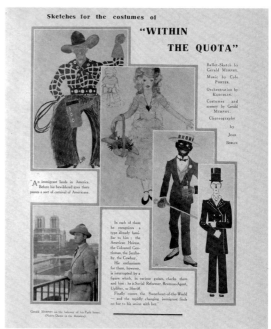

Program for *Within the Quota*, 1923. Gerald is seen at lower left on
the balcony of his Paris apartment.

Gerald vehemently opposed ("Rum Raid Liquor Ban"), as well as tidbits about planes, automobiles, ocean liners, and skyscrapers (symbols of America's new hegemony), and a real-life love scandal then in all the papers ("Ex-Wife's Heart-Balm Love-Tangle").[87] The backdrop may also have contained an echo of the headlines that had appeared on October 23, 1913 ("Millionaire's Wife Fined as Smuggler"), when Adeline Wiborg, to the mortification of herself and her family, was tried and fined for not paying customs duty on twenty trunks brought home from Europe.[88]

With sophisticated irony and a genuine appreciation for American popular culture, Gerald centered his plot on a bumbling Swedish immigrant who meets a host of larger-than-life American characters and ends up fulfilling the American Dream by becoming a movie star and winning the love of "America's sweetheart." The mythology of instant success and the adulation of celebrities mingle with jibes at self-righteous authority personified by four "Puritans," each in a different guise: Social Reformer, Prohibition Agent, Spiritual Uplifter, and Sheriff. Jean Börlin, who choreographed the ballet (and also played the Immigrant), added a touch that is

so like Gerald that he it might have suggested it: In one scene, the Immigrant is offered bootleg whisky; he innocently drinks it and is arrested by the Prohibition Agent, who confiscates the bottle and then swigs the brew himself.

As Millicent Hodson and Kenneth Archer have pointed out, each of the characters in *Within the Quota* is lifted from contemporary film: the Immigrant derives from Charlie Chaplin's film of the same name from 1917, while the Jazz Baby was modeled on the rebellious "It" girl, Clara Bow; the American Heiress, on Gloria Swanson; the Sweetheart of the World, on Mary Pickford; the Cowboy, on Tom Mix; and the Colored Gentleman, on soft-shoe performers such as Earl "Snakehips" Tucker and Ulysses "Slow Kid" Thompson (not Al Jolson minstrel types, but graceful master dancers with refined manners that equaled those of Gerald).[89]

Sara Murphy drew several of the costume designs for the production, perhaps modeling the American Heiress on her aptly named snobby sister Hoytie.[90] The small collage Gerald created for the production's program cover features photographs of urban buildings crowded together in a vertiginous, multiperspectival composition

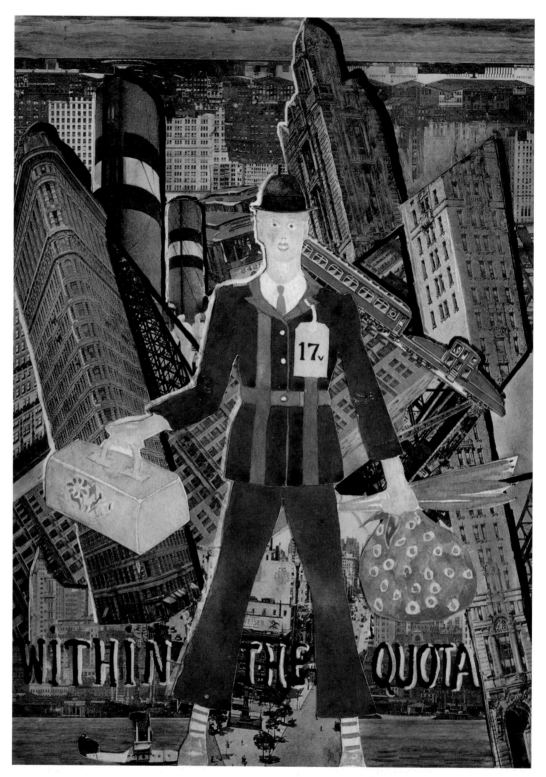

Gerald Murphy (with watercolor figure by Sara Murphy?), *The Immigrant* (collage for
Within the Quota), 1923. Watercolor, gouache, and collage on paper, 11 × 8 in.

that evokes the hustle and bustle of city life. The collage's metropolis is identifiable as New York: one sees the Flatiron Building, the fretwork of an elevated train line, and a number of other Manhattan skyscrapers. Two smokestacks, à la *Boatdeck,* also appear. Painted in watercolor (possibly by Sara) and pasted on top of the collaged cityscape is the disoriented figure of the newly arrived Immigrant, wearing an ill-fitting, old-fashioned blue suit. Between his legs, like a secret signature, is pasted the logo of Mark Cross.[91]

Within the Quota premiered as the last number on a bill that also included Léger's *La Création du monde,* on October 25, 1923, at the Théâtre des Champs-Élysées in Paris. Critics praised its popular theme and lively score. It was added to the repertoire of the Swedish company's American tour that began at the end of November 1923, after more highbrow offerings flopped.[92] Despite unanimous praise in the press, Richard Myers (later a good friend of the Murphys) offered a different opinion. He wrote from Paris to friends in the United States on November 7, 1923: "Don't pay money to see that Swedish Ballet that is going to try and conquer New York. It's the rottenest thing I've ever seen—they're nothing but a lot of good measures gone wrong. Clods! They played to empty houses here."[93]

SUMMERING IN CAP D'ANTIBES

On the pleasant shore of the French Riviera, about half way between Marseilles and the Italian border, stands a large, proud, rose-colored hotel. Deferential palms cool its flushed façade, and before it stretches a short dazzling beach. Lately it has become a summer

Hôtel du Cap d'Antibes, c. 1923.

resort of notable and fashionable people; a decade ago it was almost deserted after its English clientele went north in April. F. SCOTT FITZGERALD, *TENDER IS THE NIGHT* (1934)

We were fortunate in that we could live well and make pleasure an art. ELLEN BARRY, ON TIMES SPENT WITH THE MURPHYS

Along with their active life in Paris, the Murphys created a beachhead in the south of France in the early 1920s. Before their arrival, there had been no summer "season" on the Riviera. Dos Passos writes in *The Best Times,* "The upper-class French and British would not be seen dead on the Riviera in summer . . . but for Americans the temperature was ideal, the water delicious, and Antibes was the sort of little virgin port we dreamed of discovering."[94]

As Gerald later recalled, the Murphys were introduced to Cap d'Antibes by Cole and Linda Porter, who invited them to be their guests there in July 1922:

We really owe Antibes to Cole Porter, who always had a great flair about places. He took Château de la Garoupe one summer in spite of the fact that no one went to the Riviera in the summer. Tourists would leave the moment it began to get warm. That whole stretch of shore was deserted. . . . There was this little tiny beach covered with a bed of seaweed that must have been there for ages. It was three or four feet thick. And we dug a little section out and bathed. We fell in love with it right away. Cole never came back. But we learned about a hotel which closed on the first of May. Before we left, we went to the hotel and asked if next year we came back in May we could stay all through the summer. And so when we came there, we stayed with one cook, a waiter, and a chambermaid. Another Chinese family stayed too. We told people about it and they came down. [Antoine] Sella [owner of the Hôtel du Cap d'Antibes] says we started the summer season.[95]

In *Tender Is the Night,* when Rosemary Hoyt asks the Divers if they like the Côte d'Azur, another character answers, "They have to—they invented it."[96] Actually, the Murphys didn't invent the way of life that came to characterize the summertime Riviera so much as they transposed it, bringing to Antibes the beach lifestyle they had enjoyed at East Hampton. The timing must have been just right, because word traveled quickly in Paris society and very soon the Côte d'Azur's beaches were crowded throughout the summer with well-to-do and celebrity sunbathers.

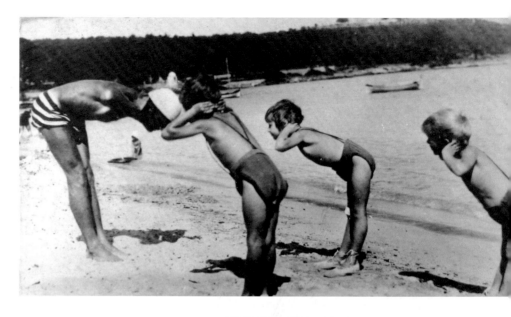

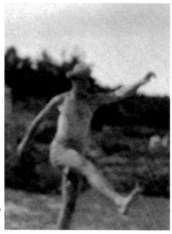

FROM TOP, LEFT TO RIGHT

Gerald doing calisthenics with his children, Baoth, Honoria, and Patrick, La Garoupe beach, Antibes, c. 1923.

GERALD AND SARA MURPHY PAPERS, BEINECKE LIBRARY, YALE

Gerald dancing on La Garoupe beach, Antibes, 1923.

GERALD AND SARA MURPHY PAPERS, BEINECKE LIBRARY, YALE

Anton Dolin in *Le Train bleu* (production still), 1924.

BIBLIOTHÈQUE MUSÉE DE L'OPÉRA, PARIS

Mrs. H. G. Squires (an old friend of the Wiborg family) with Sara, La Garoupe beach, Antibes, 1923, photographed by François Biondo.

GERALD AND SARA MURPHY PAPERS, BEINECKE LIBRARY, YALE

Le Train bleu, performed by the Ballets Russes, Paris, 1924, with costumes designed by Coco Chanel.

HOWARD D. ROTHSCHILD BEQUEST, HARVARD THEATRE COLLECTION, HOUGHTON LIBRARY, HARVARD UNIVERSITY

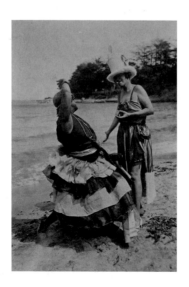

In 1924, Diaghilev and Cocteau had the Murphys' life in Antibes in mind, it seems, when they were looking for a vehicle to showcase the acrobatic talent of the company's handsome new dancer, Anton Dolin, for the ballet that resulted, *Le Train bleu,* is about the summer exodus of the beau monde from Paris to the Côte d'Azur and the cult of physical fitness practiced there. (The ballet was named for the express train that took passengers from Paris to the Riviera.) In addition to creating the summer bathing season, the Murphys, especially Gerald, swam miles every day, performed gymnastics and calisthenics, and often danced on the beach. Frolicking in the water, yoga (see p. 145), golf, and tennis, all of which are pantomimed in the ballet, were routinely practiced by the Murphys and their guests. A certain amount of "voguing"—striking the right pose and attitude—was part of the Murphys' scene and was also included in the ballet's choreography. "Is *anything* so satisfying as to be picturesque?" Sara had written years before.[97]

Other aspects of the production similarly recalled the Murphys' life in Antibes. Henri Laurens's set brings to mind the newly manufactured portable bathing cabanas the Murphys installed on La Garoupe beach, and Coco Chanel may have based her costume designs on Gerald's innovations in resort wear.[98] The thirty-eight-foot-long curtain featured an enlargement of a gouache painted by Picasso, depicting two gigantic women running on the beach. Like other of the ballet's creators, its composer, Milhaud, was a frequent guest at the Murphys' home, where he played the piano and enjoyed going through Gerald's extensive collection of jazz recordings. *Le Train bleu* premiered at the Théâtre des Champs-Élysées in Paris on June 20, 1924, to favorable receptions by the press and the public.

Picasso, Fitzgerald, and the Murphys as Muses

The Murphys had known Picasso since early 1922 through the Ballets Russes, but they did not know his family until the summer of 1923, when Picasso, his wife Olga, their two-and-a-half-year-old son, Paulo, and Picasso's mother, Doña Maria (who was visiting France for the first time), stayed with them at the Hôtel du Cap d'Antibes. At first the relationship between Sara and Olga was formal, as can be seen in a note written by Sara during their stay: "Chère Madame Picasso, Our children are going to the beach at 9:45 and will return at 11:30 (they eat lunch at 12). We would be so happy if your baby could

Le Train bleu, performed by the Ballets Russes, Paris, 1924, with stage décor by Henri Laurens and costumes by Coco Chanel.
BIBLIOTHÈQUE MUSÉE DE L'OPÉRA, PARIS

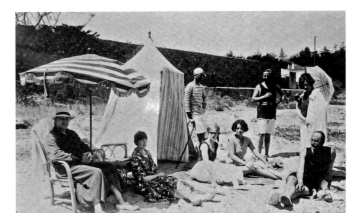

Sir Charles Mendl, Elsie de Wolfe, Gerald Murphy, unidentified women (seated), Monty Woolley, Sara Murphy, and unidentified man, La Garoupe beach, Antibes, 1926.
GERALD AND SARA MURPHY PAPERS, BEINECKE LIBRARY, YALE

accompany them, with his nurse. Would you and M. Picasso want to go bathing with us a little later? The beach is really very nice and we have an American canoe."[99] The little note not only suggests the still-new relationship between Sara and Olga, but also affirms what others have observed about the structured nature of the Murphys' routine as well as the way they capitalized on their Americanness.

As the summer progressed, however, the two families spent a great deal of time together and grew close. Sur-

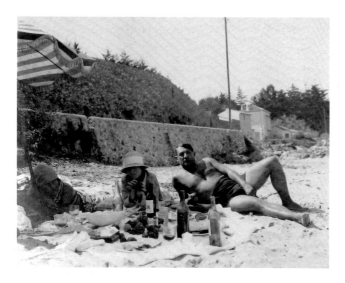

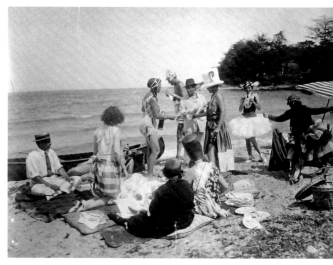

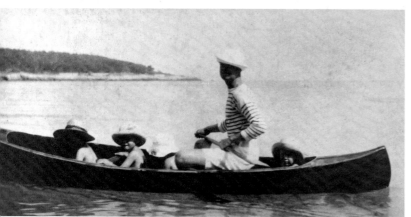

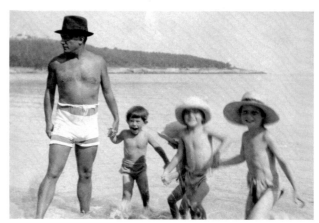

La Garoupe beach, Antibes, July 1923. **TOP LEFT** Sara with Olga and Pablo Picasso. **BOTTOM LEFT** Gerald paddling the Murphy's canoe accompanied by (left to right) Honoria, Baoth, Paulo Picasso, and Patrick. **TOP RIGHT** The Mad Beach Party, photographed by François Biondo. Pablo Picasso's mother, Doña Maria, seated in black dress; Ginny Carpenter in striped skirt; Picasso in black hat; Sara in white top hat; Olga Picasso in tutu; Mrs. Squires bowing with arms outstretched. **BOTTOM RIGHT** Pablo Picasso, his son Paulo, and the Murphy children: Patrick, Baoth, and Honoria.

viving notes from Sara to the Picassos record plans for picnics, dinners, and play dates for the children. By the winter, back in Paris, Sara was writing: "Chères Picassos, We are here for eight to ten days. We would very much like to see you. Would you like to have one of our orgies? Can it be Sunday night? We'll dance; we'll drink, and be crazy. With best wishes from Gerald and me."

The family albums that Sara assembled and tied with Mediterranean cloth contain snapshots of the Picassos on the beach with the Murphys and sometimes with other friends. In one, the three Murphy children, Paulo, and Picasso hold hands in the surf; in another, Gerald rows the four children in his "American" canoe. There is also a set of about fifty photographs taken by a professional photographer, François Biondo, showing a costume party thrown by the Comte and Comtesse de Beaumont on the beach.[100] Some of these photographs have become legendary, having appeared in numerous publications, but there are a number of unposed "outtakes" that have a documentary fascination for their revelation of sundry

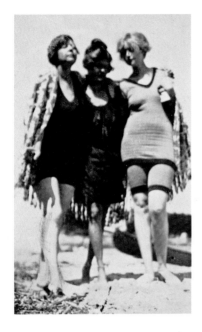

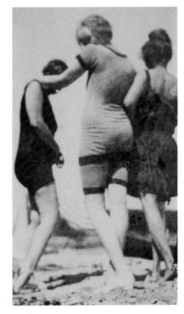

details: the food that was served, the parade to the beach by the party's female guests (separate from the men), the group's interactions (Picasso frequently appearing off to the side, observing the group), and so on.

Most important, the photographs from this summer show commonplace scenes that Picasso transformed, in drawings and paintings, into idealized images of classical figures on a generalized shore. Among them are images of the Murphys and their friends exercising on the beach. There are also two snapshots of Sara with Rue and

Ginny Carpenter (the wife and daughter of the composer John Alden Carpenter), taken in July, which echo the more than twenty studies of the Three Graces Picasso made during this time, some on Hotel du Cap d'Antibes stationery. A few months later, in a sketchbook containing designs for the ballet *Mercure,* which includes a "Dance of the Three Graces," Picasso drew three women in contemporary dress, and then the same three as nudes in front of the stage prop for the ballet.[101]

Picasso seems to have been taken with Sara, and as-

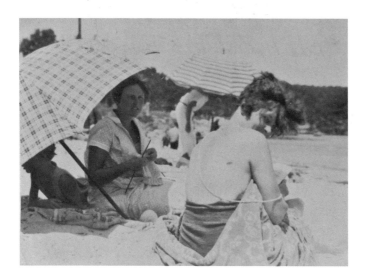

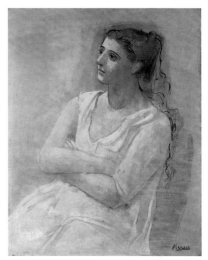

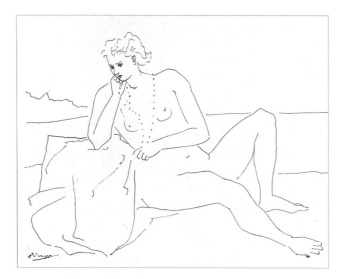

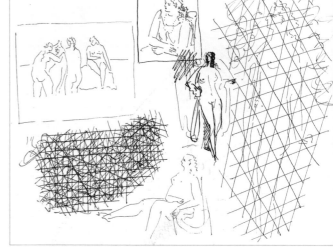

Sara, with her legendary pearls draped over her back for sunbathing, and Ada MacLeish (under umbrella), La Garoupe beach, Antibes, 1924.

GERALD AND SARA MURPHY PAPERS, BEINECKE LIBRARY, YALE

Pablo Picasso, *Reclining Nude with Pearl Necklace*, 1923. Ink on paper, 10 × 14 in.

PRIVATE COLLECTION

Pablo Picasso, *Woman in White*, 1923. Oil on canvas, 39 × 31 ½ in.

THE METROPOLITAN MUSEUM OF ART, ROGERS FUND, 1951; ACQUIRED FROM THE MUSEUM OF MODERN ART, LILLIE P. BLISS COLLECTION

Pablo Picasso, sketch of *Woman in White* (top center) in *Baigneuses* (*Bathers*; sketchbook 67, page 11), 1923. India ink on paper, 10 ½ × 14 ¼ in.

MARINA PICASSO COLLECTION; COURTESY OF GALERIE JAN KRUGIER & CIE, GENEVA

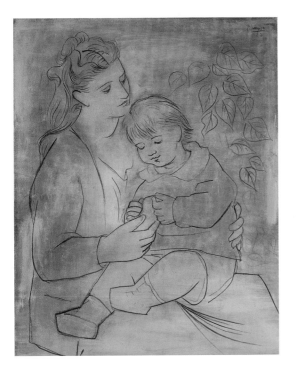

Pablo Picasso, *Mother and Child*, 1922. Oil on canvas, 39 ⅜ × 31 ⅞ in.

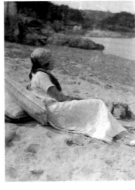

TOP Sara with Patrick at Houlgate, France, c. 1922. **BOTTOM LEFT**
Sara on La Garoupe beach, Antibes, c. 1923.

Pablo Picasso, *Femme allongée*, 1923. India ink on paper with Hôtel
du Cap d'Antibes letterhead, 8 ¼ × 10 ½ in.

sociated her with her ever-present string of pearls. Fitzgerald, too, linked Sara with her penchant for wearing pearls while sunbathing. In a description of Nicole Diver early in *Tender Is the Night,* he writes: "A young woman lay under a roof of umbrellas making out a list of things from a book open on the sand. Her bathing suit was pulled off her shoulders and her back, a ruddy orange brown set off by a string of creamy pearls, shone in the sun."[102] Idealized nudes wearing what look like pearl necklaces appear in countless works by Picasso from this time. These are generalized images, not portraits, but Sara in likelihood was among the sources of inspiration that fed into them. Some seem to be composite images, a blend across the spectrum from the real to the imaginary that encompasses Sara, Olga, classical art, imaginary women, and so on. The most famous of these is the 1923 painting *Woman in White*—and while one must always be wary of trying to pin down a one-to-one reference with Picasso, the argument for a con-

nection between Sara and *Woman in White* gains credence from a tiny drawing of the painting set into a beach scene in one of Picasso's Antibes sketchbooks, where the woman wears pearls.

The figures in Picasso's work that have been identified by art historians as Sara do not have her physiognomy, but they do seem to have something of her—a tenderness, calm, and self-possession that images of Picasso's wife and the classical types he drew prior to 1923 do not in general share.[103] Paintings such as *Mother and Child* (1922), for example, capture Sara's legendary warmth and visceral attachment to her children, as well as her distinctive self-containment, described by Gerald as her "strength in repose."[104] This quality is reiterated by Fitzgerald in *Tender Is the Night:* "She gave an impression of repose that was at once static and evocative."[105] It is also noted by Archibald MacLeish: "Her reticence by which you'd mean her power of feeling what she had not put in words."[106]

Pablo Picasso, *Sheet of Studies: A Man, Hand, and Feet* (study for *Toilette of Venus*), 1923. Pen and ink on graph paper, 4 ½ × 3 ¼ in.
MUSÉE PICASSO, PARIS

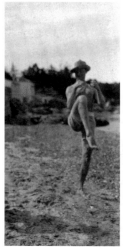

Gerald dancing on La Garoupe beach, Antibes, July 1923.

Gerald dancing (with Olga Picasso wearing white hat), La Garoupe beach, Antibes, 1923.

GERALD AND SARA MURPHY PAPERS, BEINECKE LIBRARY, YALE

Most men who met Sara Murphy felt her allure. In a letter to her, Fitzgerald writes: "I used you again and again in *Tender:* 'Her face was hard & lovely & pitiful' and again 'He had been heavy, belly-frightened with love of her for years'—in those and in a hundred other places I tried to evoke not *you* but the effect that you produce on men." In the same letter, he lauds her strength of character: "I have seen you again and again at a time of confusion take the *hard* course almost blindly because long after your powers of ratiocination were exhausted you clung to the idea of dauntless courage."[107] It is likely that "good, kind, beautiful, lovely Sara," as Hemingway was fond of addressing her,[108] was one of the lines of inspiration for Picasso's creation of a type of ideal woman. Typical of Picasso's layered and often oblique references are his studies made with sand, in which he used the medium of his encounters with Sara as the foundation for his paintings.

Throughout the summer of 1923, Picasso revisited an idea for a major work involving the serenade of a beautiful woman. Originally conceived as a "Toilette of Venus" (an homage to female beauty), the final painting, *The Pipes of Pan* (1923), depicts two solemn men. There are more than forty studies that relate to this painting. The earliest sketches show one woman crowning another with a laurel wreath; these are followed by drawings depicting one or two nudes being serenaded by a man playing the panpipe (also known as the "flutes of love"); this idea was then discarded, and the remaining sketches show variations of a nude couple dancing or embracing, or of a male holding up a mirror to a nude beauty (sometimes wearing pearls) while a little boy or baby looks on from above and a seated youth plays the panpipe. Scholars have usually interpreted the standing figure with the mirror as an idealized self-portrait of the artist.[109] However, it may also have been influenced by Gerald Murphy. Picasso made several studies of the male figure alone, in three of which the body appears to be in motion. Gerald often performed dance and pantomime routines for his friends, eliciting bursts of laughter and applause. Fitzgerald captured this aspect of Gerald in the following description of Dick Diver: "The man in the jockey cap was giving a quiet little performance for this group; he moved gravely about with a rake, ostensibly removing gravel and meanwhile developing some esoteric burlesque held in suspension by his grave face. Its faintest ramification had become hilarious, until whatever he

said released a burst of laughter."[110] There are in fact five blurry snapshots of Gerald dancing on the beach in just such a performance. One of those photos happens to be similar to Picasso's sketch, a correspondence that is in likelihood just a coincidence, but is suggestive nonetheless of Picasso's milieu at the time, since we know that he and his wife were there when the photos were taken.

One possible impetus for Picasso to revisit this theme may have been his initial perception of the Murphys as embodying the ideal of romantic love. Many people, including Fitzgerald, Dorothy Parker, and Donald Ogden Stewart, saw them this way. Gerald's immense regard for Sara was unwavering and lasted throughout their marriage. Ellen Barry noted: "Gerald was always quoting Sara, interpreting Sara—'Sara says this,' 'Sara thinks that'— which gave Sara an aura of enormous wisdom."[111] Honoria spoke of how her father admired her mother's looks, including her beautiful face and figure—always reflecting back upon her his adoration.[112]

In the end, however, *The Pipes of Pan* contains not a scene of love, but one of empty isolation. Picasso's biographer John Richardson is certain that the figure on the left in the painting is Gerald Murphy—"no doubt about it"—noting that Picasso could capture his subjects through "the way they stood, carried themselves, or projected character, without limning a likeness."[113] In the months between their time together in Antibes and the painting of *The Pipes of Pan* back in Paris, Picasso may have discerned that a troubled personality lay beneath Gerald's charming and delightful façade.[114]

In the years that followed, the Picassos and the Murphys continued to see one another in both Paris and the south of France. In a 1926 note addressed to the Picassos at La Haie Blanche, their villa in Juan-les-Pins, Sara wrote to cancel a soirée, mentioning that "above all Gerald regrets [not being able to dance] 'la Charleston.'" In another letter from the same summer, she asks, "Wasn't last night fun?" But gradually the relationship between Picasso and the Murphys seems to have cooled. In one rather curt letter from 1926, Gerald, without his usual politesse, asks for his disks (records) back and says that the chauffeur will pick them up. There are a few more communiqués up to 1929, then several postcards in the years after that. Most affecting is the last letter, dated March 17, 1961, when Sara wrote to Picasso after a silence of more than twenty years:

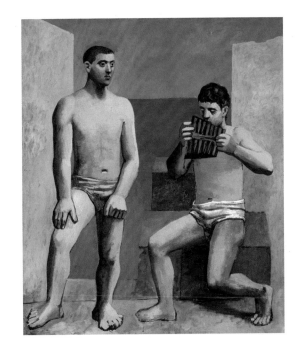

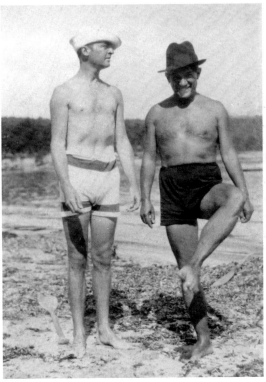

Pablo Picasso, *The Pipes of Pan*, 1923. Oil on canvas, 80 ¾ × 68 ½ in.
MUSÉE PICASSO, PARIS

Gerald with Pablo Picasso, La Garoupe beach, Antibes, July 1923.
GERALD AND SARA MURPHY PAPERS, BEINECKE LIBRARY, YALE

Villa America, Antibes, c. 1925.

Here we are two old friends that want to wish you their best from America—where they have read in magazines the news of your second marriage—one remembers so well (and is sure that you remember too) the beautiful days we all had together back then at Antibes. . . . Some people even think you and we, and our three children, started the summer season in the Midi! Alas, we lost our two sons—in 1935 [sic]—to our great sorrow. How life changes! Our daughter—Honoria is married and she has—as we had—two sons and a daughter who, thank God are very well. Accept our best regards and all our wishes for good fortune and long life and happiness—as you deserve.

> With affection and the hope to see you again one day,
> Sara and Gerald Murphy

As far as we know, Picasso did not write back.

Life at Villa America

Americans know how to make things luxurious while making them simple. FERNAND LÉGER, "THE NEW REALISM" (1935)

The Murphys found Antibes so congenial that toward the end of the summer of 1923 they bought a modest chalet, which they named, significantly, Villa America and remodeled in keeping with their minimalist aesthetic. They moved in during the summer of 1925, and over the years added to the buildings on the property, even building a *vacherie* for two cows so the children could have fresh milk. Their simplified family routines, dress, and décor put into practice a modern way of liv-

Fernand Léger, *Large Comet Tails on Black Background (Grandes Queues de comètes sur fond noir)* (front [top] and back [below]), 1930. Oil on canvas (three panels), 79 × 106 ¼ in.

FRONT: GALERIE MAEGHT, PARIS; BACK: MUSÉE NATIONAL FERNAND LÉGER, BIOT, FRANCE

ing that the French avant-garde and intelligentsia had for the most part discussed only theoretically in magazines such as *L'Esprit nouveau* and *Bulletin de L'Effort Moderne.* Le Corbusier, whose first International Style building had appeared in 1922, was impressed by the Murphys' imaginative renovation of Villa America, praising in particular the new flat roof, which allowed a sun deck to be built on top.[115]

As with the Murphys' Paris apartment, the Antibes house was small and unpretentious, with American innovations like screen doors and stainless-steel bathroom fixtures and American gadgets like waffle irons and electric fans. A letter to Robert Benchley from a friend who rented the Ferme des Orangers, one of the guesthouses at Villa America, in 1930 contains this description:

Mrs. Murphy must have exquisite taste. What an immense relief to have a living room in France that is not one of those disheartening Louis XIV or Louis XV salons! It must be decidedly unconventional, as Louise, our formidable Toulousain cook, has shown only too plainly her horror at there not being a single piece of rococo furniture in the house. . . . I forgot the screen doors, for which heaven be praised. Louise shows her inexpressible contempt for this great American invention by always leaving them thrown wide open; for she insists that they keep the flies in the house.[116]

The interior of Villa America was decorated with black floors, zebra rugs, lots of mirrors, and big glass bowls filled with flowers. In 1930 Léger created a large double-sided screen for the villa, entitled *Large Comet Tails on Black Background,* which marked a change in his work from geometric and mechanical themes to biomorphic and celestial imagery. Probably due to the changing circumstances of the Murphys' lives, the room divider was never installed, and the two sides are now in separate collections. A photograph taken in April 1932 shows Léger in his Paris studio, standing in front of the screen.

The villa opened onto a black-and-white-tiled terrace

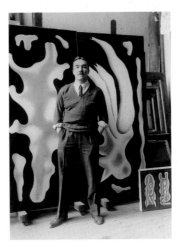

Fernand Léger standing in front of *Large Comet Tails on Black Background,* April 1932, photographed by Thérèse Bonney in Léger's studio at 86, rue Notre-Dame-des-Champs, Paris.

COURTESY OF THE BANCROFT LIBRARY, UNIVERSITY OF CALIFORNIA, BERKELEY

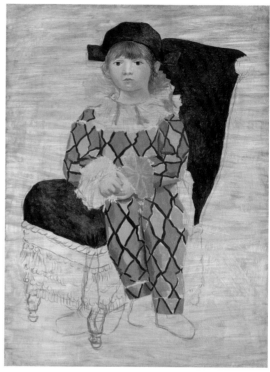

Pablo Picasso, *Paulo as Harlequin*, 1924. Oil on canvas, 51 ¼ × 38 ½ in.
MUSÉE PICASSO, PARIS

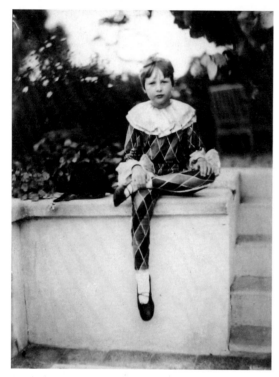

Salon de la Jeunesse, an exhibition of work by the Murphy children, installed at Villa America, Antibes, c. 1926. In a letter to his daughter, Honoria, Gerald related that when Pablo Picasso critiqued the children's work in the Salon, he admired her drawing of a cow, which she had made using a single line, without lifting her pencil from the paper.

GERALD AND SARA MURPHY PAPERS, BEINECKE LIBRARY, YALE

Honoria wearing Paulo Picasso's harlequin costume, Villa America, c. 1926, photographed by Man Ray.

HONORIA MURPHY DONNELLY COLLECTION

(instead of the usual red clay), where the Murphy family and guests often took meals on a large table under a silvery linden tree. Surrounding the house, terraced gardens covering almost seven acres of hillside were shaded by exotic trees planted by the former owner. Flowering plants were everywhere, as well as vegetable gardens, a citrus orchard, and olive trees. Fitzgerald evoked the magic of the place in *Tender Is the Night,* and Philip Barry used it as the setting for his play *Hotel Universe.*[117]

Life at Villa America centered on the children. Sara and Gerald were extraordinarily devoted parents who lavished time and energy on making their children's lives rich and exciting. They planned elaborate Easter egg and treasure hunts—one complete with a map leading to an island with a buried "pirate's" trunk filled with "jewels."[119] The children had art exhibitions—Salons de la Jeunesse—judged by Picasso, no less, and Man Ray visited and took

photographs of the family alone and in various groupings, including one of Honoria posed in Paulo Picasso's harlequin costume.

With Gerald's talent for stage managing and arranging things to perfection and Sara's ineffable allure and intelligence, the Murphys fashioned a charmed life in Antibes. Kenneth Silver writes:

Life at Villa America was spent as much as possible out of doors, in the ample gardens and at the nearby Plage de la Garoupe. Calisthenics, swimming, and sailing, often in the company of their three children, Baoth, Patrick, and Honoria, were part of the Murphys' routine; there was also much adult entertaining, with their wide circle of American and French friends. This was a New World idea of leisure: energetic yet casual, with a willful flaunting of haut-bourgeois formality, and a highly self-conscious embrace of all that might be rendered elegant by virtue of its simplicity.[119]

According to countless testimonies, every event was marked by wonderful food and drink, music, entertainment, and the gathering of creative people. These were not large parties generally, usually no more than a group of eight or ten "who all liked to talk."[120] The Murphys generated excitement by always being the first to get hold of the latest recording of American jazz, to learn a new dance, to sing a new song, or to screen a Hollywood movie, but what made them memorable and inspiring to writers and artists was an aesthetic infrastructure—as ordered and labored over as Gerald's paintings—on top of which they improvised gaily.

Let us turn again to Fitzgerald, who evokes through the character of Rosemary Hoyt the toil and artistry that underlay the Murphys' faultless style: "She felt a purpose, a working over something, a direction, an act of creation different from any she had known. . . . Her naiveté responded whole-heartedly to the expensive simplicity of the Divers, unaware of its complexity and its lack of innocence, unaware that it was all a selection of quality rather than quantity from the run of the world's bazaar." He goes on to describe the emptiness experienced by Dick Diver following the vast attention lavished on a fleeting moment: "the excitement that swept everyone up into it was inevitably followed by his own form of melancholy. . . . This excitement about things reached an intensity out of proportion to their importance, generating a really extraordinary virtuosity with people. . . . He had the power of arousing a fascinated and uncritical

love. . . . The reaction came when he realized the waste and extravagance involved. He sometimes looked back with awe at the carnivals of affection he had given, as a general might gaze upon a massacre he had ordered to satisfy an impersonal blood lust."[121]

Gerald's "carnivals of affection" were tied to his intense desire to have life "matter." It was a heroic effort to make the daily living of life beautiful and perfect. Archibald MacLeish's daughter-in-law, Peg, in describing a day spent with the Murphys years later in their garden in Snedens Landing, New York, articulated the ephemeral nature of this artistry: "An artist can do this with his painting, a poet with his poem—that capturing of the essence of a moment—but somehow, Dow's [Gerald's] special gift seems to have been in the very doing itself, so that the record is left not in any concrete form that can be examined by others, as a painting or a poem can be, but is simply held in the minds of those who were present at the moment of creation."[122]

CONCEALED SELF-PORTRAITS

While putting great effort into fashioning, with Sara, what Tomkins calls "a life that was lived at the very highest level,"[123] Gerald also left a more permanent record of his artistry, for he continued to paint pictures both in Paris and in a little studio he set up at Villa America. Of the fourteen pictures he painted (not including the curtain for *Within the Quota*), only seven survive. Like Gerald himself, his paintings are refined, elegant, and original. Even eighty years after their creation, they appear remarkably fresh and modern. Looking at them reveals another dimension of the Murphys' way of "making it new." *Razor* (1924, p. 91), which transfers Gerald's longstanding appreciation of humble objects—in this case, a matchbook, fountain pen, and safety razor—into paint on canvas, partakes of the then still novel modernist penchant for elevating the commonplace to high-art status. (Picasso and Cocteau, for example, had scandalized audiences of the Ballets Russes production *Parade* in 1917 with their introduction of street entertainments and other popular forms into the refined realm of the ballet.[124]) Another work by Gerald, *Watch* (1925, p. 95), likewise channels his proclivity for combining minute observation with obsessive labor, into a six-by-six-foot painting. *Bibliothèque* (*Library*, 1927; p. 101) and the lost *Boatdeck* mirror the Murphys' attraction to the clean, simplified geometry of the modern era. And *Cocktail* (1927, p. 103)

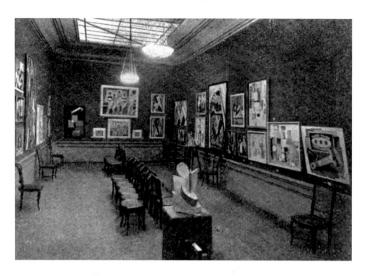

Gerald Murphy's *Razor* (1924), installed as part of the exhibition *L'Art d'aujourd'hui,* Paris, December 1925.

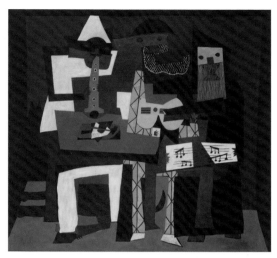

Pablo Picasso, *Three Musicians,* 1921. Oil on canvas, 79 in. × 87 ¾ in.

speaks not only of the rage for cultural and commercial imports from the United States, but to the discipline that underlay what was seen as the Murphys' carefree American way of life.

When Gerald's paintings were rediscovered during the heyday of Pop art, they were seen as deadpan and impersonal. The critic Hayden Herrera, writing in 1974, even commented that "some tragic dysfunction . . . prevented [Murphy] from allowing his art to serve as a vehicle for the expression of deeply held values and feelings."[125] Now, however, Gerald's paintings appear—like much art and literature of the 1920s—to have a coded secret life and to be laden with private meaning, hinting, beneath their deceptively simple and elegantly pristine surfaces, at Gerald's persistent feelings of defectiveness and inadequacy.[126] Of course, we will never know if Gerald consciously or unconsciously embedded hidden symbols in his pictures or if he would have bristled, laughed, or been mystified at such readings. But we do know about his apprehensions from his letters to Sara and Archibald MacLeish. Moreover, he kept a box, probably dating from the 1950s, filled with clippings and handwritten notes containing thoughts he had come across that had struck a chord.[127] The recurrent theme of these notes and clippings is self-condemnation: for example, a piece of scrap paper holds the lament "I should like to break with myself," and a sheet of personal stationery contains lines copied from *Macbeth:* "Cans't thou not minister to a mind diseased."

Razor, which was probably painted in Paris, is a more conventionally sized easel painting than the gigantic *Boatdeck,* but the scale of the objects *within*—a Gillette safety razor, a Parker Big Red duofold fountain pen, and a box of Three Stars safety matches—is enormous. (Gerald once said: "I seemed to see in miniature detail, but in a giant scale."[128]) Still striking today for its bold color and signlike flatness, the painting contrasted dramatically with the complicated and nuanced modern canvases that hung beside it at the *L'Art d'aujourd'hui* exhibition in December 1925. Even Purist works by Le Corbusier and Ozenfant, to whom Gerald is often compared, appear more painterly and less posterlike than this work.[129] The items Murphy chose to depict were the first of a certain kind of modern object: the ubiquitous, mass-produced personal convenience that turns consumers into walking advertisements. Given his background, Murphy understood the power of the brand name and the vulnerability of the public to commercial manipulation.

Flat and simplified as it is, *Razor* is filled with allusions, plays on words, and symbolism. Herrera's comparison of it to Picasso's *Three Musicians* (1921) is not far-fetched: the head of the razor becomes a human face with two round eyes; the diamond-patterned shaft, a body in harlequin dress (as in Picasso's painting); and the red-and-

yellow fountain pen, a toreador with "black cap, slits for eyes, sliver of a circle for a mouth and a yellow pen clip for a nose."[130]

In *Razor* the art historian Christopher Swan sees "protests and revelations that Murphy felt unable to express by any other means." He interprets the painting as "a painful and private vision bound up with Murphy's ambivalent relationship to objects, to irreconcilable differences with his father, and ultimately to questions about masculinity and Murphy's own repressed bisexuality."[131] Swan notes that the three objects were marketed as breakthroughs against hazard: the "leak-proof" pen, the sulfur-tipped "safety" matches, and the nick-resistant "safety" razor. But mistakes in handling them could leave "marks"—ink stains, burns, and cuts. Two of the objects are crossed in heraldic fashion—a punning reference to Gerald's father's company, Mark Cross, as well as to his father's penchant for wordplay on the Mark Cross name in his advertisements. But there are further messages: In 1915 Gerald worked on the patent for a Mark Cross safety razor. Smaller and more delicate than the Gillette, Murphy's razor failed to capture the market because men found it too slight and dainty. The razor's lack of success confirmed Patrick Murphy's opinion that his son was not made of the right stuff and would never amount to much in the tough world of commerce.[132] The Big Red pen, marketed as indestructible and just the tool for the "big" businessman, was another attribute of masculine success in an arena where Gerald felt lacking.

Departing from Swan's argument, one notes that the safety matches surmount the pen and razor in their size, color, and position, and thus might be interpreted as referring to victory over past derision and the safe haven that Gerald found through Sara and his children. Standing above the emblems of failure, the three stars (note that each differs slightly from the one beside it, unlike the identical threesome on the actual matchbook cover) represent the ultimate proof of masculinity—paternity. Honoria, Baoth, and Patrick—the three "stars" in Gerald's life—enabled him to overcome self-doubt and function as a "real" man.

The star icon appears repeatedly in images dating from the Murphys' years in Europe. Perhaps, for Gerald and Sara, stars affirmed their identity as Americans. But it seems that for Gerald, stars were also a symbol of his family. They show up, for example, in the sign he made for the entrance to Villa America (p. 93), where the five

gold-leaf stars to the left of the painting in likelihood stand for the Murphy family unit. Art historian Jocelyne Rotily writes: "The number five was sacred to Murphy. It figures almost ritually in most of his works. I might add that the figure five is more generally considered to be the number of union, centrality, harmony, and equilibrium. This symbolism, shared by several civilizations, must have been familiar to Murphy, who was interested in ancient civilization."[133]

The year after painting *Razor,* Gerald created the six-foot-square *Watch,* a precisely rendered oil painting of the inside of a watch surrounded by parts of other watches. Painted in fourteen shades of gray with touches of yellow, ocher, and black, *Watch* took Gerald's narrow palette and machine imagery to a new level. The watches he used as models still exist: the central one is a railroad watch designed for Mark Cross, and the other, in the background (with Roman numerals on its face), was a

Mark Cross safety razor (left), designed by Gerald Murphy in 1915, and Gillette safety razor, c. 1915.

Gillette safety razor, Three Stars safety matches, and Parker "Big Red" fountain pen.

PRIVATE COLLECTION

present to Gerald from Sara.[134] The myriad dials, springs, and levers in the painting, magnified to hundreds of times their normal size, are all part of a type of mechanism characterized (like Gerald) by precision and control. It is telling that Gerald used watchmaker's terms to refer to his heart. When Charles Lindbergh crossed the Atlantic, for example, Gerald wrote to Hemingway: "Thank God that somebody like Lindbergh does something like what he's just done some of the time. It tightens the main spring."[135] In 1931 he confessed to Archibald MacLeish: "After all these years . . . I awaken to find that I have apparently never had one real relationship. . . . My subsequent life has been a process of concealment of the personal realities. . . . The effect on my heart has been evident. It is now a faulty 'instrument de précision' [a term applied to high-quality timepieces]."[136] Indeed, the Murphys' structured way of life appeared to some as "ruled by the clock." On a visit to the Murphys in 1931, Léger expressed his exasperation: "It is almost as if Time is a member of the family . . . someone who is consulted and who dominates everything."[137] And Richard Myers wrote to his wife in 1933: "Gerald just managed me within an inch of my life—every minute accounted for."[138]

For the most part, the central watch in Gerald's painting is an accurate depiction. Daniel Nied, director of the National Association of Watch and Clock Collectors, reports: "It is meticulously correct in representing all the parts of a watch except that the mainspring to the left

Harry's Bar, Montana-Vermala, Switzerland, 1930. The star icon appears prominently in this bar that Gerald and Sara bought and ran to enliven dreary nights during their son Patrick's treatment for tuberculosis in Switzerland.

Gerald, Baoth, and Patrick with star-decorated surfboard, c. 1934.

Mark Cross railroad watch used by Gerald for his painting *Watch*.

[the larger grooved wheel] is separated from the center wheel [in yellow] by the metal sheath—the light gray curving element in the picture. And the balance wheel [the large orange-and-black circle on the right] is placed too far to the right to allow contact with the escape wheel. Without these connections the watch could not work."[139] Although it is possible that Gerald made these alterations for aesthetic reasons, there is a case to be made that this painting is a secret self-portrait of a defective, nonfunctioning self.[140]

Other aspects of the painting buttress this reading. The watch face at the upper right, with Roman numerals, has its hour hand pointing to the number three—possibly another reference to the three Murphy children. The "F" and the "S" that appear on the regulator of the central watch stand for "fast" and "slow," but, as Amanda Vaill has pointed out, they also do double duty as signifiers for Sara and for Fred Murphy, Gerald's brother, whose time had run out in May 1924, just around the time Gerald began the painting.[141] Finally, the round central watch face may be another self-reference: Gerald was self-conscious of what he deemed his "Irish moon face."[142] Thus, Gerald's precise and complex nature, as well his perceived shortcomings, from a too-round face to an emotional defect, may here be put on display—but in a manner that is sentiment-free and hidden well enough to escape detection.

Watch is perhaps the best example of what Jocelyne Rotily has called Murphy's "sacred approach to modern American objects." She notes that he and the American painter Charles Demuth shared a "use of typography that turned a painting into a coded, ciphered game."[143] Ironically, there is a timeless, almost spiritual quality to *Watch*. Gerald wrote that his Jungian psychoanalyst said: "It belongs in some kind of shrine or chapel."[144]

Watch was Gerald's single entry in the 1925 Salon des Indépendants. It was highly praised as "astonishing" and "seducing," and that has remained the consensus through time.[145] Later in the same year, Gerald painted *Still Life with Flowers* (p. 99), a watercolor that has something of the naiveté of folk art about it, and an oil entitled *Doves* (p. 97).[146] The composition of the latter, as in most of Gerald's paintings, is a neatened-up version of Cubist fragmentation and displacement, similar to the kind found in the work of Gris, Ozenfant, and Le Corbusier. Curving and rectilinear forms are locked together and balanced against one another. The delicate, pearly pas-

tel tonalities and graceful curves suggest femininity, as does the outline of the bird on the left, which has the "pigeon-breasted" look of women's fashion at the turn of the nineteenth century. Sara's full figure is brought to mind (p. 17), and the birds' slightly wary expression recalls her often "watchful" gaze.[147] William Rubin points out the similarity to Max Ernst's bird iconography and notes, "The isolation of the largest bird's head, as in a window, lends an almost Surreal quality to the image."[148] Also in the Surrealist vein is the dark, corniced column behind the dove on the left, which appears to morph into a menacing male profile, bringing to mind the wasp in *Wasp and Pear*, painted a few years later, in 1929 (p. 105).

In 1926 Gerald entered two works in the Salon des Indépendants. One, titled *Still Life (Nature morte)* in the exhibition catalogue, may have been *Razor*.[149] The other, *Laboratory (Laboratoire)*, is lost, but there is a short description of it in Murphy's notebook.[150] *Bibliothèque (Library)* and *Cocktail* (both 1927), like *Razor* and *Watch*, carry references to Gerald's father.[151] In 1962 Gerald told Douglas MacAgy, director of the Dallas Museum for Contemporary Arts, that *Bibliothèque* was inspired by recollections of his father's study.[152] The picture has a fixed rigidity that may be attributed to what Rubin calls its "thoroughgoing geometricity."[153] Cubist scaffolding creates a loose grid structure of shapes aligned along the vertical and horizontal axes, punctuated by

Amédée Ozenfant, *Still Life (Nature morte)*, 1926. Oil on board, 12 ¼ × 17 ½ in.

Fernand Léger, *Flowers (Les Fleurs)*, 1926. Oil on canvas,
36 ⁵/₁₆ × 25 ³/₄ in.

circles that lock the picture into place around the center column. This device is indebted to Léger, who experimented with bisected compositions throughout 1925 and 1926, as seen in *Flowers*. The strictly frontal or profile views of *Bibliothèque* add to an impression of severity. The base of the globe and the handle of the magnifying glass also reprise Léger's manner of painting shiny metallic forms using the sharp contrast of white against black. Further, as Vaill points out, "the magnifying glass reveals only a blank, empty lens. Similarly, the title plates of the spines on the three bound books are blank, and the countries and continents depicted on the globe have no names."[154] This library is an austere place—one of learning and expensive good taste, but emotionally barren.

Like *Bibliothèque*, *Cocktail* was inspired by Patrick Murphy's well-appointed furnishings—in this case, by his bar tray.[155] The mixed drink was considered an American invention, and serving drinks was one of the many ways the Murphys capitalized on the French craze for all things American. Gerald made an elaborate ritual of mixing cocktails and took great pains to have just the right proportions of ingredients; having the perfect accoutrements was also essential. In *Cocktail,* the elements of the cocktail hour are arrayed with military precision across a Cubist grid, again presenting a highly ordered universe (which is especially notable, given the carefree subject matter). As Kenneth Silver has pointed out, "Despite its theme, this is a picture not about intoxication, but about its opposite—the discipline required of those who would lead the good life without succumbing to its anarchic potential."[156]

On a piece of scrap paper he kept in his box of quotes and clippings, Gerald wrote: "Aristotle (paraphrase): Business or toil is merely utilitarian. It is necessary, but it does not enrich or ennoble a human life. Leisure, in contrast, consists of all those activities by which a man grows morally, intellectually, and spiritually." Another piece of paper has written on it five adages along the same lines, such as "Make a business of leisure" and "We have more occupation from our leisure than from our occupation." The sayings sound like Patrick Murphy's never-ending litany of moral axioms, but for one key fact: their content goes to the heart of the elder Murphy's disapproval of his son's unproductive, "arty" ways. Could *Cocktail* contain a hidden rebuttal to Patrick Murphy, in a sense arguing that there are different ways of being responsible and being a man? The tight order of the composition and the painstaking work required to paint the trompe l'oeil cigar box and tax label (which took Gerald four months), as well as the undercurrent of reproductive fecundity communicated by the phallic cigars, corkscrew, cherry, and bisected lemon (which brings to mind a microscopic diagram of sperm ready to fertilize an egg), all evoke a masculinity that encompasses a work ethic and heterosexuality, but on the artist's own terms.[157]

Portrait (1928, p. 115) was probably the next work Gerald painted.[158] In the compartmentalization of the various elements of the painting and in the disparity of their scales—as in the huge eye in the center of the composition and the small facial profile at the bottom left—*Portrait* recalls Surrealist works such as René Magritte's *Midnight Marriage* (1926) and *The Secret Game* (1927, both Royal Museums of Fine Arts of Belgium) as well as Léger's paintings, such as *Composition with Hand and Hats* (1927, Musée National d'Art Moderne, Centre Georges Pompidou, Paris).[159] Paradoxically both impersonal and

Cigar box and bar
accessories.

GERALD AND SARA
MURPHY PAPERS, BEINECKE
LIBRARY, YALE

utterly personal, *Portrait* presents a fractured assemblage of standardized facial features in combination with quintessential markers of individuality—finger- and footprints. (Gerald printed his foot directly on the canvas and meticulously enlarged his own thumbprints.) Nonetheless, the detached isolation of the incongruously scaled elements—each in its own section—suggests a fragmented personality that is always disappearing inside a complicated self-presentation, just out of reach.[160]

Shortly after the painting was finished, the five Murphys, accompanied by Vladimir Orloff, set sail for the United States on October 23, 1928.[161] One reason for the trip was that Gerald had been asked to collaborate with the director King Vidor for Metro-Goldwyn-Mayer on the first all-black feature film from a major studio. F. Scott Fitzgerald had arranged a meeting when the director was in France, and Vidor had been impressed by Gerald's vast knowledge of spirituals, folk songs, blues, and jazz. In Los Angeles, the Murphys stayed with the Vidors for a while and then moved into a bungalow in Beverly Hills. Gerald became discouraged when the authentically African American score Vidor had initially pitched was compro-

mised. Irving Thalberg thought the music Vidor and Murphy had selected was "too depressing and too strange." He added songs by Irving Berlin and brought in Lionel Barrymore to coach the black cast in the use of "Negro dialect."[162] Gerald, who found minstrel shows demeaning and thought African American songs were the country's finest artistic creation, its true classical music, resigned and is not listed on the film's credits.

While in Hollywood, the Murphys decided to have their children's tonsils removed. Vidor recounts that he and his wife thought it was a horrible idea and that it "caused a lot of problems with at least one of them."[163] He was referring to Patrick, who fell ill on this trip. The Murphys always claimed it was a chauffeur who infected Patrick, but the mass tonsillectomies may have had something to do with it.

Sometime in 1929, after the family's return to France following their stay in California, Gerald painted his last work, the disturbing *Wasp and Pear*. Gerald describes the painting in his notebook: "Picture: hornet (colossal) on a pear (marks on skin, leaf veins, etc.) (*battening* on the fruit, clenched)." Gerald seems always to have taken

Drawing of a worker bee's foreleg, from R. E. Snodgrass, *Anatomy of the Honey Bee* (© 1956 Cornell University).

Photograph of a wasp "battening" a pear.

Illustration of the Passe Colmar pear, in U. P. Hedrick's *The Pears of New York* (Albany, NY: J. B. Lyon, 1921).

the time to notice and observe minutiae; in a letter to Sara dated September 2, 1914, for example, he writes of "watching a caterpillar choose its chrysalis leaf." With *Wasp and Pear*, he continued his painting strategy of enlarging small objects to giant size. Here, however, he includes a further magnification, superimposing a detail of the insect's tarsal pad at the end of its leg.[164] This type of detailing is common in botanical drawings. Indeed,

Gerald claimed he was inspired by "the large technically-drawn and colored charts of fruits, vegetables, horses, cattle, insects (pests)" he had seen as a flight school cadet at Ohio State University.[165] He also may have come across such illustrations, and drawings of fruit in cross-section, in his landscape architecture studies at Harvard.[166] Interestingly, the red-brown body and black and yellow markings of the wasp in *Wasp and Pear* are characteristic of the European hornet, "the only true hornet in Ohio."[167]

In the upper right corner of the painting is a section depicting the hexagonal cells of a wasp nest. While the white cells would still contain larvae, the brown cells indicate that some pupae have matured into workers, suggesting that the scene takes place close to autumn, when the period for catching insects and raising larvae is coming to a close. In the fall wasps start to "batten," or fatten themselves on fermenting or overripe fruit. At this stage the insects are referred to as "drunken wasps"; becoming aggressive and more likely to sting, they are at their most dangerous during this time.[168] Although accurate in terms of depicting a specific season, the painting is inaccurate in its rendering of the wasp. The scale of the insect is greatly exaggerated in relation to the pear (even the large European hornet is usually no more than an inch and a quarter long); the legs and wings are attached to the wrong segment of the body; the shape of the head (narrow at the top, large at the bottom) should be reversed; the white spiral inside the head is an invention; and the open mandible, which appears to be in the "lapping" stage of feeding, is shown at the wrong angle and is distorted so that it reads as a voracious human profile. Such distortions add to the painting's suggestion of sexual aggression. The fall fruit Gerald chose to de-

pict is a pear, with its pleasing, sensuous shape so suggestive of the female body. (Vaill notes the similarities between *Wasp and Pear* and Man Ray's photograph *Le Violon d'Ingres* [1924], which features a nude with a distinctly pear-shaped bottom.[169]) Furthermore, another meaning of "batten" is "thrive at another's expense," and the hunched insect with its hideous profile appears to be preying on the womanly shaped pear. As with the lemon in *Cocktail,* the little seed exposed in the pear's cross-section suggests insemination.[170]

It is possible that the wasp represents something of Gerald himself. He suffered from a poor self-image—"I have never been able to feel *sure* that *any*one was fond of me, because it would seem to be too much to claim, knowing what I did about myself"[171]—and this occasionally manifested itself in stinging, waspish behavior.[172] Perhaps he also felt himself unworthy of the perfect, beautiful Sara (of the "deliciously ripe figure"[173]). Maybe he even believed that their relationship was detrimental to her.

As Gerald painted *Wasp and Pear,* he felt that his work was moving in a new direction. At this moment, however, life intervened. Patrick, who had not been well since May 1929, was diagnosed with tuberculosis on October 10. Gerald immediately took the boy to Montana-Vermala in the Swiss Alps for a cure while Sara closed Villa America. As Dorothy Parker, who was visiting, reported to Robert Benchley, Gerald determinedly set about "pouring all his energy into Patrick, in the endeavor to make him not sick," renouncing everything outside caring for his son, including painting. "Gerald has absolutely isolated himself with him [Patrick]—does every single thing for him and takes his meals with him."[174] Depending on when *Wasp and Pear* was painted, one of many alternate interpretations could encompass Gerald feeling preyed upon and consumed by family obligations.

After October 1929, as far as anyone knows, Gerald never took up a brush again. Given that artists have continued to be artists even under the direst circumstances, one wonders why Gerald felt "obliged" to give up the one thing that made him happy.[175] Archibald MacLeish suggests that "Gerald wasn't Irish for nothing. He bore the stigmata . . . he took the illness as a judgment on himself. He hadn't earned the right to art."[176] Parker drew a similar but slightly different conclusion: "there is something else—that morbid, turned-in thing that began with his giving up his painting and refusing to have it mentioned. . . . I think there is a little of 'Very well; since all

I'm good for is to be a nurse, then I'll BE a nurse' in his position now."[177]

Tomkins hypothesizes that "Gerald wasn't ruthless enough [to be a great artist]. He wasn't someone who would do it no matter what."[178] In a like-minded vein, Roger Wilcox, another friend of the Murphys in their later years, commented: "Gerald expressed privately to me that he felt that his painting was inadequate, even though he loved doing it—he did not consider himself an artist with the level of talent as the great artists he respected. He told me that an artist had to be dedicated totally because unless you commit yourself one hundred percent you will never be good enough. . . . If he had not had these unfortunate experiences he probably would have kept on with it. But something in Gerald's sense of honor could not put aside his duties as a father and husband, the commitments to his family."[179] King Vidor further buttressed these assessments: "He was a Spartan character. He would think he had a duty to do, [and] he would do it. A lot of fellows with an artistic urge would say, 'I am going to follow this thing to hell over anything else and just do it,' but he was such a resolute sort of gentleman that he would weigh those duties very heavily and probably make a decision from them."[180]

Attributed to Gerald Murphy, *Still Life with Curtain, Violin, and Flowers in Vase,* c. 1936. Crayon on paper, 7 × 8 ¼ in.

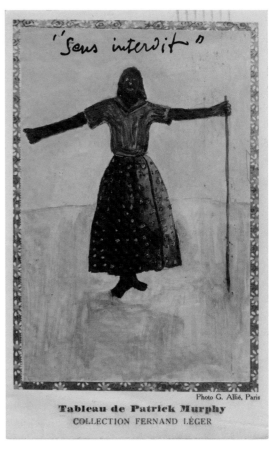

Photo G. Allié, Paris

Tableau de Patrick Murphy
COLLECTION FERNAND LÉGER

Fernand Léger, collaged postcard, 1934. Léger's handwritten notation reads: "Look at this sad expression! Watch! Hurray for water! Hurray for water! Which makes us beautiful."

Léger had the postcard on the right printed in 1930, with Patrick Murphy's painting *Gens Interdit (No Trespassing)* on the front.

There are two minor addenda: An entry in Gerald's notebook dated July 14, 1936, reads: "Window sill with curtains, geranium in pot against brilliant blue sponged sky." A crayon drawing found in the Murphy family papers seems to be a study for this idea. On a table sit an orange tablecloth, a fringed placemat, part of a violin, and geraniums in a blue pot, all depicted in a Gris-like Cubist style. Floating behind this tableau are lace curtains— possibly a reference to Gerald's "lace-curtain Irish" background—through which peeks a bright blue sky. As far as we know, Gerald took the image no further.[181] According to Roger Wilcox, Gerald also decorated the shutters of his home in East Hampton with unusually stylized flowers and fruits.[182] When Douglas MacAgy saw them, he was sufficiently impressed to ask if he might include them in a 1960 exhibition of work by Gerald and others he was organizing for the Dallas Museum for Contemporary Arts, titled *American Genius in Review No. 1*. Gerald flatly refused, even after several entreaties.

THE END OF A GOLDEN ERA

I will draw that veil over the last days of shutting up the place in Antibes. Because what is more horrible than a dismantled house where people have once been gay? DOROTHY PARKER, LETTER TO ROBERT BENCHLEY, NOVEMBER 7, 1929

A few weeks after the Murphys received the news of Patrick's diagnosis, the stock market crashed. The Depression that ensued had a devastating effect on the Murphys' fortunes. Frank Wiborg died on May 12, 1930, and Patrick Murphy (Gerald's father) followed on November 23, 1931. The Murphys were never as wealthy as people assumed. They had been living quite comfortably on Sara's annuity of $20,000 per year, with some extra infusions here and there—"like a grain of sand on the beach compared to really wealthy people," Tomkins notes.[183] With the stock market crash, however, not only did Sara's annuity decrease, but the favorable exchange rate they had experienced in France also dropped, and it soon became necessary for Gerald to take the helm of

the floundering Mark Cross company in order to support his family. October 1929 thus marked the end of the "golden life" the Murphys had created, as well as the end of Gerald's life as a painter.

When Patrick first fell ill, the Murphys decamped from Antibes to Montana-Vermala, later moving to the Swiss town of Ramgut for the prescribed two-year cure. Sara, who was "irrepressibly positive and always managed to find something to be cheerful about,"[184] set her mind to making the best of their lives in Switzerland. She convinced Dorothy Parker to stay for an extended visit, and Robert Benchley and the families of Hemingway, Dos Passos, and Donald Ogden Stewart all came at various times as well. In the summer of 1930, the Murphys opened a night spot, Harry's Bar (see p. 62). With a chef and a dance band, "it was the most exciting thing that had ever happened in Montana-Vermala."[185] Léger visited several times and also kept in touch through postcards, over which he would sometimes make silly drawings. A serious postcard from Léger has a reproduction of a painting by Patrick on the front, with this notation underneath: "Tableau de Patrick Murphy. Collection Fernand Léger." On the back, Léger addressed the card to "Patrik [sic] Murphy, Artiste Peintre." Léger felt an especially deep attachment to young Patrick and recognized his talent as a budding artist.

Fitzgerald also frequently visited during 1930 as his wife Zelda slowly descended into madness at a clinic on Lake Geneva. He and Gerald confided in each other during this period, both apparently dropping their customary façades. As Amanda Vaill and Linda Patterson Miller have pointed out, the flawed Dick Diver who emerges in the second half of Tender Is the Night is closer to the real Gerald than many critics have thought. Vaill writes: "The story of Dick Diver's feelings of emptiness and imposture, his betrayal at the hands of a world he thought he could manipulate, his struggle to come to terms with the renunciation of his idealism and his talent. These feelings, this betrayal, this struggle . . . all were Gerald Murphy's."[186]

In the fall of 1930, Gerald traveled to Basel, where he underwent Jungian therapy with Dr. Hans Schmid-Guisan. He later told Tomkins: "At one point I had a problem and went to see a shrink in Basel and I got rid of the problem."[187] The exact nature of the problem was not disclosed. During his time in Basel, Gerald had a photographic portrait made, showing multiple versions of himself, seen from various vantage points, sitting around a table (see p. 160). It is a fitting metaphor for the identity struggles he faced and the smoke and mirrors he put up to conceal them.

The *Weatherbird* Interlude

By the end of 1930, the Murphys' world had changed drastically, as had the world at large. Financial considerations caused them to sell both their place in Paris and their boat, the *Honoria*. They rented out the large guesthouse at Villa America and made up their minds to sell the entire property. After these concessions, with typical disregard for fiscal realities, they then decided to build a new boat—large, commodious, and elegant—which they planned to use as a "floating villa and living classroom" à la today's "Semester at Sea" for their children. It was ready to sail in April of 1932. They dubbed it the *Weatherbird* after a Joe "King" Oliver jazz tune.

According to their captain, Vladimir Orloff, Gerald and Sara had taken up sailing in 1924 in order to help him, their new Russian friend, without offending his pride.[188] Such an extreme response was not uncharacteristic of the Murphys. Knowing that the highly cultivated and aristocratic Orloff had been a naval architect in Russia and that he was barely scraping by working for Diaghilev, they said to him, according to Jacques Livet, executor of Orloff's estate: "You know, Vova [Orloff's nickname], once Villa America is finished we'll need to have a boat to go up and down the coast. Since we know nothing about it, you can take care of it."[189] Sara, who was a born sailor, would brave any sea, but not Gerald. Livet recalls that on Gerald's first trip with Orloff, accompanied by Archibald MacLeish, they encountered rough seas, and when they at last dropped anchor, an ashen Gerald exclaimed: *"Enfin, la terre!"* ("Finally, earth!"). After a few weeks, however, he rallied, and over the next thirteen years Orloff sailed three boats for the Murphys (the *Picaflor*, the *Honoria*, and the *Weatherbird*), having designed the last two for them. Man Ray's startling 1925 photographic proofs taken on the first vessel, the *Picaflor*, show a nude Gerald—who had no scruples about wearing as little clothing as possible—sailing along at a steady clip (see p. 113).

Despite the dislocation and stress associated with Patrick's illness, the Murphys continued to take sailing trips in the 1930s that were the delight of their friends and family.[190] Music was a constant companion, with either records playing on the Victrola or someone playing

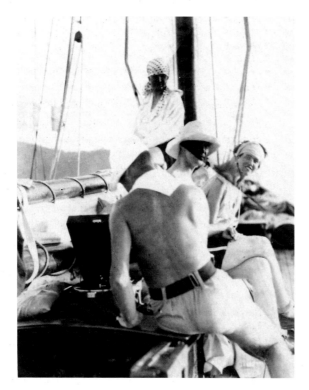

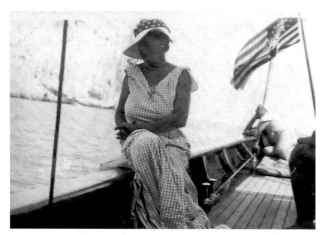

Gerald playing a record on his Victrola aboard the *Weatherbird*, 1932. The playwright Philip Barry and his wife, Ellen Barry, sit beside him on deck; Sara, wearing a polka-dot headscarf, stands in the background.

Sara on the *Weatherbird* (with Gerald in the background), summer 1934.

Fernand Léger, *Gerald Murphy*, from *Weatherbird Portfolio*, summer 1934. Watercolor and pencil on paper, 12 ¾ × 9 ½ in.

Fernand Léger, *Sara Murphy*, from *Weatherbird Portfolio*, summer 1934. Watercolor and pencil on paper, 12 ¾ × 9 ½ in.

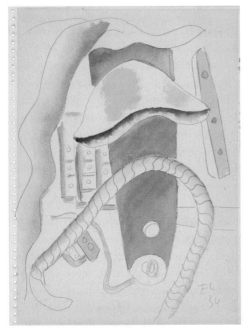

Fernand Léger, abstract drawing from *Weatherbird Portfolio*, summer 1934. Watercolor and pencil on paper, 12 ¾ × 9 ½ in.

Fernand Léger, abstraction from *Weatherbird Portfolio*, summer 1934. Graphite and blue, brown, and gray watercolor on paper, 12 ¾ × 9 ½ in.

the small piano in the saloon. In 1934 Patrick had recovered enough for the entire family to take a voyage on the *Weatherbird*. Léger accompanied them and commemorated the trip with a portfolio of twenty-four watercolors. He inscribed the cover: "A Sara, à Gerald, leur mousse très dévoué" (To Sara, to Gerald, their very devoted cabin boy). In one of the watercolors, Sara appears wearing a polka-dot hat. She is viewed from behind, with her dress pulled off her shoulders, as was her custom when sunbathing. In another, Gerald wears his characteristic skullcap, and he too is seen from the back. As with Picasso's Antibes sketches of 1923, photographic documentation of this trip makes it possible to look over the artist's shoulder as he captures the essence of his experience. Léger's ability to notice and transform the most banal objects into something memorable is evident in the portfolio's studies of twined rope, sailing gear, and so on.

Also guests on the *Weatherbird* in the summer of 1934 were new friends of the Murphys, Dudley Poore and Richard Cowan. Dos Passos knew that Poore (an editor at *The Dial* who was accompanying Cowan on a tour of the gardens of Europe) would be crossing the Atlantic on the same ocean liner as Sara and Gerald and suggested that he look them up. They took an immediate liking to one another, and in June the Murphys invited Poore and Cowan first to lunch on the *Weatherbird* while it was docked in Gibraltar and then on a cruise to North Africa and Spain. In August they invited them to stay at Villa America. Photographs and home movies show Poore and Cowan dining and lying on the deck of the *Weatherbird* and walking to La Garoupe beach. Cowan, a handsome, twenty-five-year-old budding landscape architect, kept a diary of the trip and also sent letters over the course of the summer to his lover and benefactor, Stewart Mitchell. This material, preserved in the collection of the Boston Athenaeum, is published here for the first time and offers a fresh glimpse of life Murphy-style.[191] A typical example is the diary entry for June 22, written in the port of Motril, Spain: "Stopped at 1pm for a swim. The water was clear as could be and of a beautiful sapphire sparkling like diamonds when we splashed in it in the sun. In the morning there were dozens of dolphins playing about the boat.... Had a champagne cocktail at five and a delicious dinner. Later some music and brandy and at 1:30 we watched the moon go down."

Cowan and Poore arrived at Villa America on August 8, after a trip to Italy. Cowan noted: "Slept 'til nine and

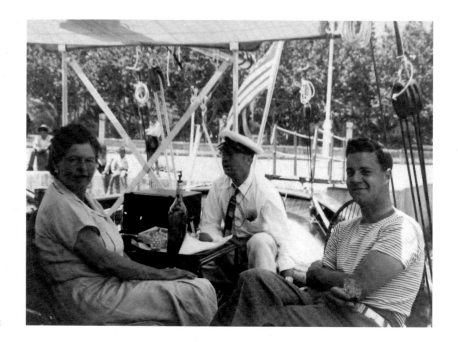

Sara and Gerald with Richard Cowan on the *Weatherbird*, summer 1934.

had breakfast under a fig tree in front of the cottage. A little later we went down to the Garoupe Beach and had a swim from the *Weatherbird*." On August 14 Cowan wrote in his diary from St. Tropez: "Gerald insisted on buying D. and I each a S. Tropez outfit from sandals to jacket and caps." He wrote to Mitchell on August 21: "Don't be jealous of G.M.'s gifts of clothes for he gives them to Dudley also." He went on: "Met Fernand Léger— the Picasso disciple—here. He's been staying as Gerald's guest in another of their cottages. Quite pleasant and very French—even tho' his paintings are terrible." Cowan and Poore stayed at Villa America until Saturday, August 25. The day before they left, Cowan wrote: "G played the victrola and we all dressed in various costumes and danced till after 11 . . . then went to Juan les Pins to the 'Hollywood' where we danced til 2 or 3 a.m."

A few days later, in Paris, Cowan met up with Sara and Honoria with their friends Alice Lee Myers and her daughter Fanny. Sara apparently set the pace, and we get a sense of how much of the Murphys' fun-loving way of life was really Sara's way—minus the intense planning and organization. Cowan's diary records the whirlwind activities. They went to the Louvre and to Mainbocher's, where Sara bought some dresses. They had drinks at Fouquets, then dressed and had dinner at Lipps. They dropped the girls off at their hotel and went to a movie,

then on to a nightclub, Le Chauve Souris in Montmartre. After taking Alice Lee home, Sara and Cowan went "way downtown" and had a sandwich at a workman's café, getting home at 3:30 A.M. The next day and night were more of the same: up at noon, lunch at Crémerie, a drive to St. Cloud, shopping with Sara, Columbe d'Or for tea, dinner of blinis and duck at the Ritz, then to night spots— this time to Le Boeuf sur le Toit, where they "danced for several hours," and then to the Melody Bar, where they "danced some more." "At daylight we went to the market—rather lovely in the early light. Bought armfuls of flowers—dahlias, asters, etc. Took them all back to Alice Lee's at 7 and cooked some breakfast there. Stayed till 8:30 and then set out to meet the train with a huge artichoke for Gerald. They all looked rather shocked to see us in evening clothes. Poor Patrick was thoroughly embarrassed." On September 1 Cowan saw the Murphys off for the United States. He wrote in his diary: "Hate to see them go, especially Sara."

The Murphys' friendship with Cowan continued to blossom. Sara's relationship with him was warm and motherly (in letters to him, she sometimes scolded him about being lax about his future and reminded him to stand up straight), but Gerald's relationship with him took a different turn as he discovered he harbored unwanted feelings for the young man.

A Truncated Life

All we have to face in the future is what happened in the past. It is unbearable. MAEVE BRENNAN, LETTER TO WILLIAM MAXWELL, SEPTEMBER 22, 1971

Outside of a man and a woman, and children, and a house, and a garden—there's nothing much. GERALD MURPHY, LETTER TO SARA MURPHY, APRIL 18, 1936

Shortly after the Murphys returned to the United States in the fall of 1934, Patrick—whose health for years had cycled between improved and worsened—suffered another relapse.[192] Sara stayed with him at Saranac Lake, in upstate New York, for another cure, while Gerald devoted his energies to running Mark Cross in New York City, working hard to rescue the family business from the jaws of bankruptcy.

The persistent battle to save Patrick—Sara was consumed with trying to get him to eat—took a toll. Seeing that she needed a break from the strain, Gerald insisted she take a trip to visit Hemingway in Key West with Ada MacLeish and John Dos Passos and his wife, Katy, in February 1935. Concerned as always about the weak and failing Patrick, the Murphys were thoroughly blindsided by the news that Baoth, their healthy, athletic son away at St. George's prepatory school in Newport, was undergoing complications from a bout of the measles. At first Gerald allayed her fears, but when mastoiditis set in he summoned Sara home. She rushed back north, but by the time she arrived, Baoth had developed meningitis. He was moved to a Boston hospital, but within ten days and after five operations on his brain, the unthinkable happened: he died on March 17, 1935, two months short of his sixteenth birthday.

On March 20, 1935, Sara wrote to Cowan: "I wanted you to know that the ashes of your roses are with Baoth's. I put in some flowers for everyone who loved him. Don't *ever ever* relinquish the truth that children,—one's own children,—are the things that matter most in life—(*Even* if the husband or wife problem should be complicated or difficult.) So *don't* (for the sake of your old friend, Sara) *ever* let life cheat you out of having your own, will you?"

On April 1 she wrote (in a letter that harks back to one written twenty years earlier to Gerald about their future together): "We try to think only of the simple things like children, and flowers, and puppies, and food—and so may find our balance again—and our friends have been an unforgettable help throughout." And on September 6 of the same year: "My dear David, And don't ever forget for a *moment* that you are young and *alive* and beautiful. . . . It is to me the inconsolable part of Baoth's loss that he loved life so,—Exactly like me—and could have taken it—the bad with the good,—and still loved it."

Throughout this tragedy, Patrick's health continued to fail, and again the Murphys' close friends rallied. All their lives Gerald and Sara excelled in cultivating and maintaining deep, rich, lasting relationships—indeed, these were among the things they valued most—and when caring, compassion, and support were called for, their circle of devoted friends responded in force.[193]

In the late fall of 1935, Léger visited Patrick at Saranac Lake, and the two of them made simultaneous portraits of each other (see p. 74). Patrick's drawing is a strong, sure likeness that captures Léger's bearlike robustness. The strength of the image belies the draftsman's frail state—fifteen-year-old Patrick weighed sixty pounds at the time. Léger's picture, which shows Patrick looking at his drawing pad as he sits in a white iron bed, is, Vaill notes, "less straightforward, and more unsettling."[194] It must have been painful for Léger to render this distressing image. Nearly swallowed by a heavy sweater, cap, and voluminous bed linens, Patrick is marginalized to the left of the page. His face and hands are so faintly rendered, he is barely visible—literally, almost fading out of the picture.

Picasso once said of Patrick that he was "un monsieur" who by chance was a child. Seven years of pain and illness made that even more true. Patrick's 1937 diary begins: "New Year's day was one of the dreariest that I ever spent. . . . I woke up in a wretched mood, took hours for my nourishment, and listened gloomily to the merry-making of my family and their guests. During the afternoon they were allowed to come in for a few minutes. . . . I am greatly inconvenienced by having to breathe out of an oxygen tank, due to breathlessness."[195] By January 16 he was too weak to write in the diary, and some notes are pasted in to mark important events. One reads: "Ernest Hemingway, Jinny Pfeiffer and Sidney Franklin, noted and only American bullfighter arrived. Ernest came in to see me for a few minutes." We learn from Honoria that Ernest left Patrick's room weeping

Fernand Léger drawn by Patrick Murphy

Patrick Murphy, *Portrait of Fernand Léger*, fall 1935. Pencil on paper, 10 ½ × 8 in.

Fernand Léger, *Patrick Murphy in Bed, Saranac Lake*, fall 1935. Colored pencil and crayon on paper, 12 × 18 in.

openly.[196] Patrick's last diary entry is dated January 24: "Had a hard time eating today and did not do well. . . . Did some etchings this afternoon but haven't printed them yet." Six days later, on January 30, 1937, he passed away peacefully, his parents holding his hands, assuring him they were there with him.

Letters full of respect and awe for the boy poured in. Philip Barry wrote: "I can't help feeling that Patrick has at last escaped a thousand million enemies who singled him out for attack for no other reason than that he was so plainly and shiningly a child of Light."[197] Fitzgerald wrote:

Dearest Gerald and Sara:

The telegram came today and the whole afternoon was so sad with thoughts of you and the past and the happy times we had once. Another link binding you to life is broken and with such insensate cruelty that [it] is hard to say which of the two blows was conceived with more malice. I can see the silence in which you hover now and after this seven years of struggle and it would take words like Lincoln's in his letter to the mother who had lost four sons in the war to write you anything fitting at the moment.

But I can see another generation growing up around Honoria and an eventual peace somewhere, an occasional port of call as we all sail deathward. Fate can't have any more arrows in its quiver for you that will wound like these. . . . The golden bowl is broken indeed but it *was* golden; nothing can ever take those boys away from you now.[198]

The years of futile struggle to make Patrick well, and the blow of Baoth's sudden death, changed the Murphys. The physical connection and the "active" love life they shared suffered during the siege, and Gerald withdrew emotionally. He wrote to Sara several times in the late 1930s of his inability to provide the "communicated affection" on which she thrived.[199] Nonetheless, his primary concern was always for Sara's well-being. He gave himself over to sparing her any further unhappiness.[200] He wrote to their architect friends Hale Walker and Harold Heller on May 16, 1938: "As you two know better than almost any of her friends she is—and will always be—hopelessly inconsolable. As time goes on she feels her bereavement more and understands less why the two boys were taken away—both of them. We have both felt that our life was definitely stopped before it was finished and that nothing that we do further has much meaning except as it can possibly be of service to Honoria and

our friends."[201] Even years later, in 1944, Gerald wrote to their friends Richard and Alice Lee Myers, whose son had been killed in World War II: "Time does not heal, as one is assured,—not if the loss has been that of one's future,— as yours has been, as ours. Sara said at breakfast on the 17th 'He [Baoth] would have been 25 this May. He would have been in the Navy!' Her eyes gleamed with a kind of pride as she said it."[202]

Despite their grief, the Murphys persisted in trying to make life as pleasurable as they knew how. Each of the several places they lived in the following years was marked with their own brand of elegant distinction modulated by whimsy and unpretentiousness. Their early love of gardens and landscape architecture never left them, and they both took pleasure in planting and arranging outdoor spaces in original and unexpected ways, always making sure the gardens provided cut flowers and fresh vegetables for their home.

While Sara's warm, generous, and optimistic love of life gradually forced itself through her grief in shadowed form, Gerald's loss of his sons seems to have finally pressured open the valve of feelings he had always suppressed. He made overtures to several young men, including Cowan, that went beyond friendship.[203] His last letter to Cowan, dated May 17, 1939, reads: "Dear Dick, Drunk with the success at the reception of my two previous missives I am now turning to a strictly business letter"; he goes on to ask about statues for the garden.[204] All three letters went unanswered. For months, it seems, there was no communication between Gerald and Cowan, and it must have been a shock for both Gerald and Sara to learn that Cowan died on October 24, 1939, in an apparent suicide.[205]

A LEGACY OF LIVING WELL

The Murphys were the most stylish people I ever met in my life—in the good sense of the word.
LILLIAN HELLMAN

In *A Moveable Feast*, Hemingway describes the Murphys as "those rich" who "never wasted their time nor their charm on something that was not sure."[206] Nothing could be further from the truth. Hemingway himself was an unknown at the time of their enthusiastic emotional, intellectual, and financial support. Léger's fortunes in the United States in the 1930s—his exhibitions, contacts, and sales to museums and collectors—were largely due to the

Murphys, who paid for three of his four transatlantic trips and engineered countless introductions. Léger wrote: "Thanks to you two that all this has been made possible, and I am eternally grateful."[207] They helped support Fitzgerald through the late 1930s when his fortunes were at their lowest ebb and no one wanted to know him, lending him money so that his daughter could attend college. In 1938 he wrote to Gerald: "As a friend you have never failed me."[208]

The Murphys also lavished encouragement and funds on Dos Passos, Richard and Alice Lee Myers, and Mrs. Patrick Campbell, the once-famous actress fallen on hard times. Gerald was determined that Maeve Brennan, the gifted Irish writer, become as well known as she deserved to be. Her short fiction is an unmined treasure only now being discovered.[209] William Jay Smith, in this publication, describes his personal brush with the legendary Murphy largesse. Calvin Tomkins is another contributor to this publication whose great gifts as a writer they perceived at an early stage.[210] Long after the 1920s, the Murphys did everything they could to see talented people succeed, and this is one of their most important legacies. Fitzgerald got it right in a letter to Sara dated August 15, 1935, where he writes of "the love and encouragement you chose to give to people who were full of life rather than to others . . . who were frozen into rigid names."[211]

Yet while the Murphys' generosity to artists and friends is legendary, less well known is the fact that they also stood up for social and political causes. In 1941, upset over the United States' isolationist policy toward the Nazi occupation of European cities, Gerald replaced the items in the display window of Mark Cross with photographs of the Mark Cross factory in Walsall, England, showing its boarded-up, blown-out windows and the air raid shelter that protected factory workers from German bombs. He also, in May 1941, ran an advertisement in the *New York Times* that paid tribute to the workers' fortitude, with photographs of the factory and workers along with the phrase "Yesterday the Bombers came again."

Gerald and Sara acted on their beliefs in other ways as well. Fanny Myers Brennan recalled: "They were broad-minded and could not bear injustice. I know that he [Gerald] stood up as a witness for Paul Draper when he was in trouble with the Un-American Activities commission. And I think a rift between MacLeish and Gerald happened at Mimi's [MacLeish's daughter's] wedding because Gerald was incensed by Archie's treatment of a

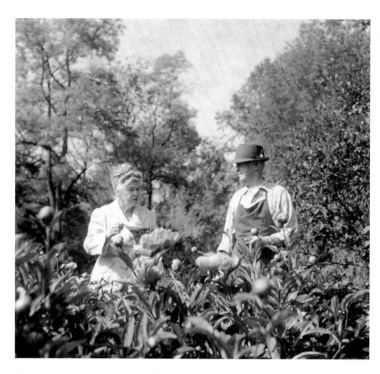

Sara and Gerald in their garden, East Hampton, c. 1963.

waiter. And I know that Lillian Hellman had trouble renting a house in East Hampton because she was Jewish and they went to bat for her."[212] In 1981 Hellman told Honoria of another occasion when the Murphys came to her aid: "Your father loaned me a fair amount of money. In 1951 [during the McCarthy era] Roy Cohn had subpoenaed [Dashiell] Hammett [Lillian Hellman's life partner], who was the trustee of a bail bond fund for radicals in trouble. They wanted the list of funders and Dash refused to give it to them, so they put him in jail. In a panic to raise bail, I mortgaged my house, hocked my mother's jewelry, and was still short on money. Gerald called me and offered to help, and on a Saturday, we went down to Mark Cross and got ten thousand dollars. Your father was one of the kindest men I ever met. He's the only Irishman I've ever met who was totally elegant—I mean elegant about people's feelings."[213]

Gerald was fond of saying that "as we grow older we must guard against a feeling of lowered consequence."[214] But after decades of relative obscurity, he found his fortunes changed as curators and critics discovered his work. In 1956 the writer Rudi Blesh included Gerald in his book *Modern Art USA: Men, Rebellion, Conquest, 1950–1956,* and in 1960 Douglas MacAgy asked him to participate in an exhibition he was organizing for the Dallas Museum for Contemporary Arts, *American Genius in Review No. 1,* on neglected twentieth-century American artists. Tomkins's profile of Gerald and Sara came out in the *New Yorker* in July 1962.

In 1963 Gerald was diagnosed with intestinal cancer. While he was in the hospital, Sara wrote to him, on August 7, 1963: "Dearest Gerald—Here I am 'at home'—'without you,'—and it is no longer a home, just a place to live—You *must* know that without you—*nothing* makes any sense—I am only half a person,—and you are the other half—it is so, however I may try—and always will be—*Please, please* get well soon—and come back to me. With love—all I have—Sara."

Gerald died on October 17, 1964. Sara, whose memory began to fail at around this time, steadily worsened and followed him eleven years later on October 9, 1975, at the age of ninety-one. Gerald had selected the epithet on her tombstone: "And She Made All of Light."

Way back in 1916, Gerald had described to Sara his perceived deficiencies and his fear that he seemed to lack the necessary qualities to carry them both over the bumpy parts of life. Although he never met his own impossible standards for perfection, he and Sara managed to survive not only the bumps, but also the crushing blows life threw at them. In the end, they achieved their dream of inventing a life that mattered—one that inspired some of the last century's finest writers and artists. Further, that life itself became a seminal work of art, prefiguring modernists such as Joseph Beuys, Allan Kaprow, David Hammons, and Rick Lowe, who have viewed the artist as a vehicle for expanding our awareness of life[215]—someone whose role is to redefine the terms and conventions of artistic practice without necessarily leaving a single object behind.

NOTES

The chapter opening epigraph is from Archibald MacLeish, quoted in Calvin Tomkins, *Living Well Is the Best Revenge* (New York: Viking Press, 1971), 6.

Subsequent epigraphs are, in order of appearance, from an undated newspaper clipping in Frank Wiborg's 1913 diary, Gerald and Sara Murphy Papers, Yale Collection of American Literature, Beinecke Rare Book and Manuscript Library, Yale University, New Haven, CT; Gerald Murphy, letters to Sara Wiborg Murphy, Honoria Murphy Donnelly Collection; Gerald Murphy, letter to Calvin Tomkins, Gerald and Sara Murphy Papers; Gerald Murphy, quoted in Amanda Vaill, *Everybody Was So Young: Gerald and Sara Murphy, A Lost Generation Love Story* (Boston: Houghton Mifflin, 1998), 134; front flap of Willard Connely's *Count D'Orsay: The Dandy of Dandies* (1952); F. Scott Fitzgerald, *Tender Is the Night* (New York: Charles Scribner's Sons, 1934); Ellen Barry, interview by Linda Patterson Miller, June 4, 1982; Fernand Léger, "The New Realism," *Art Front* (New York) 2, no. 8 (December 1935), 10; Dorothy Parker, letter to Robert Benchley, in Linda Patterson Miller, ed., *Letters from the Lost Generation: Gerald and Sara Murphy and Friends,* expanded edition (Gainesville: University Press of Florida, 2002), 46–53; Maeve Brennan, letter to William Maxwell, William Maxwell Correspondence, Rare Book and Manuscript Library, University of Illinois at Urbana-Champaign; Gerald Murphy, letter to Sara Murphy, Honoria Murphy Donnelly Collection; Lillian Hellman, interview by Honoria Murphy Donnelly, c. 1981, Gerald and Sara Murphy Papers.

Unless otherwise noted, all correspondence between Sara and Gerald Murphy is in the Honoria Murphy Donnelly Collection.

The author wishes to thank art historian Kathryn Greenthal, who researched and wrote the section of the text related to the Murphys' Cambridge years (pp. 27–29).

1 Gerald Murphy, letter to Calvin Tomkins, July 29, 1960. Copies of the correspondence between Tomkins and the Murphys are kept in the Gerald and Sara Murphy Papers, Yale Collection of American Literature, Beinecke Rare Book and Manuscript Library, Yale University, New Haven, CT. Unless otherwise noted, all correspondence between Tomkins and the Murphys is from this source.

2 Quoted in *Those Paris Years: A Conversation Between Archibald MacLeish and Samuel Hazo,* videocassette (University Park: Penn State Audio-Visual Service, 1987).

3 Brendan Gill, "Gerald and Sara Murphy," in *A New York Life: Of Friends and Others* (New York: Poseidon Press, 1990), 320.

4 Ibid., 317.

5 Vaill, *Everybody Was So Young,* 226.

6 Frank Wiborg's diaries are in the Gerald and Sara Murphy Papers, Beinecke Library, Yale.

7 Vaill mentions that Henry Paulinus Wiborg might also have been "one of the pioneer businessmen of Cleveland." Vaill, *Everybody Was So Young,* 7.

8 From Wiborg's diary entry for February 2, 1889: "My impression [is] that my father died Feb. 2, 1866."

9 Clipping in Wiborg's 1882 diary.

10 Sara Murphy, unpublished memoir, quoted in Vaill, *Everybody Was So Young,* 8.

11 "The Charming Daughters of Mr. and Mrs. Frank Wiborg," *Cincinnati Commercial Tribune* [?], October 31, 1897. Another clipping in Wiborg's diary reports on the meeting with Wilhelm II: "Dined with Wilhelm II," Cincinnati *Enquirer,* August 15, 1897.

12 "Tribute of a Famed Artist to Trio of Cincinnati Girls: Charles Dana Gibson Writes to Friend of the Misses Wiborg, Whom He Met in London" (source and date unknown), clipping in Wiborg's 1907 diary. The article announces that Gibson's "tribute stirs not only local, but national, pride in young American womanhood" and notes that the girls "are so carefully chaperoned by their handsome mother."

13 "Shock for Misses Wiborg—Girls in Society Mistaken for Professional Entertainers," *Tribune,* June 30, 1913, clipping in Wiborg's 1913 diary.

14 Clipping in Wiborg's 1911 diary (title, source, and date of article unknown).

15 Inserted in Wiborg's 1912 diary. In the same letter, Adeline writes: "Bob Breeze is terribly about—a nuisance, I'm sick to

death of him and she [Olga] has had two narrow escapes [she was engaged twice]. There's nothing so deadly as boredome [sic] and *stagnation* to make girls or men make mistaken choices."

16 "Nobility Enjoyed 'Vegetable' Ball," Cincinnati *Enquirer*, July 24, [1913], clipping in Wiborg's 1913 diary. The article notes: "Mrs. Frank Wiborg, of New York and Cincinnati, and her three beautiful daughters gave a marvelous 'vegetable' cotillion tonight."

17 Sara writes in her diary on November 7, 1913: "H. and O. bought me an original Bakst . . . enjoyed birthday greatly this time." Sara's diaries are also in the Gerald and Sara Murphy Papers, Beinecke Library, Yale.

 Gerald writes to Sara on June 10 the following year: "Aeons ago I should have told you that in latter June your Bakst picture returns from an extensive American exhibition tour and awaits,—as do we all, your pleasure and return in August."

18 After forty-five years of marriage, Gerald remarked, in a letter to Calvin Tomkins dated July 29, 1960: "Sara is so essentially and naievely [sic] original that to this day I have no idea what she will do, say or propose." Similarly, Richard Wilcox reported that Gerald told him a few days before he died: "After all these years Sara is still a mystery to me." Wilcox, audiotape interview by Linda Patterson Miller, June 8, 1982.

 The Murphys' daughter, Honoria, recalled: "Mother was always very game. She was spunky. She'd go sailing with Ernest [Hemingway] in the worst seas and never [get] seasick. And then, I'll never forget it, in Saranac Lake when my brother was ill she'd go out tobogganing, and she'd go around these curves—whichever was the most dangerous—and I remember, we'd watch her, terrified. She was absolutely fearless." Honoria Murphy Donnelly, audiotape interview by Linda Patterson Miller, fall 1979.

19 Esther Murphy researched and planned (but did not execute) biographies of Madame de Maintenon and Madame Pompadour. Lisa Cohen is writing a biography about Esther Murphy, Madge Garland, and Mercedes de Acosta, to be published by Farrar, Straus and Giroux in 2008.

20 I am grateful to Nighat Saliemi, archivist at the Hotchkiss School, for sending me copies of Gerald Murphy's records.

21 Reverend H. G. Buehler, letter to Alfred E. Stearns, October 17, 1907, Gerald Murphy records, Hotchkiss School archives.

22 On the subject of Gerald's sexuality, Brendan Gill writes: "There is no actual evidence that Gerald was homosexual or had homosexual experiences in his youth, but there *is* evidence that something caused him to take a forbidding view of sex. . . . It may have been his view of sex as somehow men-

acing to him that caused him to substitute for the ordinary rough-and-tumble of life a fabricated elegance of person and conduct." Gill, *A New York Life*, 324. One must add that it is clear, based on correspondence, that Gerald was powerfully attracted to and desirous of Sara, and that their physical relationship up until the time of Patrick's illness was passionate.

23 Gerald Murphy, letter to Archibald MacLeish, January 22, 1931, Archibald MacLeish Papers, Manuscript Division, Library of Congress, Washington, DC. The full letter is reprinted in Miller, *Letters from the Lost Generation*, 53–58.

24 Vaill, *Everybody Was So Young*, 46. A handwritten note, kept in a box of sayings and articles collected by Gerald, reads: "To be extremely well-dressed is, I suppose, a form of disguise and a means of self assurance" (Gerald and Sara Murphy Papers, Beinecke Library, Yale). This may have come from Harold George Nicolson's 1957 play *Journey to Java*, the title of which is written at the top of the paper.

 The author Maeve Brennan, in an undated letter to William Maxwell written toward the end of Gerald's life, comments: "Gerald is dying. His weight has fallen from 165 to 112. . . . he said, 'All my life, wherever we went I used to buy clothes, sandals, hats, jackets, I suppose it is the merchant in me. Now I am shedding my reptilian skin, I am going to be translucent.'" William Maxwell Correspondence, the Rare Book and Manuscript Library, University of Illinois at Urbana-Champaign.

25 Gerald Murphy, letter to Calvin Tomkins, January 9, 1962.

26 Fitzgerald, *Tender Is the Night*, 16.

27 Gerald reports this in a letter to Sara, August 26, 1915.

28 Gerald, letter to Sara, August 4, 1916. He writes: "Sally, my own: I am very sad—and miss you too much for any peace of mind. . . . It crushes me to think that you may even be tempted to believe what you said this morning about 'old hag of a wife'—for I know that it is some cursed thing in me that makes you think it. . . . Too often I have spoken to you of my weakness—if only it took some other form! . . . If I could only be all that I *want* to be to you. What prevents me!? It seems so weak. I feel that sometimes it may be my cross—if there be such things. Nothing else matters to me—it begins to take on the proportions of the main issue. Unless I better it—I had best not lived. Do be honest with me about myself. I have no one but you—and love no one but you—no one."

29 Gerald, letter to Sara, postmarked November 12, 1916.

30 Gerald, letters to Sara, January 7, 1918, and February 2, 1918.

31 Gerald, letter to Sara, June 4, 1919. He adds: "What great, great luck it is. The future is golden, I do feel it."

32 Sara, letter to Gerald, June 2, 1919. Frank Wiborg, Hoytie, and Patrick Murphy were in London together at the time of Baoth's birth.

33 Gerald, letter to Sara, June 1, 1919.

34 According to the report of the School of Landscape Architecture for 1918–19, in June a new course in landscape topography, known as Landscape Architecture 12, was offered by Stephen Francis Hamblin, who also gave his course on trees and shrubs in the first session of the Harvard Summer School.

35 Gerald, letters to Sara, June 3 and June 18, 1919.

36 Vaill, *Everybody Was So Young,* 88.

37 Sara, letter to Gerald, June 25, 1919.

38 In yet an earlier letter, dated June 2, 1919, Sara had described to Gerald how Honoria, missing her father, went looking for him, "pounding to + fro to find you in the bathroom," and how she treated her new brother: "She goes in to see the baby once every 5 or 10 minutes . . . it is so sweet to see her on tiptoe, peering into his crib, calling *Babie* in what I feel sure is meant to be a tender tone,—but what turns out to be a perfect shout."

39 See Gerald Murphy's student folder, UAV 510.283.5, Harvard University Archives, Harvard University Library, Cambridge, MA. Kathryn Greenthal is grateful to Barbara S. Meloni, public services archivist at the Harvard University Archives, Harvard University Library, and to Mary Daniels, special collections librarian at the Frances Loeb Library, Harvard Design School, for their assistance with information about Gerald's years at Harvard.

40 Vaill, *Everybody Was So Young,* 95. See also Melanie L. Simo, *The Coalescing of Different Forces and Ideas: A History of Landscape Architecture at Harvard, 1900–1999* (Cambridge, MA: Harvard University Graduate School of Design, 2000), 9–20.

41 Gerald's transcript is in his student folder in the Harvard University Archives.

42 Gerald and Sara Murphy, audiotape interview by Calvin Tomkins, c. 1960.

43 F. Scott Fitzgerald, "Echoes of the Jazz Age," in *The Crack-Up: F. Scott Fitzgerald,* ed. Edmund Wilson (1945; reprint, New York: New Directions, 1956), 14.

44 For the most comprehensive and original examination of the Murphys as typifying French stereotypes of the new, chic American, see Wanda M. Corn, "An American in Paris," in her *The Great American Thing: Modern Art and National Identity, 1915–1935* (Berkeley: University of California Press, 1999), 90–133.

45 See Frederick Lewis Allen, *Only Yesterday: An Informal History of the Nineteen-Twenties* (New York: Harper Brothers, 1931). I am grateful to Michael Lewis, professor of art at Williams College, for suggesting I consult this book.

46 Archibald MacLeish, quoted in Miller, *Letters from the Lost Generation,* xxxvi.

47 Fitzgerald, *Tender Is the Night,* 18–19.

48 Interview by Tomkins, c. 1960.

49 Quoted in Vaill, *Everybody Was So Young,* 99.

50 Interview by Tomkins, c. 1960. For a comprehensive account of gallery exhibitions in Paris during these years, see Malcolm Gee, *Dealers, Critics and Collectors of Modern Painting: Aspects of the Parisian Art Market between 1910 and 1930* (New York: Garland, 1981).

 Goncharova was in a group show at the Galerie La Boétie in June and July 1921. This was before the Murphys arrived in Paris, but the gallery may still have had some of her work on view. See Drue Alexandra Fergison, "*Les Noces:* A Microhistory of the Paris 1923 Production" (Ph.D. diss., Duke University, 1995), 207. I am grateful to Kathryn Greenthal for calling this thesis to my attention.

 Goncharova's studio was actually at 13, rue Visconti, one street north of the rue Jacob.

51 Boris Kochno, conversation with the author, Paris, February 1982. For an account of his work with Diaghilev and the way sets were painted, see Vladimir Polunin, *The Continental Method of Scene Painting: Seven Years with the Diaghileff Company,* ed. Cyril W. Beaumont (London: C. W. Beaumont, 1927).

52 Interview by Tomkins, c. 1960.

53 Sophie Lévy, director of the Musée d'Art Américain, Giverny, suggested the importance of the Murphys to Man Ray and vice versa in a conversation with the author, April 2005.

54 Many of Fred Murphy's letters survive and are held in the Gerald and Sara Murphy Papers in the Yale Collection of American Literature at the Beinecke Rare Book and Manuscript Library. Unless otherwise noted, all correspondence from Fred Murphy is from this source. His letters show him to have been an extraordinarily appealing and courageous person. With typical self-deprecating wit, he wrote to his mother on January 1, 1924: "As for the Legion of Honor, I thought it fair you should have it. . . . I won it before I was maimed. . . . I must translate the citation and send it to you. . . . From a casual scanning of this paper one could deduce that unless I had been in the Argonne in October 1918, the entire allied armies would have been decimated, Marshall Foch would have closeted himself in the cabinet de toilette and opened a vein in his wrist with his Gillette razor, and that Pershing would now be peddling wiener-schnitzel or sauerkraut in German South Dakota. It seems I won the war single-handed."

55 Orloff helped Gerald stretch canvases and transfer original drawings onto canvas, using the same methods as stage-set painters. In a joint interview by Linda Patterson Miller in September 1994, Honoria Murphy Donnelly and

Fanny Myers Brennan (daughter of Richard and Alice Lee Myers, and Honoria's closest friend) both recalled that no one but Orloff was allowed into Gerald's studio in Antibes.

Philip Clapp, professor emeritus of materials science and engineering at the University of Connecticut, who has been searching for Gerald's lost paintings, has theorized that one reason Gerald may have stopped painting was because he no longer had Orloff to help him. Philip Clapp, letter to the author, September 30, 2003.

56 Gerald Murphy, letter to Douglas MacAgy, undated (written in response to a letter from MacAgy dated May 17, 1962), Douglas MacAgy Papers, Archives of American Art, Smithsonian Institution, Washington, DC. Unless otherwise noted, all correspondence between MacAgy and Gerald Murphy is from this source.

57 Among the items included in Vladimir Orloff's undated inventory list for Villa America (in the Honoria Murphy Donnelly Collection) are copies of *Bulletin de L'Effort Moderne* from the period 1924–26.

58 "Independent and Otherwise in Paris," *Shadowland* 8, no. 4 (June 1923), 45. Gerald's Salon entries are numbered 3439–42 in the exhibition's catalogue, which also states that he was born in Boston and resided at 23, quai des Grands-Augustins in the sixth arrondissement.

59 In an email to the author, June 20, 2006, Richard Kay, aircraft/impact bearing/thin section engineer at Impact Bearings, San Clemente, CA, wrote of the machinery depicted in *Turbines*: "It is all smoke and mirrors. . . . This is not a turbine and it would not function in real life. The bearing is not mounted correctly to work and the long object projecting from the ball bearing's middle is made up. . . . But it sure looks nice."

Gill Detweiler, senior applications engineer at SKF, confirmed Mr. Kay's identification of the ball bearing and wrote of *Turbines* that the arrangement was "no kind of machine. This is just some artistic rendering." Email to the author, June 20, 2006.

Gerald also painted a lost work entitled *Ball Bearing* in 1926.

60 Vaill, *Everybody Was So Young*, 116.

61 For a discussion of this, see Corn, *The Great American Thing*, 118–19.

62 Fred Murphy, letter to Anna Murphy, February 11, 1924.

63 William Rubin, with the collaboration of Carolyn Lancher, *The Paintings of Gerald Murphy* (New York: Museum of Modern Art, 1974), 34.

64 Quotation from interview by Tomkins, c. 1960. I am grateful to Paulette O'Brien for assiduously searching for the lost Murphy paintings in Paris and its environs.

65 "American's Eighteen-Foot Picture Nearly Splits Indepen-

dent Artists," *New York Herald Tribune* (Paris), February 8, 1924, 1–2. See also Vaill, *Everybody Was So Young*, 136.

66 Vaill, *Everybody Was So Young*, 136.

67 Ellen Barry, audiotape interview by Linda Patterson Miller, June 4, 1982. Ellen Barry was married to the playwright Philip Barry, most famous for *The Philadelphia Story*. His play *Hotel Universe* is set in a fictionalized version of Villa America, the Murphys' home in Cap d'Antibes. Like Sara Murphy, Ellen was born to a wealthy, established family, while her husband, like Gerald, came from more modest Irish American beginnings; he also attended Yale. The Barrys were lifelong friends of the Murphys.

68 Corn, *The Great American Thing*, 117.

69 Barry, interview by Miller, June 4, 1982.

70 Honoria Murphy Donnelly with Richard N. Billings, *Sara and Gerald: Villa America and After* (New York: Times Books, 1982), 12. MacLeish's poem appears in *The Collected Poems of Archibald MacLeish* (Boston: Houghton Mifflin, 1962).

71 Myers Family Papers, Beinecke Rare Book and Manuscript Library, Yale University, New Haven, CT.

72 Gerald, letter to Sara, February 10, 1915.

73 Vaill, *Everybody Was So Young*, 115.

74 Gerald Murphy, letter to Calvin Tomkins, undated "postscript" on notepad paper.

75 Fred Murphy, letter to Anna Murphy, February 22/23, 1923. The Bullier had been a working-class dance hall since the mid-nineteenth century.

76 "Un Bal 'transmental' chez Bullier," *Éclair*, February 26, 1926. Clipping in Fonds Bal Bullier, Collections des Arts du Spectacle, Bibliothèque Nationale de France, Paris.

77 "Le Bal des artistes russes," *Comoedia*, February 25, 1923, 2. Clipping in Fonds Bal Bullier, Collections des Arts du Spectacle, Bibliothèque Nationale de France, Paris.

78 According to Drue Fergison ("*Les Noces*," 34), the ball was filmed by Pathé studios, but the footage could not be located in the Pathé archives or in those of the Cinémathè de Paris at Les Halles.

A clipping from an unidentified newspaper entitled "Foire de nuit à Bullier," dated February 18, 1923, in the Collections des Arts du Spectacle, Bibliothèque Nationale de France, Paris, notes: "Enfin, le bal sera filmé." It does not mention Pathé studios.

79 "L'Amérique sera symbolisée par un groupe important de maisons extraordinaires, grate-ciels ornés d'enseignes lumineuses conçues par Murphy." "Foire de nuit à Bullier," *Comoedia*, February 22, 1923, 2 (author's translation).

80 Gerald Murphy's notebook is in the Honoria Murphy Donnelly Collection. It seems that Nijinska was also influenced by the Kamerny Theater. A letter from the composer John

Alden Carpenter to Diaghilev dated September 5, 1924, speaks of Nijinska's idea for the choreography of Carpenter's ballet *Skyscrapers,* which Diaghilev was planning to produce: "When I talked with Mme N in Monte Carlo she had a most interesting idea of a choreography which would suggest the manifold activities of American life going on simultaneously on different levels, high in the air, on the street, and under the ground." (Fonds Kochno, archives of the Bibliothèque de l'Opéra, Paris.) Diaghilev delayed finalizing a contract, and Carpenter finally went elsewhere. The ballet premiered at the Metropolitan Opera in 1926. (It is likely that Carpenter was introduced to Diaghilev by the Murphys, as Rue Carpenter was a close friend of Sara's.)

81 Léopold Survage, another Russian artist working for Diaghilev, writes: "Larionov was working intensely with Gerald Murphy in the summer of 1922." He does not elaborate but is probably referring to the décor for *Mavra,* which premiered on June 3, 1922. Survage, "Larionov, homme actif; Gontcharova, femme douce et discrète," in Tatiana Loguine, ed., *Gontcharova et Larionov: Cinquante ans à Saint Germain-des-Prés* (Paris: Klincksieck, 1971), 134.

82 John Dos Passos, *The Best Times: A Twentieth Century Odyssey* (New York: New American Library, 1966), 148.

83 For accounts of the party, see Tomkins, *Living Well Is the Best Revenge,* 31–33, and Vaill, *Everybody Was So Young,* 118–20. In his interview by Tomkins, c. 1960, Gerald misremembered the date as June 17; a printed invitation to the party sent to Stravinsky, now in the Paul Sacher Stiftung, Basel, gives the date as July 1, 1923. There is also a firsthand account in Survage, "Larionov, homme actif; Gontcharova, femme douce et discrète," 134, 137.

84 This poster has not yet come to light.

85 For more on *Within the Quota,* see Olivia Mattis's "*Les Enfants du Jazz:* The Murphys and Music" and Amanda Vaill's "Concealment of the Realities: Gerald Murphy in the Theater" in the present volume. Also see Corn, *Great American Thing,* 100–103.

86 Fred Murphy wrote to his mother on October 18, 1923: "Gerald is working hard. His name is on all the posters advertising the Swedish Ballet. I think it will be a great success. He's written all the choreography and painted the scenery himself."

For more on Gerald's engagement with Dadaist themes and strategies, see Elizabeth A. Tucker, "*Within the Quota:* Gerald Murphy's Dadaist Vision of America" (master's thesis, University of Wisconsin, 2004). Gail Levin considers this notion in "The Ballets Suédois and American Culture," in Nancy Van Norman Baer, ed., *Paris Modern: The Swedish Ballet, 1920–1925* (San Francisco: Fine Arts Museums of San Francisco, 1995).

87 In the papers at the time were stories with such headlines as "Dancer Renews Heart-Balm Case," referring to Cornelius Vanderbilt Whitney's compensatory $1 million payoff to his jilted showgirl girlfriend Evan Burrows Fontaine. Vaill, *Everybody Was So Young,* 132.

88 Adeline Wiborg was arrested on September 5, 1913, upon her return from abroad on the *Mauritania.* Accused of attempting to avoid customs duty by declaring $4,000 worth of foreign purchases to be worth $440, she was chastised by the judge after pleading guilty and fined $1,750. On October 23, the day of the verdict, Frank Wiborg wrote in his journal: "I am deeply humiliated. . . . Adeline feels it all dreadfully."

89 Millicent Hodson and Kenneth Archer, "Recreating the Quota," *Dance International,* Spring 1998, 21–27. Hodson and Archer believe it is likely that Gerald first introduced Rolf de Maré to black jazz. The impresario later brought many African American performers to Paris, including Josephine Baker.

90 Amanda Vaill writes: "The Millionairess, whom Gerald described as 'a study of American women entering the Ritz' and who is wearing a rope of golf-ball-sized pearls, an ostrich-plumed cape, and a tiara, looks exactly like Hoytie Wiborg." *Everybody Was So Young,* 131.

In a letter to Calvin Tomkins dated January 3, 1962, Gerald writes: "One of the characters was 'the Sweetheart of the World' (Mary Pickford-inspired). Sara had designed her dress. She was a moving mass of roses and rosebuds with a Leghorn hat full of them suspended over her arm." Murphy goes on to say that Cocteau had told them that the rose was the most powerful symbol in the world.

91 See also Robert M. Murdock, "Gerald Murphy, Cole Porter, and the Ballets Suédois Production of *Within the Quota,*" in Baer, *Paris Modern,* 108–17. Other relevant essays in this excellent catalogue include Erik Näslund, "Animating a Vision: Rolf de Maré, Jean Börlin, and the Founding of the Ballets Suédois"; Gail Levin, "The Ballets Suédois and American Culture"; and Judi Freeman, "Fernand Léger and the Ballets Suédois: The Convergence of Avant-Garde Ambitions and Collaborative Ideals."

92 Vaill, *Everybody Was So Young,* 133.

93 Richard Myers, letter to Stephen Vincent and Rosemary Benet, November 7, 1923, Myers Family Papers, Beinecke Library, Yale University.

94 Dos Passos, *The Best Times,* 148.

95 Interview by Tomkins, c. 1960.

96 Fitzgerald, *Tender Is the Night,* 17.

97 Quoted in Vaill, *Everybody Was So Young,* 56.

98 Ellen Barry notes: "Gerald had discovered the French mariner shirt, the blue-and-white-striped cotton shirt, when he had gone to Marseilles one day shopping for things for

the boat. He saw those wonderful cotton shirts that were designed for the French navy. And they were the absolutely perfect garment for the south of France since they're light and still they're cotton, and they're warm enough on the boat; so he brought back dozens of them to Antibes and we all wore them. He gave them as gifts to friends and it was the uniform of the summer of 1923." Barry, interview by Miller, June 4, 1982.

Also see "Classics: The Espadrille," *Esquire,* July 1986, 16: "And in those first few years, when they had the entire Côte d'Azur to themselves, Gerald Murphy came across something else. Espadrilles. Murphy took to wearing espadrilles—those rope-soled sandals with canvas uppers—not so much to create a fashion (which he did) as to adapt to his surroundings. Espadrilles were protective coloration in that maritime setting. Fishermen and sailors made them out of materials they had at hand, sailcloth and a kind of hemp made from esparto grass. Murphy had the good sense to wear espadrilles in combination with the blue-and-white striped French sailor's jersey. The throngs who followed his lead to the Riviera copied his style of dress as well, the Prince of Wales included."

Ralph Lauren and others continue to design resort wear based on Murphy's staples of mariner shirt, linen pants, and espadrilles (see, for example, his summer 2006 collection).

99 Quoted in English translation in Vaill, *Everybody Was So Young,* 124. The original letter, written in French from the Hôtel du Cap d'Antibes and sent to Mme. Picasso at the same address, is in the folder titled "Murphy lettres à Picasso," in the archives of the Musée National Picasso, Paris. Unless otherwise noted, all correspondence between the Picassos and the Murphys is from this source.

100 See Vaill, *Everybody Was So Young,* 124–25.

101 Picasso, it should be noted, had made sketches of the Three Graces in his classicizing style in 1921. The ballet, conceived by Picasso, with music by Erik Satie and choreography by Léonide Massine, was commissioned by the Comte de Beaumont for his Soirées de Paris, a series of ballets produced by Beaumont and held at the Théâtre de la Cigale in Paris. Picasso began work on the ballet in February 1924 and it premiered on June 15 the same year, to general pandemonium.

102 Fitzgerald, *Tender Is the Night,* 6.

103 One exception is the *Woman Looking in a Mirror* of the summer of 1920 in the Picasso estate. See Christian Zervos, *Pablo Picasso,* vol. 4 (Paris: Éditions Cahiers d'Art, 1957), 148.

104 Gerald, letter to Sara, November 29, 1914.

105 Fitzgerald, *Tender Is the Night,* 26. He also describes Nicole watching her children play in the surf "with a lovely peace" (10).

106 Archibald MacLeish, "Sketch for a Portrait of Mme. G___M___," in *The Collected Poems of Archibald MacLeish,* 53. This is not to say that Olga Picasso, who had a young child then, is not also part of Picasso's conception of motherhood during this time.

107 F. Scott Fitzgerald, letter to Sara Murphy, August 15, 1935, Gerald and Sara Murphy Papers, Beinecke Library, Yale.

108 Ernest Hemingway, letter to Sara Murphy, December 27, 1939. On June 13, 1939, he writes: "I could never thank you for how loyal and lovely and also beautiful and attractive and lovely you have been always ever since always." Both letters, Gerald and Sara Murphy Papers, Beinecke Library, Yale.

109 See, for example, William Rubin, *Picasso and Portraiture* (New York: Museum of Modern Art, 1996), 58.

110 Fitzgerald, *Tender Is the Night,* 6.

111 Barry, interview by Miller, June 4, 1982. Harry Crosby, cofounder of the Black Sun Press, wrote after meeting Sara at a nightclub that she was "very sphinx-like but knowing—particularly when she danced." Quoted in Vaill, *Everybody Was So Young,* 137.

112 Honoria Murphy Donnelly, audiotape interview by Richard Billings, 1982, Honoria Murphy Donnelly Collection. See also Miller's interviews of Brennan (September 1994) and Wilcox (June 8, 1982), both of whom mention Gerald's tremendous admiration and respect for Sara.

113 John Richardson, conversation with the author, April 17, 2006. I am grateful to Mr. Richardson for his counsel and his most generous sharing of sources, information, and insights regarding Picasso and Murphy. For the most comprehensive and perceptive understanding of Picasso, see John Richardson, *A Life of Picasso,* 2 vols. (New York: Random House, 1991, 1996).

114 Mr. Richardson has discovered that *The Pipes of Pan* was completed not in the Riviera, but in Paris. See his forthcoming *A Life of Picasso: The Triumphant Years,* vol. 3: *1917–1939* (New York: Alfred A. Knopf, 2007).

115 Corn, *The Great American Thing,* 118. Corn notes: "He [Gerald Murphy] made chic what Léger talked about in his lectures and what the magazine *L'esprit nouveau* promoted in art" (118). See "An American in Paris," Corn's excellent chapter on the Murphys' brand of American modernism in *The Great American Thing.*

116 Robert Benchley Collection, Howard Gotlieb Archival Research Center, Boston University. I am grateful to Kathryn Greenthal for carrying out this research.

117 For descriptions of Villa America, see Donnelly, *Sara and Gerald,* 16–38; Archibald MacLeish, "American Letter to Gerald Murphy," in *New Found Land: Fourteen Poems* (Boston: Houghton Mifflin, 1930); Dos Passos, *The Best*

Times, 149–50; and Donald Ogden Stewart, *By a Stroke of Luck!* 194.

Fitzgerald describes "a little menagerie for pigeons and rabbits" in *Tender Is the Night,* 26. Honoria Murphy Donnelly recalls: "We had our pets to take care of—dogs, rabbits, turtles, pigeons, and guinea pigs." Donnelly, *Sara and Gerald,* 31.

118 See Donnelly, *Sara and Gerald,* 34–37. Honoria Murphy Donnelly tells of her parents waking her and her brothers one morning in 1928 with the news that they had received a letter about a map buried in their garden that would lead them to a buried treasure. They dug and found a rusted box with an old parchment map inside. After a few days' preparation, they sailed to a faraway cove and followed the map's many twists and turns until they found the spot marked "X." With inexpressible excitement, the children dug and found an old chest filled with jewels and coins (all fake). It was years before they learned that the treasure hunt had been staged by Gerald and Sara. See also Vaill, *Everybody Was So Young,* 196–97.

119 Kenneth E. Silver, *Making Paradise: Art, Modernity, and the Myth of the French Riviera* (Cambridge, MA: MIT Press, 2001), 110.

120 Barry, interview by Miller, June 4, 1982.

121 Fitzgerald, *Tender Is the Night,* 27. Fitzgerald also writes: "The enthusiasm, the selflessness behind the whole performance ravished [Rosemary], the technic *[sic]* of moving many varied types, each as immobile, as dependent on supplies of attention as an infantry battalion is dependent on rations, appeared so effortless that he still had pieces of his own most personal self for everyone" (77).

122 Quoted in Donnelly, *Sara and Gerald,* 231.

123 Calvin Tomkins, conversation with the author, May 19, 2004.

124 See Kirk Varnedoe and Adam Gopnik, eds., *Modern Art and Popular Culture: Readings in High and Low* (New York: Museum of Modern Art, 1990), the cover of which features Murphy's painting *Razor.* See also Deborah Menaker Rothschild, *Picasso's* Parade: *From Street to Stage* (London: Philip Wilson, 1991).

125 Hayden Herrera, "Gerald Murphy: An Amurikin in Paris," *Art in America,* September–October 1974, 79.

126 Amanda Vaill was the first to see deeper personal significance in Gerald's paintings (*Everybody Was So Young,* 143 ff.). She writes: "What had begun as an exercise in formalism had become a means to put distance between himself and images that carried a heavy load of personal connotation" (212).

Indeed, artists often include coded self-references in their work. John Richardson describes Picasso's use of alter egos

such as the harlequin as "a form of secret exhibitionism that is self-exposure in the form of allegory." Richardson, "L'Amour Fou," *New York Review of Books,* December 19, 1985, 60.

127 Gerald and Sara Murphy Papers, Beinecke Library, Yale.

128 Douglas MacAgy Papers, Archives of American Art.

129 For a discussion of the formal sophistication of this painting in its use of the logic-disrupting devices of Cubism and Dada, see Herrera, "Gerald Murphy: An Amurikin in Paris," 76.

130 Ibid., 76–77.

131 Christopher Swan, "Danger, Safety and the Hand: Gerald Murphy's *Razor* (1924)" (paper presented at the Frick Symposium on the History of Art, New York, April 14, 2003).

132 Ibid. See also Vaill, *Everybody Was So Young,* 64–65.

133 Jocelyne Rotily, "A Picture of America by Gerald Murphy," in Sophie Lévy, ed., *A Transatlantic Avant-Garde: American Artists in Paris, 1918–1939* (Berkeley: University of California Press, 2003), 62, n. 20. Charles Demuth's *The Figure 5 in Gold* (1929, Metropolitan Museum of Art) naturally springs to mind.

134 In an undated letter to Sara (probably written in 1915), Gerald writes: "Sallymine . . . Your kindness of the watch and cuff-links has made me think: and I am rather over-impressed that you should love me so,—(as surely you must when you do me these great kindnesses.) Why this touch of sadness for me in your kindness?—because the process of convincing myself that I deserve it is trying!"

135 Gerald Murphy, letter to Ernest Hemingway, May 22, 1927, quoted in Miller, *Letters from the Lost Generation,* 27.

136 Gerald Murphy, letter to Archibald MacLeish, January 22, 1931, Archibald MacLeish Papers.

137 Fernand Léger, letter to Simone Herman, quoted in Christian Derouet, ed., *Léger, Lettres à Simone* (Zurich: Skira; Paris: Musée National d'Art Moderne, Centre Georges Pompidou, 1987), 18, and in Vaill, *Everybody Was So Young,* 232.

138 Richard Myers, letter to Alice Lee Myers, February 1933, Myers Family Papers, Yale University.

139 Daniel Nied, email to the author, July 10, 2006. Nied writes further: "The escapement uses a hollow cylinder into and around which the escape wheel teeth must interact. This cylinder is also the arbor for the balance wheel, and it allows the interaction of the two, that causes the balance wheel to go back and forth. In Gerald Murphy's painting these two wheels are too far apart to allow any contact between the cylinder and the escape wheel. The escapement function is to regulate the rate at which the power of the time piece is dispensed, allowing it to keep time."

140 Indeed, it brings to mind Gerald's insistent references to his

"defect." He writes to MacLeish on January 22, 1931: "My terms with life have been simple: I have refused to meet it on the grounds of my own defects, for the reason that I have bitterly resented those defects since I was fifteen years of age" (Archibald MacLeish Papers). On June 26, 1936, he writes to Sara: "My defect though not openly ruinous affects life and people very fundamentally" (quoted in Miller, *Letters from the Lost Generation*, 168).

I am grateful to Theodore A. Stern, MD, chief of the psychiatric consultation service at Massachusetts General Hospital and professor of psychiatry at Harvard Medical School, for first suggesting that *Watch* might be a self-portrait if the watch in the painting was defective.

141 Vaill, *Everybody Was So Young*, 144.

142 Donnelly, *Sara and Gerald*, 30. See also Linda Patterson Miller, "Gerald Murphy in Letters, Literature, and Life," in the present volume.

143 Rotily, "A Picture of America by Gerald Murphy," 62, n. 19.

144 Gerald Murphy, letter to Douglas MacAgy, November 14, 1962. Gerald writes that the psychoanalyst whom he went to for therapy in Basel, Switzerland, in the fall of 1930, saw *Watch* at the Salon des Indépendants in 1925. See also Rotily, "A Picture of America by Gerald Murphy," 62, n. 17.

145 Florent Fels called Murphy "a poet and painter" in "Le Salon des Indépendants," *L'art vivant* 1, no. 6 (March 20, 1925), 27.

146 Folk art was one of Murphy's passions. See Rubin with Lanchner, *The Paintings of Gerald Murphy*, 17.

147 Fitzgerald writes of Nicole Diver in *Tender Is the Night*: "She sat in the car, her lovely face set, controlled, her eyes brave and watchful" (14).

148 Rubin, *The Paintings of Gerald Murphy*, 17.

149 Rubin writes that *Nature morte* (entry #2635) was *Razor* (ibid., 30). Vaill, however, believes that it might have been the lost *Ball Bearings* or another lost work (*Everybody Was So Young*, 173).

150 See Trevor Winkfield's "The Notebook as Sketchbook" in the present volume.

151 Barry, interview by Miller, June 4, 1982.

152 Gerald Murphy, letter to Douglas MacAgy, following a telephone conversation of October 24, 1962.

153 Rubin, *The Paintings of Gerald Murphy*, 38.

154 Vaill, *Everybody Was So Young*, 193.

155 Ibid.

156 Silver, *Making Paradise*, 112.

157 Amanda Vaill suggests another self-referential aspect of the painting, arguing that the five cigars and glasses probably refer to the five members of Gerald's immediate family. Vaill, *Everybody Was So Young*, 193–94.

Furthermore, William Rubin (who credits his colleague Sara Mazo for this insight) identifies the iconography on the painting's cigar box lid as a "private allegory summing up [Murphy's] own interests and endeavors; there is the globe, which appeared in *Library*, the flywheel seen in *Engine Room* and *Watch*, the compass, which alludes to mechanical drawing, the schooner that reflects his love of yachting, and of course, the palette." Rubin, *The Paintings of Gerald Murphy*, 38 and n. 95.

158 In a note to Calvin Tomkins dated May 29, 1964, Gerald writes that Vladimir Orloff "still has my last painting 'Portrait.'" Gerald's memory was often faulty about the dates and sequences of his work. I agree with Rubin and Vaill, who date *Portrait* to 1928 and *Wasp and Pear* to 1929 (see Vaill, *Everybody Was So Young*, 419 n. 211).

159 See Carolyn Lanchner, *Fernand Léger* (New York: Museum of Modern Art, 1998), 24.

160 For more on *Portrait*, see Kenneth E. Silver's "The Murphy Closet and the Murphy Bed" in the present volume.

161 The passenger list for this transatlantic voyage on the *Saturnia* also lists Baroness Hilla von Ehrenwiesen Rebay, the leading force behind the foundation of the Solomon R. Guggenheim Museum and a friend of Léger.

162 See Vaill, *Everybody Was So Young*, 199–206.

163 King Vidor, audiotape interview by Linda Patterson Miller, Beverly Hills, June 29, 1982.

164 I am grateful to Henry Art, Samuel Fessenden Clarke Professor of Biology, and Manuel Morales, assistant professor of biology, both at Williams College, for this information.

165 Quoted in Vaill, *Everybody Was So Young*, 212.

166 The handbook for the Harvard School of Landscape Architecture of 1919 (Harvard University Archives, 27–28) states: "[For those] interested in our native flora as students in botany . . . to those who would know more intimately our ornamental plants, . . . the afternoon will be devoted to a field excursion to illustrate the morning lectures; or, if stormy, to readings in the Special Library of the School of Landscape Architecture, the College Library, or the Boston Public Library, each of which has a very large collection of books on ornamental plants and their uses. These readings will be varied to fit the desires of the student. The Codman Collection of books on Landscape Architecture at the Boston Public Library is the most complete public collection in America. The Special Library of the School of Landscape Architecture contains, besides books on Planting Design and many pictures of plant compositions of particular interest to students in the course, a constantly increasing collection of 'plant portraits.'"

167 William F. Lyon and Gerald S. Wegner, "European Hornet," Ohio State University Extension Fact Sheet/ Entomology, http://ohioline.ag.ohio-state.edu (accessed June 2006).

168 Jones and Son Pest Control, "About Wasps," http://www.trapawasp.co.uk/about_wasps.htm (accessed July 2006).

169 Vaill, *Everybody Was So Young*, 212.

170 For this interpretation, see Vaill, *Everybody Was So Young*, 212; and Herrera, "An Amurikin in Paris," 77.

171 Gerald Murphy, letter to Archibald MacLeish, January 22, 1931, Archibald MacLeish Papers.

172 Nearly everyone who knew Gerald describes him as the most charming of men, but one who was also very moody and could be petulant. Fanny Myers Brennan recalled: "If Gerald was displeased, you knew it. He would draw back and say very very cutting things." Brennan, audiotape interview by Linda Patterson Miller, June 22, 1981.

173 Vaill, *Everybody Was So Young*, 28.

174 Dorothy Parker, letter to Robert Benchley, November 7, 1929, in Miller, *Letters from the Lost Generation*, 46–53.

175 "There is nothing more to add except that I was never happy until I started painting, and I have never been thoroughly so since I was obliged to give it up. I wonder how many aspiring American artists have been claimed by the harmful belief that if a business is your 'inheritance' that it is heresy not to give up all in favor of it?" Gerald Murphy, quoted in Rudi Blesh, *Modern Art USA: Men, Rebellion, Conquest, 1900–1956* (New York: Alfred A. Knopf, 1956), 95.

176 [Benjamin DeMott], "The Art of Poetry, no. 18" (interview with Archibald MacLeish), *Paris Review* 14, no. 58 (1974), http://www.theparisreview.com/media/3944_MACLEISH.pdf.

177 Dorothy Parker, letter to Robert Benchley, November 7, 1929, in Miller, *Letters from the Lost Generation*, 50. Regarding Gerald's resentment of family obligations, see Miller in the present volume.

178 Calvin Tomkins, conversation with the author, May 19, 2004.

179 Wilcox, interview by Miller, June 8, 1982.

180 Vidor, interview by Miller, June 29, 1982.

181 Amanda Vaill suggested the Irish lace connection in a conversation with the author, January 2005.

182 Wilcox, interview by Miller, June 8, 1982. The shutters are now lost.

183 Calvin Tomkins, conversation with the author, May 19, 2004.

184 Ibid.

185 Vaill, *Everybody Was So Young*, 220.

186 Ibid., 229. See also Miller in the present volume.

187 Calvin Tomkins, conversation with the author, May 19, 2004.

188 Jacques Livet, conversation with the author, April 23, 2005. Livet, a photographer, was Orloff's neighbor during the 1950s. They became close friends and Livet served as the executor of Orloff's estate.

189 Jacques Livet, letter to Honoria Murphy Donnelly, July 29, 1981, Gerald and Sara Murphy Papers, Beinecke Library, Yale. Livet relays Orloff's account of the first cruise with Gerald in this letter.

190 Barry, interview by Miller, June 4, 1982. Barry describes the boat: "It was a beautiful two-masted schooner with a boat deck with a deck house, which was an American thing—I don't think any other European yachts had a similar arrangement. Well, you could sit on benches on the side so that you were sitting on deck but in an enclosed area."

191 I am grateful to Kathryn Greenthal, who brought the Cowan papers to my attention: Richard David Cowan Papers, in Stewart Mitchell Papers, Boston Athenaeum. All correspondence between Cowan and the Murphys cited in this essay is from this source.

Stewart Mitchell, director of the Massachusetts Historical Society, was sending Cowan to see the gardens of Europe, recalling the purpose of Gerald's trip abroad in 1921. See Douglas Shand-Tucci, *The Crimson Letter: Harvard, Homosexuality, and the Shaping of American Culture* (New York: St. Martin's Press, 2003), 141–44.

192 The title of this section is taken from a letter Gerald wrote to Calvin Tomkins on July 29, 1960, in which he says of the *New Yorker* profile Tomkins was proposing to write: "You may find it difficult to do a portrait of a truncated life."

193 For more on this period, see Miller, *Letters from the Lost Generation*, which brilliantly traces the network binding these friends together; and Vaill, *Everybody Was So Young*, which transforms exacting scholarly research into literature.

194 Vaill, *Everybody Was So Young*, 263.

195 Patrick's diary is in the Gerald and Sara Murphy Papers, Beinecke Library, Yale.

196 Donnelly, interview by Billings, c. 1981.

197 Philip Barry, letter to Gerald and Sara Murphy, February 1937, Gerald and Sara Murphy Papers, Beinecke Library, Yale.

198 F. Scott Fitzgerald, letter to Sara and Gerald Murphy, January 31, 1937, Honoria Murphy Donnelly Collection.

199 On April 18, 1936, for example, he writes: "I suppose it's downright tragic . . . when one person who *lives by communicated* affection should have chosen a mate who is (damn it) deficient."

200 Honoria Murphy Donnelly said: "Ever since the boys' deaths he worried about her first. And he dedicated his life to seeing that she was always all right. Somehow he felt he had to make up for it in every way—for the loss of those boys." Donnelly, interview by Miller, fall 1979.

201 Miller, *Letters from the Lost Generation*, 211–12.

202 Gerald Murphy, letter to Richard and Alice Lee Myers, March 18, 1944, Myers Family Papers, Yale University.

203 In a conversation with the author, June 9, 2006, the dancer and choreographer Marc Platt stated that Gerald made overtures to him during the planning stage of the ballet *Ghost Town* in 1939. I would like to thank Mr. Platt for his willingness to discuss Gerald Murphy and the collaboration on *Ghost Town* in detail. See Mark Platt with Renée Renouf, "*Ghost Town* Revisited: A Memoir of Producing an American Ballet for the Ballet Russe de Monte Carlo," *Dance Chronicle*, 24, no. 2 (2001), 147–92.

Gerald also seems to have taken more than a platonic interest in the young Alan Jarvis, who went on to become the director of the National Gallery of Canada in Ottawa. See Vaill, *Everybody Was So Young*, 314–15.

204 For one of Gerald's previous letters to Cowan, see Silver, present volume, pp. 116–17.

205 Gerald wrote to Alexander Woollcott later that week: "The boy I intended to ask to help me with the plant material (and whom I planned to telephone as I passed near Boston) was at that moment wrapping himself in a blanket and laying himself down beside the gas stove in the kitchen of a friend's home in Gloucester." Gerald Murphy, letter to Alexander Woollcott, dated "Tuesday 1:30 p.m.," Alexander Woollcott Papers, Houghton Library, Harvard University, Cambridge, MA.

206 Ernest Hemingway, *A Moveable Feast* (New York: Scribner, 1964), 208.

207 Léger, letter to Sara Murphy, October 6, 1940, Gerald and Sara Murphy Papers, Beinecke Library, Yale. The Murphys financed Léger's trips to the United States in fall 1931, September 1935, and November 1940. Léger dedicated his essay "New-York par F. LÉGER," in *Cahiers d'art*, nos. 9–10 (1931): "À Sara Murphy."

Simone Herman, Léger's mistress, accompanied him on the 1935 trip. She wrote to the director of the Centre Georges Pompidou on January 21, 1980: "Je suis contente qu'un certain américain ai songé à écrire un livre sur Sara et Gerald Murphy; ils le méritent—ils furent des mécènes et amis exceptionnels; par le compréhension, leur générosité et leur tait." (I am happy that a certain American has dreamed of writing a book on Sara and Gerald Murphy; they deserve it—they were patrons of the arts and exceptional friends; for their understanding, their generosity, and their taste.)

On March 13, 1980, she wrote to Jardot: "J'ai été très émue par le livre sur Sara et Gerald Murphy que vous avez eu la si grande gentillesse de m'offrir [Tomkins's *Living Well Is the Best Revenge*]. Je n'ai pas connu l'age d'or (1925 . . .) au Cap d'Antibes alors que les Murphys étaient un couple jeune et fascinant. J'ai fait leur connaissance à New York en 1935—Murphy avait offert le voyage de Léger pour lui permettre de séjourner à NY lors de sa premier composition au Musée d'Art Moderne—Surpris, je crois, de le voir arriver avec une jeune femme; mais la sympathie a été immediate et Murphy nous a offert à tous les deux le séjour d'un mois à Chicago, à l'hôtel, pour que Léger soit présent à son exposition à L'art Institut—Cela vous donne une idée de leur générosité." (I was very moved by the book on Sara and Gerald Murphy that you very kindly gave me. I was not familiar with the golden age [1925 . . .] at Cap d'Antibes when the Murphys were a young and fascinating couple. I met them in New York in 1935—Murphy had offered the trip to Léger to allow him to stay in New York for his first composition at the Museum of Modern Art. They were surprised, I believe, to see him arrive with a young woman; but their kindness was immediate, and Murphy offered for both of us to stay in Chicago at a hotel for one month so that Léger could attend his exhibition at the Art Institute [of Chicago]—This gives you an idea of their generosity.) Both letters are in Fonds Jar C1-10662, Bibliothèque Kandinsky, Centre Georges Pompidou, Paris.

208 Fitzgerald, letter to Gerald Murphy, March 11, 1938, in Miller, *Letters from the Lost Generation*, 208. In 1940, after the Murphys wired him funds, he also wrote: "There was many a day when the fact that you and Sara did help me at a desperate moment (and remember it was the first time I'd ever borrowed money in my life except for business borrowings like Scribners) seemed the only pleasant human thing that had happened in a world where I felt prematurely passed by and forgotten." Miller, *Letters from the Lost Generation*, 253.

209 See Angela Bourke, *Maeve Brennan: Homesick at the New Yorker* (New York: Counterpoint, 2004). I am grateful to Dr. Bourke for help and suggestions and also to Maeve Brennan's niece Yvonne Jerrold for her assistance. Holly Golightly, the protagonist of Truman Capote's *Breakfast at Tiffany's*, is reputedly modeled in part on Maeve Brennan.

210 When Tomkins was discussing the possibility of doing a profile on them, Gerald expressed to him, in a letter dated July 29, 1960: "I feel that there is something to be written. I know that you can do it." A year later, on July 23, 1961, Sara wrote: "As we have always told you,—you are one of the really good writers, and will go far—very far."

211 Gerald and Sara Murphy Papers, Beinecke Library, Yale.

212 Francis Myers Brennan, interview by Miller, June 22, 1981. Myers adds, regarding the MacLeish reference, that she "can't be sure about that."

213 Lillian Hellman, audiotape interview by Honoria Murphy Donnelly, New York, c. 1981, Gerald and Sara Murphy Papers, Beinecke Library, Yale.

214 William Maxwell, Introduction, in Maeve Brennan, *The Springs of Affection* (Boston: Houghton Mifflin, 1997), 10.

215 Joseph Beuys: "Life itself might be a work of art.... Art can be the way people live." Rick Lowe: "We can approach our lives as artists.... If you choose to, you can make every action a creative act ... [and] encourage a state of mind, a way of thinking about how to live, which you could call a work of art." Both quoted in Michael Kimmelman, "Art: In Houston, Art Is Where the Home Is," *New York Times,* December 17, 2006. I am grateful to Adam Rothschild for calling this article to my attention.

THREE STARS

SAFETY MATCHES

Gerald Murphy, *Villa America*, 1924–25.
Oil and gold leaf on canvas, 14 ½ × 21 ½ in.
CURTIS GALLERIES, MINNEAPOLIS

Gerald Murphy, *Watch*, 1925. Oil on canvas,
78 $\frac{1}{2}$ × 78 $\frac{7}{8}$ in.

483689

Gerald Murphy, *Doves*, 1925. Oil on canvas,
48 ⅝ × 36 in.
CURTIS GALLERIES, MINNEAPOLIS

Gerald Murphy, *Still Life with Flowers*,
c. 1925–26. Gouache on paper, 11½ × 9 in.
PRIVATE COLLECTION. COURTESY OF GARY
SNYDER FINE ART, NEW YORK.

Gerald Murphy, *Wasp and Pear*, 1929. Oil on canvas, 36 ¾ × 38 ⅝ in.

THE MURPHY CLOSET AND THE MURPHY BED

KENNETH E. SILVER

My terms with life have been simple: I have refused to meet it on the grounds of my own defects, for the reason that I have bitterly resented those defects since I was fifteen years of age. . . . You of course cannot have known that not for one waking hour of my life since I was fifteen have I been entirely free of the feeling of these defects. In the vaults of the Morgan Museum on Madison Avenue I was shown once when I was twenty the manuscript of Samson Agonistes, and while I was listening to a recital of its cost, I read "O, worst imprisonment! To be the dungeon of thyself." I knew what it meant, then. . . . My subsequent life has been a process of concealment of the personal realities,—at which I have been all too adept.

GERALD MURPHY, LETTER TO ARCHIBALD MACLEISH, JANUARY 22, 1931

IN/OUT

If there's an aspect of Gerald Murphy that still needs to be set free—and of which he was, as he himself believed his whole life long, the prisoner—it's his queerness. Citing the generally accepted usage at the turn of the century of the term "defect" or "defect of character," Amanda Vaill believes, and surely she's right, that Gerald was talking about his recognition of his homosexuality when he wrote to Archibald MacLeish of his "defects."[1] He probably expected MacLeish, with whom he'd never done more than allude to his ongoing agony, to know what he meant by "defect," but he still didn't want to have to name it. This was 1931, Gerald was a married man and father, and he was writing to a heterosexual male. But his need to unburden himself, however he could manage it, was especially great at this point. His youngest child, Patrick, had not long before been diagnosed with the tuberculosis that would eventually take his life. Gerald was despondent and had started to avoid some of his closest friends, like MacLeish. This letter was written by way of an apology and as an explanation for his behavior.

Whether Gerald Murphy led an active homosexual sex life or simply fantasized about doing so, we know that his "defect" caused him enormous pain. That it was formative for his life and art seems a not-unreasonable as-

sumption. In what follows, I would like to offer a few thoughts on his rather complicated situation. I should also say, right at the start, that if my discussion of Gerald's sexuality causes discomfort to any of his descendants or his admirers, I am sorry for the indiscretion. I slightly knew his wonderful daughter, Honoria Murphy Donnelly, and her father's sex life was certainly *not* a subject I ever broached with her. But it's a subject, nonetheless, that begs for clarity, and I hope that it is in the spirit of enlightenment that the speculations that follow are received. Although his production was small, Gerald Murphy now looks to many of us like one of the most interesting American artists of the early twentieth century. It seems to me that whatever we can say of value about his life and work is of value to us all. I also believe that Gerald would have wanted someone to speak up for his secret life.

NOW/THEN

I first became aware of Gerald and Sara Murphy in the early 1970s, when my friend Stephen Frankel loaned me a copy of Calvin Tomkins's beautiful little book *Living Well Is the Best Revenge*, an elaboration of the author's profile of the Murphys that appeared in the *New Yorker* in 1962. Like other texts that touch the pulse beat of an era, *Living Well Is the Best Revenge* seemed to reach out in many directions at once. For a period that saw the 1920s as a precedent for its own creative hedonism, the "lifestyle" of the Murphys and their friends, those who

Detail from Gerald Murphy, *Portrait* (see p. 115).

were referred to in the 1960s and 1970s as "the beautiful people," was instructive. As a lesson in nobility, the behavior of Gerald and Sara Murphy, faced with the worst tragedy that can befall parents—the death of their children—was exemplary (an example made all the more powerful by its timely concatenation with the deaths of John F. and Robert F. Kennedy). As a forerunner of Pop art, Gerald Murphy was the perfect ancestor figure. But *Living Well Is the Best Revenge* was something else too. When my friend loaned me the book, he was passing along something that neither of us consciously recognized at the time—the vindication for a certain kind of American male and a queer palimpsest to be decoded. This was the period immediately following the Stonewall riots of 1969, the definitive turning point in what was then called "gay liberation" (a term, for better or worse, that would surely have struck Gerald Murphy—so long his own jailer—with particular force).

Gerald's revealing letter to MacLeish would not be published until 1991, when it was included in *Letters from the Lost Generation,* correspondence compiled by Linda Patterson Miller. But if the book Tomkins wrote twenty years earlier presents us with a married Gerald deeply in love with his wife (which he was) and a father completely devoted to his children (which he was as well), it is also one in which the psychodrama of gender identification, if not sexuality per se—both major themes in Gerald's life—inevitably forced its way into the narrative. By the last years of his life, the period during which Tomkins interviewed the Murphys, Gerald seems to have had a pretty clear idea of how he became who he did. An important precondition for the intensely aestheticized life to come, as Gerald apparently understood it, was his unhappiness at Yale:

I hated New Haven and never felt I got anything of what I wanted out of it. You always felt you were expected to make good in some form of extracurricular activity, and there was such constant pressure on you that you couldn't make a stand—I couldn't, anyway. The athlete was all-important, and the rest of the student body was trained to watch and cheer from the sidelines. There was a general tacit Philistinism. One's studies were seldom discussed. An interest in the arts was suspect. The men in your class with the most interesting minds were submerged and you never got to know them.[2]

On similar themes, Tomkins also quotes liberally from the impassioned letters Gerald wrote to his bride-to-be, Sara Wiborg. Tomkins paraphrases a section of one in which Gerald confesses his scorn for a social system that labels all talk of books, music, or paintings between men as "effeminate," and concludes with Gerald's own words to Sara: "I long for someone with whom, as I walk the links, I can discuss, without conscious effort, and with unembarrassed security the things that do not smack of the pavement."[3] Gerald also admits to being subject to bouts of depression (which he called "the black service").[4]

"By not making a stand," Tomkins concludes, in regard to Gerald's years at Yale, "Murphy was elected to the top fraternity (DKE), was tapped for Skull and Bones, was made manager of the Glee Club and chairman of the dance committee, and was voted best-dressed man in the Class of 1912."[5] What would have constituted "making a stand" then at Yale, such that Gerald felt it was beyond his ability? We can't know, but I think it will become clear that it was something akin to owning up to one's (homo)-sexuality, if only in private. Certainly when Gerald says that an interest in the arts "was suspect," we know he means one thing only—that one was suspected of being queer. We also know that two of Gerald's best friends at Yale were Cole Porter and Monty Woolley, both of whom were famously gay later in life, although Porter, like Gerald, married and married well. The drama of Gerald's life before the more acute drama of the illnesses and deaths of his sons was, already at Yale, twofold: on the one hand, he was repelled by his own (undoubtedly exciting) attraction to men; on the other, he was guilt-ridden about "not making a stand," that is, remaining in the closet and thereby thriving socially.

I no longer remember whether Stephen and I discussed Gerald Murphy's elusive sexuality or his fears about effeminacy. But I recall his defense of Gerald as a *dilettante,* which I found striking, since I'd always assumed (in my middle-class-work-ethic heart) that dilettantism was indefensible. What Stephen meant was that in Gerald he recognized a man who was good in a great many areas that we cared about—art and design, food and fashion—all of which were considered female pastimes and/or prerogatives and therefore frivolous and inappropriate for a man. That Gerald was a serious painter seemed to allow room for whatever *else* he was, however atypical. What's more, Gerald seemed to do it all with great ease, and to always be surrounded by immensely talented companions. Whether or not Gerald painted,

designed, and entertained effortlessly—and we now know that he himself felt he did *not*[6]—his accomplishments in art and style were in addition to fulfilling his masculine responsibilities, as those have been traditionally understood. For in addition to being a devoted husband and father, Gerald took over his late father's ailing company, Mark Cross—America's most prestigious purveyor of luggage, writing accessories, and equestrian goods—and returned it to profitability. If Gerald was a dilettante, surely he was a dilettante to be emulated.

MASCULINE/FEMININE

Allusions to masculinity, "effeminacy," and intimations of homosexuality are by no means absent from Tomkins's account of the Murphys and their circle, but they are minor observations in the ongoing saga of the remarkable couple and their ménage. Sometimes Gerald is only marginally implicated in such questions. One incident recounted by Tomkins involves F. Scott Fitzgerald, whose behavior was, characteristically, outrageous: "The Murphys gave a party at Villa America that could have been, and probably was, the model for the Divers' famous dinner party in *Tender Is the Night*. Fitzgerald again seemed to be under some compulsion to spoil the evening. . . . He started things off inauspiciously by walking up to one of the guests, a young writer, and asking him in a loud, jocular tone whether he was a homosexual. The man quietly said, 'Yes,' and Fitzgerald retreated in temporary embarrassment."[7]

More to the point, Tomkins notes Ernest Hemingway's persistent discomfort with Gerald: "Although Hemingway adored Sara," he writes, "he seems to have had reservations about Gerald. He judged men according to his own rigorous standards of masculinity . . . and Gerald, in spite of his performance on skis and in the bull ring, was perhaps not tough enough to suit him."[8] By his own admission, Gerald found himself, and undoubtedly he was not alone in this, repeatedly trying to prove his manliness to Hemingway. Describing a ski trip to Schruns, Austria, with Hemingway and John Dos Passos, Gerald told Tomkins: "I struggled along, trying to keep up with them, and felt terribly ashamed that I was holding them up. . . . Ernest would stop every twenty yards or so to make sure we were all right, and when we got to the bottom, about half an hour later, he asked me if I had been scared. I said, yes, I guess I had. He said then he knew what courage was, it was grace under pressure. It was childish of me,

but I felt absolutely elated."[9] Sometimes Hemingway *provoked* Gerald into proving himself, as he did in Pamplona in 1926, when, against Gerald's better judgment, with Ernest, Hadley Hemingway, Pauline Pfeiffer, and Sara watching, he went into the bull ring, from which he fortunately emerged unscathed.[10] But such demonstrations notwithstanding, Gerald was consistently subject to ridicule from the straight men in his circle, and sometimes behind his back, as when his good friend MacLeish, the next year—also obviously out to prove *his* masculinity—wrote to Hemingway of "those damn schoolgirl quarrels of Gerald's."[11]

Still, being thought not sufficiently masculine, or overly feminine, was one thing; but being thought queer was something else again. Fitzgerald's attempt—misguided but undoubtedly well-meaning, as Vaill astutely concludes—to hook Gerald up with Edouardo Velasquez, a young South American who was "undergoing psychoanalysis to 'cure' his homosexuality,"[12] was deeply disturbing to Gerald. This was the period when Patrick was first stricken with tuberculosis, and Velasquez, apparently by way of offering comfort, had insisted on giving Gerald a cross that had belonged to his mother. Several years later, after Patrick's death, Gerald sent the cross to Fitzgerald, asking him to please return it to Velasquez, with whom he wanted no contact whatsoever, a point he insisted upon (while also insisting to Fitzgerald that he had never seen Velasquez in the intervening period).[13]

If Fitzgerald was a confused matchmaker of sorts, Hemingway was downright subversive regarding Gerald's sexuality. Gerald told Tomkins that the novelist was "extremely sensitive" to the question of who was and who was not homosexual, and, he believed, tried to make Gerald give himself away:

[Hemingway] said, casually, "I don't mind a fairy like X—, do you?"—and for some reason I said "No," although I had never met the man. I have no idea why I said it, except that Ernest had the quality of making it easier to agree with him than not; he was such an enveloping personality, so physically huge and forceful, and he overstated everything and talked so rapidly and so graphically and so well that you just found yourself agreeing with him. Anyway, instead of saying I had never met the man I agreed with him, and he gave me a funny look. Afterward I almost wondered whether it had been a trap laid for me. In any case, after that I always felt he had a reservation about me, and I was never nearly so close to him as Sara.[14]

DRESSED/UNDRESSED

"Are you what they call a fop?" Fitzgerald inquired of Gerald Murphy, with what seems to have been his usual mixture of disingenuousness and provocation. Gerald, as he later recounted to Tomkins, replied that he was, rather, a dandy, "which is something entirely different. . . . I liked clothes that were smart, without having any interest in fashion or styles, and I dressed just the way I wanted to, always."[15] Indeed he did, and whether one finds Gerald's sartorial splendor impressive or excessive, it was a major aspect of his personality. How Gerald dressed, and the styles he set, is no small part of the Gerald Murphy myth. *Living Well Is the Best Revenge* includes a number of striking photographs that demonstrate his immensely refined taste (he was, after all, the Mark Cross heir). We see Sara and Gerald in 1926 at La Garoupe beach in Cap d'An-

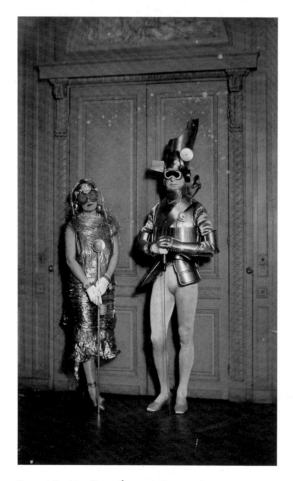

Sara and Gerald at Comte Étienne de Beaumont's Automotive Ball, photographed by Man Ray, 1924.

tibes (see p. 3), looking especially splendid: she's wrapped in what appears to be a striped robe with a striped belt cinching her waist and carries a sun umbrella over one shoulder, its tassel dangling from its handle; arm in arm with his wife, Gerald wears the male beach attire he helped popularize on the Côte d'Azur—a striped *chemise de marin,* long light-colored shorts, and espadrilles with laces tied at the ankles (all adaptations of local working-men's attire). He also wears a scarf on his head to protect him from the sun and leans against a walking stick, the thumb of his other hand stuck into what appears to be an army-issue webbed belt. There's also a photograph of Gerald, "who hated to carry anything in the pockets of his clothes,"[16] holding a small square of striped fabric in which are wrapped personal items—*à la japonais,* or as a kind of "hobo chic" (see p. 39). Then there is a photo of Sara and Gerald in costume for Comte Étienne de Beaumont's "automobile ball." Both wear goggles; Sara is dressed in what looks like celluloid, and Gerald appears to wear the armor of a modern knight (the *automobiliste* is presumably an updated *chevalier*): "tights, and a metallic tunic that he had to be welded into,"[17] along with what appears to be a side-view mirror mounted near his shoulder.

In addition to the pictures in *Living Well Is the Best Revenge,* we now have, in various archives, many more pictures of Gerald's wardrobe, a number of which were reproduced by Vaill in her 1998 book *Everybody Was So Young.* Among the items on display in these photographs are a French apache outfit,[18] a safari getup, Venetian gondoliers' garb, a Chinese robe and hat (a gift from MacLeish), and numerous pieces of Tyrolean *tracht—*lederhosen, vests, shorts with suspenders, and so on—which date from when the Murphys went to Switzerland to treat Patrick's tuberculosis. There are also several photographs of Gerald in a cowboy hat and chaps, taken out west when he was there with Hemingway—this a half-century before Robert Mapplethorpe's photographs of the gay leather scene. In fact, Fitzgerald once responded to Gerald as if his wardrobe implied kinky sex: Gerald told Tomkins that Fitzgerald saw him, one day in Paris, carrying a kind of purse or soft briefcase he'd had a Parisian saddler make up for him, based on the bags used by messengers at the Bourse—black pigskin with buckled compartments. "I've been watching you," Fitzgerald reportedly said, "and I've decided you're a masochist—you go to all that trouble with buckles and straps and little bags because you're a masochist.'"[19]

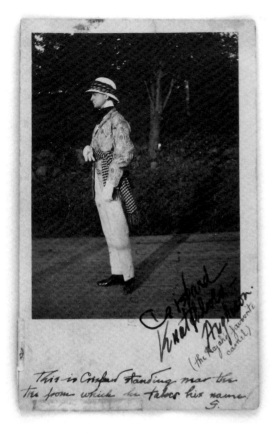

This is Crawford standing near the tree from which he takes his name. G.

LEFT Gerald wearing a safari outfit (from a postcard to Hoytie Wiborg), 1913.

BELOW Gerald wearing a French apache outfit, c. 1923.

LEFT BELOW Gerald in Chinese robe and hat given to him by Archibald MacLeish.

BELOW BOTTOM Gerald in lederhosen, c. 1929–30.

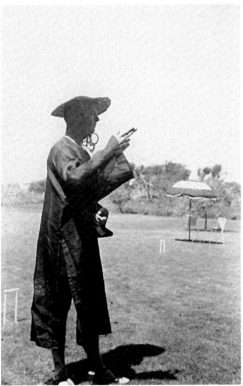

If Gerald liked dressing up, he seemed to like taking off his clothes just as much. The photographic record that has come to light since *Living Well Is the Best Revenge* is fairly unequivocal on this score. We already knew from Tomkins's book, of course, how Gerald looked in swim trunks at La Garoupe. Whether cavorting with friends or exercising with the children, he was often, appropriately, in the new, less-covered-up styles of the early 1920s. Vaill then showed us an image we hadn't seen before: Gerald on the terrace of Villa America, a giant bouquet held up across his midsection, implying, as if he were a showgirl at the Folies Bergères, that flowers alone assured his statuesque modesty. Does this mean that Gerald was a little campy? Undoubtedly, but he was also something else: an exhibitionist. As the 1920s progressed, we see Gerald wearing less and less, the situation permitting. We see him in a very skimpy bathing suit at Villa America, and on two of his sailboats—the schooners *Honoria* and *Weatherbird*—either in a thong (rendering him, with the exception of his genitals, all but naked) or completely nude. We also see him nude in a series of photographs taken on the first of his boats, *Picaflor,* the racing sloop he owned between 1924 and 1927.

Of course, if this were St. Tropez nowadays, there would be nothing surprising—we would expect to find many, if not most, bathers in one or another state of nudity. But we never see Gerald Murphy among a crowd of similarly disrobed sun worshippers. No one in any of the photographs, and there are many, is nearly as uncovered as Gerald. He creates a disturbance in the visual field. In fact, by playing with social expectations in this way he was walking a narrow line, and he must have known it, because, as all the men and even the women in Gerald's world would have known, there was an altogether acceptable homosocial form of nudism—that of the prep school and the athletic club (or, in my own experiences in the 1950s, the all-boys summer camp), where men being naked together was not only acceptable, but the very *sign* of heterosexuality. To be unembarrassed, unguarded, and unexcited in the presence of other naked males—so went the logic of all-male nudism—was the most "natural" thing in the world; to be anything *other* than disinterested would have been the marker of one's *un*-naturalness. From the perspective of a closeted gay man, or a closeted bisexual, this kind of public self-exposure is at once a provocation and a challenge—and rhetorically foolproof. One may blatantly expose

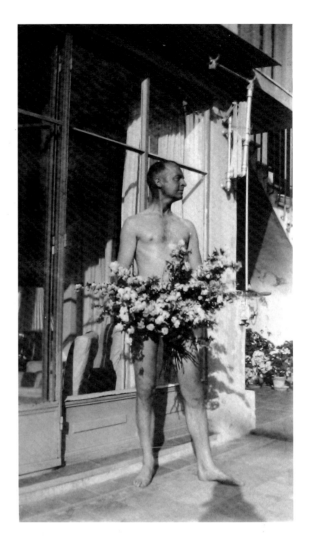

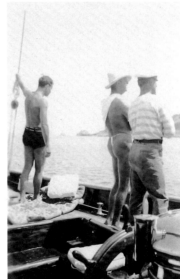

Gerald with bouquet, Villa America, Antibes, spring 1932.

Gerald standing next to Vladimir Orloff, with Richard Cowan to the left, on the *Weatherbird*, 1934.

BOTH PHOTOS GERALD AND SARA MURPHY PAPERS, BEINECKE LIBRARY, YALE

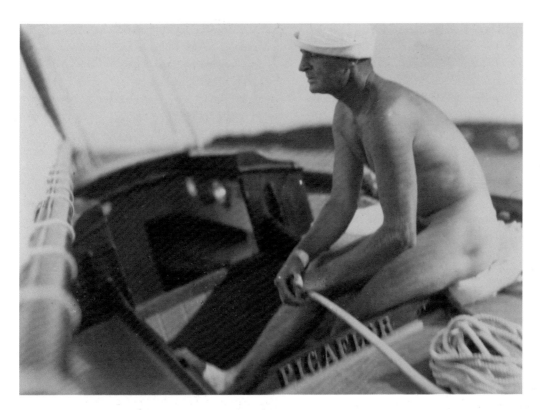

Gerald nude sitting on
the *Picaflor*, photographed
by Man Ray, 1925.

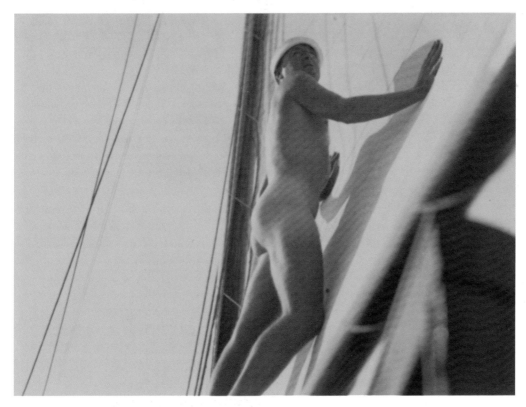

Gerald nude standing
against the sail of the
Picaflor, photographed
by Man Ray, 1925.

oneself without fear of recrimination, since any male who would call attention to one's excessive nudity would risk becoming—automatically, structurally—the beholder of an *interested* gaze.

That is to say, Gerald Murphy's peculiar and highly charged exhibitionism—displaying himself *au naturel*—allowed him, ironically, to feel normal. This must have been no small thing for someone who since puberty had believed himself to be defective. For the man of his era who was forced to hide the nature of his sexual orientation(s), and who thus felt so often at a distance from his own body and its satisfactions, the chance to be naked in public was an opportunity to feel unalienated, and thus powerful. Living in one's body, being constantly aware of it, and noticing others were aware of it, meant that one in fact *had* a body, despite all the psychic energy that had been expended in denying that very body by which one might be betrayed. That this might make others, especially other men—straight *or* gay—feel uncomfortable would only have had the effect of making Gerald feel *more* comfortable and in control, since the entire question of the male body and its desires had thus been successfully transferred from his psychic shoulders to those of "the other." Becoming the object of the gaze, Gerald divested himself of the burden of *possessing* the desiring gaze, with the added benefit that if, per chance, his nudity were alluring enough to another man, something might come of it. Surely this aspect of self-exposure can never be entirely discounted. Just because one is a tease does not necessarily mean that one does *not* mean business.

SELF/OTHER

I realize that I have stepped into psychoanalytic territory, an area in which, as an art historian, I have no special expertise. But my "clinical" experience as a gay man—for whom "gay liberation" arrived within months of my twentieth birthday—provides, I hope, what other kinds of training have not. What might look opaque or merely frivolous to most people does not necessarily look that way to one of Gerald's secret-sharers, especially not to one who himself lived in the closet until he was a grown man. Which brings me to more usual terrain—to Gerald Murphy's art, in particular to the lost painting *Portrait*, of 1928, which we know from a black-and-white reproduction. It's Gerald's only oil portrait, most of his other work being one form or another of still life (although Gerald's subject matter and the scale of his work often defy easy categorization). William Rubin referred to *Portrait* as "one of the most detached and impersonal images an artist has ever made of himself."[20]

Portrait is, in fact, a self-portrait, dominated by an overscaled rendering of one of Gerald's eyes, which stares straight out, or straight *back*, at the viewer (there is always this difficulty in speaking of artists' pictures of themselves, since we are, in effect, looking at them looking at themselves). By means of a Cubist-derived, collagelike play of disjunction and juxtaposition, it is possible at once to sense the man who is its maker and not really see him. In fact, we might say that in *Portrait* Gerald is hiding in plain sight: the lips are based on his own, the footprint and its contour were both made from his own body, and the three thumbprints are meticulously reproduced versions of Gerald's own as well. (Two entries in Gerald's notebook apply directly to this painting: "Picture: an eye,—lashes, brow, lids, etc., big scale,—even pores, hairs" and "Use tracing of a foot in a picture."[21]) To these parts of himself, he has added three fragments of rulers (one with the number 5 clearly indicated—symbolic perhaps, as Vaill has suggested, of the five members of the Murphy family) and a schematic profile of a man at the lower left, a "conglomerate standard facial profile of a Caucasian Man from the archives of the Bibliothèque Nationale."[22]

Portrait appears to play a cat-and-mouse game with the spectator, at least *en grisaille*, the only way we can ever know the work, short of its rediscovery. Here is Gerald's physical substance within a highly abstracted field, offering both access to his person and entry into a convoluted, highly ordered, but ultimately mysterious mental landscape. He himself described his paintings as "intimate but not personal,"[23] which, I suspect, was a way of throwing off track a too-curious interrogation of his themes. Because, to the contrary, almost all Gerald Murphy's paintings are extremely personal, even when they are composed of industrially produced objects, so many of which relate quite directly to either his father's business—as in *Razor* (1924) and *Watch* (1925)—or his father's life—as in *Bibliothèque* (1926–27) and *Cocktail* (1927). So not surprisingly, *Portrait* is both intimate and personal, the self-portrait of a man who has spent his life both looking carefully and being extremely conscious, as we know, of being looked at.

In fact, I think that *Portrait* is a portrait of the artist as

Gerald Murphy, *Portrait*, 1928 (lost).
Oil on canvas, 32 × 32 in.

a gay man looking out from the closet. The giant eye, of course, sets the theme: this does not seem to be the loving gaze of a benevolent, all-forgiving observer, but the focused stare of he who watches—it is the look of surveillance. Let's remember that Gerald told MacLeish several years after he made this painting that the line from John Milton's *Samson Agonistes* that reads "O, worst imprisonment! To be the dungeon of thyself"—had hit him like a shot. That his own body is indexically present in *Portrait*—the body that Gerald insisted on exhibiting as the only way to be certain of being in complete self-possession—is almost an act of self-love, a kind of caress of the man for himself. But, of course, this homosexual self-regard is also the desiring look at the other, the first step toward knowing other men in an intimate, physical way. The "conglomerate" standard man at the lower left represents both the men who are forever on Gerald's mind and his wish to be free of his "defect," his desire to be normal, to be no more than a statistic of ordinariness. The rulers that so mercilessly measure both Gerald and

all men are not merely the usual form of self-evaluation—the kind of agony of self-doubt and desire for self-improvement that all men and women, straight and gay, know so well—but are also, as he must have realized, an occupational hazard of homosexuality: when the object of desire bears such a striking resemblance to oneself, both oneself *and* the other are constantly being evaluated, and the possibility of finding one or the other wanting—what we usually call competitiveness—is enormous. This does not, fortunately, vitiate the possibilities for love, but it does perpetuate a kind of endlessly reinforcing process of measurement, which must be recognized and kept in check. Is it only an accident that Gerald Murphy's *Portrait* shares striking characteristics with works by Jasper Johns? I have argued elsewhere that Johns's combination of body parts and abstraction, as in *Target with Plaster Casts* (1955), and bodily imprints and rulers, as in *Pinion* (1966), are also "queer" portraits of the closeted experience.[24] Haven't Gerald and Johns both found their way to a profound and appropriate lan-

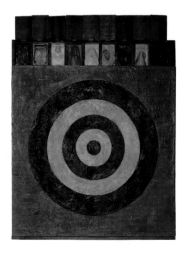

TOP Jasper Johns, *Target with Plaster Casts*, 1955. Encaustic on canvas with plaster casts, 51 × 44 × 3 ½ in.

COURTESY OF CASTELLI GALLERY, NEW YORK

BOTTOM Jasper Johns, *Pinion*, 1966. Lithograph on paper.

COURTESY UNIVERSAL LIMITED ART EDITIONS, INC., BAY SHORE, NY

guage for describing desire under duress, for talking about that which, at least before the 1970s, was taboo?

Yet, having finally made a work of art that more or less directly addresses his most private hell, Gerald must have felt a certain relief. Is that why he told Dos Passos, at just the moment he was working on *Portrait*, "My latest things are a moving mass of looseness and liberation"[25]—

because this picture (which looks neither loose nor liberated by any normal reckoning) may have been for him an extraordinary act of self-disclosure? As I said at the beginning of this essay, I do not know whether Gerald Murphy acted on his homosexuality. In a postscript to his 1931 letter to MacLeish, Gerald wrote: "My human relationships have been affected always by the existence of a fact,—a defect, over which I have had only enough control to scotch it from time to time. It has not been always bearable."[26] Does this mean that he was only occasionally able to control his feelings, or only sometimes able to control *acting* on his feelings? I don't know the answer, but we can now say with certainty, owing to documents that have recently come to light, that, at least until the late 1930s, Gerald's intense romantic feelings for men were undiminished, and that he still longed, as he had written to Sara during the period of their courtship, "for someone with whom, as I walk the links, I can discuss, without conscious effort—and with unembarrassed security—the things that do not smack of the pavement." I'd like to conclude, then, with Gerald Murphy giving expression to some of those feelings that he usually worked so hard to rein in. There is a paragraph in his letter of April 19, 1939, to Richard Cowan—a gay man who killed himself later in the year—that, in its intensity of description and its elliptical quality, is reminiscent of *Portrait*. "Strange Boy, but not unfriendly, I feel (somehow)," is how Gerald hesitantly addresses Cowan, before he warms up to his subject:

Last night I had with me that splendid h[a]ndk[er]ch[ief]. with the lacy filigree monogram. You had it made (I wonder where its workers are now?). It started a train of thought (rare thing that passes too occasionally through this giant structure, the Murphy brain) and I got to remembering things: your lingering over the bedded flowers in the Spanish Paseo, the things you laughed at, the way the hair grows on your neck, the loose Greek mould of your body, your staring at the passing foam on water, what brown looks like near you, the skin on your hands, your silences, your sudden height when you stand up.... Should one remember these and the thousand more secret things. Is it idle? Has it more meaning if the rememberer as time advances sees, knows and likes fewer, fewer people ("...the sense of loneliness in the crowded desert...") Was it all lost? Will one ever *enjoy* it? Did it happen? Was it a handkerchief I had with me alone at the theatre? [27]

Whether in the months before his suicide Cowan answered any of these questions is unknown, but *we* at least

can reply, Yes, Gerald: it *did* happen, it's *not* lost—your gorgeous, agonized, brilliant, sad, and triumphant life happened, and we have the letters, and the memoirs, and the photographs, and—best of all—the paintings to prove it.

NOTES

This essay would have been impossible without the pioneering work of Linda Patterson Miller, Calvin Tomkins, Amanda Vaill, William Rubin, and Wanda Corn. I am grateful, as well, to the Murphy descendants for allowing me to reproduce photographs from the family archive and to the Boston Athenaeum for allowing me to quote from Murphy's letter to Richard Cowan. I cherish the memory of a few lovely afternoons in East Hampton with Honoria Murphy Donnelly, who shared her reminiscences of her family with me, and who demonstrated by her great good cheer and utter decency why we are all still so captivated by the Murphys. I am especially indebted to Deborah Rothschild for inviting me to formulate my thoughts on Gerald Murphy for this project and for her research, advice, and discussion, without which I would not have known where to begin.

The epigraph is from a letter in the Archibald MacLeish Papers at the Library of Congress, Washington, DC, reprinted in full in Linda Patterson Miller, ed., *Letters from the Lost Generation: Gerald and Sara Murphy and Friends,* expanded edition (Gainesville: University Press of Florida, 2002), 53–58.

1 Amanda Vaill, *Everybody Was So Young: Sara and Gerald Murphy, A Lost Generation Love Story* (Boston: Houghton Mifflin, 1998), 24.

2 Gerald Murphy, quoted in Calvin Tomkins, *Living Well Is the Best Revenge* (New York: Viking, 1971), 14.

3 Quoted in ibid., 18.

4 Ibid., 17.

5 Ibid., 14.

6 "It would seem that all my time has been spent in bargaining with life or attempting to buy it off." Gerald Murphy to Archibald MacLeish, January 22, 1931, in Miller, *Letters from the Lost Generation,* 54.

7 Tomkins, *Living Well Is the Best Revenge,* 108.

8 Ibid., 100.

9 Quoted in Vaill, *Everybody Was So Young,* 172.

10 Ibid., 179.

11 Quoted in ibid., 189.

12 Ibid., 226.

13 Ibid., 281.

14 Miller, *Letters from the Lost Generation,* 6.

15 Quoted in Vaill, *Everybody Was So Young,* 155.

16 Tomkins, *Living Well Is the Best Revenge,* 55.

17 Vaill, *Everybody Was So Young,* 137.

18 Gerald appears to have been a serious collector of the apache "thug" style (see p. 111). Gerald wrote to Calvin Tomkins in July 1960: "When we lived at l'Hotel des Reservoirs Cocteau sent [Raymond] Radiguet to see me and question me regarding a collection of apache type clothing I'd been buying around Paris. They were both very envious of it. Grey corduroy bell bottom trousers with waistcoat up to the ribs all in one, little black jacket with fitted waist, turned-up collar and perked [?] out in back, black neck scarf, ruffled front, black and white shadow checked beret-casquette, etc. I gave him the addresses, but he said he wouldn't go as strangers often got knifed there." Gerald and Sara Murphy Papers, Yale Collection of American Literature, Beinecke Rare Book and Manuscript Library, Yale University, New Haven, CT.

19 Vaill, *Everybody Was So Young,* 156.

20 William Rubin with the collaboration of Carolyn Lanchner, *The Paintings of Gerald Murphy* (New York: Museum of Modern Art, 1974), 42.

21 Quoted in ibid.

22 Ibid. Rubin says: "The account of the components of *Portrait* is Murphy's own, and is to be found in [Douglas] MacAgy's papers." See also Vaill, *Everybody Was So Young,* 193–94.

23 Quoted in Rubin, *The Paintings of Gerald Murphy,* 10.

24 See my "Modes of Disclosure: The Construction of Gay Identity and the Rise of Pop Art," in Russell Ferguson, ed., *Hand-Painted Pop: American Art in Transition, 1955–62* (Los Angeles: Museum of Contemporary Art; New York: Rizzoli, 1992). It is interesting to note that although we have no record of any interest on Gerald's part in the art of Jasper Johns, he did express interest in the art of Johns's longtime romantic partner, Robert Rauschenberg: "p.s. I was so struck by Rauschenberg's 'Portrait' of himself at the head of your article on him. Do you recall by chance, that in my 'Portrait, 1930' [*sic*] there was an enlarged eye (center), the print and tracing of my foot, an (idealized) mouth, and three replicas in a row of my thumb-print, which latter I had done with a brush with a single camel's hair? Don't tell R. as, according to his dictum, he might destroy *his* 'Portrait,'—and *mine* must go first." Gerald Murphy, letter to Calvin Tomkins, April 12, 1964, Gerald and Sara Murphy Papers, Beinecke Library, Yale. I am grateful to Deborah Rothschild for bringing this letter to my attention.

25 Gerald Murphy, letter to John Dos Passos, August 5, 1928, quoted in Vaill, *Everybody Was So Young,* 199.

26 Miller, *Letters from the Lost Generation,* 58.

27 Gerald Murphy, letter to Richard David Cowan, April 19, 1939, Richard David Cowan Papers, in Stewart Mitchell Papers, Boston Athenaeum. I am grateful to Kathryn Greenthal for having brought this letter to Deborah Rothschild's and my attention.

CONCEALMENT OF THE REALITIES

Gerald Murphy in the Theater

AMANDA VAILL

In November 1909, when Gerald Murphy was a sopho-more at Yale University, his father, Patrick, sent him a min-atory paternal note. Never a good student, Gerald was seemingly close to failing three of the five courses he was taking, and barely passing the other two; the dean of stu-dents had written the elder Murphy to express his con-cern, and Patrick was lowering the boom on his son. "Come, brace up," he wrote him. "You can't afford to let this thing go *now*. It means *failure*."[1] Although Gerald paid his father sufficient heed that he pulled his marks up to passing that year—and never received another pro-bation notice while at Yale—the fate of Patrick's letter gives a clue to where the young man's real interests and attention lay, for apparently he left the envelope con-taining it lying about on his desk, where a friend used it for a message pad. "Dear Gerald," ran the penciled note. "I very much want to see 'Herod.' Will you leave a ticket for a seat at the office for me?"

The play his friend wanted to see—and for which Gerald apparently had access to tickets—was Stephen Phillips's 1900 *Herod and Mariamne*, generally called sim-ply *Herod*, a poetic tragedy about the paranoid Judean king that had just opened in a sumptuous production at New York's Lyric Theatre. With a cast of more than two hundred and scenery "of the most lavish splendor," it

was—said the *New York Times*—"a work of such great beauty, with such depths of passion, such tender imagery, and such a noble sweep of intensely cumulating tragedy, that it seemed . . . the actors . . . could only step in to mar what the poet has accomplished."[2] In other words, *Herod* bore the same relationship to turn-of-the-century Broad-way's usual fare—melodramas like *The Count of Monte Cristo* with James O'Neill (father of Eugene) or farces like Somerset Maugham's *Jack Straw*, starring John Drew—as the lush, exotic watercolors of the Russian graphic artist Léon Bakst, for which Gerald had developed a taste,[3] did to academic paintings like Emanuel Leutze's *Washington Crossing the Delaware* (1851), a particular fa-vorite of Gerald's parents, who used to drag him on pil-grimages to the Metropolitan Museum of Art to gaze at it.[4] *Herod* stood for a stylized version of reality in which the sorts of things that were never discussed in the Mur-phys' drawing room—incest, murder, madness, sexual inversion—could be not only mentioned but celebrated, because everybody knew that the action onstage wasn't *real*, or even a representation of the real: it was theater.

Gerald Clery Murphy was one of three children—two sons and a daughter—of Patrick Francis Murphy, a first-generation Irish American from Boston. A self-made merchant prince, the elder Murphy was the owner of the Mark Cross company, a luxury retailer where America's often *arriviste* upper classes could purchase the trappings of the high life enjoyed by aristocratic Europeans and

Detail from a photograph of Gerald Murphy taken with a hinged mirror, 1930 (see p. 160).

thereby gain an additional measure of respectability. The Murphys themselves had acquired the patina of haute bourgeoisie Mark Cross sought to confer: they had a New York brownstone and a summer house in South-ampton, the swells' watering place on Long Island's South Shore, where Patrick—a much sought-after after-dinner speaker at civic and business banquets—might unwind over a game of golf and a cocktail or two. He was a frosty paternal figure: in Gerald's recollection, he avoided all "close relationships, even family ones. He was solitary and managed, though he had a wife and children, to lead a detached life."[5] Both Patrick and his wife, Anna, a dour, strong-willed, and devoutly Catholic woman, were people of rigidly conventional if upscale taste and little or no emotional intelligence; from an early age Gerald felt both lonely and alienated in the bosom of his family.

This alienation, coupled with his awareness of what he later called "a defect over which I have only had enough control to scotch it from time to time," made his "subse-quent life . . . a process of concealment of the personal realities."[6] It seems obvious now that this "defect"—and its manifestation, which so clearly impressed itself on Gerald that he dated his "subsequent life" from his six-teenth year—must have been an awareness of his homo-sexuality; for in the first three-quarters of the twentieth century, the term "defect" (or "defect of character") was frequently applied to an attraction for the same sex. But such an awareness would have horrified the senior Mur-phys if they had known of it and must have caused the adolescent Gerald agonies of anxiety; it can be no acci-dent that his interest in theater of all kinds dates from this period, for in the theater concealment is normative and unconventional behavior is unexceptional.

The only theatrical activity available to Gerald at this point in his life, however, was a 1906 amateur production put on at Southampton's Maidstone Club: a burlesque with libretto by "Banyard Pshaw" and music by "Victor Sherbert," entitled *Mrs. Clymer's Regrets: The Twice Sup-pressed but Ever Popular Production,* that was in fact the work of his elder brother, Fred, then about to start his senior year at Yale. A glance at the dramatis personae—Mrs. Clymer and her daughter; Lord Help-Us (played by Fred); the Earl of Finanhaddie; and assorted "Maidens and Rakes"—gives an idea of the plot: a "Lady with Money" (as she describes herself in one of the songs) tries to get her daughter married off to an English no-bleman of straitened means who is visiting East Hamp-

Program cover for *Mrs. Clymer's Regrets,* Maidstone Club, Southampton, NY, August 24, 1906.

ton in the company of his complaisant father, the Earl. There are inevitable complications, but all comes right in time for the finale—which included "Imitations of Miss Ethel Barrymore" by Miss Helen Hotchkiss and some-thing described as a "Donkey Ballet," which possibly had to be seen to be believed.[7] Fanciful as this send-up seems, it wasn't far from a representation of the truth, at least for the members of its audience: most of them were denizens of the society pages for whom transatlantic marriages—often of convenience—were not only famil-iar but desirable, and whose spacious houses might eas-ily have the sort of "Grecian Garden" Mrs. Clymer's did.

Despite his nascent interest in the stage and his close connections to the production—in addition to his brother, other cast members included Sara Wiborg, whom he would marry ten years later, and her sisters—Gerald didn't take part in *Mrs. Clymer's Regrets;* his academic standing was precarious, as so often, and he was spend-ing the summer under the strict guidance of a tutor. Nor was the play itself really to his taste—too bourgeois, too much like the "mid-summer club-porch chatter" he dis-dained.[8] What stirred his blood was the kind of richness

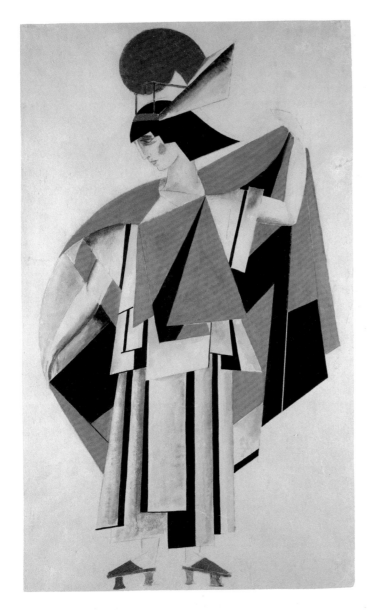

Alexandr Vesnin, costume design for the Kamerny Theater production of Jean Racine's *Phèdre*, 1922. Gouache and bronze on paper, 21 ½ × 13 in.

and artifice he found in the Bakst scenic designs he admired; or elemental and stylized drama, like Harley Granville-Barker's production of Euripides' *The Trojan Women,* which he and Sara attended when they were engaged, and which they discussed animatedly.[9] But such aesthetic avant-garde fare went over the heads of most of the New York audience: several "uncouth auditors" (as an irate letter-writer to the *New York Times* put it) "thought that the tragedy was humorous, and guffawed at the most intense moments . . . [or] whispered . . . even in the midst of the finest acting."[10]

It wasn't until Gerald and Sara Murphy arrived in Paris in 1921, accompanied by their three small children, that Gerald found himself in a climate where the art and theater on view offered him the creative stimulation he hardly knew he'd been waiting for. His reaction to the modernist canvases he saw soon after his arrival is well known—"There was," Gerald wrote of it later, "a shock of recognition which put me into an entirely new orbit"[11]— but what was happening on the stage in Paris during the 1920s was at least as exciting and formative for him. Just months before the Murphys landed in France, Jean Cocteau had created a Dada opéra bouffe, *Le Boeuf sur le toit,* which featured the Fratellinis—clowns from the Cirque Médrano—and a jazzy, Brazilian-inspired score by Darius Milhaud. In true Dadaist fashion, it wasn't really

The Kamerny Theater's production of *Giroflé-Girofla*, 1922.

The Kamerny Theater's Cubist-inspired production of *Antigone*, 1927.

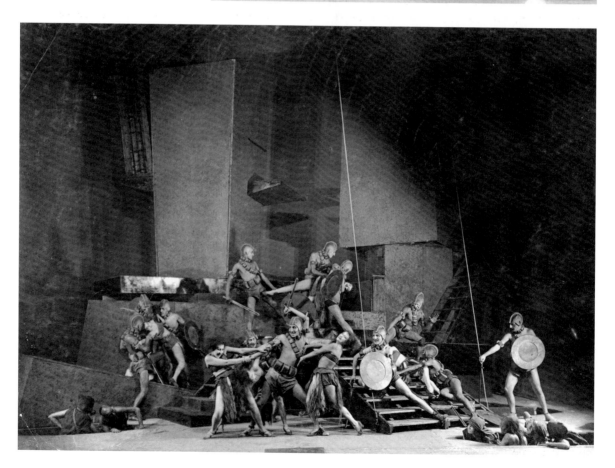

"about" anything—just the antics of its eight cartoonish characters, the Barman, the Red-headed Lady, the Décolletée Lady, the Policeman, the Negro Boxer, the Bookmaker, the Gentleman in Evening Dress, and the Negro Boy—but it was a sensation nonetheless, drawing its audience equally from the aristocratic salons of the Right Bank and the artists' ateliers of the Left Bank in the sort of crossover that was as foreign to the New York Gerald had left behind as the goings-on onstage were. And it showed Gerald—as definitively as the paintings he marveled at did—that art could be as powerful restricting itself to two dimensions as it was in three.

This lesson was repeated by another theatrical sensation the Murphys encountered in Paris: the avant-garde Kamerny Theater, a visiting Moscow troupe whose work was the farthest thing imaginable from the lifelike mimesis of its Russian rival and predecessor, Konstantin Stanislavsky's Moscow Art Theater. Instead of naturalism, which he believed was a fatal handicap to effective dramatic presentation, the Kamerny's founder and director, Alexander Tairov—like his sometime colleague, the director Vsevolod Meyerhold—espoused what he called "the theatricalization of theatre,"[12] in which the look of productions was as important (maybe more important) than their texts. Tairov had recruited numerous avant-garde Russian artists, such as Alexandra Exter, Alexander Vesnin, Vladimir and Georgy Stenberg, Mikhail Larionov, and Natalia Goncharova, to carry out scenic designs for his company and also to make costumes, which in a Murphyesque comment he called "the actor's second skin . . . something inseparable from his essence."[13]

The Kamerny actors did Jean Racine's *Phèdre* in constructed faces (not masks), with the star, Alice Coonen, climbing up a steeply raked platform trailing a red cape as long as the set was wide;[14] they did an adaptation of G. K. Chesterton's chase-thriller, *The Man Who Was Thursday,* on a three-story Constructivist set designed by Vesnin, featuring scaffolding, stairways, elevators, and slides and poles for quick escapes; and they did a silly 1890s operetta called *Giroflé-Girofla* on the wings of a biplane. Gerald, and Sara too, were wild about them: they went to all ten of the Kamerny's Paris performances in March 1923, threw a highly theatrical dinner party for the company in the half-finished apartment they were renovating on the quai des Grands-Augustins, and—when it transpired that despite its *succès d'estime* in Paris the company couldn't pay the bills for its engagement—

wrote Tairov a $3,000 bank draft ($33,000 in 2006 dollars) to cover expenses.[15] For Gerald, it was truly a case of putting money where his mouth, and his heart, were. And shortly after the Kamerny left Paris for Moscow, he did so yet again, in an enterprise that resonated even more profoundly with him.

Since well before World War I, Sergei Diaghilev's Paris- and Monte Carlo-based Ballets Russes had been an engine of modernism. Diaghilev had produced the first Cubist-inspired ballet, *Parade,* in 1917, with music by Erik Satie, scenario by Jean Cocteau, décor and costumes by Pablo Picasso, and a program note by Guillaume Apollinaire, which introduced the word "surrealism" into the popular lexicon.[16] He had hired and popularized composers like Milhaud, Igor Stravinsky, Ottorino Respighi, and Manuel de Falla; artists like Picasso, André Derain, and Henri Matisse; choreographers like Bronislava Nijinska and Michel Fokine. No *Swan Lakes* or *Giselles* for Diaghilev; discarding the sort of traditional mimesis that had governed ballet in the imperial era, he was producing witty, transgressive, sometimes gender-bending work whose emphasis was not on reality, or fan-

Mikhail Larionov, caricature of Sergei Diaghilev, Natalia Goncharova, and Igor Stravinsky, 1914.

tasy, but on artifice. Both Gerald and Sara fell under the Ballets Russes' spell almost as soon as they arrived in Paris: Sara's sister Mary Hoyt Wiborg (known as Hoytie) introduced them to Diaghilev's sometime patron Comte Étienne de Beaumont, and soon they were part of the de Beaumont–Ballets Russes *galère,* "a world somewhere between *Guermantes Way* and *Sodom,*" said one contemporary chronicler, where "a well-set-up young man would attract the glances of as many men as women."[17] And when Gerald decided to start studying painting seriously, the teacher he found for himself was Goncharova, a painter and set designer who, with her husband, Larionov, was allied with the Ballets Russes *and* the Kamerny Theater.

Goncharova, who had designed the sets for Diaghilev's productions of *Le Coq d'or* and other ballets, practiced in two genres: a blend of Cubism and Futurism that used strong shapes and colors in energetic semiabstract compositions, and a Neoprimitive pictorial style that had its source in Russian folk and religious art. It was in the former mode that she set her students (Sara was studying alongside her husband) to work: "She started us with *absolutely* abstract painting," Gerald recalled. "Absolutely non-representational."[18] But she also sent them out to receive practical training in Diaghilev's scenery atelier, painting backcloths for some of the company's ballets; and through their connection with the Diaghilev company they became caught up in what Gerald later called "a sort of *movement*"—the group of artists and musicians and *amateurs* and hangers-on that clustered around the Ballets Russes. "You knew everyone in it," said Gerald, "and you were expected to go to the rehearsals, and they wanted your opinion and they discussed it with you."[19] For Gerald, whose human collages—his friendships, his party-giving, his mentoring of others—rivaled the Precisionist canvases he was beginning to produce under Goncharova's tutelage, such a sense of artistic community had a powerful additional attraction.

In the spring of 1923, the circle around Diaghilev was buzzing about the new ballet he was producing, choreographed by Nijinska to a raw, raucous score by Stravinsky and with décor and costumes designed by Goncharova. The ballet was called *Les Noces.* Because of their connection to Goncharova, Gerald and Sara were invited to help with the execution of her designs—a spare unit set, with a simple wooden bench placed before a painted blue drop, and severe brown-and-white peas-

ant costumes. The two of them also attended rehearsals and famously decided to mark the ballet's première by holding one of the first of their iconic parties, an all-night celebration on a barge-restaurant in the Seine for "everyone directly connected to the ballet, as well as friends of ours who were following its genesis"[20] that quickly assumed the aura of a legend. What was it about Nijinska's rather austere work that struck such a chord for Gerald?

A primitivist folk ballet that used a geometric, Constructivist choreography, full of wedges, triangles, and squares, to depict the marriage rituals of Russian peasants, *Les Noces* was severely antiromantic. The idea, said the choreographer, was to convey a sense of implacable social force in which the individual wishes of the bride and groom were meaningless. "There is no question of *mutuality of feelings,*" Nijinska wrote of her creation.[21] Did Gerald hear an echo of his own angst during his courtship of Sara, when the strictures and pressures of her disapproving family and his sent him into a series of black depressions? Did he—as a bisexual man whose inner life was closeted even from himself—feel as helpless in the grip of society's expectations for him as the bridegroom in Nijinska's ballet? If he did, Nijinska's stylized, overtly theatrical treatment of this theme permitted him the luxury of responding to it without betraying himself—concealing those painful "personal realities" behind costumes, sets, and presentation.

Very soon he put the lessons he was learning from his theatrical observations—that onstage you could present truth in disguise, so stylized and decorated that it could pass as entertainment—to real use himself. For in the summer of 1923, Gerald received an exciting commission from Diaghilev's rival impresario, Rolf de Maré of the Ballets Suédois, to design the sets and costumes and write the scenario for a one-act ballet whose score (at Gerald's suggestion) was written by his old Yale friend Cole Porter.[22]

Within the Quota, as the ballet was called, told the story of a fresh-faced, clueless innocent from Sweden who arrives in New York with only a satchel, a hobo's bundle, and a landing card, and subsequently undergoes a series of picaresque adventures at the hands of a dramatis personae straight from central casting, circa 1923—a Jazz Baby, a Cowboy, an American Heiress, a Colored Gentleman, a Social Reformer, a Sweetheart of the World. At the ballet's end, he is improbably transformed

Natalia Goncharova, *Les Noces:* author's reproduction of costume design, 1921. Pen and ink on tracing paper mounted on paper, 21 ⅝ × 17 ⅝ in.

Nicholas Semenoff as the Bridegroom, with male members of the cast of the Ballets Russes production of *Les Noces,* 1923.

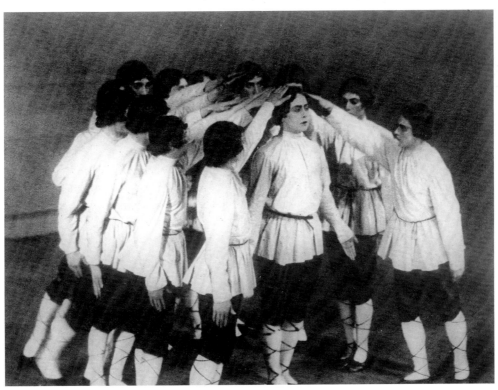

into a movie star by a cameraman who "films" the action onstage.[23]

Although this sort of burlesque bore more than a passing resemblance to parodic sketches like Fred Murphy's Maidstone Club romp or the undergraduate reviews Gerald had seen at Yale, its real influences were the avant-garde productions Gerald had seen or heard about in Paris: Satie and Cocteau's *Parade,* in which the characters are Acrobats, Managers, a Chinese Magician, and a Little American Girl; *Le Boeuf sur le toit,* with its similarly labeled cartoon dramatis personae; and the stylized presentations of the Kamerny Theater and *Les Noces.* And under the camouflage of the ballet's stylized surface, Gerald was able to settle some old scores.

His backdrop for *Within the Quota,* the front page of a fictional American newspaper, enlarged to mammoth size, made sly fun of the Establishment to which his and Sara's families catered and belonged (see p. 43). "Unknown Banker Buys Atlantic," screamed the main banner headline, in a dig at the exchange-happy American plutocrats who had been buying up everything *but* the ocean in recent years, while "Ex-Wife's Heart-Balm Love

Sara Murphy, costume design for Sweetheart of the World from *Within the Quota,* 1923. Graphite and watercolor on paper, 11 ½ × 9 in.
DANSMUSEET, STOCKHOLM

Tangle" winked at a celebrated million-dollar palimony case involving the Socially Registered New Yorker Cornelius Vanderbilt Whitney. In the ballet's scenario, the immigrant—or "the European," as he is referred to—meets up with a slinky Heiress, with whom he dances a fox-trot, but she is frightened off by a Social Reformer; then the European is diverted by the vaudeville dancing of the Colored Gentleman, who is driven away by a Prohibition Agent; then "the Jazz Baby, who dances a shimmy in an enticing manner, is also quickly torn from him."[24] Many of these characters are manifestations of the kind of patriarchal disapproval that had dogged Gerald in his youth and—in part—had driven him from the United States,[25] but they're presented in such a stylized way, using stereotypes lifted from contemporary films, that Gerald had plausible deniability of his intentions. He may have been alienated from the culture of his homeland, but he wasn't ready to turn his back on it entirely. At the end of his ballet, he allowed the European to overcome society's disapproval by becoming a Star; perhaps Gerald himself hoped for the same thing.

In fact, he did become a star: *Within the Quota* was a hit with audiences on both sides of the Atlantic (it was added, due to box-office demand, to the Ballets Suédois's American tour), and Gerald's career as a painter took off like a rocket. His gigantic *Boatdeck* was the sensation of the 1924 Salon des Indépendants ("it could scarcely be seen, so great was the crush around [it]," reported the Paris *Herald*[26]). It was followed by other works that helped to earn Gerald the praise of Picasso, who said "he liked very much my pictures, that they were simple, direct and it seemed to him Amurikin,"[27] and Fernand Léger, who seconded the pronouncement: "Gerald Murphy," he proclaimed, "was the only *American* painter in Paris."[28]

During the next five years, Gerald and Sara became the center of a glittering constellation that included those two painters, Cole Porter, Jean Cocteau, Philip Barry, Archibald MacLeish, Dorothy Parker, John Dos Passos, and—perhaps most famously—Ernest Hemingway and F. Scott Fitzgerald, many of whom would immortalize the Murphys, sometimes in disguise, in their work. They created havens, in Paris and at their Villa America in Antibes, where they and their friends could simultaneously pursue both the life of art and the art of living. And in 1929, when their younger son, Patrick, was diagnosed with tuberculosis, the whole glorious edifice came crashing down upon them.

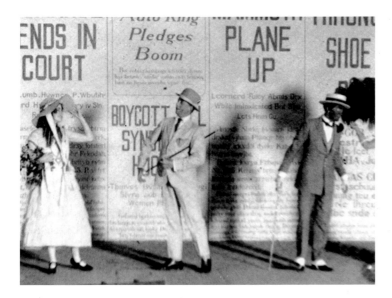

Detail showing backdrop and costumes for
Within the Quota, 1923 (see p. 43).
GERALD AND SARA MURPHY PAPERS,
BEINECKE LIBRARY, YALE

Gerald in particular never recovered from this blow. In a spasm of guilt—for having tried to be true to himself, and not to what society expected of him?—or in some strange effort to bargain for Patrick's life with the one thing that really mattered to him, he stopped painting when Patrick became ill, rolled up all his canvases and put them in storage, and never took up a brush again. Although both Murphys made brave efforts to maintain the friendships and the joy of former days, it wasn't the same. And the years after Patrick's diagnosis seemed to confirm this grim realization. Gerald's father died, forcing the son to take up the burden of running Mark Cross, a job he performed with flair but little relish; the Murphys closed Villa America and returned to the United States; death, divorce, financial reversals, and madness overtook the friends they cherished; and in an especially cruel twist, their healthy son, Baoth, contracted meningitis and died suddenly in 1935, followed two years later by Patrick. In September 1939 war was declared in Europe; less than a year later German troops would occupy their beloved Paris.

At this anguished juncture, Gerald made one more foray into the world of theater. The Ballets Russes had been effectively dismantled following Diaghilev's death in 1929, although successor companies, employing some of the same dancers or choreographers, had continued to perform using some permutation of the Ballets Russes name; and in 1939 one of these, Sergei Denham's Ballet Russe de Monte Carlo—which despite its name spent much of its time in New York—retained Gerald's services as a librettist for a ballet on a western theme. In fact, Denham had wanted Gerald's friend Dos Passos, recently on the cover of *Time* magazine in conjunction with the publication of his novel *The Big Money*, to do the scenario, but Dos Passos wasn't interested. Gerald, on the other hand, was. So it was he who put the Ballet Russe together with the new work's composer, Richard Rodgers[29]—and it was he who now concocted the ballet's story line with its young choreographer, a Ballet Russe dancer called Marc Platoff, originally Marcel Leplat from Seattle, Washington, who as Marc Platt would soon earn fame as the dancing Curley in *Oklahoma!*'s dream ballet, "Laurey Makes Up Her Mind."

Platt was a young innocent, a fair-haired boy with a winning smile and an ebullient stage presence, and Gerald was immediately drawn to him as much as to the idea of the ballet. To help Platt get a feel for the material, Gerald lent him (and Rodgers, as well as the designer, Raoul Pène Du Bois) his extensive collection of books and notes on nineteenth-century frontier history, his copies of vintage sheet music, and his records; and he put Platt up at the New Weston Hotel, where the Murphys lived in a penthouse apartment, so that when Gerald returned after a day minding the store at Mark Cross, the two of them could work on the ballet scenario together. "Gerald Murphy gave me my working base," Platt remembered later. "First of all, he became a friend. Second, he supplied the music as well as the ideas out of his own

AMANDA VAILL **127**

Raoul Pène du Bois, costume sketch for a Bright Star Miner in the Ballet Russe de Monte Carlo production of *Ghost Town*, 1939. Gouache and pencil on paper, 19 ¹⁵⁄₁₆ × 13 ¹⁵⁄₁₆ in.

head, from his own experience. Although I was unaware of his work with the Ballets Suédois, he shared his thoughts on what would work and what would not."[30] The scenario they constructed between them mapped out characters, setting, costumes, action, even dances; and for Gerald it must have seemed at times that he was back in the golden days of *Within the Quota*. "It was so exciting," said his daughter, Honoria, "that my father had gotten involved in the arts again."[31]

Or for the last time—for *Ghost Town,* the ballet Gerald helped to create, was his final venture into art. The title itself has a painful resonance—it echoes Dorothy Parker's lament when she helped the Murphys close Villa America: "What is more horrible than a dismantled house where people have once been gay?"[32]—and the scenario is equally poignant: a young couple hiking in Colorado stumble on a ruined mining camp inhabited only by an old wreck of a miner named Ralston, who in

flashback tells them of the town's glory days, when he himself was young and in love and the town was a magnet for prospectors and celebrities, like the opera star Jenny Lind and the poet Algernon Charles Swinburne. Alas, the vein of ore on which the town's fortunes were built has run out, Ralston's sweetheart has left him for the Bonanza King, and Ralston has been left to live on memories. The parallels with the losses Gerald had absorbed during the previous decade are striking; equally so were those with his present—for, as Marc Platt recently told Deborah Rothschild, Gerald made a sexual advance to him toward the end of their work together, an advance that Platt (who was not that way inclined) rebuffed,[33] and Gerald would be rejected artistically when Sergei Denham and the rest of the Ballet Russe management cut him out of further participation in the production and denied him any credit in the ballet's program. But no matter how much Gerald may have felt like the aged Ralston, left alone to live on dreams, in the scenario he worked out with Platt those "personal realities" were disguised so artfully with authentic period details, not to mention a cast overstuffed with historical personages, that the pathos of *Ghost Town*'s self-revelations went unnoticed by even his closest friends.

It was, however, one of those close friends—Archibald MacLeish, to whom he had once confessed that "I have apparently never had one real relationship or one full experience" because of his feelings of imposture and concealment[34]—who gave Gerald's story its final and least disguised theatrical form in his Pulitzer Prize–winning verse drama, *J.B.* (1958), a retelling of the biblical story of Job. (Another friend, the playwright Philip Barry, had used Gerald as the basis for the protagonist of his unproduced, unpublished 1923 play *The Man of Taste* and had borrowed elements of him and of Sara for his 1929 *Hotel Universe*.[35]) Ostensibly an effort to make sense of the purposelessness and capriciousness of the destruction of World War II, *J.B.* situates its action in a circus tent, where two unemployed actors, Mr. Zuss and Nickles, take on the respective roles of God and Satan. Nickles offers Zuss the same wager his counterpart offered God in the Bible: that when misfortune visits a man whom God has blessed with wealth and happiness, he will lose his faith, turn on God, and curse Him. MacLeish's Job—or J.B.—is a rich and successful New England businessman with a loving, beautiful wife and five children, but his charmed life is ended by Zuss and Nickles's wa-

ger: a son is killed in a military accident; a son and daughter are victims of a fatal car crash; another daughter is murdered; the youngest daughter dies in an atomic bombing; J.B.'s bank is destroyed and his fortune lost; and he is plagued with boils that cover his body.

Although the afflictions are different in number and in kind, in effect they mirror what MacLeish had seen happen to his friends Gerald and Sara Murphy: the loss of their children, their way of life, and, in MacLeish's view, their fortune. He may not have known that years before, on one of his Atlantic crossings, Gerald had copied out six pages of verses from Job, including—all by itself, at the top of a page—this one: "Then said his wife unto him: Dost thou still retain thy integrity? Curse God and die!" But MacLeish *did* know that cursing God was what Sara herself had done on the day of Baoth Murphy's memorial service, when she had rushed out of the church and had shaken her fist at heaven; he'd been at her side that day and had never forgotten it. In the Bible, Job's wife has no name, and after this one expostulation, she is silent and unmentioned. So in MacLeish's play, as he himself

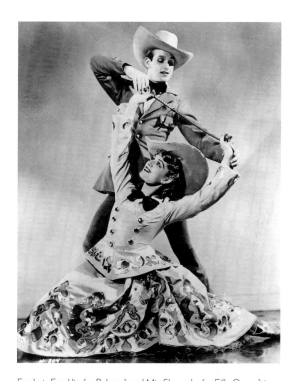

Frederic Franklin (as Ralston) and Mia Slavemka (as Eilly Orrum) in the Ballet Russe de Monte Carlo production of *Ghost Town*, 1939.

admitted, the character had to be "an almost total invention." MacLeish made her beautiful—and not only beautiful, but famous, in the way great beauties of the Edwardian era, such as Sara Wiborg, were: a beauty whose "picture was published,"[36] as Sara's was in the rotogravure society pages and on the cover of *Town and Country*. And MacLeish called his character Sarah. "There is no such name in the *Book of Job*," he noted later. "She is never called Sarah."[37]

There is an even more important departure from the biblical story at the climax of the play—a departure that, camouflaged though it was by MacLeish's verse and Elia Kazan's staging, came uncomfortably close to candor in describing the toll tragedy had taken on the Murphys' marriage. In the Bible, Job's nameless wife makes no further appearance after she cries out, "Curse God and die!" But in the play, Sarah is so outraged and bereaved by what has happened to her family and by what she sees as J.B.'s passivity in the face of suffering that she leaves her husband. Although Sara Murphy didn't leave Gerald during the hard years of their sons' illness and death, the two of them—said MacLeish's son, and Gerald's godson, William MacLeish—"had a very, very bad patch there."[38] And one can only guess at what Gerald, with his passion for "concealment of the personal realities," must have felt to see it openly portrayed.

With such openness, however, came resolution. In the play's final moments, J.B.'s wife returns to him, and this chronicle of misfortune achieves a quixotically hopeful ending: the lights have gone out everywhere, says Sarah, but if they will each just "blow on the coal of the heart," it will glow again. "We'll see where we are," she says. "We'll know. We'll know."[39] If the theater had once been a place for Gerald Murphy to conceal his personal realities, it had become a place where he might begin to be reconciled to them.

In the years after *J.B.*'s première, there would be pain for both Gerald and Sara—Ernest Hemingway's suicide, his cruel posthumous portrait of them in his memoir *A Moveable Feast,* and other deaths and losses—but there would be joy as well, in watching their three grandchildren grow, and in celebrating Gerald's rediscovery as a painter by the art establishment, with an exhibition at the Dallas Museum for Contemporary Arts and a profile in the *New Yorker* by Calvin Tomkins. Years before, Gerald had confessed to MacLeish: "I have never been able to feel *sure* that *any*one was fond of me, because it would

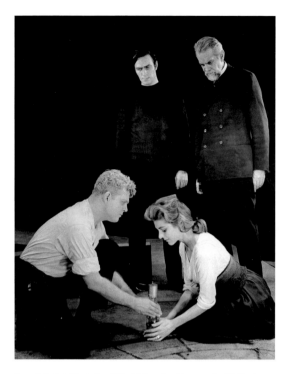

From left: Pat Hingle (as J.B.), Christopher Plummer (as Nickles), Nan Martin (as Sarah), and Raymond Massey (as Zuss) in Archibald MacLeish's *J.B.*, 1958.

COURTESY OF PHOTOFEST, INC

seem too much to claim, knowing what I did about my-self."[40] Now, however, he allowed himself to revel quietly in the love of his friends. And in the last days of his life, Gerald had the satisfaction of knowing that—through Archibald MacLeish's agency—his painting *Wasp and Pear* had been taken into the permanent collection of that temple of modernism, the Museum of Modern Art. It had been MacLeish's hope that his friend could die "thinking of himself as a painter,"[41] and through his efforts the words he'd said about Gerald in *J.B.* became true: "We'll see where we are. We'll know. We'll know."

NOTES

1 Patrick Francis Murphy, letter to Gerald Murphy, November 20, 1909, Gerald and Sara Murphy Papers, Yale Collection of American Literature, Beinecke Rare Book and Manuscript Library, Yale University, New Haven, CT.

2 "Phillips' Herod Acted at the Lyric," *New York Times,* October 23, 1909.

3 See Gerald Murphy, letter to Sara Wiborg, [September 7, 1913], Gerald and Sara Murphy Papers, Beinecke Library, Yale. According to this letter, Gerald took Sara to a Bakst exhibition and later bought a drawing or engraving himself.

Unless otherwise noted, all correspondence between Sara and Gerald is in the Gerald and Sara Murphy Papers, Beinecke Library, Yale.

4 Gerald Murphy, letter to Douglas MacAgy, October 13–14, 1962, Douglas MacAgy Papers, Archives of American Art, Smithsonian Institution, Washington, DC.

5 Gerald Murphy, letter to Esther Murphy, [1957], Donnelly Family Collection.

6 Gerald Murphy, letter to Archibald MacLeish, January 22, 1931, Archibald MacLeish Papers, the Library of Congress, Washington, DC.

7 Program from *Mrs. Clymer's Regrets,* Donnelly Family Collection.

8 Gerald Murphy, letter to Sara Wiborg, September 9, 1914.

9 Sara Murphy, letter to Gerald Murphy, June 2, 1915.

10 E. A. Thompson, "An Ill Behaved Audience," *New York Times,* June 6, 1915.

11 Gerald Murphy, letter to Douglas MacAgy, undated (written in response to a letter from MacAgy dated May 17, 1962), Douglas MacAgy Papers, Archives of American Art.

12 Alexander Tairov, *Notes of a Director,* trans. William Kuhlke (Coral Gables, FL: University of Miami Press, [1969], 142.

13 Ibid., 125.

14 Jean Hugo, *Le Regard de la mémoire* (Paris: Actes Sud, 1983), 224.

15 Gerald Murphy, letter to Douglas MacAgy, following a telephone conversation of October 21, 1962. Douglas MacAgy Papers, Archives of American Art.

16 Vincent Cronin, *Paris: City of Light 1919–1939* (London: Harper Collins, 1994), 63.

17 Jean-Louis Faucigny-Lucinge, *Un Gentilhomme cosmo-polite* (Paris: Perrin, 1990), 105 and 108 (author's translation).

18 Gerald and Sara Murphy, audiotape interview by Calvin Tomkins, c. 1960, transcript in the Gerald and Sara Murphy Papers, Beinecke Library, Yale.

19 Ibid.

20 Gerald Murphy, quoted in Calvin Tomkins, *Living Well Is the Best Revenge* (New York: Viking, 1971), 31.

21 Bronislava Nijinska, "The Creation of 'Les Noces,'" trans. Jean M. Serafetinides and Irina Nijinska, *Dance Magazine,* December 1974, 59.

22 For more on Porter's part in the project, see Olivia Mattis's "*Les Enfants du Jazz:* The Murphys and Music" in the present volume.

23 A description of the scenario for *Within the Quota* appeared in *La revue de France* and is quoted in Bengt Häger, *Ballets Suédois* (New York: Harry N. Abrams, 1990), 44. The original scenario has apparently been lost, and this is the only source.

24 Ibid.

25 "A government that could pass the Eighteenth Amendment [which prohibited the sale or consumption of alcohol] could, and probably would, do a lot of other things to make life in the States as stuffy and bigoted as possible" is how Gerald phrased it to Calvin Tomkins. Quoted in Tomkins, *Living Well Is the Best Revenge*, 21.

26 "Curious Art Seen at Indépendants," *New York Herald* (Paris), February 9, 1924, 2.

27 Quoted in William Rubin, *The Paintings of Gerald Murphy* (New York: Museum of Modern Art, 1974), 30.

28 Quoted in Tomkins, *Living Well Is the Best Revenge*, 26.

29 Richard Rodgers, *Musical Stages* (New York: Random House, 1975), 194.

30 Marc Platt with Renée Renouf, "*Ghost Town* Revisited: A Memoir of Producing an American Ballet for the Ballet Russe de Monte Carlo," *Dance Chronicle* 24, no. 2 (2001), 147–92.

31 Honoria Murphy Donnelly, interview by the author.

32 Dorothy Parker, letter to Robert Benchley, [November 7, 1929], Robert Benchley Collection, Howard Gotlieb Archival Research Center, Boston University.

33 See Deborah Rothschild's "Master's of the Art of Living" in the present volume.

34 Gerald Murphy, letter to Archibald MacLeish, January 22, 1931, Archibald MacLeish Papers, Library of Congress.

35 See Amanda Vaill, *Everybody Was So Young: Gerald and Sara Murphy, A Lost Generation Love Story* (Boston: Houghton Mifflin, 1998), 127–28.

36 Archibald MacLeish, *J.B.*, manuscript draft, 1958, Archibald MacLeish Papers, Library of Congress.

37 Archibald MacLeish, interview by Stuart Drabeck, transcript, section A, 13, Archibald MacLeish Collection, Greenfield Community College, Greenfield, MA.

38 William MacLeish, interview by the author.

39 Archibald MacLeish, *J.B.: A Play in Verse* (Boston: Houghton Mifflin, 1957), 153.

40 Gerald Murphy, letter to Archibald MacLeish, January 22, 1931, Archibald MacLeish Papers, Library of Congress.

41 [Benjamin DeMott], "The Art of Poetry, no. 18" (interview with Archibald MacLeish), *Paris Review* 14, no. 58 (1974), 70; see http://www.theparisreview.com/media/3944 _MACLEISH.pdf.

GRAN FABRICA

DE

THE NOTEBOOK AS SKETCHBOOK

TREVOR WINKFIELD

"**S**tupid as a painter" was apparently such a common term of abuse one hundred years ago that Marcel Duchamp felt compelled to devote his entire existence to refuting it, thus laying himself open to the charge of being too intellectual, though he was never, so far as I can tell, subjected to the cruelest cut of all and dismissed as a mere "literary painter."

Moron or egghead? As the saying goes, there's no winning. Either way, our hapless painter feels permanently pinioned on the horns of this particular dilemma. The situation becomes more confusing when one discovers that even painters such as Maurice de Vlaminck, who outwardly seemed proud of their bohemian boorishness and reveled in the pure sensuality of paint, nonetheless found it necessary to confide their deepest thoughts on their medium to the pages of a book.

Perhaps it all boils down to the sad fact that some artists, whatever medium they're working in, suspect that their finished products are somehow insufficient, full of loose ends, lacking some ineffable quality (the classic "What I meant to say was . . ."), which then demands justification in another form. And the form that continuation usually takes is the written or spoken word, the nails in the coffin of artistic autonomy. Is it any wonder that so many artists, perpetually frustrated over this seemingly

Detail from Gerald Murphy, *Cocktail*, 1927 (see p. 103).

insurmountable dichotomy between the visual and the linguistic, have sunk into depression, gone mad, or quit the field entirely?

The Paris to which Gerald Murphy migrated in the 1920s was a veritable imbroglio of garrulousness and printed matter, thick with myriad artistic credos scrambling to gain the upper hand. Everyone was talking at once—and more or less everyone was listening, since artistic Paris had become not only a hothouse for its own products, but a clearinghouse for foreign hybrids, which had mushroomed in the previous decade and a half. And what a decade and a half! Rendering Renaissance Florence a staid, one-note tea party by comparison, the years 1905 to 1922 had produced wave after (often overlapping) wave of avant-gardes, mingling to form a heady brew. Layered on a base of still-lingering Impressionism (then, as now, the lazy aesthete's style of choice), the transient flowering of Fauvism was soon superseded by that of Cubism, which rapidly became the prevalent house style of the burgeoning School of Paris. But then Expressionism made its presence felt, swiftly followed by Futurism. Metaphysical art put in an appearance, then Orphism, only to be shoved aside by Dada, which in turn had to contend with the simultaneous eruptions of Suprematism and Constructivism. On the sidelines, Purism emasculated Cubism, while a resurgent Classicism sought to put back the clock. Meanwhile, most devious of all, the ground rules for Surrealism were being hatched

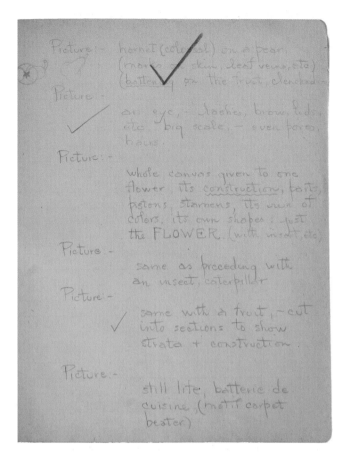

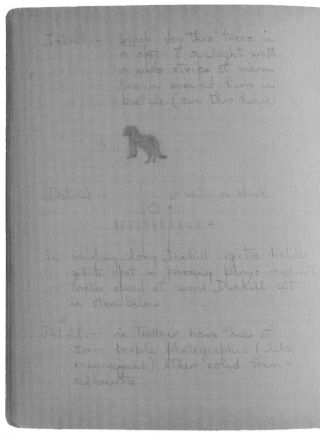

Gerald Murphy's notebook, 8 3/4 × 6 7/8 in.

ALL IMAGES FROM NOTEBOOK: GERALD AND SARA MURPHY PAPERS,
BEINECKE LIBRARY, YALE

Murphy's notebook.

around café tables, while behind closed doors academicians seethed. It was only natural that this laboratory became such a magnet for the adventurous, the voluble, and the opinionated. Was there any place else for a bohemian to live? Especially since, compared to most other capital cities, it was possible (though not necessary) to live there dirt cheap.

Economy, of course, was not a factor in Gerald Murphy's decision to move to Paris. He was wealthy. But the city's affordability enabled artists whom Gerald wished to emulate to thrive there, and that's what mattered. As an expatriate, surrounded by intelligent, creative painters, Gerald too could be a painter. Paris made him a great American painter, one who utilized components from the myriad art movements he encountered there. He couldn't paint before he went to Paris, and he wouldn't paint after he returned to the United States. Without this fact in

mind, the handful of paintings Gerald Murphy produced in France could be dismissed as mere flukes, a dilettante's hobby, aberrations in a businessman's career.

Even a cursory glance at one of the paintings Gerald began to eke out over a seven-year period beginning in 1922 confirms that they are, as the saying goes, "well thought out." Closer scrutiny confirms them as some of the most intellectually rigorous tableaus of their period. Visual evidence apart, written witness of Gerald's cerebral approach to painting may be found in his notebook, which he bought and began to fill shortly after his arrival in the French capital. (Some speculate the first entries date from 1923, though I suspect a year earlier.) Measuring 8 3/4 by 7 inches, with a striped cover and forty-three lined pages, the notebook served as both a commonplace book and an *aide-mémoire*. Things Gerald had seen and wanted to see in terms of future projects lade

its pages. Painstakingly inscribed in pencil, in an almost schoolboyish hand, entries in the notebook range in subject from ideas for future paintings, scenarios for potential plays or film sketches, notations of details he thought to include in his pictures, observations on architecture (again with an eye to enlivening future compositions), to seemingly random (but telltale) notations on writers and poets who currently absorbed him.

The notebook, then, could equally be tagged *The Artist's Eye* or *A Spy's Manual,* since nobody other than a spy or an artist would be bothered to tabulate such seemingly irreconcilable slivers of minutiae garnered from the fringes of society and sight: "smoke puffs (steam) silky with sun thro' them in procession across sky. . . . People coming thro' revolving doors." And only a spy or an artist would be clever enough to rearrange them into a vibrant whole. Though the clues to Gerald's psyche provided by this notebook (and its miraculous survival) are relatively few, we should nonetheless be grateful for even these crumbs. They help us to peek, albeit gingerly, through the scrim that cloaks the working of this most fecund of minds.

It should come as no surprise to find that Gerald's first paintings, once he had disembarked and settled in Paris, dealt with maritime architecture. The lost paintings *Turbines* (1922, p. 36), *Engine Room* (1922, p. 36), and *Boatdeck* (1924, p. 38) all display nautical furniture in abundance. Indeed, the sea is the central subject of this lost generation of paintings, though the sea evoked obliquely, as ambiance rather than as matter. Water as a subject would recur even more obliquely throughout his brief career. (Not fortuitously, Gerald spent a large portion of his European sojourn overlooking the Mediterranean.) Gerald later recalled that these early works were based on notes (and no doubt sketches) made on visits below deck during his transatlantic crossing in 1921, proof even at this early date that he was in the habit of recording ideas.

One thing scarcely mentioned in the notebook is color, though it is an outstanding characteristic of Gerald Murphy's painted world. Color as much as form attracted him; indeed, his often strident emphasis on color sets him apart from all his American contemporaries, barring his fellow expatriate Stuart Davis. Those of us who first came to know Gerald Murphy at a distance through black-and-white photographs in the 1974 Museum of Modern Art catalogue were taken aback when later the actual paintings were before our eyes. Nothing in black and white prepares one for Gerald's perfect coloristic pitch, his paradoxical ability to make hues pop and yet sit on the surface, to imply both flatness and recession, to be at once vivid and muted, making irreconcilabilities true. Since *Turbines* and *Engine Room* survive only as small monochrome photographs (the former as a magazine reproduction), the brumous, cavernous interiors they display might lead one to presuppose a gloomy palette. And yet this would probably be wide of the mark. Instead of the oily browns, metallic silvers, dull creams, bituminous blacks, and polished whites the eye presumes, both paintings could just as easily have involved variations on green or purple. Who knows? We simply have no idea of their original tints.

It's certainly peculiar to realize that Gerald, on his arrival in Paris, was more interested in depicting how he'd reached France than in plonking down an easel and depicting a typical French street scene. Most tourists would gravitate toward the latter. (Stuart Davis certainly did.) It's an early indication of Gerald's oblique attitude to reality that he plumped for the former approach, a warning for us not to expect the expected as far as his vision is concerned.

The early pages of the notebook are peppered with mechanical insights, such as memorandums to incorporate in some future painting a "row of bosses beside cabin or boiler," together with "'pas de vice,' bolt openings, shapes, forms, holes, etc." Gerald even planned an entire tableau around "acetylene welders at work on constructed iron-work, goggles, light-flashes." Most revealing of all, he supplies the key that provides the "Open sesame!" not only to these first paintings but to his entire oeuvre, via the outline of a scene from a projected play:

Scene of a house interior with all chairs and furnishings done in colossal (or heroic) scale. People dwarfed climbing seriously into great chairs to talk to each other; struggling under weight of huge pencil to write notes on square feet of paper: Man's good-natured tussle with the giant material world: or man's unconscious slavery to his material possessions.

The surreptitious introduction of gigantism "sets the stage" for Gerald's paintings. I like to think that it has its origins (apart from the obvious oneiric ones, which we all share) in Gerald's childhood dislike of Emanuel Leutze's gargantuan *George Washington Crossing the Delaware* (1850), which he was dragged to see louring on the walls

of the Metropolitan Museum of Art in New York. The painting's bombastic scale is difficult enough for an adult to encompass; to a child, it must have seemed over-whelming, threatening, belittling. We can well imagine young Gerald feeling shrunk to Alice-in-Wonderland proportions while cowering before it. In a similar fashion, this is what spectators are made to feel when confronted by Gerald's early canvases. And its opposite, too: because we now know them only as small photographs, Gerald's early paintings could be any size, at first seeming enor-mous, overpowering, and next, shrunk to domestic scale, even miniaturized. The same applies to their viewers. The theatrical *Engine Room,* in particular, possesses an op-eratic air, as though we are the audience, peering from a balcony through a proscenium arch onto a lighted stage, a tableau to be read across as well as into, both flat and recessional, gloomy yet bathed in a glowing, nacreous haze. As a result, the painting looks closer to a Symbolist drama than to the Precisionist painters to whom Gerald is often shackled (with little historical justification and, to my mind, unfairly).

Working at Mark Cross, Gerald had no doubt devel-oped a seller's eye early on. Subjected to advertising, he learned what would sell; in turn, it would be his task to devise ways to promote his company's products. How to arrange leather goods in the store's windows in order to catch just the right amount of light. How to select the perfect materials (and their hues) on which to display shelved merchandise. How to decide on the ideal size for typography to attract attention to labels. Should prices be visible or discreetly hidden? What colors attract or run the risk of repulsing customers? Which manufactured goods look best when screened by glass? And so on. There are more ways for a painter to explore the rudi-ments of his craft than by enrolling in an art school and endlessly consulting Goethe's color wheel. Scrutinizing Gerald's early work, it comes as no surprise that he had a profound admiration for European posters with regard to both their economical (but very devious) exploitation of shapes and colors and their psychological underpin-nings. Of value, too, was his initial training, early in 1922, with the Russian expatriate painter Natalia Goncharova in her Paris studio. Though it was barely six months in duration, its impact was radical—one might almost say seminal. It made Gerald a painter and not simply an un-focused aesthete. Goncharova was one of the first teach-ers to insist that her students, whether figurative artists

or not, concentrate on elementary shapes and blocks of color rather than on recognizable entities and details (a reduction that she herself had gleaned from Russian Constructivism, and even earlier from Russian folk arts). Mass, to Goncharova, was more important than outline, a lesson that in 1922 must have shocked many as both daunting and liberating. For Gerald, who (as his note-book shows) was obsessed with visual detail, it must have been especially challenging.

Goncharova had been responsible for designing stage sets and costumes for several productions while still in Russia, and in Paris she continued her association with Sergei Diaghilev and the Ballets Russes, corralling Ger-ald, his wife, Sara, and other students to help her exe-cute set designs by the likes of Pablo Picasso, André De-rain, and Georges Braque. Not only did this menial work provide an entrée into an entirely new and fabulous so-cial world, but it taught Gerald how to think big and paint flat (in the process receiving free painting lessons from the masters). The scenery began as a small maquette and was then gridded and enlarged to fill a stage. Painted either flat on the floor or resting on large trestles, the backcloths and wings had to be painted from above, a practice Gerald soon adopted when painting his own canvases. The mobility of the stage props he painted, and their ability to be slotted or rolled into assigned positions across a stage, no doubt played a large part in his for-mulation of his own studio practices. These were likely (though this was never confirmed by Gerald himself) built around the maneuverability of collage pieces, moved around and tested in various locations on the picture plane before being assigned a final position. Whether these collage pieces were actual or mental is a moot point. Certainly the end result, in his later paintings, was a painted collage.

The latter part of Gerald's notebook is taken up with quotations from some of his favorite tomes (or at least the biographies he was reading at the time). Virtually all the extracts he quotes deal with larger-than-life charac-ters. The exceptional in all its forms was obviously at-tractive to him. Small wonder, then, that he would be taken by Napoleon's portentous claim: "Men who are truly great are like meteors: they shine and consume themselves that they may lighten the darkness of the earth." Without indulging in secondhand psychology, it seems more than likely that Gerald saw himself as some-thing of a Napoleonic painter, one whose task was to

overwhelm. He may have been in his mid-thirties when he began his brief painting career, but he had a young man's ambition to take on the world. How else to account for *Boatdeck,* that exemplar of the stupendous, painted just months after the subterranean *Turbines* and *Engine Room?* It's as though jettisoning diurnal gloom, along with his earlier tubular writhings, allowed Gerald to leave his underground studio and resurface to become a plein air painter, though not in a fashion that would endear him to a French audience. If its import is to be understood, *Boatdeck* has to be seen as a gesture as well as a painting, almost a parody of American "bigness." When it was shown at the 1924 Salon des Indépendants, it almost, one might say, "blew everything else out of the water." Standing at roughly eighteen feet tall by twelve feet across, it dwarfed its companions in the gallery. Fifty years earlier, its bulk (though not its subject) would have raised few eyebrows, being typical of Salon behemoths (or *machines,* as they were referred to, a moniker that is apt in Gerald's case). In the intervening period, however, paintings had shrunk in girth. Picasso's landmark *Les Demoiselles d'Avignon* (1907), to name but one major statement, was a mere eight feet square, and that was an exception. Most early modernist pictures had shrunk to a size that allowed them to be easily carried off in a collector's arms.

Gerald Murphy's *Boatdeck,* installed at the Salon des Indépendants, Grand Palais, Paris, 1924.
BOSTON EVENING TRANSCRIPT, MARCH 15, 1924

In the past, *Boatdeck* has been described as a Cubist work. But unless "Cubist" has become a catchall designation for modernism (as "Futurist" once was), a much better label for this monster would be Exhibitionist. Exhibiting as it does a flair for showmanship, it also redefines how a painting should look in an exhibition, two tactics that were not fully exploited, either by Gerald Murphy or by any other American painter, until the Abstract Expressionists' massive weavings of a quarter century later. By emphasizing its height as opposed to its width, Gerald guaranteed it would overpower its neighbors, as it did, much to the consternation of Paul Signac, president of the Salon's selection committee. Formerly but briefly a revolutionary companion of Georges Seurat in the heyday of Pointillism, Signac had devolved, after his mentor's early death, into an insipid marine painter of almost academic sweetness. Not surprisingly, Signac felt compelled to resign from the Salon committee when confronted by Gerald's giant smokestacks. These were not the kind of seascape components Signac could condone. On a deeper level, *Boatdeck* must have struck him as a bottled message bobbing on the waves, a prophetic note to the effect that the future of painting was passing into America's hands.

Based on strong, slanting verticals terminated by horizontals (creating, essentially, a slanting L shape), the tableau has the cropped compactness of a snapshot. Indeed, Gerald often adopted a photographer's viewpoint in his paintings, and his notebook contains several notations that could serve as ideas for either paintings or photographs. One of the compositions he envisioned, noted on a trip to New York in the fall of 1926, involved a view from the elevated Third Avenue subway looking "*down* into shops, lighted windows dressed, eggs in crates, kitchen utensils, drugstore, . . . *across* at sills and windows, up at roof cornices: 3 perspectives." *Boatdeck*'s horizontal cabins and ventilators are peered into, the smokestacks looked up at. Everything is examined as though through a viewfinder, like a cartouche permanently lodged inside Gerald's head, ensuring each of his paintings would become a self-enclosed world.

Boatdeck was the last of Gerald's paintings to allow its subject matter to wander beyond its borders (the curtailed smokestack at the top edge). All his subsequent works are enclosed within borders, reminding us that we are dealing with a composition and not a slice of life. I have the feeling that not only the size of the painting,

but also its physical weight had an impact on Gerald's sense of composition. *Razor* (1924, p. 91), his next painting, projects such self-contained solidity that one is tempted to inquire as to both its weight and its dimensions. It has become not only a mass, like *Boatdeck,* but an object. In 1936, long after Gerald had been forced to abandon painting, he wistfully described in his notebook a projected object he hoped to make: "Construction in frame: rug-beater (rattan), sickle, parts of recognizable household objects such as hammer (handle sawed $^1/_2$ off?), use (of color on some?)." Though this object remained at the conceptual stage, it shows how much the notion of objecthood still retained its hold on Gerald—and his continued fascination with rug beaters, which a decade earlier formed the basis of an unrealized "still life, batterie de cuisine (motif carpet beater)." Not for the last time will Gerald's choice of objects be prone to Freudian interpretation, though in my opinion wrongly: what we see in Gerald's paintings is very much what we get. In Gerald's world, a razor is simply a utensil, not an invitation to castration. Certain images can *suggest* something else—human profiles play hide and seek in several of his paintings—but they never *symbolize* anything else. Others may differ on this point, but it was this painterly straightforwardness that appealed to the Pop art generation, who undertook the task of rediscovering him in the 1960s.

Gerald used his notebook as other artists use their sketchbooks: as a place not only to record ideas, but to expand on and then test them. Thus we find a preliminary written sketch, "fly (or insect) in colossal scale on match-box (or well-known household article)," usurped in the next entry by the definitive idea for *Razor:* "razor, fountain pen, etc. in large scale nature morte big match box." In the finished painting, as in *Boatdeck,* we are presented with three contrasting viewpoints compressed into a single object—the razor is looked at from the bottom, from the side, and from the top, heraldically flattened out as though run over by a steamroller. This idea finds echoes in another notation by Gerald—"fly (colossal) on lump sugar, or through a window pane or glass seen as from beneath, feet first"—and provides further evidence that he viewed things totally differently from other painters. Though billboard size in conception, *Razor* is, in fact, barely the size of a modest coffee-table top. One thinks of Duchamp's readymade *Why Not Sneeze, Rrose Sélavy?* (1921), comprising a little metal birdcage full of lightweight sugar cubes, which, when the

cage is lifted, turn out to be not so light, but carved from white marble. A similar sense of humor having nothing to do with laughter percolates throughout Gerald's paintings, emphasizing incongruity in all its forms. Why is *this* razor crossed with *that* fountain pen, and why are both implements splayed against a matchbox? And why is the matchbox larger than both the razor and the fountain pen? (It is, after all, behind them.) Search under "Surrealism" as well as "Dada" for a possible answer to these queries, especially in the "Surrealist Precursor" folder labeled "Comte de Lautréamont." Though by now a hackneyed concept, Lautréamont's 1869 visualization of the chance encounter on a dissecting table of an umbrella and a sewing machine was, at the time *Razor* was being painted, a brand-new revelation, as was Surrealism itself. The concept produced a painting that brings to mind display more than it does composition.

Surprising in one who had originally studied (albeit briefly) to be a landscape architect, Gerald registers almost solely as a fabricator of urban spaces. Those months spent plotting the trajectories of garden paths obviously stood him in good stead, however: *Razor* reveals him to have become a proficient weaver of outlines and fabricator of textures, where everything is traced out as though for a blueprint or a horticultural chart. Gerald's notebook teems with references to botany and its painterly possibilities—virtually all of them, alas, unrealized (though one of Gerald's surviving watercolor studies depicts a floral arrangement). As is befitting for a former landscape designer, nature always appears tamed and domesticated in his jottings. No twig is allowed to flourish independently outdoors, in its natural environment, but is cut down to become an element of interior design: "bunch violets against black and white marble of my dresser (grey background?)." A lemon is removed from a tree to become a mere appendage in a still life: "Nature morte cocktail tray, shaker, glasses stemmed cherries inside lemon knife . . . (cut by lemon yellow?)." (This litany forms the basis of Gerald's 1927 painting *Cocktail* [p. 103].) Further down the same notebook page, Gerald goes so far as to propose opposing a calla lily leaf with a wrench—a direct confrontation of nature with the manmade. Even crabs are seen as parts of the zodiac, rather than as inhabitants of the deep.

It is as though, as a painter, Gerald perfectly understood the world of objects but not the world of nature, and certainly not the world of people (also curiously ab-

sent from the notebook, save via their artifacts). The lack of people in Gerald's paintings is initially puzzling, given what we know of his energetic social life. He was available, and a friend of almost everybody. But his painterly depopulation becomes more understandable if we see Gerald's life as compartmentalized. His paintings were a reaction against, and not an extension of, his social life. Once the studio door was closed, he put the *beau monde* behind him. Alone, he allowed a dispassionate aloofness to take hold. This aloofness is reflected in his paint surface, a facture limned with a brush that harbors a curious blend of both frivolity and austerity. Devoid of virtuosic flourishes, the paint's sleek flatness has an almost nineteenth-century look, veering closer to Albert Bierstadt and Frederic Edwin Church than to Paul Cézanne or André Derain—Gerald never mistook thick, frothy excess for emotion. The paint itself never acts as the sole motivating force behind the gestation of a tableau. It simply does the task it was set to do, and does so radiantly. A surface akin to decals results. This method involved no mere "filling in." Rather, a patient layering within strict boundaries was favored. And yet there's nothing cold about these calculated surfaces, which attract rather than repel. They elicit close encounters with their unexpected warmth, even though at times Gerald appears to have polished his pockets of paint, not brushed them.

Watch (1925, p. 95), that kaleidoscopic dissection of the inner workings of a timepiece enlarged to the size of a town hall clock—its jigsaw pieces impeccably slotted into position (though not the position a horologist would approve of)—has a picture plane that resembles not so much the classic window, but more a tray that we have to peer down into, a receptacle as opposed to a screen. Its probing of machinery's inner workings resumes where *Engine Room* left off. In one of the most extensive entries in his notebook, Gerald confronts head-on a fundamental conundrum of early modernism, the reconciliation of painterly with mechanical forms: "There are forms (and the manner of presenting them) which are 'painting' forms—just as there are forms that are 'mechanical' forms. These are characteristic of painting with its own values and *limitations*,—the result of matière: canvas, paint, brushes etc.,— just as mechanical forms are the result of worked *metals*. Mechanical form per se may not give itself fully to painting as a value (geometric form does, being more abstract),—but mech'l form, and presentation has value as an influence as it approaches the

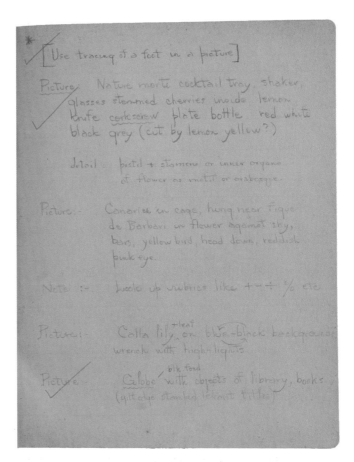

Murphy's notebook.

geometrical." It's this supposed dichotomy between the painterly and the mechanical that *Watch* so triumphantly resolves. Under Gerald's brush, a gleaming sprocket is as seductive as one of Jean-Baptiste-Siméon Chardin's pewter jugs. The fact that Duchamp, Francis Picabia, Morton Livingston Schamberg, and Fernand Léger had earlier made similar discoveries in no way diminishes Gerald's breakthrough.

Doves (p. 97), of the same year, shows the encroaching influence of Surrealism. Though it began as a notebook observation ("capital, ionic, corinthian, in large scale, with deep shadows [constructive],—with one or more pigeons clustered flat on it"), it is in many ways a forerunner of the later abstract *Portrait* (1928, p. 115). Ostensibly portraying a flock of cooing doves (and not the pigeons Gerald first envisaged), *Doves* doubles, by applying Salvador Dalí's paranoiac-critical method (or simply by squinting), as a frontal portrait: doves' eyes be-

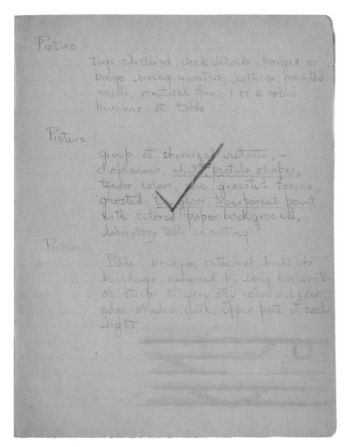

Murphy's notebook.

Murphy's notebook.

come human eyes, with a nose and a chin culled from architectural fragments. One thing suggests another: an architrave in shadow becomes a human profile. It might be thought that this is carrying "seeing faces in the fire" too far, but I don't think so. There's no denying that in this picture a hitherto suppressed aspect of Gerald's approach to composition begins to make its ghostly appearance (aided in no small measure by the limpid tonalities): one line defines two subjects.

Notes for *Laboratory* (1925), a damaged (and lost) painting done at the same time as *Doves*, describe a group of chemical retorts and speak of them as having diaphanous shapes and graceful, ghosted forms—exactly the same tender qualities found in *Doves*. In this latter tableau we also find Gerald using, in his typical, sly way, one of the "detail" annotations that figure throughout the notebook. "Thicken line to give weight or fixity to a form," he reminds himself, giving a sketch showing just such a partial thickening—and there at the top of *Doves*, though

in a more painterly way than the graphic sketch would lead us to expect, Gerald carries out his suggestion: a circular architectural device is bisected to decrease its girth by half.

We might also note that by the time Gerald got around to executing an idea, it was often transformed from its original conception. One of Gerald's unexecuted paintings, noted earlier, revolved around a bunch of violets set "against black and white marble of my dresser (grey background?)." The dresser may have disappeared, but the idea of marbleized patterning was resurrected in *Bibliothèque* (*Library*, 1926–27, p. 101), via the decorative edge of a book seen head-on. Similarly, though Gerald may not have directly used "dots around form such as in italian papers," the notation surely suggested the Pointillist shading of the rotund fruit in *Wasp and Pear* (1929, p. 105).

While the notebook fulfilled a function as both *aide-mémoire* and the site for future projects, actual memo-

ries played their part in Gerald's paintings, too. *Doves*, for instance, originated in a memory of seeing pigeons fluttering among Genoese buildings during an Italian sea voyage. Three paintings, *Watch, Bibliothèque,* and *Cocktail,* similarly had their origins in childhood recollections of items seen in his parents' house. It is all the more remarkable, then, that not a trace of nostalgia can be found in any of Gerald's works: everything is viewed dispassionately. In later life, he even considered the emotionless flatness of Pop art too romantic. Yet his own paintings are nothing if not romantic, though of a romanticism more akin to the classicism of a Nicolas Poussin than Jean-Antoine Watteau's Rococo caprices. Like Poussin, Gerald Murphy elevated his paintings' attributes to the level of mythic objects, on a level with regalia.

Early in the notebook, Gerald describes a proposed "ballet of métiers," whose stage décor involves "girder work horizontal and vertical in black and red lead," "diagonal wall, light ochre, sunlit, flat, solid," and "different level platforms, stairs"—visually, an architecture of strong horizontals and verticals, the very architecture he would utilize in building his final tableaus. The lost *Portrait,* which because of its advanced abstraction was probably Gerald's final painting, is nothing but a collaged grid of horizontal and vertical bands upon which anatomical fragments are grafted (the face as a plan). One step further along this abstract route and total disintegration would surely have ensued.

Tragedy, in the form of Life, curtailed that route. After barely more than a dozen paintings, Gerald Murphy's career as an artist was over, so we'll never know how his trajectory might have continued. Though he forever lamented the necessity of abandoning his art career, I suspect, on a very deep level, Gerald himself realized that over a seven-year period he'd done enough. What he didn't realize at the time (this only became apparent with his posthumous 1974 Museum of Modern Art retrospective) was that he'd formulated a perfect oeuvre, unique in American art for its compactness and quality. Each painting enhances its companions; each also is complete within itself.

But as the notebook proves, that's not all. For this limited oeuvre is enriched by the constellation of unrealized projects that swirl around it, supplying us with a whole extra hinterland of images to draw upon. Though the projects only survive as notebook outlines, they serve to trigger a parallel mental exhibition, if only we can connect the dots. For adepts, this proves not too hard an aesthetic task. The concrete evidence of Gerald Murphy's finished projects provides a template, allowing us to reconstruct—nay, fabricate—the ones he left undone. How easy it is for us to visualize "canal seen head on, locks rising one upon the other to horizon (in middle) flanked by houses with broken roof-line. Bulks of barges in locks at one side or other." Or the totally unexpected athletic array comprising "foot-ball scrimmage, headgear, nose-guard, shin protectors, etc. Sweaters, letter 'Y' 'H' 'P', colors, cleated shoes, ball in segments." Let alone the colorful geometry involving "billiards, three balls, wooden triangle, cue-handles, tips, chalked score, beize green, mahogany rim on table."

How he would have used "blue govt. stamp with engraved watered motif and numeral 7" may be a little more difficult to visualize, but not impossible. Close your eyes and concentrate, if you don't believe me.

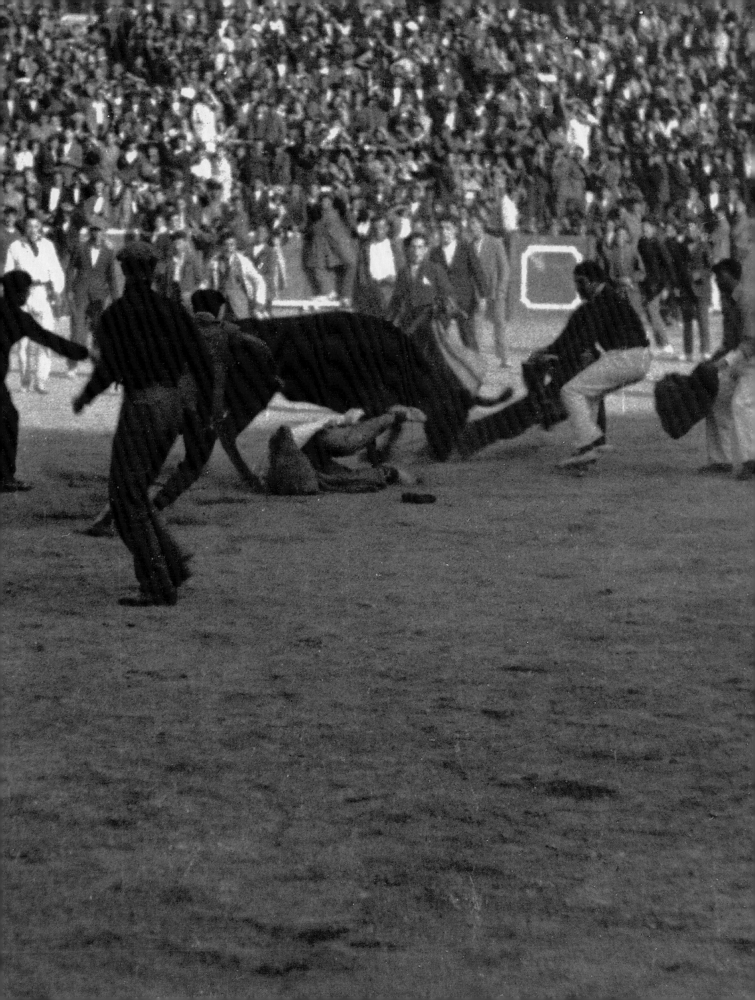

GERALD MURPHY IN LETTERS, LITERATURE, AND LIFE

LINDA PATTERSON MILLER

When Gerald Murphy walked the streets of Paris in 1921, he saw for the first time—like a modernist pilgrim— "Paintings by Braque, Picasso, and Juan Gris."[1] "What he felt at this moment was the shock of discovery," Calvin Tomkins tells us, reporting also Gerald's subsequent words to Sara: "If that's painting, it's what I want to do."[2] That this modern art informed by Cubist principles created such a seismic shift in Gerald's orientation well illustrates its transformative power and the great degree to which it reconfigured the world for the Murphys and their circle during the 1920s and thereafter. By 1925, when the Murphys had met most of the artists who would comprise their "group," Cubism had already reinvented artistic realism for a new age. As scientific and technological advancements challenged traditional notions of space and time, artists sought an artistic integrity that had less to do with physical verisimilitude and more to do with emotional ambiguity. To accomplish this, they created a malleable language out of geometric forms and multiple perspectives that competed for authority on the canvas and on the page (for Cubism shook up the world of writing in equal measure). As imagery and angular lines and shapes worked both sequentially and on different planes simultaneously, Cubist art evoked in unsettling ways an invisible emotional space and the sense of life in motion. Art historian Herbert Read rightly argues that Cubism's revisionist imperative called for "a new vision to express a new dimension of consciousness—not only harmony, but the truth which is, alas, fragmentary and unconsoling."[3]

So as to render the emotional and intellectual truths of a multidimensional and rapidly changing world, early-twentieth-century artists talked about a fourth and even a fifth dimension in art, even as they resisted any doctrinaire approach to art and purposefully renounced theories as stultifying. Cubist artists sought to depict an "intellectual conception and not visual appearance, encapsulating what is known rather than what is merely seen."[4] Pablo Picasso, one of the leading figures of Cubism, often noted the elusive dimensions of the known world, which he brought to his canvas by painting what he could not see directly with his eyes. The writer Ernest Hemingway, who adopted Cubist techniques in trying to write the way the painters painted, caught the power of invisible space by choosing to omit rather than add physical detail to his stories. When the writer knew what he was leaving out of the story, Hemingway said, the reader would feel it more than understand it. This idea of feeling life more acutely had something to do with the post–World War I world, which to Hemingway and his colleagues seemed shattered and misaligned, and in many ways lost. Archibald MacLeish came to believe

Detail from a photograph of Ernest Hemingway fighting a bull in "The Amateurs," Pamplona, Spain (see p. 150).

that Gertrude Stein got it wrong, however, when she called them a "Lost Generation." "It was not the Lost Generation which was lost," he said, but "the world out of which that generation came."[5] Following the war, this generation of artists would discover that world by reinventing it as they lived it, primarily within a Cubist framework.

Fernand Léger, one of the early Cubist painters and among the first of this group to meet the Murphys, articulated well how quickly and permanently this new vision, characterized by oddly skewed and overlapping planes and angular juxtapositions and layers of shadow and light, would usurp the way they saw and experienced the world. "Days and nights, dark or brightly lit, seated at some garish bar," he wrote, the "epic figure who is variously called inventor, artist or poet" would literally see and enter the surrounding world on Cubist terms. He would experience "renewed visions of forms and objects bathed in artificial light. Trees cease to be trees, a shadow cuts across the hand placed on the counter, an eye deformed by the light, the changing silhouettes of the

Juan Gris, *Guitar and Pipe*, 1913. Oil and charcoal on canvas, 25 ½ × 19 ¾ in.

passers-by." What would emerge is "the life of fragments: a red finger-nail, an eye, a mouth. The elastic effects produced by complementary colours . . . in the whole of this vital instantaneity which cuts through him in every direction. He is a sponge: sensation of being a sponge, transparency, acuteness, new realism."[6]

Acting upon and living this "new realism," Léger, along with the Murphys and their friends, felt a spiritual kinship with the earliest Cubist artists, who believed "that they were creating a new language not only for their contemporaries but also possibly for the future, and that they were doing so in a spirit of brotherhood among men."[7] Artistic collaboration in a communal spirit seemed particularly important to the Cubist founders, who challenged the artistic conventions of the day. As they gathered in the early 1900s at the Abbaye de Créteil, a commune situated outside Paris, they discussed "wide-ranging themes of modern life" while also establishing "a communal life of artistic production" influenced by early notions of Cubism.[8] By 1909 some of them had begun to meet at the home of Alexandre Mercereau, one of the commune's founders, who encouraged an interdisciplinary exchange between painters and writers. Paul Fort furthered this conversation at his Tuesday evening gatherings of writers and artists at the Closerie des Lilas in Paris (where Hemingway would later craft his taut Michigan stories that became *In Our Time*). After several of these artists working in the Cubist mode exhibited their new art at the 1911 Salon des Indépendants, they continued to meet regularly at the studio and garden of Jacques Villon and Raymond Duchamp-Villon, for they cherished the collaborative spirit that underscored "the role of art in coming to terms with modern life, and with its increasingly fragmented and condensed experience."[9]

Although Cubism as a formal "movement" seemed to end with the outbreak of war in 1914, its ideals as defined within "a spirit of brotherhood" still worked their magic on artists like the Murphys and their friends, who established, during an all too brief period during the 1920s, their own personal and artistic "collective" at the Murphys' Villa America on the French Riviera. F. Scott Fitzgerald, in *Tender Is the Night,* captured the feel of sitting on La Garoupe beach, "under the filtered sunlight of [the Murphys'] umbrellas, where something went on amid the color and the murmur." Here, indeed, was "the centre of the world" wherein "some memorable thing was sure to

Yoga on La Garoupe beach, 1926. The Murphys' "American" canoe can be seen on the right.

happen." The novel's naive Rosemary Hoyt recognizes while observing this group that "they seemed to have a very good time," and all with an air of "expensive simplicity." But Rosemary was "unaware" that "the simplicity of behavior, also the nursery-like peace and good will, the emphasis on the simpler virtues, was part of a desperate bargain with the gods and had been attained through struggles she could not have guessed at."[10] And so it was with the Murphys and their circle.

The stories of this richly inventive group of artists—predominantly American writers—have assumed almost mythic proportions over time. Edmund Wilson, a literary critic and contemporary of this group, recognized that with such "amusing or romantic" characters as Fitzgerald and the Murphys, "anecdotes grow rapidly into legends."[11] Certainly the anecdotes associated with life at Villa America are difficult to sort through and verify. The Murphys, with their zest for living and their determination to remain brave in the face of life's capricious cruelties, were the stuff of myth. Those who partook of rich summer days at Villa America in the 1920s looked back at those times as special, for the Murphys made liv-

ing an art. "We will never feel quite so intensely about our surroundings any more," wrote Fitzgerald in retrospect.[12] On the beach and on the Murphys' garden terrace, the days were filled with the bonhomie of games, conversation, drink, and good food. Sara Murphy recalled that the gaiety stemmed not so much from parties as from mutually felt affections: "You loved your friends and wanted to see them every day, and usually you did see them every day. It was like a great fair, and everybody was so young."[13]

To the degree that the Murphys' lives embodied both the allure and the devastation of the era, they have emerged in later years as the most compelling metaphor for the 1920s. Indeed, they stand at the emotional center—in direct and indirect ways—of much of the era's art, including its painting (inspiring works by Picasso and Léger) and, even more pervasively, its literature. Gerald and Sara Murphy and life at Villa America indelibly informed such American literary works as Fitzgerald's *The Great Gatsby* and *Tender Is the Night;* MacLeish's poetry and his verse play *J.B.;* Philip Barry's *Hotel Universe* and *Here Come the Clowns;* Donald Ogden Stewart's *Mr. and*

Mrs. Haddock Abroad and his memoir *By a Stroke of Luck!*; and countless other memoirs by such American writers and journalists as John Dos Passos, Lillian Hellman, and Hemingway. Although Hemingway's Paris memoir (published posthumously in 1964 as *A Moveable Feast*) draws heavily on the Murphys (identified as "the understanding rich"), his complicated understanding of the Murphys, and particularly Gerald, also influenced his earlier fiction, including *For Whom the Bell Tolls* (as this essay will demonstrate).

In addition to the many literary works inspired by the Murphys is a large body of letters written to and from the Murphys. These letters often stand individually as their own "framed" masterpieces. When gathered together—letters composed over a lifetime—they comprise a larger collective portrait of an era and its extraordinary art. MacLeish, whose lifelong correspondence with the Murphys enhances this portrait, recognized that those who romanticize the era tend to overlook the wider-ranging contribution of the "art of letters." "What was actually happening," MacLeish stated, "was that the arts—including the art of letters—were accomplishing what only rarely in human history they have accomplished as well: They were discovering a profound, and . . . unnoticed change in the human situation—the change for which *The Waste Land* and *Ulysses* and the *Cantos* created metaphors; the change which we all now recognize as real, but which no one recognized at all until Stravinsky and Picasso and Eliot and Pound and Joyce and the rest had given it form—forms."[14] Although MacLeish was primarily referencing here the art of literature, he also recognized that the art of letter-writing created its own forms and metaphors, and he believed that if Gerald had not been a painter, he could have been a writer, for he wrote like a poet.[15] Although most of the correspondents who comprised this group wrote eloquently and with a distinctive style, Gerald's letters in particular are masterpieces of conception—small paintings on paper. For example, his exact and elegant print neatly fills the spaces of a postcard, lining up around the sides to form a frame. Katy Dos Passos would comment that Gerald was the only one to create a "Post Card Style." "I am planning a monograph on this with examples," she told Sara Murphy on April 8, 1945. "It will be known as the Murphy Telescope Style or something of that kind—probably just known as 'the Murphy Style.'"[16]

Whereas the more traditional collection of letters fo-

cuses on the correspondence of one individual, or of two individuals in a back-and-forth epistolary relationship, a group correspondence allows for the more Cubistic layering and angularity that emerges from a multiplicity of voices. A group correspondence is unusual, however, primarily because the bulk of the letters often become lost to time. Fortunately, many of the artists who associated with the Murphys became famous early on and saved their correspondence, much of it now available in archives or in private collections, and also as published most fully in *Letters from the Lost Generation: Gerald and Sara Murphy and Friends*.[17] Arranged chronologically with a cross-cutting of multiple writers and respondents, the epistolary canvas as represented in this book of letters resonates with innuendoes, relative truths, omissions, distortions, clarifications, and qualifications—all to highlight finally the things not seen directly. In sum, it evokes the continuity of the lived life that the Cubist artists hoped to reproduce in their art by rendering images and perspectives both sequentially and simultaneously. It also provides clues to understanding the omissions and distortions that contribute to the emotional veracity of the era's literature. Since the Murphys' emotional impact on the artists of this circle was profound and intricately woven, no one individual or work can render wholly or truthfully this story. Instead, their letters and their published literature, when read both in sync and in counterpoint, reveal the fuller narrative of how their relationships and their experiences together, particularly during the 1920s, shaped their art and recast their lives.

In order to understand the Murphy-related experience as its own Cubist portrait, it helps to remember the crucial role that multiple perspectives as related to storytelling played in modernist American literature. William Faulkner both innovated and perfected the technique of utilizing a collective voice in *The Sound and the Fury* (1929). In this groundbreaking work, Faulkner told the saga of the Compson family through four different points of view, beginning with the first-person perspectives of three of the Compson children and culminating with the perspective, as filtered through a more detached third-person voice, of the black matriarch Dilsey. Although these points of view stand individually, they also merge progressively and simultaneously into a collective voice, one epitomized by the inarticulate wailing of the retarded brother Benji, who yearns to recapture the innocence lost to time and human corruption.

Wien, I.
Maria Theresia Denkmal

Archibald and Ada MacLeish with Sara and Gerald Murphy,
Vienna, 1927.

The multiple voices that comprise the collective story of the Murphys and their friends include most of the American writers who became intimates of the Murphys during the 1920s and who also, as in Faulkner's novel, yearned later to recapture a paradise lost. John Dos Passos was among the first to meet the Murphys and to experience the Riviera paradise, and MacLeish thereafter called him the "Pathfinder." Archie and his wife Ada met the Murphys in 1923, the same year as did Dos Passos, followed soon thereafter by Scott and Zelda Fitzgerald. By 1925 the Murphys had met Donald Ogden Stewart, Robert Benchley, Alexander Woollcott, and Philip Barry (New York luminaries variously associated with the *New Yorker* magazine, the Algonquin Round Table, Broadway, and radio). They had also met Ernest and Hadley Hemingway, at the urging of Scott Fitzgerald, and Pauline Pfeiffer (who became Hemingway's second wife in 1927). Immediately upon meeting the Murphys, most of

these friends agreed with Dos Passos's description of the good life, as it appears in a letter he wrote to a friend back in New York. Dos Passos reported that he was "working in a red plush room at the Murphys' place at Antibes" and was "being 'entertained' as the New York Herald would say with great elegance and a great deal of gin fizz. Wonderfully good bathing. The Riviera in summer is a strange and rather exciting place."[18] This description of paradise evokes that brief period during the 1920s that Gerald and the others would later try to recapture in memory and in art. As Gerald recognized, though, when he told Sara that it was "right to preserve a memory if one can," emotional time would always be disproportionate to real time.[19] Only in art could life be invented and contained. Although the Murphys closed up Villa America and returned to the United States in the early 1930s, primarily because of the illness of their son Patrick, they believed then that they would return. As the passing years brought the deaths of both their sons (Baoth in 1935, Patrick in 1937), however, they never reopened the villa. When Gerald revisited Paris and the Riviera following World War II, he hesitated to return to Villa America, for he was "prepared to be saddened." "But no!" he told Sara in a June 30, 1950, letter, "immediately one is caught up by the compelling beauty of it—that shining *transparent* sea. . . . The villa *is* untended in appearance, but the garden no! The palms, the large conifer, the linden, the eucalyptus (like a tower) have now eclipsed the view of the water, so that it's a secret garden, not the free outlook it had."[20] Although they would not return to live there permanently, Gerald believed, as he told Fitzgerald after the death of Patrick, that Villa America would remain alive in memory. "Houses and gardens," he wrote Fitzgerald on March 1, 1938, "devised for a life that's been telescoped, stand breathing."[21]

Although most of Gerald's letters, like this one to Fitzgerald, are richly allusive and lyrical, they can also seem veiled—either because they are too controlled or too hyperbolic. This was certainly the case with his letters to Hemingway that he wrote shortly after they met in late 1925. These letters represent the bulk of the extant letters from that decade (probably because these friends did not correspond as much during the years they saw each other often, between 1925 and 1929), and they reveal how extensively the Murphys, and especially Gerald, influenced the literature of Hemingway as well as Fitzgerald. Gerald's letters written to Hemingway during

1926 seem particularly powerful and complicated, because of the great degree to which they set in motion the emotional dissonance that would come to characterize the collective correspondence of all these artists and also the art of the day. Gerald's letters to Hemingway and Hemingway's letters to Sara of the 1930s work in tandem to illuminate the predominant artistic theme of the era: life as one would like it to be stands always in stark conflict with life as it is.

Most American literature of the 1920s builds around this conflict between the dream and the reality of life. Fitzgerald's *The Great Gatsby*, which he was completing during 1924, the first year he came to know the Murphys in France, most epitomizes this conflict, expressed through Jay Gatsby's profound belief in the dream that shimmers atop the underbelly of that dream. Fitzgerald captures the conflict in the contrasting imagery of the evocative social swirl: the flowery, drifting party versus the dusty, cigarette-butt residue of the party's aftermath. Even the narrative structure of the novel creates that jarring contrast between the ideal and the real as the work zigzags toward its final tragedies, cutting back and forth between yearning and outreach and violence (revealed in such images as the spinning wheels of Owl Eyes's car after it has crashed at the end of Gatsby's party). Each chapter in the novel begins with the dreamy ideal and ends in the harsh violence of the real, setting up repeated and jarring juxtapositions as in a Cubist painting. The epicenter of that conflict comes when Gatsby meets Daisy Buchanan after five years of dreaming of her. Since no reality could ever hold up to the power of that imagined ideal, the novel's narrator, Nick Carroway, describes the bewildered look on Gatsby's face and the sense of the lost dream that floats around Carroway's parlor, where the meeting between Gatsby and Daisy has been staged. Even before it has begun, the dream has already ended.

The conflict that defined much of the era's literature and art, including painting, dance, and music, most often created dissonance rather than artistic resolution. As MacLeish understood well, "the shimmer and sheen of the inventiveness" of the era's art merely succeeded in heightening the "tragic depth of the theme."[22] Ironically, shortly after many of them had first begun to gather on the terrace of the Murphys' newly renovated Villa America in 1925, they discussed in the abstract this idea of tragedy. John Peale Bishop's ideas on tragedy had stimulated their thinking, and MacLeish wrote to Bishop to relate to him their discussion about terror, which Bishop had defined as "the horror of evil, of unexpected, sharply contrasted depravity, of helplessness before one's own nature—*not death, but life and its terrible possibilities.*"[23] Murphy and MacLeish had agreed with this idea. "So completely obvious!—like all profound observations," MacLeish told Bishop. "We are afraid of our own lives—and beside that fear, death, which is at least a fact, is a small matter."[24]

None among this group felt that helplessness more than Gerald, who agonized over what he regarded as his personal weaknesses, and who gave up his painting in the face of life's terrible complications, which for the Murphys included the tragic and untimely deaths of both their sons. Although Murphy's recognition of what he called his "personal defects" troubled him and his relationships throughout his life, his personal turbulence seemed to peak during the years he was painting. The emotional honesty that modernist art demanded required that the artist look both outward and inward simultaneously, and Murphy's *Portrait* (1928, p. 115)—a starkly segmented collage and one of his final paintings—reflects his personal and artistic fragmentation. Some critics regard this work as modern art's most detached and coldly analytical self-portrait. Because Murphy felt that no one could ever possibly like him for himself, he engaged in a process of self-invention that became a form of self-protection. He believed that if this invented self could attract people to him, it could simultaneously prevent them from seeing his real self. Although everyone who knew Murphy recognized his originality—that creative vision that ordered Murphy's art and his life—it was Fitzgerald who perceptively accused Murphy of "keeping people away with charm."

When MacLeish demanded an explanation for Murphy's unwarranted coldness to him in late 1930, Murphy wrote him a long and self-revealing letter. You see, Murphy told MacLeish, "I have never been able to feel *sure* that *any*one was fond of me, because it would seem to be too much to claim, knowing what I did about myself": "Eight years of school and college, after my too willing distortion of myself into the likeness of popularity and success, I was left with little confidence in the shell that I had inhabited as another person. . . . My subsequent life has been a process of concealment of the personal realities,—at which I have been all too adept. They were not the most important things necessarily, but they were

the things which nourish human relationships. What I have contributed to this was 'ersatz',—and I have begun to pay for it."[25]

That Murphy had already begun to pay for the ersatz quality of his relationship with Hemingway by the time he made these confessions to MacLeish in early 1931 becomes graphically demonstrated through the letters that he wrote to Hemingway shortly after they met in late 1925. At that time, Murphy was already a recognized painter. He had exhibited in the major shows and salons of Paris, and both Picasso and Léger thought he was the best American painter working in the modern manner. Hemingway was still relatively unknown, although *In Our Time* had just been published in the United States and critics were beginning to recognize this new, modern literary voice. Dos Passos, the "Pathfinder" (or as Hemingway would call him in *A Moveable Feast*, the "pilot fish"), had been anxious for Murphy and Hemingway to meet, and he brought Hemingway to the 1925 Salon des Indépendants, where Murphy was exhibiting *Watch* (1925, p. 95). It was probably not until later that year, however, when Hemingway would once again see Murphy at the *L'Art d'aujourd'hui* exhibit (where *Watch* was again on show) that they solidified their relationship.[26] Hemingway had consciously been modeling his cubistically layered style after the modern painters, and he was immediately taken with the precision and complexity of Murphy's *Watch,* which rendered simultaneously the mechanisms of exterior and interior time. He was also taken with both Gerald and Sara—"grand people," he would tell Fitzgerald.[27]

Hemingway's feelings toward Gerald would later sour, however. As Hemingway lived and worked in the unheated Paris studio that Murphy loaned him during the fall of 1926, he talked repeatedly with Murphy about his personal remorse and uncertainty over leaving his wife, Hadley, for Pauline Pfeiffer. Murphy advocated specific steps that Hemingway should take, asserting that Hemingway's "remorse and self-reproach" had "already tended to blur the facts." Above all, Murphy advised in a letter of September 6, Hemingway should act "cleanly and sharply" in upholding his separation from Hadley. Murphy claimed to be acting on principle: he felt that Hadley had become "miscast" for her role as keeper and guardian of Hemingway's talent. Hemingway must consider his talent foremost, he said: "I'll go down (in your estimation if necessary) fighting just to state my belief and god-almighty valuation of that thing in you which life might

trick you into deserting." This letter starkly contradicts the letter Murphy had written Ernest and Hadley just months before, in mid-July, after returning from spending the week in Pamplona with them. Here, Murphy emphasized how "right" Ernest and Hadley were for each other: "As for you two children: you grace the earth. You're so right: because you're close to what's elemental. Your values are hitched up to the universe." Hemingway must have noted Murphy's radical emotional shift and become suspicious, especially in light of the letter's overall tone, which was a little too bold in its intimacy. "What follows will be read by only you and me," Murphy stated prior to launching into his no-holds-barred assessment of Hadley and her relationship with Hemingway.[28] Hemingway realized later that Murphy had gone too far in making assumptions about Hemingway's personal life, and he decided that Murphy—who he now believed was too much of a dandy and lacked personal consistency—could not be trusted.

Hemingway's remorse and rancor about Gerald eventually worked its way into the manuscript for *A Moveable Feast.* "I had hated these rich," Hemingway wrote in an excised portion, "because they had backed me and encouraged me when I was doing wrong. But how could they know it was wrong and had to turn out badly when they had never known all the circumstances?"[29] Indeed, Hemingway's memoir illustrates how swiftly life can turn and how starkly life as one would like it to be conflicts with life as it is. Hemingway noted his regret, for example, that after meeting Gerald he had read aloud his finished draft of *The Torrents of Spring* to both Gerald and Sara—"which is about as low as a writer can get and much more dangerous for him as a writer than glacier skiing unroped before the full winter snowfall has set over the crevices." He blasted both of the Murphys as the "understanding rich who have no bad qualities" until "they have passed and taken the nourishment they needed," leaving everything dead behind them, but Gerald seems to have been his primary target; Sara becomes implicated more by association than for any negative feelings he harbored toward her. While he was at work on *A Moveable Feast* in 1958, he confessed to MacLeish that while he "never could stand Gerald . . . but did," he "loved Sara," adding that concerning "poor Sara and Gerald," he would not "write about it" in his letter.[30] Instead, he clearly had determined to convey those feelings more graphically in the emotional undercurrents of his manuscript.

That Hemingway loved Sara becomes evident in the

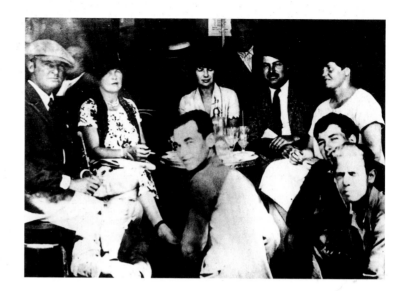

Gerald and Sara with Pauline Pfeiffer
and Ernest and Hadley Hemingway
(with bootblacks), Pamplona, Spain,
summer 1926.

Ernest Hemingway fighting a bull in "The Amateurs," Pamplona, Spain, 1925.

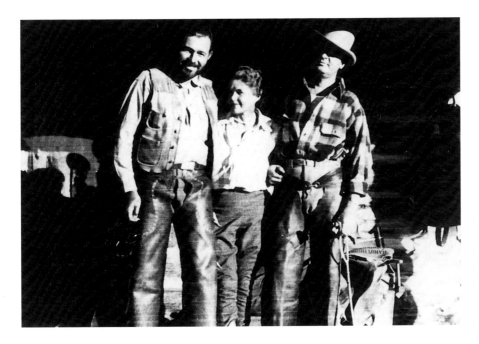

Ernest Hemingway
with Sara and Gerald
at Nordquist L Bar T
Ranch, Wyoming,
September 1932.

letters they wrote to each other during the 1930s, letters that also provide the counterpoint for Gerald's letters to Hemingway during the 1920s. To the great degree that Gerald's letters seem strained and emotionally unreliable, yet nonetheless effusive, Hemingway's letters to Sara seem equally effusive but honest in the candor, respect, and love that characterized their relationship. "Dear beautiful Sara" (or variations thereof), Hemingway would begin, whether he was writing from Key West, where he lived with Pauline during the 1930s, or from Cuba, where he had moved with his third wife, Martha Gellhorn, by the start of World War II. He often ended his letters to Sara in characteristic Hemingway style, using repetition for emphasis, as on December 8, 1935: "With very much love much love and love also with love, Ernest."[31]

Sara and Hemingway corresponded throughout the 1930s, and they also saw each other often, in Wyoming, or in Florida, or in upstate New York, where Sara stayed in Saranac Lake with Patrick during his extended (and ultimately unsuccessful) treatment for tuberculosis. Following Baoth's death in 1935, Sara struggled with a growing sense of isolation and despair in Saranac Lake. She also began to confront her marital strains with Gerald, who often stayed in Manhattan to manage the Mark Cross company while she remained with Patrick upstate. During these years, Sara continued to correspond with both Hemingway and Gerald. Sometimes written in

sync, these letters form their own Cubist narrative of this period, offering multiple and sometimes conflicting points of view, and they also complement one another by casting light on some between-the-lines implications. Taken together, all of this correspondence from the 1920s and 1930s demonstrates yet again how extensively the theme of life's tragedy extended out like a spiderweb into the intricately woven art of the day.

The marital strains that had begun to surface between the Murphys during the 1930s related to Gerald's ambivalent sexuality. Over the years, he had hinted at a repressed homosexuality in letters to Sara and to friends such as MacLeish, referencing what he called his "weakness" or "defect"; by 1936 he was naming it more openly as his "sexual deficiency." He and Sara discussed what they called "topic A" by way of letters, which seemed to loosen some of Gerald's constraint. In this correspondence, Gerald expresses the belief that in failing to deal with his sexual and emotional deficiencies, he had betrayed both Sara and himself. He tells Sara that he is "less of a believer" in relationships than she is because he does not "*admire* human animals as much": "I am not as capable (for a fundamental sexual deficiency)" and "I lack the confidence (quite naturally) to command it." "You are luckier than I am," he concludes. "I *fear* Life. You don't."[32] With this latter statement, Gerald evokes the definition of tragedy that he and his artist friends had

arrived at ten years earlier on Villa America's terrace: a fear of life exacerbated by one's helplessness in the face of himself.

As Gerald tried to understand what he saw as his own inadequacies and the Murphys struggled to resolve their marital strains, Sara turned increasingly to Hemingway for companionship and frank talk. She had just received Gerald's letter of April 16 acknowledging his sexual inadequacies and fear of life when she left for Key West, Florida, to spend a week with Hemingway on board his boat, the *Pilar*. Sara clearly shared with Hemingway her despair over Gerald's increased detachment, as it seems that she was more confident in challenging Gerald directly, by way of a follow-up letter, upon her return to upstate New York. Although her letter has not survived, Gerald's return letter to her makes clear that she had now questioned him explicitly about his possible homosexuality. Hemingway's own forthrightness with Sara about what he saw as Gerald's unreliability no doubt prompted this letter, which caught Gerald off guard. He took a while to think about Sara's direct question, "a poser," before responding on June 25. "I've thought about it much," he wrote, "but didn't feel up to answering it." "My ideas on topic A are so bad," he continued, "that even I think so. I'm afraid I've always skulked the question. Wanted to and was aided and abetted, I guess, by family and education." Gerald goes on to quote from his recent reading of Santayana's *Last Puritan*: "He had been brought up to believe that all women were ladies but not that ladies were women." "I'm not looking for alibis," Gerald concluded. "Too late, too late. People are defective. Life is defective. My defect though not openly ruinous affects life and people very fundamentally. . . . Unfortunately it gives one a feeling of inferiority." "As for changing," he speculated, "either it's impossible to change any thing so elementary,—or I'm too weak."[33]

Given the content of Sara's and Gerald's letters to each other, and their timing (sandwiching Sara's visit with Hemingway), Sara's probable discussions with Hemingway concerning Gerald's "defect" no doubt confirmed Hemingway's earlier suspicions. Gerald himself came to believe that Hemingway had sized him up from the beginning as a liar and a phony. Hemingway had put Gerald to the test in this regard in early 1928, when he confronted him, in an indirect yet patently clear way, about his sexual identity. Gerald later told Calvin Tomkins that Hemingway "was extremely sensitive to the question of who was [a homosexual] and who wasn't" and asked Gerald "casually": "I don't mind a fairy like X—, do you?" Although Gerald "had never met the man," he said, "No." "I have no idea why I said it," Gerald admitted, "except that Ernest had the quality of making it easier to agree with him than not. . . . Anyway, instead of saying I had never met the man I agreed with him, and he gave me a funny look. Afterward I almost wondered whether it had been a trap he laid for me."[34] Gerald seemed to know by 1928 that Hemingway had seen through his complicated lies, and he recognized also that Hemingway, at that precise moment, had written him off. Although Hemingway clearly and not altogether incorrectly blamed Gerald for his divorce and consequent remorse and unhappiness, the key to his troubled relationship with Gerald and his lifelong skepticism about him lies even further buried in another excised portion of *A Moveable Feast:* If the decisions that Murphy encouraged him to make "were wrong," Hemingway wrote, it was only because "they all turned out badly finally from the same fault of character that made them. If you deceive and lie with one person against another you will eventually do it again."[35] Essentially, Hemingway identified here the tragic character flaw that Murphy himself recognized but seemed powerless to change.

Without doubt, Hemingway's feelings about Gerald's unreliability influenced the narrative structures and themes of *A Moveable Feast*. His unsettling juxtaposition of the warmth of the Riviera sun with the harsh cold of Austria in winter, where mountain avalanches can suddenly slide and bury, captures his belief that he had been too "inexperienced" not to put his trust in Gerald and had not known "how not to be overrun and how to go away"; trusting the "pilot fish," he had followed the guidance of the "understanding rich," under whose charm he was "as trusting and as stupid as a bird dog who wants to go out with any man with a gun, or a trained pig in a circus who has finally found someone who loves and appreciates him for himself alone."[36] By allowing himself to be too easily led during a vulnerable time, Hemingway suspected that he had given in to the good life represented by Pauline's, and the Murphys', money and that he had ultimately betrayed his writing in the process. Gerald's appeal to his commitment as an artist—"I'll go down (in your estimation if necessary) fighting just to state my belief and god-almighty valuation of that thing in you which life might trick you into deserting"—rang hollow in light of Gerald's

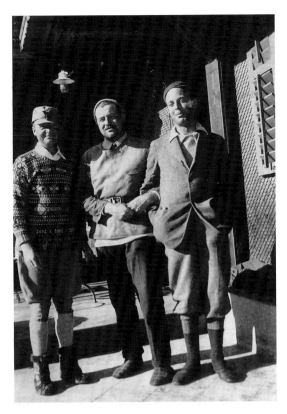

Gerald, Ernest Hemingway, and John Dos Passos, Schruns, Austria,
March 1926.

own later desertion of his painting, having allowed life's
cruel "tricks" to influence his fate as an artist.

Hemingway incorporated some of the same ideas
that appear in *A Moveable Feast* in his 1940 novel *For
Whom the Bell Tolls*. In many respects, this story of be-
trayal and loss and human interconnectedness, set in
Spain during the Spanish Civil War, is the emotional and
thematic predecessor of *A Moveable Feast*, for there are
strong parallels between the two works. Not unlike *A
Moveable Feast*, the novel opens with a description of
the protagonist, Robert Jordan, who is "young" and "ex-
tremely hungry" and "worried," as he moves "behind the
enemy lines in all this country": "It was as simple to move
behind them as it was to cross through them, if you had
a good guide. It was only giving importance to what hap-
pened to you if you were caught that made it difficult;
that and deciding whom to trust. You had to trust the
people you worked with completely or not at all, and you
had to make decisions about the trusting."[37]

Hemingway's complicated feelings about Gerald can
be unearthed here, as they can be in *A Moveable Feast,*
particularly when examined in light of a letter that Hem-
ingway wrote to Sara from Cuba on December 27, 1939,
as he was finishing work on the manuscript. In coded lan-
guage, Hemingway suggests that Sara and Gerald played
a significant role in his conception and execution of the
novel (further confirming that Hemingway's relationship
with the Murphys figured larger in his emotional life and
art than his biographers and literary critics have yet rec-
ognized). He begins: "Dearest Sara. Thank you for the
lovely letter. I had kept your other letter from France with
me always to answer. Had hoped we would all be in
France this fall. Then the war—and book still unfinished.
Now I will go in the spring when this is done. Am in the
last part now." Farther into the letter, he makes a seem-
ingly offhand reference to the novel: "I put a couple of
things in it for you that you may find some time."[38] De-
spite Hemingway's propensity to boast, he seldom told
friends he had written things for them, and this line should
be taken literally. Indeed, when analyzed in light of both
textual and biographical evidence (some of it further em-
bedded in epistolary clues), Hemingway's statement to
Sara suggests that he deliberately used both Sara and
Gerald as models for Pilar and Pablo, the leaders and
figureheads of Hemingway's fictional band of Loyalists
fighting the Fascists during the Spanish Civil War. Hem-
ingway was alerting Sara to this fact, perhaps, as a means
of both acknowledging and furthering their discussions
about her relationship with Gerald.

Imagining the beautiful Murphys of Villa America
fame as crude peasant stock might require a willing sus-
pension of disbelief except that Hemingway often used
real people, thinly disguised, in his fiction. He also em-
bedded insider references that those in the know would
recognize. By taking a physical reality and then distort-
ing or inverting it, he was better able to convey an emo-
tional truth. (He wrote in his preface to *A Moveable Feast:*
"If the reader prefers, this book may be regarded as
fiction. But there is always the chance that such a book
of fiction may throw light on what has been written as
fact."[39]) His portrayal of the Murphys as peasants ironi-
cally mocks their moneyed, elegant lifestyle, but it also
reflects their bohemian life in 1920s France—what Hem-
ingway later derided as their "fiesta" concept of life.
The Murphys' creative attire and their entertainments on
the Riviera—all orchestrated by Gerald—embodied a

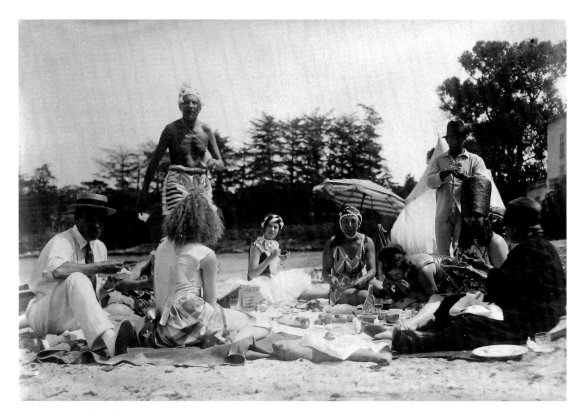

ABOVE The Mad Beach Party, La Garoupe beach, Antibes, July 1923, photographed by François Biondo. From left: Unidentified man, Ginny Carpenter (viewed from behind), Comte Étienne de Beaumont (standing), Olga Picasso, Comtesse Edith de Beaumont, Sara (biting food), Picasso (standing), Rue Carpenter, and Picasso's mother (in black).

RIGHT Gerald raking La Garoupe beach, Antibes, 1928. Gerald's orchestration of the day's events at Villa America extended to the beach, which he saw as a canvas. Wearing a bathing suit and a hat, he daily shaped and tried to control La Garoupe by raking it of seaweed.

BOTH PHOTOS GERALD AND SARA MURPHY
PAPERS, BEINECKE LIBRARY, YALE

gypsylike freedom and flair. At Villa America and on La Garoupe, Sara wore flowing skirts with scarves knotted about her waist, neck, and head, while Gerald dressed up in invented costumes, his favorite getup comprising a peasant shirt, gypsy pants, rope sandals, and a black cap. Sometimes Gerald provided their guests with "costumes," as during the summer everyone wore striped sailors' shirts that Gerald had discovered in a French market. Although Hemingway drew upon this spirited and colorful Villa America life in order to evoke in Pablo and Pilar the physical dimensions of the Murphys' characters and lifestyle, he primarily captured in Pablo and Pilar the Murphys' psychological complexities.

In Pilar, one of Hemingway's most powerful and unconventional female characters, Hemingway portrayed Sara's strength. He worked into the text the cadences and thematic thrust of Sara's 1930s letters to him, as when Pilar says to the novel's protagonist, Robert Jordan: "Everyone needs to talk to someone. Before we had religion and other nonsense. Now for everyone there should be someone to whom one can speak frankly, for all the valor that one could have one becomes very alone."[40] Although Gertrude Stein, with her Buddha-like build and demeanor, bore a strong physical resemblance to Pilar, Pilar's psychological qualities are identifiably Sara's: her intuitive knowledge (Harry Crosby described her as "sphinx-like but knowing"[41]); her immediate understanding of situations and people; her graphic awareness of life's brutalities (two sons dying at the age of sixteen); her forthright talk; her anger. Sara vented her anger at friends, such as Fitzgerald, who exasperated her, just as she cursed a cruel God, raising her fist high as she stalked Park Avenue following her first son's death in 1935.[42] She told Fitzgerald in a letter written shortly thereafter that she now felt a "sympathetic vibration" for Zelda's inner turmoil, which she called Zelda's "violence."[43] MacLeish believed that Sara's "reticence" comprised "her power of feeling what she had not put in words."[44] He also said that Sara was "all woman."[45] In her femininity, however, Sara exuded a certain masculine power, such that she preferred being with men and was to her male friends, including Hemingway, a comrade. Hemingway tells Sara in a letter of late December 1940 that he has "no closer friend" than her and that they are "the only two non serious people left."[46] Like Sara, Pilar has a healthy temper, a rich, throaty laugh, a comfortable sense of self, and a no-nonsense demeanor.

If Pilar is a woman of straightforward reliability, she has a husband who is neither simple nor trustworthy. When Agustin (also a member of the Loyalist group) compares Pilar and Pablo, he could just as well be talking about Sara and Gerald: "'No Pilar,' Agustin said. 'You are not smart. You are brave. You are loyal. You have decision. You have intuition. Much decision and much heart. But you are not smart. . . . Pablo I know is smart.'"[47] Because he is smart, Pablo is dangerous and, as Robert Jordan recognizes, "very complicated." Sara acknowledged openly that she was of the heart, while Gerald was of the head. In a letter of August 20, 1935, she tells Fitzgerald that "it seems not to matter *nearly* so much what one thinks of things— as what one feels about them."[48] Gerald, in contrast, used his intellectual bent to distance himself from life, even as he tried to organize it. He repeatedly apologized to his friends for being "super-organizational" and agonized over his ultimate inability to control life.[49]

Hemingway's many coded references to Gerald throughout *For Whom the Bell Tolls* confirm his understanding that Sara would pay heed to the subtext of his novel. From the opening description of Pablo, Hemingway begins to emphasize his round head as a characteristic feature. Gerald was self-conscious most of his life about the shape of his head, which he thought was too round. In several of Sara's earliest letters to Gerald, written while they were dating, she jokingly calls him "fat face," and later Gerald himself would self-mockingly refer to his "Irish moon face," which he tried to square off with sideburns and hats, the latter of which might also have been worn to disguise his slightly balding pate. Hemingway's description of Pablo stresses that "his face was almost round and his head was round," and he refers as well to Pablo's balding head. In addition, Hemingway emphasizes Pablo's organizational skills: "Pablo is an organizer," says Pilar, as he organizes people gathering in a plaza into lines. Pablo is vehemently anti-Catholic, hating priests "even worse than he hated Fascists," recalling Gerald's rejection of what he saw as the Catholic rigidity and pretense of his upbringing. Finally, Pablo mirrors Gerald's moodiness and underlying sadness: in Pablo's sullenness "there was a sadness that was disturbing to Robert Jordan. He knew that sadness and to see it here worried him. . . . I don't like that sadness, he thought. That sadness is bad. That's the sadness they get before they quit or before they betray. That is the sadness that comes before the sell-out."[50]

Gerald with a beard, Switzerland, 1932.

Pablo's pattern of behavior throughout the novel—to turn tail and run during moments of crisis—reflects a pattern of behavior that both Sara and the Murphys' friends, including Hemingway, recognized in Gerald. In the face of himself and what he called his "ersatz" nature, Gerald often found it easier to avoid friends, as he did in 1930 while in the United States for a brief visit: "Gerald is here," MacLeish told Fitzgerald, "but no one has seen him. . . . Skulks like a shadow."[51] When Patrick took ill in 1929, Gerald went on a racing cruise and tried to ignore Sara's telegrams imploring him to return. Sara believed that Gerald had reneged on his responsibilities and was consequently betraying himself.[52] Shortly after this cruise, Gerald gave up painting and went with Patrick and the family to a sanitarium in Switzerland, where he increasingly turned inward, retreating at one point to a monastery nearby. Here he grew a beard (not unlike Pablo's stub-

ble) and contemplated quitting everything. MacLeish noted that in the end Gerald did something very Irish—he turned on himself.

After Gerald had quit painting and returned to the business world (having rejected it in 1921), he dubbed himself "the Merchant Prince." "I was never happy until I started painting," he confessed years later, "and I have never been thoroughly so since I was obliged to give it up." He questioned "how many aspiring American artists have been claimed by the harmful belief that if a business is your 'inheritance' that it is heresy not to give up all in favor of it." He recognized that "if one *is* to be a painter of note nothing really prevents it. . . . I cannot forget that Uccello suddenly gave up painting in favor of mathematics—but returned to painting after a long lapse."[53] Gerald never returned to his art, and, like Pablo, he seemed to know that he had betrayed his real work to become a capitalist and to live the good life. In Hemingway's novel, Anselmo denounces Pablo for betraying himself and his calling: "Until thou hadst horses thou wert with us. Now thou art another capitalist more." Robert Jordan, though, understands the power of those horses and the strong allure of the good life: "'The old man was right,' he thought. 'The horses made Pablo rich and as soon as he was rich he wanted to enjoy life. Pretty soon he'll feel bad because he can't join the Jockey Club.'"[54]

Although Gerald had renounced the country club set that he and Sara had left behind in New York during the 1920s, Hemingway seemed to feel that he embraced that clubbiness once again when he returned to New York and the life of money in 1933. As Hemingway makes sardonic references to Pablo's "Palace of Fear," he simultaneously mocks Gerald's elegant lifestyle, his fear of life, and his personal and artistic betrayal. From the first moment that Robert Jordan sees Pablo, he knows that Pablo cannot be trusted, for Pablo has turned—on the cause, on others, and, most significantly, on himself. Pablo embodies the betrayal and the uncertainty around which the novel revolves, and he is very much Gerald as Hemingway had come to see him. Self-emasculation runs as a major theme throughout the novel, with Hemingway repeatedly likening Pablo to an effeminate lover who has also become, in every respect, a coward. "But since a long time he is *muy flojo*," Anselmo says of Pablo. "He is very flaccid. He is very much afraid to die." And while he "was a very good man," as Pilar recognizes, he is now "terminated"—one of those Spaniards, Robert Jordan

perceives, who "turned on you. They turned on you often but they always turned on everyone. They turned on themselves too."[55]

Both *A Moveable Feast* and *For Whom the Bell Tolls* are about going into new, unknown country, determining who the enemy is, and discovering that the enemy is yourself when you allow yourself to be duped and to lose hold of the center. Toward the end of *For Whom the Bell Tolls,* Robert Jordan reflects upon the complications of the Spanish fighting, where there are no clear sides and issues of trust and confidence assume huge proportions: "If a thing was right fundamentally the lying was not supposed to matter. There was a lot of lying though. He did not care for the lying at first. He hated it. Then later he had come to like it. It was part of being an insider but it was a very corrupting business."[56]

When *A Moveable Feast* came out in 1964, three years after Hemingway's death and just a few months before Gerald's, Gerald read it and wrote to MacLeish about it on May 30, 1964: "I am—*contre coeur* [reluctantly]—in Ernest's book. What a strange kind of bitterness—or rather accusitoriness. Aren't the rich (whoever they are) rather poor prey? What shocking ethics! How well written, of course. What an indictment." Murphy's reference to Hemingway's "rich" seems a bit disingenuous since he does not state directly that he sees himself as being implicated; instead, he ends his comments to MacLeish by saying, "Poor Hadley."[57] Whether or not he recognized, or allowed himself to see, Hemingway's use of him in *A Moveable Feast,* he probably did not recognize himself in *For Whom the Bell Tolls.* Sara no doubt did, however, given Hemingway's letter to her referencing the things he had put in the novel that she "may find some time."

Shortly after Fitzgerald's *Tender Is the Night* was published, in 1934, Hemingway wrote to Fitzgerald to express his belief that he had modeled Dick and Nicole Diver after Gerald and Sara without knowing anything about their psychological complexities. Fitzgerald had romanticized them, Hemingway told him, so as to capture their charm but not their real character; though he had created a "marvelous description of Sara and Gerald," he had then "started fooling with them, making them come from things they didn't come from, changing them into other people." "You can take you or me or Zelda or Pauline or Hadley or Sara or Gerald but you have to keep them the same and you can only make them do what they would do. . . . Invention is the finest thing but you cannot invent anything that would not actually happen." He adds: "You could write a fine book about Gerald and Sara for instance if you knew enough about them and they would not have any feeling, except passing, if it were true."[58]

Hemingway reread *Tender Is the Night* a couple of years later, as he was at work on *For Whom the Bell Tolls,* and he came to change his mind about Fitzgerald's novel, which he found on the second reading to be far more powerful in accurately rendering the Riviera experience with the Murphys. As he wrote to Maxwell Perkins on March 25, 1939: "I found Scott's *Tender Is the Night* in Cuba and sent it over [to Key West]. It's amazing how *excellent* much of it is. If he had integrated it better it would have been a fine novel (as it is) much of it is better than anything else he ever wrote." In fact, he concluded, "much of it was so good it was frightening."[59] It is perhaps telling that Hemingway was rereading Fitzgerald's Riviera novel as he began his own "fine book" on the Murphys. While he seems to have softened his stance regarding Fitzgerald's characterizations of the Murphys, he clearly believed now that he knew enough about Gerald and Sara to "only make them do what they would do" and that "they would not have any feeling, except passing," because it was "true." Sara had been furious over Fitzgerald's use of them in *Tender Is the Night,* probably because Fitzgerald had made a big deal out of it, telling everybody that the book was about the Murphys and even formally dedicating the book to them ("To Gerald and Sara MANY FETES"). Perhaps Hemingway made that seemingly passing reference in his letter to Sara—that he had put things in the novel for her—to deflect the larger implications of his use of her and Gerald as models for two of his characters. Certainly, both Sara and Hemingway were aware of the deeper, unspoken emotional levels of their relationships to each other and to Gerald. If Sara did discover the specific parallels in Hemingway's novel, no evidence of her reaction to the book remains. Indeed, her relationship with Hemingway had abated and their correspondence, for the most part, ceased, once Hemingway had married Martha Gellhorn and published *For Whom the Bell Tolls.*

It is interesting to note, though, the final parallels with the Murphys in the novel's characterizations, particularly in the way that Pablo and Pilar have made certain accommodations and compromises by the end of the novel. Although Pablo remains a coward, Pilar clearly continues to love him, and she and Pablo leave together

for the city with Maria, their "adopted," war-ravaged "daughter," between them. After the loss of their sons, Gerald and Sara gathered their forces and, with their one surviving child, Honoria, moved to New York. MacLeish described later how, following Patrick's death, "there was a bleak, blank memorial service in an empty New York church—a service in which the silences were like the confrontation with the Voice out of the Whirlwind in the Book of Job—and then the three survivors moved into an apartment near the family business (near also, ironically enough, the Museum of Modern Art, which Gerald passed in the mornings, turning his head away). There Gerald took for himself a small bedroom, bare as a monk's cell, where he seemed to close the door upon his life."[60]

MacLeish believed that Gerald was, above all, "an artist of major importance (Picasso thought him the best American painter of his time and the Modern Museum Show supports the judgment)," but that his significance had become lost to his "irrelevant fame as a character in contemporary fiction." In correspondence written prior to his death in 1982, MacLeish described himself as "a last survivor" who worried that enthusiasts had gotten everything wrong about the 1920s and especially about Gerald, who was too often regarded as a "dilettante": "I care deeply about G.M.'s reputation and I'd like to do what I can for it. But not at the dilettante level of which you rightly speak. Any one who thinks he was a dilettante is too ignorant to bother with." MacLeish believed in particular that Fitzgerald's *Tender Is the Night* had unduly fostered a slick and superficial rendering of Gerald: "Scott tried to make a Proustian character out of Gerald in *Tender Is the Night* and failed—and precisely for that reason."[61]

Gerald had come to feel that Fitzgerald had gotten it right in his novel, however, in its anticipation of life's complications smothering a dream. Although the novel came out in 1934, it was not until after Baoth's death in 1935 that Gerald fully appreciated how Fitzgerald had discovered, with awful clarity, the prominent theme of their real-life story: "You are the only person to whom I can ever tell the bleak truth of what I feel," he told Fitzgerald on December 31, 1935. "I know now that what you said in 'Tender is the Night' is true. Only the invented part of our life,—the unreal part—has had any scheme any beauty. Life itself has stepped in now and blundered, scarred and destroyed. . . . How ugly and blasting it can be,—and how idly ruthless."[62] Gerald, having come to

recognize that life would never be as he would like, despite his best attempts to manipulate it, was speaking as Dick Diver would have spoken in the novel's aftermath. The repeated coming together and jarring of the romantic and the realistic lends the novel its creative tension, just as it came to define the metaphoric dimensions of the Murphys' lives—and the thematic and aesthetic center of modernist art. To the degree that their lives both engaged and illustrated the romantic dreams and the nightmares representative of the day, the Murphys became larger than life and an artist's dream to depict.

If Hemingway was initially drawn by Gerald's inventiveness and charm, so too was Fitzgerald. And both artists recognized Gerald's complications as they used him in their fiction. Fitzgerald, who wanted to see the Murphys, and particularly Gerald, in a romantic light, could not, in the end, do so. By the early 1930s, the reality of life had intruded to destroy the romance, causing Fitzgerald to look more deeply into Gerald's character as he reworked the novel prior to publication. In the end, Dick Diver did not become Fitzgerald (as so many literary critics, including Hemingway, have suggested) so much as he took on the basic personality of Gerald, including the "flaw" that plagued him and influenced his relations with his friends. Diver, like Gerald, suspects an inner weakness of character that he tries to overcome by acting in ways contradictory to his true desires; as his organizational capacity increases, he suffers a disintegration of self. Beneath the surface charm of both Diver and Gerald were troubled souls.

Dick Diver's appearance and his actions clearly resemble Gerald Murphy's as Fitzgerald knew him in France during the 1920s. Diver's complexion, like Gerald's, is "reddish and weather-burned," his eyes "bright, hard blue," his nose "somewhat pointed"; and "there was never any doubt at whom he was looking or talking," for his gaze was direct, attentive. "His voice, with some faint Irish melody running through it, wooed the world," and people who were with him "felt the layer of hardness in him, of self-control and of self-discipline."[63] Fitzgerald often thought about Murphy in terms of his actions: "Gerald walking Paris," he wrote in his notebook, or "Gerald's Irishness, face moving first" (a line that he subsequently used in the novel), or his "last afternoon with Gerald, for benefit of two women. Portentousness." He studied Gerald's moves even as he mocked them, for he could appreciate the drama inherent in his style and in his life, and

Gerald fascinated him. "When I like men I want to be like them," Fitzgerald wrote. "I want to lose the outer qualities that give me my individuality and be like them. I don't want the man; I want to absorb into myself all the qualities that make him attractive and leave him out. I cling to my own innards."[64] His biographer Andrew Turnbull said that Fitzgerald "stood in awe of Gerald's unfailing propriety," and "what he admired about Gerald he put into the character of Dick Diver: the elegance, the turns of phrase, the flare for entertainment, above all Murphy's appreciation of others, his power to draw them out and see the best in them."[65] He also put into the character of Dick Diver the overriding self-doubts that helped form Gerald's identity as a person and as an artist.

Dick Diver, like Gerald, recognizes the paralysis of self-judgment. He believes he might be the best psychologist who has ever lived, even as he worries he is second-rate (like his colleague Gregorovious, who is satisfied with competence rather than greatness). He fears that he might accept life, professionally and personally, on a lower scale: "'God, am I like the rest after all?'—So he used to think starting awake at night—'Am I like the rest?'" To prevent his inner fears from squashing his potential brilliance, Diver works hard to dazzle and distract. He woos people "with an exquisite consideration and a politeness that moved so fast and intuitively that it could be examined only in its effect." If people choose to submit to the "amusing world" that he opens for them, "their happiness was his preoccupation." Yet knowing the effect he can have on people, he tends to work them over rather than genuinely love them. Nicole Diver comes to recognize that Dick's contagious excitement is "inevitably followed by his own form of melancholy" when he realizes "the waste and extravagance involved" as he compromises, out of fear and vulnerability, his talent. He wants to be recognized as a professional, but he also wants to "be good," "to be kind," "to be brave and wise." Even more than that, he wants to "be loved."[66]

So it was with Gerald, as Fitzgerald and Murphy's other artist friends seemed to understand well. Murphy's worry that his weak character might undermine his relationships and his art led him to confess to Hemingway, on July 14, 1926, that his desire to do things well was one of his great "complications." This came shortly after Gerald had listened to Hemingway read his work in progress, *The Sun Also Rises,* which anticipates the tragic undercutting of the years to come for this group of artists. Although Jake

Barnes and Brett Ashley yearn for each other in Hemingway's novel, they cannot realize each other fully because of Jake's war wound, which has rendered him impotent. Hemingway establishes parallel and yet contrasting cab scenes between Brett and Jake that underscore the impossible discord between their desires and their lived reality. The first cab scene, which follows their departure from a bar crowded with people, highlights Brett's exposure and vulnerability as it foreshadows her self-realization in the conclusion of the novel: "Well, we're out away from them," Jake says, prior to their getting into the taxi, which carries them "up the hill," past the "lighted square," then on into the dark, still climbing. Jake and Brett (previously "sitting apart") are "jolted close together" and her hat is off, suggesting self-exposure. With her head thrown back, the physical contours of Brett's face glow in the almost surrealistic lighting of the scene: "I saw her face in the lights from the open shops," Jake says. "Then it was dark, then I saw her face clearly." This view of Brett, highlighted by the glare of the workmen's acetylene flares on her face and neck, emphasizes her beauty: her "face was white," Jake says, "and the long line of her neck showed in the bright light of the flares. The street was dark again and I kissed her."[67]

As the keen darkness repeatedly shifts into a sudden and intense light, the highlighting and distortion of Brett's physical form allows for a glimpse into her emotional interior. Brett's eyes match this movement as they shift from flatness to open exposure, like the lens of a camera: "Her eyes had different depths," Jake says, and "sometimes they seemed perfectly flat. Now you could see all the way into them." As Brett looks out, Jake looks into Brett: "She was looking into my eyes with that way she had of looking that made you wonder whether she really saw out of her own eyes. They would look on and on after every one else's eyes in the world would have stopped looking. She looked as though there were nothing on earth she would not look at like that, and really she was afraid of so many things."[68]

Hemingway's use of the acetylene flares to emphasize the distortion created by harsh and suddenly shifting lighting might well have been influenced by Gerald, whose notebook entries from 1926 include one that describes "acetylene welders at work on constructed ironwork, goggles, light-flashes."[69] Hemingway was thinking about Gerald as he worked on the manuscript: for a period of time, he used Gerald's name for the character

Gerald on the terrace of Villa America,
c. 1926.

Photograph of Gerald taken with a hinged mirror, 1930. This photograph was made into a postcard, on the back of which is stamped: "Photographie J. Weiss, Basel." During the fall of 1930, while the Murphys were living in La Bruyère, Switzerland, waiting out Patrick Murphy's cure for tuberculosis, Gerald traveled to Basel to consult a Jungian analyst, Dr. Schmid-Guisan. How fitting that this portrait was taken at a time when Gerald was actively probing his identity. Gerald wears a black armband, indicating that he was in mourning (his father-in-law died in May 1930). Similar photographs exist of Marcel Duchamp and the author Henri-Pierre Roche, both taken in New York in 1917.

who would become, in the final version, Robert Cohn.[70] Since Cohn betrays everyone, including himself, by secretly running off with Brett while still adhering, unrealistically, to the romantic idea of life as portrayed in movies, Hemingway seemed to reinforce his own sense of betrayal as he brooded secretly over his impending separation from Hadley, for which he finally came to blame Gerald. In the novel's final cab scene, Brett tells Jake that they "could have had such a damned good time together."[71] The more jaded and realistic Jake responds: "Isn't it pretty to think so." His knowledge of the reality stands in stark and heart-wrenching conflict with the idea of the reality that they both might prefer.

One imagines that as Gerald and his friends discussed the idea of tragedy on that evening in 1925, the scene on the terrace, as observed by an outsider, might have mimicked Léger's description of how Cubism created for these friends a new way of seeing—skewed and angular and overlapping, with layers of shadow and light. One imagines that as they talked about how tragedy was not death but life, with its terrible conflicts between the dream and the reality, the Antibes lighthouse beam, way below and out beyond the terrace, would have spun in regular sweeping arcs. If only metaphorically, the light would have cast their faces and the terrace stones in starkly shifting patterns of light and dark, as it also highlighted, in staccato-like bursts, the interlocking branches of the linden tree. Philip Barry (who was there that evening) would later capture that tragic feel of broken spaces that grew out of their brief time together on the French Riviera. He describes the terrace in his play *Hotel Universe*:

like a spacious out-door room irregularly paved with flags of gray stone. The house itself forms one wall on the left, a wall from which two screened doors open—the first from a hall, the second from a sitting-room. Down Left, against this wall a flight of outside stairs, guarded by a slender iron railing, mounts to a balcony. The other entrance is at Right, down from the garden by stone steps. A three-foot wall follows the back and left sides of the Terrace just to where the row of small cypresses, which screens the garden terrace, begins. Over and beyond the wall nothing is visible: sea meets sky without a line to mark the meeting. There, the angle of the Terrace is like a wedge into space.[72]

Sitting at the center was Gerald Murphy, whose art and life reflected and refracted the "fragmentary and unconsoling" truths of an always unfinished Cubist narrative.

NOTES

1 Calvin Tomkins, *Living Well Is the Best Revenge* (New York: Viking Press, 1971), 25.

2 Ibid.

3 Herbert Read, *A Concise History of Modern Painting* (New York: Frederick A. Praeger, 1959), 81.

4 Bruce Altshuler, *The Avant-Garde in Exhibition: New Art in the Twentieth Century* (New York: Harry Abrams, 1994), 33.

5 Archibald MacLeish, "Expatriates in Paris," in his *Riders on the Earth: Essays and Recollections* (Boston: Houghton Mifflin, 1978), 92.

6 Léger, quoted in Read, *A Concise History of Modern Painting*, 88.

7 Josep Palau i Fabre, *Picasso Cubism (1907–1917)* (Barcelona: Ediciones Poligrafa, 1990), 23.

8 Altshuler, *The Avant-Garde in Exhibition*, 26.

9 Ibid., 31.

10 F. Scott Fitzgerald, *Tender Is the Night* (1934; reprint, New York: Charles Scribner's Sons, 1962), 18, 38, 26, and 29, respectively.

11 Edmund Wilson, letter to Arthur Mizener, April 4, 1950, in Elena Wilson, ed., *Edmund Wilson: Letters on Literature and Politics 1912–1972* (New York: Farrar, Straus and Giroux, 1977), 479.

12 F. Scott Fitzgerald, "Echoes of the Jazz Age," in *The Crack-Up: F. Scott Fitzgerald*, ed. Edmund Wilson (1945; reprint, New York: New Directions Paperbook, 1956), 22.

13 Quoted in Tomkins, *Living Well Is the Best Revenge*, 41.

14 MacLeish, "Expatriates in Paris," 90.

15 Archibald MacLeish, conversation with the author, October 17, 1979.

16 Katy Dos Passos, letter to Sara Murphy, April 8, 1945, in Linda Patterson Miller, ed., *Letters from the Lost Generation: Gerald and Sara Murphy and Friends, Expanded Edition* (Gainesville: University Press of Florida, 2002), 292.

17 Originals of the Murphys' letters to their friends are located in the following collections: Ernest Hemingway Papers, John F. Kennedy Presidential Library and Museum, Boston; Archibald MacLeish Papers, the Library of Congress, Washington, DC; F. Scott Fitzgerald Papers, Princeton University Library, Princeton, NJ; John Dos Passos Papers, University of Virginia Library, Charlottesville; Alexander Woollcott Papers, Houghton-Mifflin Library, Boston; and Robert Benchley Papers, Mugar Memorial Library, Boston University. Most of the letters to the Murphys are in the Donnelly Family Collection and in the Gerald and Sara Murphy Collection, Yale Collection of American Literature, Beinecke Rare Book and Manuscript Library, Yale University, New Haven, CT. The bulk of this correspondence has been brought together and published in Miller, *Letters from the Lost Generation*.

18 John Dos Passos, letter to John Howard Lawson, [Antibes, August 1924], in Townsend Ludington, ed., *The Fourteenth Chronicle: Letters and Diaries of John Dos Passos* (Boston: Gambit, 1973), 358.

19 Gerald, letter to Sara, April [May] 23, 1950, in Miller, *Letters from the Lost Generation,* 317.

20 Miller, *Letters from the Lost Generation,* 322–23.

21 Ibid., 207–8.

22 MacLeish, "Expatriates in Paris," 93.

23 MacLeish, letter to John Peale Bishop, August 8, 1925, in R. H. Winnick, ed., *Letters of Archibald MacLeish: 1907 to 1982* (Boston: Houghton Mifflin, 1983), 169. In this letter, MacLeish quotes Bishop's own writing on tragedy and mentions that he and Gerald had "spent the last five days cruising down the coast into Italy and discussing backward and forward two of your remarks on the subject of tragedy." He then describes how the discussion spilled over to the Villa America terrace on the evening of August 7, 1925: "Last night in the Murphys' garden we went on with it with Esther [Murphy, Gerald's sister] and the Barrys [Philip and his wife Ellen] and Ada [MacLeish's wife] and Sara."

24 Ibid.

25 This letter of Gerald's is exceptionally long and contrasts sharply with his more minimalist postcards. He felt the need to unburden himself to MacLeish, who never forgot the significance of Gerald's self-analysis. See Gerald Murphy, letter to Archibald MacLeish, January 22, 1931, in Miller, *Letters from the Lost Generation,* 53–58.

26 Some confusion has emerged as to exactly when Murphy and Hemingway met because of the two different shows at which Murphy exhibited *Watch*: first the Salon des Indépendants in the spring, and then *L'art d'aujourd'hui* at the Grand Palais in late December. Amanda Vaill, in her *Everybody Was So Young: Gerald and Sara Murphy, A Lost Generation Love Story* (Boston: Houghton Mifflin, 1998), 166, helps to clarify how their initial meeting ultimately led to their meeting later in the year, the latter being the meeting that solidified their relationship.

27 Fitzgerald had also been urging Hemingway to meet the Murphys. On December 15, 1925, Hemingway wrote to Fitzgerald to confirm that Fitzgerald was right about the Murphys: "They're grand people. Nice people are so damned nice." In Carlos Baker, ed., *Ernest Hemingway: Selected Letters 1917–1961* (New York: Scribner, 1981), 176. See also Hemingway, letter to Archibald MacLeish, October 15, 1958, in Baker, *Ernest Hemingway: Selected Letters,* 885.

28 Gerald Murphy, letters to Ernest Hemingway, [July 14, 1926] and [September 6, 1926], in Miller, *Letters from the Lost Generation,* 19–23.

29 Hemingway's portrayal of the Murphys as the "understanding rich" appears in the last pages of the book; see *A Moveable Feast* (New York: Scribner, 1964), 207–11. Hemingway's manuscripts for *A Moveable Feast,* in the Ernest Hemingway Papers, John F. Kennedy Presidential Library and Museum, show that he reworked the text considerably. He was particularly uncertain about the final portion of the manuscript, which related to the Murphys, and some of these sections were excised from the final version.

30 Hemingway, *A Moveable Feast,* 208–9; and Hemingway, letter to Archibald MacLeish, October 15, 1958, in Baker, *Ernest Hemingway: Selected Letters,* 885.

31 Miller, *Letters from the Lost Generation,* 150.

32 Gerald, letters to Sara, April 16, 1936; April 18, 1936; and June 26, 1936, in Miller, *Letters from the Lost Generation,* 162–64 and 168–69.

33 Gerald, letter to Sara, June 26, 1936, in Miller, *Letters from the Lost Generation,* 168–69. Although Sara drove down to Florida with John and Katy Dos Passos, she spent six days on board the *Pilar* with Hemingway, as she stated in her follow-up letter to Pauline (who had been away visiting family in Arkansas). See Sara Murphy, letter to Pauline Pfeiffer Hemingway, [May 11, 1936], in Miller, *Letters from the Lost Generation,* 164–65.

34 When Calvin Tomkins was beginning to write about the Murphys and life in France in the 1920s, Gerald Murphy and Tomkins corresponded, and Tomkins also conducted several taped interviews. Transcripts of these interviews, as well as copies of the Murphy-Tomkins correspondence, are in the Donnelly Family Collection. Gerald's statements about Hemingway are drawn from these interviews.

35 From Hemingway's *A Moveable Feast* manuscripts, Ernest Hemingway Papers, John F. Kennedy Presidential Library and Museum.

36 Hemingway, *A Moveable Feast,* 208–9.

37 Ernest Hemingway, *For Whom the Bell Tolls* (New York: Scribner, 1940), 104.

38 Miller, *Letters from the Lost Generation,* 244–45. Some of these ideas about Hemingway and *For Whom the Bell Tolls* first appeared in Linda Patterson Miller, "Role Models in *For Whom the Bell Tolls,*" in Frederic J. Svoboda and Joseph J. Waldmeir, eds., *Hemingway: Up in Michigan Perspectives* (East Lansing: Michigan State University Press, 1995), 229–39.

39 Hemingway, *A Moveable Feast,* preface.

40 Hemingway, *For Whom the Bell Tolls,* 98.

41 Harry Crosby, letter to Henrietta Crosby, December 20, 1934, quoted in Geoffrey Wolff, *Black Sun: The Brief Transit and Violent Eclipse of Harry Crosby* (New York: Vintage Books, 1977), 155.

42 See Honoria Murphy Donnelly with Richard N. Billings, *Sara and Gerald: Villa America and After* (New York: Times Books, 1982), 91.

43 Sara Murphy, letter to F. Scott Fitzgerald, August 20, [1935], in Miller, *Letters from the Lost Generation,* 140.

44 From MacLeish's poem "Sketch for a Portrait of Mme. G___M___," first published in 1926, in MacLeish, *New and Collected Poems: 1917–1976* (Boston: Houghton Mifflin, 1976), 107–9.

45 Archibald MacLeish, conversation with the author, October 17, 1979.

46 Ernest Hemingway, letter to Sara Murphy, [c. late December 1940], in Miller, *Letters from the Lost Generation,* 260–61.

47 Hemingway, *For Whom the Bell Tolls,* 104.

48 Miller, *Letters from the Lost Generation,* 139–40.

49 See, for example, Gerald Murphy, letter to John Dos Passos, August 27, 1957, Dos Passos Papers, University of Virginia. Fitzgerald emphasized these qualities in Dick Diver, the protagonist in *Tender Is the Night,* whom he modeled after Gerald.

50 Hemingway, *For Whom the Bell Tolls,* 12, 114, 140, and 15, respectively.

51 Archibald MacLeish, letter to F. Scott Fitzgerald, September 15, [1930], in Winnick, *Letters of Archibald MacLeish,* 236.

52 Dorothy Parker, who was at Villa America at this time, wrote to Robert Benchley to report that Gerald did not return from the cruise because of a broken mast, but rather because "every time they touched port there would be telegrams and special deliveries from Sara telling him it was his duty to come back and be with his children." Dorothy Parker, letter to Robert Benchley, [November 7, 1929], in Miller, *Letters from the Lost Generation,* 50.

53 Quoted in Rudi Blesh, *Modern Art USA: Men, Rebellion, Conquest, 1900–1956* (New York: Alfred A. Knopf, 1956), 93–96.

54 Hemingway, *For Whom the Bell Tolls,* 19–20.

55 Ibid., 218, 29, 35, and 148, respectively.

56 Ibid., 249.

57 Gerald Murphy, letter to Archibald MacLeish, May 30, 1964, in Miller, *Letters from the Lost Generation,* 334.

58 Ernest Hemingway, letter to F. Scott Fitzgerald, May 28, 1934, in Baker, *Ernest Hemingway: Selected Letters,* 407.

59 Ernest Hemingway, letter to Maxwell Perkins, March 25, 1939, in Baker, *Ernest Hemingway: Selected Letters,* 483.

60 Archibald MacLeish, "Gerald Murphy," in *Riders on the Earth,* 125.

61 Archibald MacLeish, letters to the author, February 13, 1978, and August 1980, collection of the author.

62 Miller, *Letters from the Lost Generation,* 150–51.

63 Fitzgerald, *Tender Is the Night,* 27.

64 Matthew J. Bruccoli, ed., *The Notebooks of F. Scott Fitzgerald* (New York: Harcourt Brace Jovanovich/Bruccoli Clark, 1972), 225, 149, 229, and 146, respectively.

65 Andrew Turnbull, *Scott Fitzgerald* (1962; reprint, New York: Ballantine Books, 1971), 163, 166.

66 Fitzgerald, *Tender Is the Night,* 151, 35–36, and 152, respectively.

67 Hemingway, *The Sun Also Rises* (New York: Scribner, 1926), 24–25.

68 Ibid., 26.

69 See Trevor Winkfield's "The Notebook as Sketchbook" in the present volume.

70 Hemingway made several revisions to the manuscript for *The Sun Also Rises,* some of them significant—such as his elimination of the entire first chapter describing Brett Ashley's background. Fitzgerald had read the manuscript at La Garoupe in the summer of 1926 and urged Hemingway to make this cut. Hemingway had been using Gerald's name in the text just prior to this. See the manuscripts for *The Sun Also Rises* in the Ernest Hemingway Papers, John F. Kennedy Presidential Library and Museum.

71 Hemingway, *The Sun Also Rises,* 247.

72 Quoted in Donnelly, *Sara and Gerald,* 18–19. Ellen Barry, in an interview with the author on June 4, 1982, said that "Villa America was in the center of the Cap under the lighthouse which my husband used as his setting for *Hotel Universe*; the fact that the lighthouse swept the light across the terrace . . . which was marvelously beautiful . . . tiled in black tiles instead of the usual red; and the black tiles and the white house gave it a modern quality."

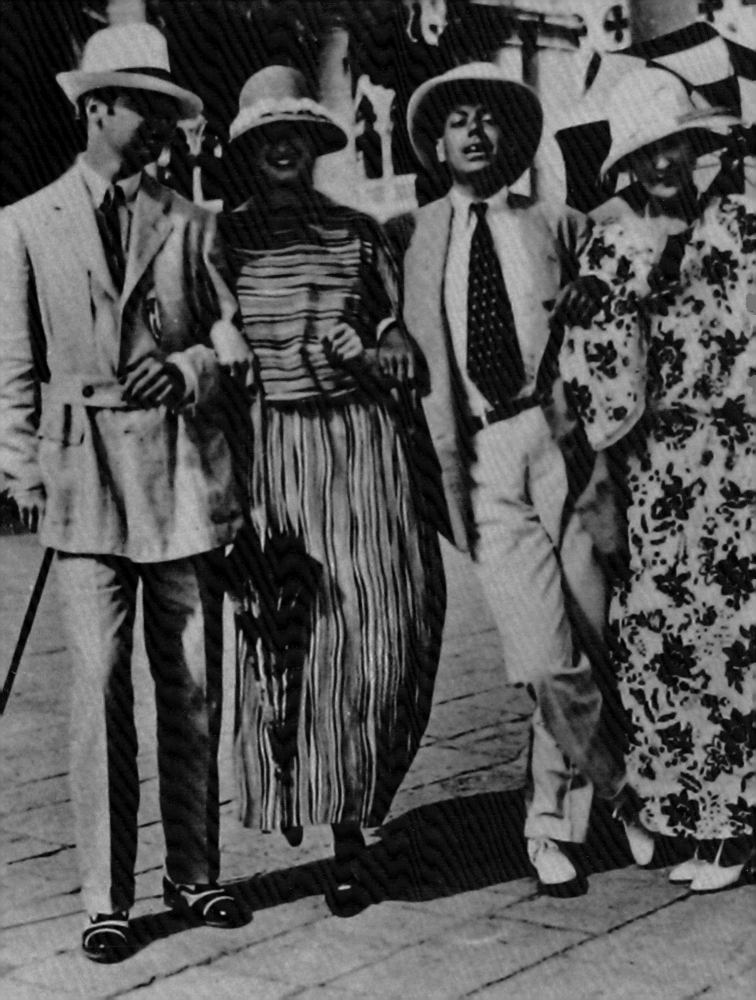

LES ENFANTS DU JAZZ

The Murphys and Music

OLIVIA MATTIS

"*Adieu New York! Bonjour Paris!*" went the title of a fox-trot by Georges Auric that Gerald and Sara Murphy had in their record collection.[1] The Murphys arrived in Paris on September 3, 1921, as part of the mass influx of American artists and intellectuals during the Prohibition era. The French, eager to learn more about American popular culture such as ragtime, the Charleston, billboard advertising, and other signs of the big city, were ready for the American incursion. Jean Cocteau articulated this state of affairs in describing the first jazz orchestra he ever heard, at the Casino de Paris: "The orchestra was tossing out trumpet calls the way that one throws raw meat or fish to some hungry seals."[2]

With their vast knowledge of American culture, the Murphys filled this need—always ready to play a Louis Armstrong recording, sing a Negro spiritual, or give an impromptu lesson in dancing the Charleston. Despite their wealth and interest in art, the Murphys were not art collectors, yet they were passionate and methodical collectors of music, particularly in the form of recordings. They had diverse musical tastes: the Murphys' record collection of Edison cylinders, 78s, and (later) LPs ranged from Claudio Monteverdi to the latest jazz, and even included songs of the Blackfeet Indians as well as a record-

ing of talking birds.[3] They played American music for Pablo Picasso, and even lent him some records.[4] Their collection was so extraordinary that it served as the basis for two motion-picture soundtracks and two ballet scores. Many people in those days, including the Murphys, collected fox-trots and other light entertainment for dancing.[5] But in Gerald Murphy's case, those recordings led him to further ethnographic study, pursuing the dance's origins on Southern plantations. He told choreographer Léonide Massine and composer Nicolas Nabokov that he "kept up contact with old black folk in Virginia and Georgia, people who could dance all those forgotten 'bear steps,' 'wolf steps,' 'fox trots,' and true–Civil War 'cakewalks.'"[6]

The Murphys' circle in Paris in the early 1920s came to include numerous musicians, starting with Cole Porter, whom Gerald had known since Yale. They befriended composers Igor Stravinsky, Erik Satie, and Virgil Thomson, conductors Ernest Ansermet and Walter Damrosch, and pianists Arthur Rubinstein and Marcelle Meyer. They assiduously collected the music of Le Groupe des Six (Auric, Louis Durey, Arthur Honegger, Darius Milhaud, Francis Poulenc, and Germaine Tailleferre), most of whom they personally knew. In the spring of 1924, the Murphys rented a house in Saint-Cloud that had belonged to Charles Gounod, where they received Satie, among other visitors.[7] "Dear friend, I cannot see you today, as I must go to Saint-Cloud to visit the Murphys,"

Detail from a photograph of Gerald Murphy, Ginny Carpenter, Cole Porter, and Sara Murphy, Venice, 1923 (see p. 173).

wrote Satie to a friend. "Yes. . . . *Very important.* Meeting with helpful and important American people."[8] Composer Edgard Varèse, invited by Sara Murphy to discuss his music with her over dinner, called her "une américaine gentille et intelligente."[9] Later they befriended Paul Robeson, the great American basso profundo, singer of "Old Man River."[10] In this way Gerald Murphy was following in the footsteps of his father, Patrick Francis Murphy, who was a friend of George Eastman, founder of both Eastman Kodak and the Eastman School of Music.[11] Sara's sister, Mary Hoyt Wiborg, was a professional music critic and an ardent champion of musical modernism.[12]

The Murphys loved every type of popular music, from cowboy songs to ragtime to flamenco. Sara in particular loved the music of Fats Waller.[13] "The minute everyone was up, the gramophone was put on. Every popular tune," recalled family friend Fanny Myers Brennan.[14] They befriended Johnny Stein, the legendary New Orleans jazz drummer, who worked with Jimmy Durante during his "first career" as a ragtime pianist, long before he became a comedian and film actor.[15] While they lived in Paris, the Murphys arranged for Stein to send them the latest American jazz recordings on a monthly basis.[16] Even at the end of their lives, the Murphys still kept up with the times: their grandchildren remember Gerald buying the first Beatles album released in the United States—*Meet the Beatles*—in 1964 and offering it to them as a gift. Later Sara heard a recording of the Doors and told her granddaughter that Jim Morrison had a nice voice.[17]

Gerald and Sara Murphy were particularly eager to share their knowledge of spirituals, which they systematically collected and then learned to sing. They would perform spirituals such as "O Graveyard!" and "Sometimes I Feel Like a Motherless Child" in two-part harmony for friends in the United States and later in Paris, with Gerald singing tenor and Sara alto. In the spring of 1921, just before leaving the United States for Europe, they performed these songs for Isabella Stewart Gardner in Boston, and then sent her a book on the subject.[18] "We are so gratified at the thought that you wish to know more of these spirituals, and we enjoyed so singing them to you," wrote the Murphys on a calling card enclosed with the book.[19] "They sang them once for Erik Satie," reports Calvin Tomkins, who notes also that Satie convinced them to sing the songs a cappella, abandoning the piano accompaniment. "Never sing them any other way,"

he apparently told them. The Murphys, always seeking authenticity, complied.[20] Sara had a beautiful voice—in her youth she had studied singing and had performed with her sisters in repertory ranging from folk songs to Wagner.[21] Singing together was one of the joys of the Murphys' marital life. In Paris, they purchased an "Auto-Gammier" to help them with solfège.[22]

The Murphys even named one of their boats after a piece of music, Louis Armstrong's 1923 ragtime hit "Weather Bird," written by Joe "King" Oliver. As their daughter, Honoria, recalled: "The *Weatherbird* was named for the jazz song my parents liked so well, and a Louis Armstrong record of it was sealed in her keel."[23] They also liked the music of Claude Debussy, particularly his atmospheric piano prelude *La Cathédrale engloutie.* Gerald used this piece to frighten his children: "Dow-Dow [Daddy] told pirate stories, and he even supplied spooky background music, having set up the gramophone in the cave," recalled Honoria. "One piece I remember was *The Engulphed Cathedral* by Debussy."[24] According to Naomi Barry, daughter of the playwright Philip Barry, that work was also played aboard the *Weatherbird* on a portable Victrola. "The *Weatherbird* sailed away in a cloud of music," she recalled.[25]

Over the course of their lives, the Murphys participated in numerous musical ventures, from Sara's days as a member of the musical "Wiborg Sisters" and Gerald's days in the Yale Glee Club to professional partnerships with Stravinsky, Porter, John Alden Carpenter, Nabokov, King Vidor, Virgil Thomson, and Richard Rodgers. For the latter four projects, the Murphys contributed recordings of vernacular music from the American West, the American South, and Spain: they were seen as "authorities" whose musical collection could be trusted as "authentic." During the 1920s, the Murphys inaugurated the Jazz Age in the south of France, where they are remembered as "Les Enfants du Jazz," the progenitors of today's Jazz at Juan festival and its surrounding musical scene.[26] As with the rest of their multifaceted lives, the Murphys used their knowledge of music and their interactions with musicians to increase their stature not only as Americans, but as experts on American culture and life.

"The Murphys were among the first Americans I ever met, and they gave me the most agreeable impression of the United States," Stravinsky is reported to have

O Graveyard!

Andante

1. O grave-yard! O grave-yard! I'm walk-in' troo de grave-yard; Lay dis bod-y down.

2. I know moonlight, I know starlight,
 I'm walkin' troo de starlight;
 Lay dis body down.

3. O my soul! O your soul!
 I'm walkin' troo de graveyard;
 Lay dis body down.

The arrangement made for this work by H. T. Burleigh. Words and melody from "Slave Songs of the United States," New York, 1867.

LEFT "O Graveyard!" was one of the spirituals that Gerald and Sara Murphy sang in two-part harmony.

FROM HENRY EDWARD KREHBIEL, *AFRO-AMERICAN FOLKSONGS: A STUDY IN RACIAL AND NATIONAL MUSIC* (NEW YORK: G. SCHIRMER, 1914)

BELOW LEFT The Murphys, who were avid amateur singers, used this device to help them with solfège.

BELOW RIGHT Music was often played aboard the Murphys' yacht, the *Weatherbird*. Here Gerald dances with his daughter, Honoria, 1932.

BOTH PHOTOS BELOW GERALD AND SARA MURPHY PAPERS, BEINECKE LIBRARY, YALE

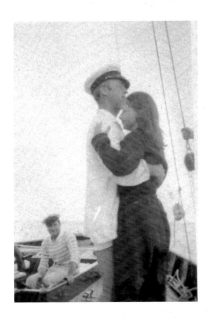

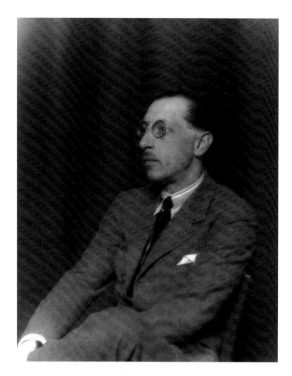

Man Ray, *Igor Stravinsky*, 1923. Gelatin silver print, 8 9/16 × 6 9/16 in.

This signed score of *Les Noces* was given by Igor Stravinsky to Gerald and Sara.

said.[27] Through their friendship with the Russian Constructivist painter Natalia Goncharova, Gerald and Sara had the opportunity in the spring of 1923 to assist in painting the sets for the première of Stravinsky's choral masterpiece *Les Noces*. The Murphys were already familiar with the Russian composer's music: Sara had attended the London performance of *Le Sacre du printemps* in July of 1913, two months after its riotous Paris première.[28] *Les Noces*, on the subject of a Russian peasant wedding, was produced by Sergei Diaghilev's Ballets Russes, with choreography by Bronislava Nijinska and with Ernest Ansermet conducting. H. G. Wells called the piece "a rendering in sound and vision of the peasant soul in its gravity, in its deliberate and simple-minded intricacy, in its subtly varied rhythms, in its deep undercurrents of excitement that will astonish and delight every intelligent man or woman who goes to see it."[29] Begun as early as 1914, on the heels of *Le Sacre du printemps,* and completed on April 6, 1923, under the patronage of the Princesse de Polignac,[30] *Les Noces* had the longest gestation of any of Stravinsky's works. It features four solo singers and a chorus of men's and women's voices accompanied by four pianists and percussion.

The music of *Les Noces* is characterized by rapid changes of meter, biting dissonances, the pervasive use of the whole-tone scale (rather than the typical major or minor scale), and a feverish pace. The bride (Nastasya) opens the work, singing at the top of her lungs and without any of the niceties of an instrumental overture to prepare the scene. Leonard Bernstein characterized the opening moment as a "cruel chord, made crueller with the lack of preparation."[31] The entire work is pounding and relentless, and is meant to be sung in a nasal peasant style, using chest voice instead of falsetto, even in the higher range.[32] Add to that four pianists playing percussively along with a percussion ensemble, plus a dance troupe enacting the action, and the reader will imagine the sensory overload provided by this work. There are also parts that are spoken on pitch and in rhythm, rather than sung, somewhat in the manner of Arnold Schoenberg's famous *Sprechstimme* technique. One critic wrote of *Les Noces* after its première: "It seems like electrification applied to ballet."[33]

The Murphys, who loved boats, hosted a party for everyone connected to *Les Noces* on Sunday, July 1, 1923 at 8 P.M., aboard a river barge called *Le Maréchal Joffre*.[34] Gerald recalled the circumstances:

Igor Stravinsky's personal invitation to the party given in his honor by Gerald and Sara, on the river barge *Le Maréchal Joffre*, in Paris on July 1, 1923.

We decided to have a party for everyone directly connected to the ballet, . . . as well as for those friends of ours who were following its genesis. Our idea was to find a place worthy of the event. We first approached the manager of the Cirque Médrano, but he felt that our party would not be fitting for such an ancient institution. I remember him saying haughtily, "*Le Cirque Médrano n'est pas encore une colonie américaine.*" Our next thought was the restaurant on a large, transformed *péniche,* or barge, that was tied up in the Seine in front of the Chambre des Députés and was used exclusively by the deputies themselves every day except Sunday. The management there was delighted with our idea and couldn't have been more cooperative.[35]

Aside from Stravinsky, Diaghilev, Ansermet, and Goncharova, the guests included John Alden Carpenter, Blaise Cendrars, Jean Cocteau, Walter Damrosch, Mikhail Larionov, Marcelle Meyer, Darius Milhaud, Pablo Picasso, the Princesse de Polignac, Cole Porter, Germaine Tailleferre, Tristan Tzara, and other luminaries. Wanda Corn has remarked that this magnificent party "would by itself have put them [the Murphys] in the annals of their time."[36]

Sara Murphy, finding the flower market closed on Sunday, created impromptu table centerpieces out of hundreds of small toys. Tomkins describes the event, as related to him by Gerald:

The first person to arrive was Stravinsky, who dashed into the *salle à manger* to inspect, and even rearrange, the distribution of place cards. He was apparently satisfied with his own seating—on the right of the Princess de Polignac. . . . Dinner went

on for hours, interspersed with music—Ansermet and Marcelle Meyer played the piano at one end of the room—and dancing by the ballerinas. Cocteau finally came aboard. He found his way into the barge-captain's cabin and put on the captain's dress uniform, and then went about carrying a lanterne and putting his head in at portholes to announce gravely, "*On coule.*"[37]

Cocteau's theatrics were followed by Stravinsky putting on a display of his own. Boris Kochno (Diaghilev's heartthrob and soon to be Cole Porter's[38]) and Ansermet picked up one of the party decorations, a laurel wreath with the words *Les Noces—Hommages,* and held it up while the composer "ran the length of the room and jetéd through the center."[39] "This is the most beautiful night of my life since my first communion," wrote Stravinsky on the menu, surrounded by the signatures of nearly everyone present.[40]

Immediately following the exhilarating success of *Les Noces,* Gerald and Sara turned their attention to another stage project, this time for the Ballets Suédois. How Cole Porter came to write the music to the "ballet-sketch" *Within the Quota* is not exactly clear. According to Tomkins, "Rolf de Maré, the company's young director, asked Murphy whether he knew of any young American composer in Paris who might do a score in the American

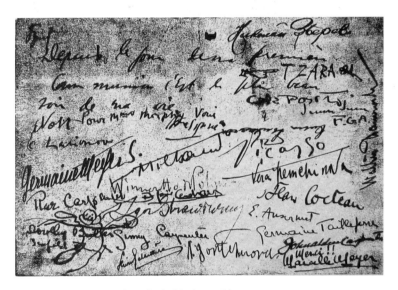

Menu from the barge party thrown by the Murphys on July 1, 1923, on which Stravinsky and other guests signed the statement: "This is the most beautiful night of my life since my first communion." The whereabouts of the original menu are unknown; this photograph is of a photocopy.

idiom, and Murphy, without a moment's hesitation, suggested the matter to Cole Porter."[41] Milhaud remembered it somewhat differently:

De Maré, about to tour the United States, was anxious to put on an authentic American work, but did not know whose help to enlist. He was afraid of landing himself with a composer still in the Debussy or Ravel mold or a musician who would compose "à la Brahms." . . . Now, I had met Cole Porter many times at the Princesse de Polignac's. This elegant young American, who always wore a white carnation in the buttonhole of his immaculate dinner-jacket, used to sing—in his grave, husky voice—songs he had written himself and which possessed the exact qualities de Maré was looking for. I introduced him to de Maré, who immediately proposed that he handle a theme marvellously attuned to his own music: the arrival of a young Swede in New York.[42]

Gerald Murphy and Cole Porter had met as undergraduates at Yale in the fall of 1910, in 112 Welch Hall—Porter's room—during Murphy's junior and Porter's sophomore year. It is interesting that Milhaud described Porter as an "elegant young American, who always wore a white carnation in the buttonhole of his immaculate dinner-jacket," because this description shows how much Porter had matured since his student days. Murphy recalled his first meeting with Porter, whom he saw as a badly dressed "little boy" from Indiana:

There was this barbaric custom of going around to the rooms of the sophomores, and talking with them to see which ones would be proper material for the fraternities. I remember going around with Gordon Hamilton, the handsomest and most sophisticated boy in our class, and seeing, two nights running, a sign on one sophomore's door saying, "Back at 10 p.m. Gone to football song practice." Hamilton was enormously irritated that anyone would have the gall to be out of his room on visiting night, and he decided not to call again on this particular sophomore. But one night as I was passing his room I saw a light and went in. I can still see that room—there was a single electric light bulb in the ceiling, and a piano with a box of caramels on it, and wicker furniture, which was considered a bad sign at Yale in 1911 [recte: 1910]. And sitting at the piano was a little boy from Peru, Indiana, in a checked suit and a salmon tie, with his hair parted in the middle and slicked down, looking just like a Westerner all dressed up for the East. We had a long talk, about music, and composers—we were both crazy about Gilbert and Sullivan. . . . He also told me that the song he had submitted for the football

song competition had just been accepted. It was called "Bulldog," and of course it made him famous.[43]

Despite his "little boy" looks, Porter possessed a worldliness that Murphy admired. By the time the two Yalies met, Porter had already been to Paris and spoke French fluently.[44]

Murphy decided to be helpful to his talented new friend. As assistant manager of the Yale Glee Club (but not one of its singers), he arranged for Porter to join the group's second tenor section and perform a new composition of his.[45] The song, called "Perfectly Terrible," appeared in the position of honor on the Christmas tour program, just before the standard closing number, "Bright College Years."[46] Porter's solo was apparently a hit, as he was asked to perform another one the following season during his junior and Murphy's senior year, when Murphy became manager. This time the song was "a satire on the joys of owning an automobile, and Porter came out in front of the curtain to sing it in the next-to-closing spot, with his hands folded behind him, while the [other singers] behind him on the stage went 'zoom, zoom, zoom.'"[47] This song, "The Motor Car," with words and music by Porter, consistently brought down the house.[48]

THE MOTOR CAR

Off we go to take a ride, take a ride, take a ride,
All the fam'ly jam inside,
Mercy, what a clatter!

Something breaks and out gets Pa, out gets Pa, out gets Pa,
Now he crawls beneath the car,
What can be the matter?

Oh! What was that awful crack, awful crack, awful crack?
Hit the trolley in the back,
Trolley's system's twisted.

What makes father look so queer, look so queer, look so queer?
His nose is hiding behind his ear,
His whole expression's shifted.

Oh, the lovely motor car,
What a wreck it's made of Pa!
Over twenty doctor chaps
Worked on him in his collapse:
*Mother wears a sickly grin
Where her face is dented in:
What do we care as long as we are
Having a ride in a motor car?

Gerald Clery Murphy.

Gerald Clery Murphy was born March 25, 1888, in Boston, Massachusetts.

Patrick Francis Murphy, his father, born in Boston, Massachusetts, is president of the Mark Cross Co., New York City. Mrs. Murphy was Anna Ryan. A brother graduated from Yale in 1908.

Murphy prepared for Yale at Hotchkiss and Andover. He served on the Sophomore German Committee and Junior Prom. Committee, was assistant manager of the Yale Musical Club Junior year and manager Senior year. He was a member of the Pundits, University Club and Elizabethan Club. Delta Kappa Epsilon. Skull and Bones. In Freshman year he roomed with Shannon at 266 York Street; in Sophomore year with Cornwall at the Hutch; Junior year with O'Brien in 473 Haughton; Senior year with Cornwall and Carhart in 39 Vanderbilt.

Murphy expects to take a position in the foreign factories of Mark Cross Co. His permanent mail address is 210 Fifth Avenue, New York City.

Cole Porter.

COLE ALBERT PORTER was born June 9, 1893, in Peru, Indiana. His father, Samuel Fenwick Porter, was born in Indiana. He graduated from Indiana University, and is now retired. Mrs. Porter was Kate Cole.

Porter prepared for Yale at Worcester Academy. He was on the Freshman Glee Club, on the University Glee Club three years, and Leader in Senior Year. He was a member of the Dramatic Association, having taken part in "Robin of Sherwood," and written the music for the Smoker Play in 1912 and in 1913. Football Cheer Leader, 1912. Corinthian Yacht Club, University Club, Wigwam and Wrangler Debating Club, Hogans, Whiffenpoofs, Pundits, Grill Room Grizzlies, Mince Pie Club. Delta Kappa Epsilon. Scroll and Key. Freshman Year he roomed alone in 242 York Street; Sophomore Year in 112 Welch; Junior Year in 499 Haughton; Senior Year with H. Parsons in 31 Vanderbilt.

Porter expects to enter the Harvard Law School, after which he will go into either mining, lumbering or farming. His permanent address is Westleigh Farms, Peru, Indiana.

ABOVE LEFT Gerald Murphy's 1912 Yale yearbook page shows his intention of living a transatlantic life ("in the foreign factories of Mark Cross Co.").

ABOVE RIGHT Cole Porter's 1913 Yale yearbook page. Did Porter really envision himself as a lumberjack? While the yearbook gives Porter's birth date as 1893, most sources list his birth year as 1891. According to Porter's biographer, Porter's passports list his year of birth variously as 1891, 1892, and 1893.

BOTH PAGES MANUSCRIPTS AND ARCHIVES, YALE UNIVERSITY LIBRARY

LEFT Yale Glee Club, 1912. Cole Porter (a second tenor) is in the front row, fourth from the left. Gerald Murphy (the group's manager) is also in the front row, third from the right.

COURTESY OF YALE GLEE CLUB, YALE UNIVERSITY

In 1912 Murphy was instrumental in tapping Porter for the Delta Kappa Epsilon fraternity (DKE, pronounced "deek"). It was for DKE that Porter composed the music and lyrics of his first show, *Cora*, a two-act musical produced on November 28, 1911, at the fraternity house, on a book by another fraternity brother, T. Gaillard Thomas II. *Cora*, which foreshadowed Porter's masterpiece *Kiss Me, Kate* in its use of the characters Tom, Dick, and Harry, had men playing all the roles, including those of the chorus girl, the mother, the "misses," and the "cocottes." Act I takes place in Tom's room at Yale, while Act II is staged in the "Rat Mort" restaurant in Paris. Porter himself played Dick, while Murphy served as the production's "toastmaster." As with the Glee Club, Murphy served not as entertainer but as "host"—a role he was rehearsing for later years.[49]

After college, Murphy's and Porter's lives continued to be deeply intertwined. Both men enrolled at Harvard for graduate studies, Murphy in landscape architecture and Porter in law and music. Fortunately, Porter didn't then pursue the career ambition stated in his yearbook: to "go into either mining, lumbering or farming." Instead, he moved to Paris in the fall of 1917, ostensibly to join the French Foreign Legion.[50] He met his wife, Linda Lee Thomas, at a wedding reception in January of 1918 at the Ritz Hotel at Place Vendôme, and they were married in December of the following year. By the time the Murphys came to Paris with their three children in June of 1921, the Porters were already established there, in one of the city's most stylish *hôtels particuliers,* at 13, rue de Monsieur in the seventh arrondissement. Both Gerald and Cole married women older than themselves: Sara was Gerald's senior by five years, and Linda was Cole's senior by eight years.[51] This made the two wives just about the same age. The Porters spent the summers of 1921 and 1922 in a rented villa in the corner of Antibes called La Garoupe.[52] The Murphys soon followed suit.

The Murphys and Porter worked on *Within the Quota* in the summer of 1923 in Venice, at the Palazzo Barbaro, a palace the Porters rented that had previously been home to Isabella Stewart Gardner.[53] Other visitors that summer included Bernard Berenson and the Princesse de Polignac.[54] Gerald worked on the sets and scenario for *Within the Quota* and Sara designed the costumes, while Porter sat at the piano, hammering out the four-piano score. This score—whose four-piano incarnation was perhaps modeled on *Les Noces*—was then given over

to the noted French composer Charles Koechlin for the process of orchestration, which he undertook from September 18 to 27.[55] Koechlin mentions this project in a letter of September 19: "At the moment I am orchestrating a ballet by the American Cole Porter. It's a difficult task as one would need a more ample orchestra. In any case, I hope that it will sound good all the same."[56] The ballet was choreographed by Jean Börlin, who also took the leading role. The conductor was Vladimir Golschmann.

Within the Quota was a musical milestone, preceding *Rhapsody in Blue* (1924) as one of the first examples of symphonic jazz. Moreover, it transformed Cole Porter from a songwriter into a composer, just as *Rhapsody in Blue* would do for George Gershwin the following year. In both cases, the songwriters made use of orchestrators: in Porter's case, it was Koechlin, and in Gershwin's, it was Ferde Grofé. Porter had been wanting to devote himself to serious composition for some time. In 1919 he had sought to take private lessons with Stravinsky,[57] and in 1920 he enrolled at the famous Schola Cantorum as a student of counterpoint, composition, orchestration, and harmony.[58] Porter referred to *Within the Quota* as "my one effort to be respectable."[59] Unlike *Rhapsody in Blue*, *Within the Quota* has not had much of an afterlife, as its score has never been published and it exists only in manuscript.[60]

Within the Quota is a parody of American society. The scenario for this witty work is as follows: "A Swedish immigrant steps off the boat in New York and encounters a parade of characters representing his new country's most stereotypical citizens, including an American Heiress, a Gentleman of Color, a Jazz Baby [flapper], a Cowboy."[61] Each time the immigrant expresses a desire (to drink some wine, to dance with the flapper, and so on), he is scolded and thwarted by a "Social Reformer." Only when he expresses the wish to go to the movies is he welcomed, literally, with open arms—by "America's Sweetheart," Mary Pickford herself. The ballet is divided into ten sections: Opening; Heiress; Heiress Reformer; Colored Gentleman; Colored Gentleman Reformer; Jazz Baby; Jazz Baby Reformer; Cowboy; Sweetheart of the World; Finale. The score is equally witty, with each character receiving his or her own lighthearted musical theme, each time rudely interrupted by the crash-and-boom music of the Social Reformer. *La Revue de France* described the work as "a thoroughly enjoyable show, full of irony, laughter and movement."[62] U.S. critics were

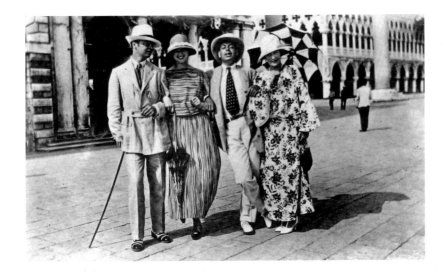

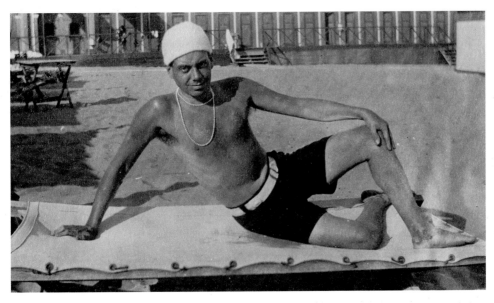

amused by the stereotypes presented, or, "ourselves as other folks see us."[63]

The première of *Within the Quota* took place in Paris on October 25, 1923, at the Théâtre des Champs-Élysées, the same theater that had witnessed the riotous premiere of Stravinsky's *Le Sacre du printemps*.[64] The piece shared a program with Fernand Léger and Darius Milhaud's polytonal jazz ballet *La Création du monde*, as well as concert works by Satie, Koechlin, and Satie's followers, "L'École d'Arcueil": Henri Sauguet, Roger Désormière, Maxime Jacob, and Henri Cliquet-Pleyel.[65] There were two further Paris performances of *Within the Quota* following the première. The Ballets Suédois then set sail for

New York on November 3, and the New York debut took place at the Century Theatre on November 28. A tour of the United States followed, with sixty-nine performances, ending in March 1924. The work proved popular with American audiences.[66]

Cole Porter made a career out of being an American in "Paree." His shows included *Paris, Fifty Million Frenchmen, Mayfair and Montmartre, Can-Can,* and *Les Girls.* Among his songs were "Quelque-chose," "Bad Girl in Paree," "Do You Want to See Paris?" "Paree, What Did You Do to Me?" "You Don't Know Paree," "Bon Voyage," "Vite, vite, vite," "Mesdames et messieurs," "Give Him the Oo-La-La," "Maidens Typical of

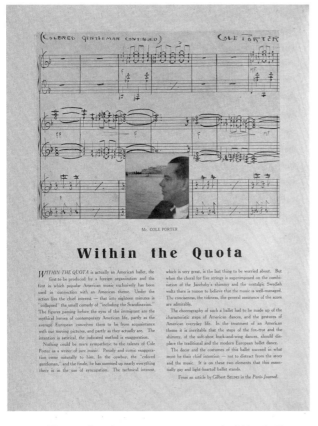

This page from the souvenir concert program for *Within the Quota* shows the syncopated theme given to the "Colered [sic] Gentleman."

JEROME ROBBINS DANCE DIVISION, THE NEW YORK PUBLIC LIBRARY FOR THE PERFORMING ARTS, ASTOR, LENOX AND TILDEN FOUNDATIONS

The American composer John Alden Carpenter was another close friend of Gerald. His wife, Rue Carpenter, a designer and art collector, was president of the Chicago Arts Club and was deeply involved in bringing modern art to that city. Carpenter attended the première of *Les Noces* in Paris and was present with his family at the Palazzo Barbaro in Venice during the genesis of *Within the Quota*. John, Rue, and their daughter Genevieve ("Ginny") attended the *péniche* party on the Seine, as well as the famous beach party at La Garoupe with the Murphys, Picasso, and the Comte and Comtesse de Beaumont. Gerald encouraged Carpenter in his compositional efforts: "You are thinking in terms of what is real and most American. Your thought has been the biggest, most daring and most challenging you've ever had," he wrote to Carpenter in late 1923 after seeing his latest score. He also proposed that Carpenter present a full-out machine aesthetic in the piece: "The principles behind the sounds of machinery and life are the same as those behind musical instruments, aren't they? . . . Build for your hearers a towering big structure of riveted steel and stone and then play all the color and ornament on it you want," he advised, adding, "It means so much to all of us."[71] This "towering big structure" proposed by Gerald became Carpenter's signature piece, the choral-orchestral ballet *Skyscrapers* (1923–26).

The scenario of this work is just as cartoonish as that of *Within the Quota*. The work is in three sections, with the first and third depicting a Manhattan skyscraper (symbol of work) and the center one depicting Coney Island (symbol of play). "At its core, then, the score explored the idea that skyscrapers—with their steel frames, elevators, and noisy construction—and amusement parks—with their roller coasters, Ferris wheels, and popular music—mirrored one another," explains Carpenter's biographer, musicologist Howard Pollack. The noisy and lively score combines the rhythmic energy of *Les Noces* with the lighthearted satire of *Within the Quota*. It contains honking car horns, which undoubtedly served as a model for the taxi sounds in Gershwin's *An American in Paris* (1928).[72] Like *Within the Quota*, *Skyscrapers* features an exaggerated urban landscape as well as a female lead (called "Herself") intended to resemble Mary Pickford. While Diaghilev expressed an interest in mounting the work, it was presented instead by the Metropolitan Opera in New York.

France," "C'est magnifique," "Who Said Gay Paree?" "I Love Paris," "Paris Loves Lovers," "Bebe of Gay Paree," and "Ça, c'est l'amour." The French returned his affection, publishing and performing dozens of Porter's songs in translation from the 1920s onward, sometimes with full orchestration.[67]

Murphy and Porter nearly had the chance to collaborate again in 1939, on an aborted ballet project to be called *Coney Island*.[68] Despite some rocky patches in their friendship, they remained close, and Porter was named Honoria Murphy's godfather.[69] Amanda Vaill describes Murphy and Porter as kindred spirits, each embodying "the soul of an outsider concealed behind a façade of urbanity."[70] Both were immensely talented, wealthy, and beset by unspeakable tragedy that ended their creative lives (the deaths of two sons for Murphy and the amputation of a leg for Porter). They even died two days apart: Porter on October 15, 1964, and Murphy on October 17.

Gerald Murphy's record collection and expert knowl-

Advertisement for the film *Hallelujah!* (1929), on the cover of *Cinematograph Times* 3, no. 59 (January 18, 1930). Gerald advised the director, King Vidor, on the music for this MGM film.

edge of spirituals and jazz led to his collaboration on another landmark work: MGM's Oscar-nominated film *Hallelujah!* (1929). Directed by King Vidor, this film was one of the first "talkies," as well as the first studio film with an all-black cast. In the trailer, MGM called the film "THE GREATEST *all-colored* DRAMA EVER MADE! *with a cast of thousands, starring* FAMOUS ALL-COLORED ARTISTS, *headed by* NINA MAE MCKINNEY *and* DANIEL L. HAYES." Although Eva Jessye was the official (although uncredited) music director, Gerald served in an informal (and equally uncredited) advisory role. Introduced to Vidor by F. Scott Fitzgerald, Gerald worked on this project from December 1928 to January 1929. The film, halfway between a drama and a musical, was a notable precursor to other, more famous, all-black modernist works (created by whites), such as Gertrude Stein and Virgil Thomson's *Four Saints in Three Acts* (1934) and Gershwin's *Porgy and Bess* (1935), as well as later black-cast films such as *Cabin in the Sky* (1943), *Stormy Weather* (1943), and *Carmen Jones* (1954).[73] "It was sort of a dynamic approach to the black people's environment in a dynamic way rather than in a classic coun-

try down south type of thing," Vidor recalled in an interview with Linda Patterson Miller. "It was very strong with jazz and music and religion and all that. . . . He [Gerald Murphy] did consult on the music."[74]

The music in *Hallelujah!* is wide-ranging, from Stephen Foster to plantation songs to honky-tonk. Gerald's influence is obvious in the film's opening sequence, which includes a snippet from one of his favorite spirituals, "Sometimes I Feel Like a Motherless Child." Other spirituals in the film include "Goin' Home," "Let My People Go," "Swing Low, Sweet Chariot," "Git on Home, Little Chillen," and "Give Me That Old Time Religion," in addition to Foster's "Old Folks at Home (Swanee River)" (1851), W. C. Handy's "St. Louis Blues" (1914), and two songs specially composed for the film by Irving Berlin: "Swanee Shuffle" (1929) and "Waiting at the End of the Road" (1929). Despite his personal role in the project, Gerald was the first of many commentators to question the film's authenticity. He wrote to Dos Passos:

I've been officiating for six weeks at a picture: should have been sure-fire stuff: 80 negroes combed from out the southern states: (the only white people here, I'll tell you), but in two weeks they had it so full of scenes around the cabin door, with talk of chittlins and corn-pone and banjoes a-strummin, that it was about as negro as Lew Dockstader's Minstrels. When they got LIONEL BARRYMORE to coach these negroes in the use of dialect, I resigned. My God! But it is considered most daring, original, planet-displacing on King Vidor's part to not have one single white person in the cast. Just think![75]

In 1933–34, another part of the Murphy record collection—the music of the American West—came in handy for a new ballet project: *Union Pacific*, with music by Nicolas Nabokov (orchestrated by Eddie Powell), scenario by Archibald MacLeish, and choreography by Léonide Massine, presented by the Ballet Russe de Monte Carlo. The costumes were designed by Irene Sharaff, and the conductor was Efrem Kurtz. This work, on the subject of the first transcontinental railroad, premiered in Philadelphia on April 6, 1934, at the Forrest Theatre, to critical acclaim. Nabokov was a good friend of Stravinsky's and was the first cousin of the famous writer. He knew nothing of the music of the American West, and needed to find an authoritative voice on the subject. He found it in Gerald Murphy, as he recalled in his memoirs:

Gerald Murphy owned a large collection of cylinders with recordings made by Thomas Edison or one of Edison's assistants at the turn of the century. He wanted me to come and listen to them. "You'll be surprised by those recordings," said Murphy. "They're sung and played by old people remembering songs and dances of their youth. Some of the music goes far back into the 1870s." In December [1933] I went to hear these extraordinary documents of vanished America. They were poignantly authentic. Not only their tunes, their harmonies, their rhythms, seemed fresh and real, but the manner of playing or singing and the choice of instruments.[76]

There was a second listening session in January 1934, with the addition of Massine. Nabokov recalled: "Shortly after New Year, Massine came to New York. We went together to the Murphys' and listened to the old recordings. We stayed many hours. Murphy also showed us other recordings, Chicago and New Orleans jazz and older ones of black music made in the Deep South."[77] The statement "We stayed many hours" gives an indication of how massive the Murphys' record collection was.[78] Then there was a third session: "A few days later I went back to Gerald Murphy. This time I came with pencils and music paper. I spent a long afternoon listening to the old Edison machine and writing down the tunes in my own musical quickscript. . . . The next morning I called MacLeish in Massachusetts and told him that, if he still wanted me, I was ready to compose the music for Union Pacific."[79] The project was partially underwritten by Dr. Albert Barnes, the famous art collector, who "bought all the seats in the balcony for the première of the ballet."[80] Like Within the Quota, Union Pacific has never been published and exists only in manuscript.[81]

The Murphys' record collection was again used for a film project in 1937: The Spanish Earth, a powerful documentary on the Spanish Civil War written by Ernest Hemingway, John Dos Passos, and Archibald MacLeish and narrated by Hemingway. Virgil Thomson is credited as the composer on the film (along with Rodolfo Halffter), but instead of composing the music he assembled it from recordings found in the collections of Gerald Murphy and Paul Bowles. "These contained choral numbers sung by Galician and Basque miners, woodwind coblas from Barcelona, and naturally lots of flamenco from Seville," Thomson recalled.[82] The Murphys had undoubtedly acquired these recordings on one of their trips

to Spain in 1933–34. Thomson's purpose in using the Murphys' recordings rather than his own composed music was to match the authenticity of the music to that of the documentary image. (Recall Nabokov's description of the Murphys' recordings as "poignantly authentic.")

Gerald's next collaborative project was the ballet Ghost Town, which premiered on November 12, 1939, at the Metropolitan Opera House, with music by Richard Rodgers and choreography by Marc Platoff (later Platt), presented by the Ballet Russe de Monte Carlo. "Historical Research by Gerald Murphy," states the concert program. Subtitled "An American Folk Ballet," Ghost Town takes place in California's Sierra Mountains during the time of the Gold Rush. Just like Porter's Within the Quota, the work marked Rodgers's first "serious" composition, four years before Oklahoma! "Gerald brought us together," recalled Rodgers in his memoirs, meaning perhaps that Gerald had selected him for the project.[83] Platt described Gerald's role in letters to his mother: "Mr. Murphy has been a great help in getting material for the ballet and if our venture even smacks a bit of success, it will be due to his efforts. . . . Mr. Murphy has given me records of songs and dances of that period. Most fascinating. . . . He took me to see the show Boys From Syracuse, the music by Richard Rodgers who is writing the music for our new ballet."[84] As so many times before, Gerald's behind-the-scenes efforts, combined with his vast musical culture, helped produce a work of value.

Music, for the Murphys, was an artistic stimulant, a source of national pride, and a soundtrack to their very lives. In the depths of their son Patrick's fatal illness, Gerald and Sara hired a five-piece dance band from Munich to lift the family's spirits.[85] Music was also the bedrock of many of the Murphys' friendships. They were ever ready to share their extensive music collection with others, and they delighted when others returned the favor. "One thousand French thanks . . . for that music," wrote Gerald to his friend Richard Myers. "It does my heart good to have it—and already the blood courses more swiftly in the veins." In another letter to Myers, he analyzed the depth of his need for music: "It seems to me that I have never been more grateful for anything or to anyone in my past life than for music sent to me by friends who knew the kind I wanted," Gerald wrote. "It brings a kind of satisfaction that nothing else does."[86] Music was central to the Murphys' notion of living well.

NOTES

1. The title of this work had its origins in the hit song "Good-Bye Broadway, Hello France," from the Broadway show *Passing Show* of 1917, and in turn inspired the title of a Mistinguett revue at the Moulin Rouge in 1924, *Bonjour Paris!* For more on this subject, see Nancy Perloff, *Art and the Everyday: Popular Entertainment in the Circle of Erik Satie* (Oxford: Oxford University Press, 1991), 109, 172–75; Glenn Watkins, *Proof Through the Night: Music and the Great War* (Berkeley: University of California Press, 2003), 253–54; and Ornella Volta, "Auric/Poulenc/Milhaud, l'école du Music-Hall selon Cocteau," in Josiane Mas, ed., *Centenaire Georges Auric–Francis Poulenc* (Montpellier: Centre d'Étude du XXe Siècle, 2001), 61–62.

2. "L'orchestre . . . lançait des appels de trompette comme on lance de la viande crue ou des poissons à des phoques." Jean Cocteau, *Portrait souvenir: Entretiens avec Roger Stéphane* (Paris: RTF, 1964), 138–39 (author's translation).

3. *Monteverdi Premier Album,* conducted by Nadia Boulanger; Victor 17611: *Medicine Song, White Dog Song,* and *Grass Dance;* Decca, *I'll Give You Talk Like That: An Actual Record of Talking Birds,* compiled by H. Lynton-Fletcher.

4. Gerald Murphy, letter to Pablo Picasso, 1926, quoted in English translation in Amanda Vaill, *Everybody Was So Young: Gerald and Sara Murphy, A Lost Generation Love Story* (Boston: Houghton Mifflin, 1998), 124.

5. Fox-trots represented in the Murphys' surviving record collection include "Sweet and Low Down," "Whistle Away Your Blues," "I Want to Be Happy," "I Never Cared about To-morrow," "Liza," "Down among the Sleepy Hills of Ten-Ten-Tennessee," "Brown Eyes, Why Are You So Blue," and "A Kiss in the Moonlight."

6. Nicolas Nabokov, *Bagazh: Memoirs of a Russian Cosmopolitan* (New York: Atheneum, 1975), 191.

7. Calvin Tomkins, *Living Well Is the Best Revenge* (1962; reprint, New York: Viking Press, 1971), 40.

8. "Cher Ami, Je ne peux pas vous voir ce jour présent: obligé, suis-je, d'aller à Saint-Cloud chez les Murphy. Oui. . . . Très important. Rencontre avec d'utiles & précieuses personnes américaines." Erik Satie, letter to Vicente Huidobro, June 29, 1924, in Ornella Volta, ed., *Erik Satie: Correspondance presque complète* (Paris: Fayard, 2000), 623 (author's translation).

9. Edgard Varèse, letter to Louise Varèse, October 29, 1925, Paul Sacher Foundation, Basel, Switzerland.

10. Honoria Murphy Donnelly with Richard N. Billings, *Sara and Gerald: Villa America and After* (New York: Times Books, 1982), 39.

11. Ibid., 62.

12. Her writings include: "Notes on Ultra Modern Composers," *Arts & Decoration* (November 1924): 38, 66, 77; "Igor Strawinsky, One of the Great Russians," *Arts & Decoration* (January 1925): 36; "The Three Emperors of Broadway: An Appreciation of the Composers in This Country Who Have Made Us Recognize the Musical Significance of Jazz," *Arts & Decoration* (May 1925): 48, 66, 72; and "Internationalism in Music," *Arts & Decoration* (August 1925): 41, 62, 78.

13. Donnelly, *Sara and Gerald,* 99.

14. Fanny Myers Brennan, audiotape interview by Linda Patterson Miller, June 22, 1981.

15. Their band went by all kinds of names: Stein's Dixie Jass Band, the Original New Orleans Jazz Band, New Orleans Jazz Band, Durante's Jazz and Novelty Band, and Jimmy Durante's Jazz Band.

16. Tomkins, *Living Well Is the Best Revenge,* 28.

17. Laura Donnelly and John Donnelly, conversations with the author, July 3, 2006.

18. The Murphys visited Gardner with composer Charles Martin Loeffler and his wife on May 12, 1921, according to the calendar of Gardner's assistant, Morris Carter (in the collection of the Isabella Stewart Gardner Museum, Boston). The book they sent Gardner immediately thereafter was Henry Edward Krehbiel's *Afro-American Folksongs: A Study in Racial and National Music* (New York: G. Schirmer, 1914), which remains in Gardner's library at the Isabella Stewart Gardner Museum. For information on Gardner's role as a patron of music, see Ralph P. Locke, "Living with Music: Isabella Stewart Gardner," in Ralph P. Locke and Cyrilla Barr, eds., *Cultivating Music in America: Women Patrons and Activists since 1860* (Berkeley: University of California Press, 1997), 90–121.

19. This calling card is also in the collection of the Isabella Stewart Gardner Museum.

20. Tomkins, *Living Well Is the Best Revenge,* 28–29.

21. Ibid., 10.

22. Solfège is the singing of melodies using "do," "re," "mi," etc. instead of words. In the "fixed-do" method of solfège, each syllable corresponds to a specific note in the scale (do = C, re = D, etc.), regardless of the song's particular key; in the "moveable-do" method, the principal note of the song, called the tonic, is represented by "do" and the other syllables are assigned accordingly.

23. Donnelly, *Sara and Gerald,* 56.

24. Ibid., 36.

25. Naomi Barry, "Sailing Away with Léger," *House and Garden,* February 1984, 132–41.

26. See the official website of the city of Juan-les-Pins: http://www.antibesjuanlespins.com//html/htm_vie-htmid-31.htm (accessed September 1, 2006).

27. Quoted in Tomkins, *Living Well Is the Best Revenge,* 8.

28. Vaill, *Everybody Was So Young,* 52.

29. H. G. Wells, quoted in Vera Stravinsky and Robert Craft,

eds., *Stravinsky in Pictures and Documents* (New York: Simon and Schuster, 1978), 159.

30 The Princesse de Polignac also commissioned Stravinsky's *Renard* of 1917.

31 Leonard Bernstein, quoted in Brendan McCarthy, "*Les Noces,*" *Ballet Magazine,* July 2003, http://www.ballet .co.uk/magazines/yr_03/jun03/bmc_les_noces.htm (accessed September 1, 2006).

32 The style is similar to that used by the modern-day Bulgarian Women's Choir.

33 Andre Levinson, quoted in McCarthy, "*Les Noces.*"

34 The date and time were erroneously given as June 17 at 7:00 P.M. by Calvin Tomkins—an error repeated in all later accounts.

35 Gerald Murphy, quoted in Tomkins, *Living Well Is the Best Revenge,* 31.

36 Wanda M. Corn, *The Great American Thing: Modern Art and National Identity, 1915–1935* (Berkeley: University of California Press, 1999), 96.

37 Tomkins, *Living Well Is the Best Revenge,* 31–32.

38 Porter's love letters to Kochno, written in French, are in the Cole Porter Collection, Irving S. Gilmore Music Library, Yale University, New Haven, CT.

39 Vaill, *Everybody Was So Young,* 120.

40 "Depuis le jour de ma première communion c'est le plus beau soir de ma vie." It is uncertain in whose hand this statement is written, but it is clearly intended as the declaration of Stravinsky, the guest of honor.

41 Tomkins, *Living Well Is the Best Revenge,* 39. This version of events is repeated in Corn, *The Great American Thing,* 102.

42 Darius Milhaud, *Ma vie heureuse* (Paris, 1973), quoted in Bengt Häger, *Ballets Suédois,* trans. Ruth Sharman (London: Thames and Hudson, 1989), 212.

43 Quoted in Tomkins, *Living Well Is the Best Revenge,* 15–16.

44 Charles A. Riley II, "Anything Goes: Cole and Linda Porter," in his *The Jazz Age in France* (New York: Harry N. Abrams, 2004), 61.

45 This is the account as told to Calvin Tomkins by Murphy (Tomkins, *Living Well Is the Best Revenge,* 16). However, Porter's class history page indicates that he was a member of the Freshman Chorus, which would have naturally fed into the Glee Club. Certainly, one would think that Porter would have been a shoo-in for the Glee Club without any assistance from Murphy.

46 This was performed on the Christmas vacation tour, which included a stop at Orchestra Hall in Chicago on Thursday, December 29, 1910. The oft-repeated story that Murphy arranged for the Glee Club to accept Porter as the first-ever sophomore member of that group is in fact a myth. The roster for that year, a copy of which is in the Cole Porter

Collection, Yale University, shows one other sophomore (C.A. Bonnell, 1913) as well as two freshmen (D.M. Parker, 1914, and W.S. Innis, 1914).

47 Tomkins, *Living Well Is the Best Revenge,* 16.

48 The following season, Porter's senior year, he was made "Leader" of the Glee Club and stole the show one more time with his solo, "A Football King." This song was performed on the Christmas vacation tour, which ran from December 19 to 28, 1912, and included stops in Cleveland, St. Louis, Kansas City, Denver, St. Joseph (Missouri), St. Paul, Chicago, and Detroit. Many thanks to conductor Jeffrey Douma and business manager Sean Maher of the Yale Glee Club for making the original programs available to me.

49 Murphy and Porter were in two other Yale clubs together: the University Club and the Pundits.

50 Porter's biographer, William McBrien, states: "Few episodes in Porter's life have generated more confusion than what precisely he did in wartime France. . . . Monty Woolley, in Paris with the U.S. Army, recalls Porter strutting up and down the boulevards in uniforms ranging all the way from a cadet's to a colonel's." McBrien, *Cole Porter* (New York: Vintage Books, 2000), 58–59.

51 Despite the birth year given for Porter in the Yale yearbook being 1893, William McBrien and many others list his birth year as 1891. According to McBrien, Porter's passports list his year of birth variously as 1891, 1892, and 1893.

52 The Porters' photo album from the 1921 stay survives in the Cole Porter Collection, Yale University.

53 Both Gardner and the Porters rented the palazzo from the Curtis family, who own it to this day. I am grateful to Kristin Parker from the Isabella Stewart Gardner Museum for this information.

54 Both are pictured in the photo albums that survive in the Cole Porter Collection, Yale University.

55 *Catalogue de l'oeuvre de Charles Koechlin* (Paris: Max Eschig et Cie, 1975), 85.

56 "En ce moment, j'orchestre un ballet de l'Américain Cole Porter. C'est un travail difficile car il y faudrait un orchestre plus nourri; mais enfin j'espère que ça sonnera tout de même." Charles Koechlin, letter to Henri Sauguet, September 19, 1923, Charles Koechlin Collection, Music Department, Bibliothèque Nationale de France, Paris (author's translation).

57 A letter from painter Paul Thévénaz to Stravinsky, dated December 2, 1919 (in the Stravinsky archive, Paul Sacher Foundation, Basel, Switzerland), reads as follows: "Dans un mois ou deux vous recevrez probablement la visite de Cole Porter, musicien américain, compositeur spécialement de rag-times qui a un certain talent et voudrait travailler avec vous????! Je lui ai dit que je n'étais pas du tout sûr que vous accepteriez un élève. Mais cela pourrait être intéressant. Il

paiera absolument tout ce que vous voudrez. C'est un très gentil garçon, intelligent & doué, et multi-millionaire."

58 An orchestration of Robert Schumann's piano sonatas 1 and 2, done by Cole Porter as a homework assignment at the Schola Cantorum, survives and is dated May 7, 1920. McBrien, *Cole Porter,* 75.

59 Cole Porter, letter to Richard Hubler, 1954, quoted in Anna Kisselgoff, "Ballet by Cole Porter to Be Danced Here," *New York Times,* May 5, 1970.

60 Two manuscript versions are held in the Bibliothèque Nationale de France, Paris: one for full orchestra (arranged by Charles Koechlin) and another for piano two-hands (arranged by William Bolcom). Another manuscript version (by Porter, for four pianos) is in the Cole Porter Collection, Yale University.

61 Quoted in Nancy Van Norman Baer, ed., *Paris Modern: The Swedish Ballet, 1920–1925* (San Francisco: Fine Arts Museums of San Francisco, 1995), 157.

62 Quoted in Häger, *Ballets Suédois,* 44.

63 F. D. Perkins, "Swedish Ballet Spices Program with U.S. Jazz: Bizarre Dance Sketch Bewildered Immigrant 20 Minutes of Ourselves as Other Folks See Us," n.d. [October 1923], newspaper unknown, clippings in Gerald and Sara Murphy Papers, Yale Collection of American Literature, Beinecke Rare Book and Manuscript Library, Yale University, New Haven, CT, and in the Cole Porter Collection, Yale University.

64 The Théâtre des Champs-Élysées would later be the site of the riots attending the premières of George Antheil's *Ballet mécanique* (1926) and Edgard Varèse's *Déserts* (1954).

65 Häger, *Ballets Suédois,* 44–45. Satie says in a letter to Rolf de Maré: "Les 'Danses du Piège de Méduse' sont à la 'Sirène' (musicale), 29, bld Malesherbes. Ne vous occupez pas du matériel: je prierai Milhaud de se charger de cette chose.... N'ayez aucune crainte, vous n'aurez rien à payer.... Si: peut-être un verre de bière froide. Oui. Ça vous va?... Je boirai ce verre moi-même, en vous remerciant." Erik Satie, letter to Rolf de Maré, n.d. [August 29, 1923], in Volta, *Erik Satie,* 558.

66 Häger, *Ballets Suédois,* 47.

67 These editions can all be found in the Bibliothèque Nationale de France in Paris.

68 Marc Platt with Renée Renouf, "*Ghost Town* Revisited: A Memoir of Producing an American Ballet for the Ballet Russe de Monte Carlo," *Dance Chronicle* 24, no. 2 (2001), 158. Murphy was to play an advisory role on the production, while Porter was considered as a possible composer. Platt was to be the choreographer.

69 Unpublished notes by Honoria Murphy Donnelly. These notes, as well as the correspondence from Cole Porter to the Murphys, are in the Gerald and Sara Murphy Papers, Beinecke Library, Yale.

70 Vaill, *Everybody Was So Young,* 35.

71 Gerald Murphy, letter to John Alden Carpenter, n.d. [late 1923], John Alden Carpenter Collection, Newberry Library, Chicago, quoted in Howard Pollack, *Skyscraper Lullaby: The Life and Music of John Alden Carpenter* (Washington, DC: Smithsonian Institution Press, 1995), 215.

72 Pollack makes this very plausible suggestion in ibid., 238. The quotation comes from ibid., 218.

73 In fact, *Hallelujah!, Four Saints in Three Acts,* and *Porgy and Bess* all used the talents of Eva Jessye, a choral conductor who would later provide the official music for Martin Luther King Jr.'s 1963 March on Washington.

74 King Vidor, audiotape interview by Linda Patterson Miller, Beverly Hills, June 29, 1982.

75 Gerald Murphy, letter to John Dos Passos, [January 19, 1929], in Linda Patterson Miller, ed., *Letters from the Lost Generation: Gerald and Sara Murphy and Friends,* expanded edition (Gainesville: University Press of Florida, 2002), 41.

76 Nabokov, *Bagazh,* 190.

77 Ibid., 191.

78 Tragically, the Murphys' vast record collection has almost entirely been lost. A few recordings survive in the collection of the Murphys' granddaughter, and some others were given by Gerald Murphy to Fanny Myers Brennan and survive in her family's possession, but the vast majority of the collection is unaccounted for.

79 Nabokov, *Bagazh,* 192.

80 Ibid.

81 Copies of the manuscript are held at the Firestone Library, Princeton University, and at the Harry Ransom Humanities Research Center, University of Texas, Austin.

82 Virgil Thomson, *An Autobiography by Virgil Thomson* (New York: E. P. Dutton, 1966), 274.

83 Richard Rodgers, *Musical Stages: An Autobiography* (New York: Random House, 1975), 194.

84 Marc Platoff, letters to his mother, 1939, quoted in Platt and Renouf, "*Ghost Town* Revisited," 160–62.

85 Tomkins, *Living Well Is the Best Revenge,* 120–21.

86 Gerald Murphy, letters to Richard Myers, May 27, 1931, and June 18, 1932, Gerald and Sara Murphy Papers, Beinecke Library, Yale.

GERALD MURPHY

Cubist Painter, Concrete Poet

WILLIAM JAY SMITH

It was the novelist Dawn Powell who introduced me to Gerald Murphy at the end of 1954, in a very unusual way. And that was as I should have expected, because there was nothing ordinary about Dawn Powell. We were neighbors in Greenwich Village and had met at one of the frequent and always animated cocktail parties of the poet James Merrill. Dawn Powell was quite simply the funniest woman I have ever met anywhere. At parties, she looked like a pretty little doll, staring up and out with sweet but deadpan amazement at all that was happening or being said around her. Then, a tiny feminine Buster Keaton, she would at just the right moment, firmly and with no expression whatever, come forth with some hilarious remark that seemed apropos of nothing at all and yet would somehow bring into sharp focus the absurdity of the entire conversation. When I sent her a book of my poems, she chose as her favorite "American Primitive," which depicts a young child gazing in horror at his top-hatted father, his pockets stuffed with folding money, who has hanged himself by his black cravat on a sunny Southern porch. The poem ends with these lines:

Only my Daddy could look like that
And I love my Daddy like he loves his Dollar.

Detail from Gerald Murphy, *Wasp and Pear*, 1929 (see p. 105).

This was, Dawn Powell said, such a brilliant depiction of an utterly charming scene that she thought a copy of the poem should be delivered to every American household, placed on the doorstep with the morning milk.

I had recently done a series of concrete poems, typewritten nonsense verses accompanied by typewriter drawings. They were quite unlike anything that I or any other poet had done at the time. I took them to my friend Milton Saul, who, with Claude Fredericks, had produced in 1947 for their Banyan Press a hand-set edition of my first book of poems. I now asked him to print up an edition of some three hundred copies of five of these typewriter creations, which I called *Typewriter Birds*. I decided to send them out as a Christmas offering to friends and literary acquaintances.

During the holiday period, I was delighted by the responses I received to my little typewritten packet. Poets Marianne Moore, Louise Bogan, and John Hall Wheelock all gave their immediate witty acceptance. Wallace Stevens's warm approval of my first book had come, as all his literary correspondence did, on the official stationery of the Hartford Assurance Company, of which he was vice president. When I saw this time the company's logo on an arriving envelope, I knew what to expect. But I was not prepared for the postcard of an Amedeo Modigliani nude that it enclosed. In the accompanying letter, Wallace Stevens said how very much he admired my typewritten birds, but, look, he wrote,

what you can do with a single letter. In the empty slots of the Modigliani nude's almond eyes, he had placed as eyeballs in wild positions the letter "o" and had added a third "o" as the young lady's navel. The result was a cock-eyed nude unlike any that had ever been painted. I had expected a similar unusual reaction from Dawn Powell, but nothing came. I soon discovered that not only had she taken pleasure in my *Typewriter Birds,* but that she had shared them with her friends, one of the most enthusiastic of whom was Gerald Murphy.

When he telephoned one morning and identified himself in his rich Irish-tenor voice, I was dumbfounded and flattered, especially when he asked if he could purchase several copies—fifteen, I believe—of my little booklet.

I had to say right off that since I hadn't planned to put them up for sale, I hadn't the vaguest idea of what a fair price would be.

"And perhaps," I stumbled, "since you are Dawn Powell's friend, I should just offer these copies as a present."

That, he insisted, he could not under any circumstances accept. "They are your work as an artist, as a poet, and you simply can't just give them away."

What I did not say—as I am embarrassed to have to say now—was that I had only the vaguest idea of who he was. I had heard only that he was a friend, a rich friend, of F. Scott Fitzgerald, and that he had served as the model of one of the leading characters in Fitzgerald's novel *Tender Is the Night.* I certainly had not the slightest inkling that he was himself a painter, and a very fine one.

"Since I can't think what to charge, perhaps you could give me something in exchange—a little something," I hesitated, " a wallet, or something of the sort, from Mark Cross."

That his family owned Mark Cross was the only other thing that I knew about him.

Gerald Murphy accepted my proposal immediately and invited my wife and me for cocktails a few days later. But before I continue, I think that I should give some idea of what exactly it was that Gerald Murphy had purchased, and what he found so attractive about it.

Typewriter Birds began on a hot summer afternoon when I was seated before my typewriter at my desk in a New York apartment on Perry Street in Greenwich Village. Through the open windows (we had no air-conditioning), I looked out on a green ailanthus tree, down through the thick branches of which came a con-

stant pecking like that of some persistent exotic bird. It was no bird, I realized, but the sound of the professional typist in the apartment above who never stopped typing and whose persistence had begun so to annoy me that, as I stared at my own typewriter keyboard trying to write myself, I started to think of the typewriter as a veritable rather obnoxious bird. I composed on the spot "The Typewriter Bird."

THE TYPEWRITER BIRD

The Typewriter Bird with the pitchfork beak
Will sing when its feathers are given a tweak,
Will sing from now till the end of the week
In the typewritten language that typewriters speak,
 The Typewriter Bird.

Ugly and clickety, cheerful, and gay
Skyscraper-blue or tenement gray,
It hops up and down in its rotary way
And sings till the bell rings, Hip-Hooray!
 The Typewriter Bird.

The Typewriter bird with the spotted fan
Flies off to the jungles of Yucatán,
Where perched on a table of old rattan,
It sings like water that drips in a pan,
 The Typewriter Bird.

It sings like water Drip-Drop! Drip-Drop!
That falls on a corrugated iron rooftop,
In a round tin pan on the wobbly rattan—
Drip-Drop! Jim-Jim! Drip-Drop! Drip-Drop!
 The Typewriter Bird.

The Typewriter Bird is a terrible bore;
It sings—Jim-Jim—and it sings encore.
It sings in London and Singapore;
It flies to the ceiling, it drops to the floor,
It bangs on the wall, it knocks at the door,
But thrown out the window, it sings no more,
 The Typewriter Bird!

When I finished the poem and was typing it up, I made some mistakes, and my four-year-old son, who was watching me, said that what I had typed looked like a bird. He begged me to make some other birds. I did, and before long I had pages of pictures, not only of birds but of people as well. The pictures pleased my son no end, because he had the distinct impression of having gen-

erated them himself. And they gave me a sensation of triumph, of having somehow come close to the earth. I felt that I had triumphed over the mechanical deadness of the typewriter, that totem of urban life then, as the computer is today, and had instinctively reached back and cut through to something primitive and unspoiled. The fact that my triumph had begun as a humorous gesture made it no less serious.

I had touched something, I felt, at the depth of the psyche, at that still center where creation begins, the heart of being from which the path of poetry makes its mysterious way. To my mind, no art, certainly no resonant art that gives off what Federico García Lorca called dark sounds (*sonidos negros*), can be generated unless the creator first achieves this good relation to the earth. The still center that I had touched had perhaps something in common with the reverential attitude of the Native American toward the elements, the sensory and spiritual connection between earth and sky, accounting for the magical instinctive balance that permits the Mohawk to walk with perfect equilibrium on the edges of skyscrapers at great heights. Perhaps it was the thought of this instinctive balance that caused me to find that the pictures emerging from my typewriter looked for all the world like those petroglyphs that Native Americans had left on the stone walls of caverns throughout the country as a record of the world with which they were in close touch and to which they paid constant tribute.

Typewriter Birds opened with "Postman Pelican," which set the tone for what followed. Of the other verses, I think that Gerald Murphy particularly enjoyed "Gondola Swan" and "Yellow-mitred Pope Joan." I think he could see that I had tried to achieve with typewriter keys a plasticity akin to that of Paul Cézanne with his still lifes of apples and he welcomed this fresh and playful visual use of machinery, which was very much in a tradition that he had established but which at the time was unknown to me.

The Murphys greeted us for cocktails in their midtown apartment—the one that Archibald MacLeish described as near the family business but not far from the Museum of Modern Art—in what seemed the most casual and friendly way, but which I realize now was with the greatest elegance, an elegance not acquired or inherited or learned from books but simply part of their natural artistic beings. They introduced us then and there to one of Gerald's paintings. All the accoutrements of *Cocktail*

POSTMAN PELICAN

In the pouch of the ambling Postman Pelican
Are hundreds of letters which he delivers,
Or takes out somewhere and quietly buries,
Or chews and swallows or throws into rivers,
Or takes home and keeps for months and months—
And *then* delivers.

GONDOLA SWAN

A most graceful bird is the Gondola Swan,
It feeds on love letters and old lemon rinds;
And lowers its neck like a long melting candle,
And raises its wings like Venetian blinds.

YELLOW-MITRED POPE JOAN

Next to nothing is known
Of the Yellow-mitred Pope Joan.

PAPA PIPER

My luck she is running very good,
Sings the big-barreled Papa Piper.
I sing like crazy, I fly like hell,
I crash boom-boom, get Prix Nobel,
My luck she is running *very* good!

(1927) were present—the cocktail shaker, the lemon, the glasses—and Gerald went about preparing the cocktails as if he were engaged in a spiritual undertaking, like saying Mass, as Philip Barry had observed.

When a week or two later I received the attaché case from Mark Cross, I could see that it was not at all the insignificant small item that I had suggested, but a memorable work superbly and specially done—the achievement of a master craftsman. Gerald told us that he had sent copies of *Typewriter Birds* to his friends—Cole Porter, Carmel Snow, Ward Cheney, John Dos Passos, and others—and had taken the liberty of giving them my address in case they wished to communicate with me. "All of them," he added, "are persons of great appreciation and have influential connections."

We would surely have seen the Murphys again had we not left a few weeks later for Europe, where we would spend the next two years in Florence, a period in my own life that I was later to think of as comparable to that of the Murphys and their circle on the Côte d'Azur after World War I. We were a similar small group of poets, painters, and composers in a beautiful spot that seemed to be ideally suited to our artistic endeavors. Shortly after I left, another group of typewriter verses and drawings appeared in *New World Writing*. I don't know whether or not Gerald ever saw *Literary Birds,* but I think that he might have welcomed my portrait of Ernest Hemingway.

. . .

Gerald Murphy's introduction to painting began in September 1921 when he happened in Paris to come upon some paintings by Pablo Picasso, Georges Braque, and Juan Gris. "I was astounded," he said. "My reaction to the color and form was immediate. To me there was something in these paintings that was instantly sympathetic and comprehensible." He began immediately to take lessons from the Russian painter Natalia Goncharova, and in the next seven years he completed fourteen paintings, of which only seven have survived, and it is on these seven that his reputation rests. His life as a painter was over at the end of 1929, and for the next seven years, from 1930 to 1937, his real life became an enactment of the tragic subjects he had chosen to depict.

It is said that although the artist chooses his subject, at times it seems rather that the subject has chosen the artist. Such was surely the case with Gerald Murphy. Out-

wardly his life on the Côte d'Azur at Villa America in Antibes was the essence of gaiety and vitality. MacLeish spoke of "the special pull of the Murphys. . . . There was a shine to life wherever they were, not a decorative *added* value but a kind of revelation of inherent loveliness as though custom and habit had been wiped away and the thing itself was, for an instant, *seen*. Don't ask me how." Certainly nothing of this shine was seen when Gerald retired to his studio to paint. It was not the bright colors that surrounded him on every side that he chose for his canvases, but the somber tones, the fourteen shades of gray in *Watch* (1925) that overwhelm the watch's gold encasement. It was the dark side of life that he depicted—the dark side that had chosen him. His greatest paintings, *Watch* and *Wasp and Pear* (1929), depict with great objectivity and precision the triumph of time and death. The depiction is epitomized in MacLeish's famous poem "You, Andrew Marvell," which Gerald Murphy must certainly have known and which no doubt inspired him.

As a member of a three-man opium commission established by the League of Nations, MacLeish went for three months in 1926 to investigate the transportation system of Persia, which at the time claimed that because of its lack of good roads it could not survive financially without the production of opium. When MacLeish landed in Marseilles on June 16, following his investigative tour, his wife and friends bribed the officer of an ocean liner moored in the harbor to allow them to watch for MacLeish's arrival from the bridge of his ship, after which they performed a welcoming Indian war dance on the pier. A few months later the MacLeishes had to return to Chicago, where Archibald's father, Andrew, died in January 1927 at the age of eighty-nine. It was here that MacLeish put down his poem, which he said came in a rush: "there at the end of a morning and finished at night." He had the images of the Persian trip fresh in his mind and apparently sat down at his desk with a copy of Andrew Marvell's poetry before him, opened to the poem "To His Coy Mistress." MacLeish is perhaps addressing not only Andrew Marvell, but also his dying father in "You, Andrew Marvell," adding a dimension to the poem by making "Marvell" a verb as well as a proper noun. The poem has an incantatory quality to it—as if it had been engendered by an opium dream—and that quality must have caught Murphy's imagination. MacLeish tells us that later in life Murphy pasted poems to his mirror while shaving. He

would memorize them and recite them later with great fervor. I can hear him reciting this poem, giving full force to its incantatory measure:

YOU, ANDREW MARVELL

And here face down beneath the sun
And here upon earth's noonward height
To feel the always coming on
The always rising of the night:

To feel creep up the curving east
The earthy chill of dusk and slow
Upon those under lands the vast
And ever-climbing shadow grow

And strange at Ecbatan the trees
Take leaf by leaf the evening strange
The flooding dark about their knees
The mountains over Persia change

And now at Kermanshah the gate
Dark empty and the withered grass
And through the twilight now the late
Few travelers in the westward pass

And Baghdad darken and the bridge
Across the silent river gone
And through Arabia the edge
Of evening widen and steal on

And deepen on Palmyra's street
The wheel rut in the ruined stone
And Lebanon fade out and Crete
High through the clouds and overblown

And over Sicily the air
Still flashing with the landward gulls
And loom and slowly disappear
The sails above the shadowy hulls

And Spain go under and the shore
Of Africa the gilded sand
And evening banish and no more
The low pale light across that land

Nor now the long light on the sea:

And here face downward in the sun
To feel how swift how secretly
The shadow of the night comes on . . .

Andrew Marvell, in "To His Coy Mistress," speaks of hearing at his back "time's winged chariot hurrying near." MacLeish, recalling the arid Persian scene, evokes, in

Marvell's words, "the deserts of eternity" that lie before us while the shadow of the night comes on.

In Gerald Murphy's painting *Watch*, all the senses are brought into play. Florent Fels, who saw it in the Salon des Indépendants of 1925, found it first "astonishing" and "soon seducing." But before the eye's seduction by the fourteen shades of gray in the painting, the ear responds to the ticking of this instrument of precision, struck, as Murphy said he always was, "by the mystery and depth of the interiors of a watch—its multiplicity, variety and feeling of movement, and man's grasp at perpetuity."

The painting, with all its sharp and exaggerated details, is presented to us as if held up close to our eyes as well as right next to our ears. In the persistent and inescapable ticking of the watch, one hears one's own heartbeat, just as Gerald Murphy apparently heard his, with an echo of that of his recently departed brother, Fred. One is reminded of the lines of the French poet Jules Laforgue, who hears in the palpitations of his heart those of his mother, who had died not long before of tuberculosis:

I hear my heart go tick-tick-tick,
It must be Mama calling me.

Time is measured here not just by endless interlocking cogs and wheels, but also by the Roman numerals, which are presented in black ebony going counterclockwise, moving backward.

The painting has a very personal reference, because it calls up two watches that were both very familiar to Murphy. One was a railroad watch especially designed by Mark Cross at the suggestion of a British army officer, who found pocket watches too cumbersome for trench warfare. The other was a small gold pocket watch that his daughter, Honoria, said he was particularly fond of. It had been given to him by Sara at the time of their engagement—until then, he told her, he had "never had anything valuable of his own." He liked to keep it propped up on a table with its mechanism showing.

An even more personal reference may be found in the initial "F," which is shown on the watch's mainspring and probably stands, as Amanda Vaill has pointed out in *Everybody Was So Young: Gerald and Sara Murphy, A Lost Generation Love Story*, for his brother Fred, who had died that year. Here it apparently also stands for "Fast,"

counterpoised against an inverted "S" for "Slow." Murphy may have had in mind T. S. Eliot's line in "The Waste Land," published in 1922, "Hurry up please it's time." The winding stem of the watch, like a crown, may suggest that Time is King, or rather it may call forth a bishop's yellow miter with a black cross suspended below, against the bishop's gold vestments. The bishop is appropriately accompanied at the lower center of the painting by what seem to be the three doves—or at least by their surreal nodding heads—that Murphy painted later—or perhaps at this same time—in the painting *Doves* (1925).

For such a busy painting—every detail intent on showing us that time never stops—it gives at the same time a sensation of beautiful peace and quiet, since that is clearly the final statement that time must always make. For those familiar with the facts of Gerald Murphy's life, this work provides also an absolute chill. Within less than a decade after he had completed this depiction of the absolute triumph of time, Gerald Murphy's two young sons would die, one after the other, each at the age of sixteen, their deaths bringing Murphy's painting career to an end in a horrible ironic example of what he had termed "man's grasp at perpetuity."

Wasp and Pear was Gerald Murphy's last painting, and he thought that it was "probably the best." Here the rich colors that lie hidden or subdued in *Watch* are brought forward to astonish us with their richness, for here it is the wealth of the world that is on display. But we soon realize that the triumph of color is illusory, for it is projected so richly only so that the defeat that awaits it may be all the more clearly emphasized. Here, indeed, we are made aware "how swift how secretly / The shadow of the night comes on."

The painting is outlined in Gerald Murphy's notebook as follows: "hornet (colossal) on a pear (marks on skin, leaf veins, etc.) (*battening* on the fruit, clenched)." The dark outline of the hornet (wasp) is literally devouring the body of the pear, which will soon rest in shadow. The pear's luscious female contour is echoed in that of what appears to be a mandolin standing beside it—so that everything that is desirable and lovely in life, all that can be touched, felt, and tasted, and all that can be praised in song, will soon be destroyed by darkness and the drilling buzz of the wasp. Gerald Murphy has given us, as Amanda Vaill suggests, a visual version of William Blake's "The Sick Rose."

O rose, thou are sick!
The invisible worm
That flies in the night,
In the howling storm

Has found out thy bed
Of crimson joy,
And his dark secret love
Does thy life destroy.

And the effect is just as breathtaking.

Archibald MacLeish presented *Wasp and Pear* to the Museum of Modern Art, and Alfred H. Barr Jr. accepted the painting shortly before Gerald Murphy died. Today it hangs there, the outstanding work of an original American Cubist painter, totally unlike anything by his Parisian colleagues.

KENNETH WAYNE

In 1925, the year that Gerald and Sara Murphy took up residence at their beloved Villa America, three other homes on the Riviera also emerged as important centers of artistic interaction: the Château de Clavary in Auribeau, near Grasse, home of the American painter Russell Greeley; the Château de Mai in Mougins, behind Antibes and Cannes, established by the French artist Francis Picabia; and Villa Noailles in Hyères, home of the Vicomte and Vicomtesse de Noailles. These four locales defined a special moment in the history of art and culture in France. Each had an impressive list of art-world visitors. What distinguished Villa America from the others was its location and the lifestyle it offered.

MONTPARNASSE, THE RIVIERA, AND INTERNATIONALISM

During the first three decades of the twentieth century, the Montparnasse area of Paris was the site of artistic ferment, the place where an international community of artists, poets, and writers tried to develop a universal art form that moved away from national traditions and conventions.[1] Marcel Duchamp called the Montparnasse community "the first really international group of artists we ever had." He asserted further: "Because of its inter-

nationalism, it was superior to Montmartre, Greenwich Village or Chelsea."[2] In Montparnasse in the early twentieth century, internationalism and modernism were inextricably linked. The artists of Montparnasse wanted to find a new artistic language that could be understood by a wide range of people. During World War I, many of Montparnasse's foreign artists and writers—or "Montparnos," as they were called—fled Paris for the safety of the Riviera.[3] They brought their cosmopolitanism to an area with an already deep-rooted internationalism. Nice had once been part of Italy (at which time it was known as Nizza), and Italian influences can still be felt in the city's cuisine, architecture, and accent, as well as in the abundance of Italian names. The British had arrived in Nice in the eighteenth century and were responsible for the construction of the city's famed boardwalk, the Promenade des Anglais (Promenade of the English). Russian aristocrats came in the nineteenth century, constructing an enormous Russian Orthodox church that testifies to that community's large size and wealth; they were followed by revolutionaries from Russia in the early twentieth century.

The Riviera thus proved to be a perfect site for the flourishing of Montparnasse ideals. There, far from the pressures of a dense urban environment, artists felt free to create brave new worlds and extend modernism's development. Alexander Archipenko, Henri Matisse, Amedeo Modigliani, Chaim Soutine, Léopold Survage,

Detail of photograph of the guest house at Villa America, c. 1926.
GERALD AND SARA MURPHY PAPERS, BEINECKE LIBRARY, YALE

LEFT Château de Clavary, Auribeau, France, home of the American painter Russell Greeley.

BELOW Francis Picabia and his companion Germaine Everling at the Château de Mai, their home in Mougins, France, c. 1930.

BOTTOM Villa Noailles, home of the Vicomte and Vicomtesse de Noailles in Hyères, France, c. 1928.

ALL PHOTOS COLLECTION OF KENNETH WAYNE

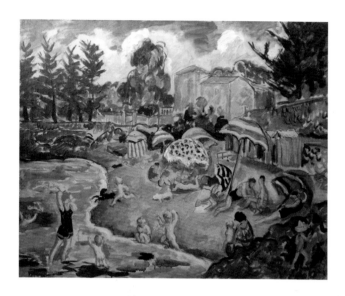

Morgan Russell, Moise Kisling, Guillaume Apollinaire, Blaise Cendrars, and Jules Romains were among the many Montparnasse artists and writers who brought their internationalist aspirations to the Riviera during World War I. Although most had left the South or died by the end of the war, they had firmly established a new trend.

The flow of culture to the Riviera increased after the war. The establishment of the express, all-first-class Train Bleu (Blue Train)—which made its first run from Calais via Paris to Nice in December 1922—played a significant role in drawing the upper class to the Riviera from the French capital.[4] So did the growing popularity of the automobile, depicted in many artworks from the 1920s (by such artists as Henri Matisse, Man Ray, and Jacques Henri Lartigue).[5] In 1925, after four years in Paris, the well-traveled Murphys took this trend to a new level. At Villa America, they created a cosmopolitan dream world for themselves that became the envy of their friends and reached legendary status. Instead of depicting a utopian world on canvas—as such Riviera artists as Claude Monet, Auguste Renoir, and especially Paul Signac, Henri Edmond Cross, Théo van Rysselberghe, and Maximilien Luce had done—the Murphys lived that "perfect" life.

FOUR ARTISTIC CENTERS

Anyone who has driven the coastline of the French Riviera from Marseilles to Menton and seen the various towns along the way would be struck by one overwhelming feature: the incredible variety from town to town, each with its own character, flavor, and history. Of the four locales that became prominent centers of artistic interaction in 1925, Villa America, in Cap d'Antibes, was the closest to the water; indeed, it was the only one within walking distance of the sea. Cap d'Antibes is on a peninsula (or cape, as its name indicates), offering spectacular views of the ocean. The Murphys undoubtedly chose a property that was close to the water because that feature reminded them of Sara's family's house in East Hampton, New York, where she and Gerald met. La Garoupe beach, made famous by the Murphys and their friends, such as Pablo Picasso, was especially appealing because, in contrast to many Riviera beaches, it is covered with sand, rather than stones. Waldo Peirce's colorful painting *Plage La Garoupe* (1920) evokes the beach's delightful charms.

Villa America was not only near the water, but also near Nice, which is visible from Cap d'Antibes. With this large town so close—not to mention the casinos, restaurants, and movie houses of neighboring coastal towns—all of the Murphys' needs could be met. The other three prominent centers of artistic interaction were miles away from the water and coastal activities, up in the hills. The Murphys could almost effortlessly enjoy the many amenities for which the Riviera is known.

Richard Cowan, a friend of the Murphys who visited them at Villa America, evoked the special charms of life there in his diary. On Friday, August 10, 1934, he wrote: "To the beach again in the morning after having been to the market in Antibes with [Sara]. Went again to Eden

[Roc] in the afternoon. [Fernand] Léger had dinner with us on the terrace with its lovely view over the palms, cypresses, eucalyptus, etc. to the bay of Cannes. After dinner, we drove to a movie in Cannes." The following day, he recorded shopping in Nice with various family members, swimming at Eden Roc, visiting a botanical garden, returning to Eden Roc for more swimming, and having a dinner in Cannes under fireworks before going to Maxime's in Juan-les-Pins for dancing. The night after that, Cowan once again had cocktails and dinner with Léger on the Murphy terrace, "looking toward the sunset and then watching the stars and the lights of Cannes come out."[6]

To the northwest of Villa America, five miles inland, in Auribeau, was Russell Greeley's Château de Clavary. In 1925 Greeley, a portrait painter born near Boston and educated at Harvard University, purchased and then renovated the Château de Clavary, a building originally constructed in 1820.[7] In her autobiography published in 1932, the English painter Nina Hamnett evokes the first impression that the château made on her when she visited about six years earlier: "The yellow flowers in the sunlight were so bright and dazzling that one had to blink

one's eyes for a few seconds before one could see. . . . The whole lawn was covered in the biggest and sweetest smelling violets that I have ever seen. . . . I felt that at last I had arrived in Paradise."[8] The château was known for its beautiful vegetation and views of the surrounding countryside.

Greeley lived at Clavary with his friend, the Anglo-French artist and bon vivant François de Gouy d'Arcy. Despite its relative isolation, the château enjoyed a regular flow of interesting visitors. The guest book and photo albums from Clavary,[9] reinforced by published accounts, allow us to construct a list of the château's amazing array of foreign and French visitors from about 1925 to 1938: artists Constantin Brancusi, Kees van Dongen, Nina Hamnett, Jean and Valentine Hugo, Marie Laurencin, Fernand Léger, Man Ray and his friend Kiki, Francis Picabia (and his then-companion Germaine Everling), Picasso, André Dunoyer de Segonzac, and Christopher Wood; composers Georges Auric, Arthur Honegger, Darius Milhaud, Francis Poulenc, Igor Stravinsky, and Germaine Tailleferre; patrons of the arts and society figures Edith and Étienne de Beaumont, Eugenia Huici Errazuriz, Jean Godebski, Walter and Mary Osgood

Villa America.

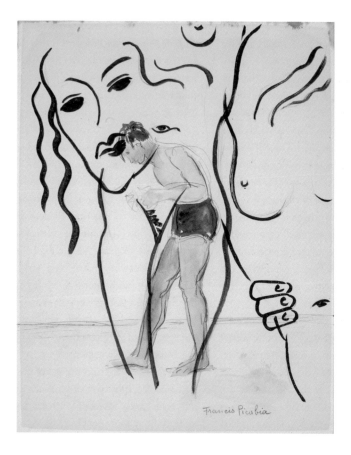

Francis Picabia, *Transparence*
(F. Scott Fitzgerald?), c. 1930
Watercolor and ink on paper,
12 × 10 in.

Hoving, and Jean de Polignac; performers such as the actor Pierre Bertin and his pianist wife Marcelle Meyer, the singer/actress Marthe Chenal, and the dancer Isadora Duncan; and writers Jean Cocteau, René Crevel, Robert Desnos, Max Jacob, Maurice Maeterlinck, Jacques Rigault, Tristan Tzara, and Paul Valéry. Art dealer Léonce Rosenberg and impresario Sergei Diaghilev also visited. Max Jacob was the first guest and appears to have been particularly close to Greeley. Clavary's foyer features a floor mosaic by Picasso.

Also northwest from Villa America, in Mougins, in the hills behind Cannes and Antibes, was Picabia's Château de Mai (named, in Dada fashion, after the month in which construction started). Picabia had the home built in 1925 and packed it full of his cherished collectibles, including his own Dada paintings.[10] In her memoirs, Picabia's then-companion, Germaine Everling, recounted life at the château, noting the very impressive list of visitors there, including Gerald Murphy.[11] Other visitors were Pablo and Olga Picasso, Jeanne and Fernand Léger, Yvonne George, Jacques Doucet, Robert Desnos, Paul

Éluard, Rolf de Maré, Gertrude Stein, Marcel Duchamp, Jean Cocteau, René Clair and his wife Marthe Chenal, Constantin Brancusi, and others.

Much farther west, in the town of Hyères, is the Villa Noailles. The abundance of shade in Hyères induces a sense of relaxation, as do the narrow cobblestoned streets and covered passages of this old medieval city. The streets wind their way up a hill, at the top of which sits the Villa Noailles, a salmon-colored building that gleams and glistens over the shaded passageways and squares below.

Charles and Marie-Laure Noailles had commissioned architect Robert Mallet-Stevens to design the villa for them in 1923, on land they had recently received as a wedding present.[12] The result was a major contribution to the nascent International Style movement. Overlooking the city and sea, the hypermodern structure is located amidst the ruins of a medieval château, making a strong statement about the new versus the old—clearly an important goal of the Noailles. There is a large indoor swimming pool and a stylish Cubist garden outside. To decorate the

villa, the Noailles commissioned and acquired various works of modern art by such artists as Jacques Lipchitz, Henri Laurens, and Léger. In 1928 they commissioned Man Ray to make a film of their friends at play at the villa, titled *Les Mystères du château du dé* (Mysteries of the château of the dice) in reference to both Stéphane Mallarmé's poem "Un coup de dé n'abolira jamais la chance" (A roll of the dice will never abolish chance) and the dice-like shape of the building. To make this "documentary" interesting, Man Ray put silk stockings over the heads of the guests, thereby creating a sense of mystery. In addition to Man Ray, other visitors and guests at Villa Noailles included composers Auric, Milhaud, and Poulenc; filmmaker Luis Buñuel; artists Alberto and Diego Giacometti, Laurens, and many others. The Noailles spent the first of their annual stays there in November 1925 and remained part-time residents thereafter.

It is clear that these châteaux and villas were not entirely separate entities; they shared visitors, together forming a strong avant-garde community. Man Ray visited not only Villa Noailles but also Villa America, where he photographed the Murphy family. He was at the Château de Clavary as well, and it can be assumed that he visited the Château de Mai regularly, since he and Picabia were close friends. Picasso and Léger can similarly be linked to all four locales. A watercolor purportedly of F. Scott Fitzgerald on the beach by Picabia (see p. 193) suggests a link between the artist and a key member of the Murphy circle. Regrettably, the Château de Clavary is the only residence to have a surviving guest book to confirm the list of visitors and dates.

Of the four estates, Villa America was the most American in orientation, as its name boldly declares. It was particularly welcoming to American literary figures, with such visitors as Fitzgerald, Ernest Hemingway, Archibald MacLeish, John Dos Passos, Dorothy Parker, Robert Benchley, Gilbert Seldes, and Philip Barry. Most of these writers were not yet well known, except for Fitzgerald, who became famous with the publication of *This Side of Paradise* in 1920. Gerald and Sara's appealing lifestyle on the Riviera fed into the characters and milieu of Fitzgerald's next major work, *The Great Gatsby* (1925), and they directly inspired the characters of Dick and Nicole Diver in Fitzgerald's next famous book, *Tender Is the Night*, which is dedicated to the Murphys (see Linda Patterson Miller's essay). The Murphys also encouraged Hemingway with his book *The Sun Also Rises* (whose title Ger-

ald especially liked). Both works have become classics of American literature. It seems fitting that Sara, who came from a family whose wealth derived from ink manufacturing and sales, and Gerald, who hailed from a family that sold high-end desk accessories, among other fine leather goods, lent so much support to writers.

The Murphys' life on the Riviera also fostered the creation of several significant artworks, including the family portraits photographed by Man Ray and works by both Picasso and Léger, who visited Villa America regularly. In a series of drawings in a neoclassical style from the mid-1920s, for example, Picasso depicted women on the beach who resemble Sara in their features. His painting *Woman in White* (1923, in the collection of the Metropolitan Museum of Art, New York), created soon after the Murphys began summering on the Côte d'Azur but before the completion of Villa America, is an excellent example of the artist's neoclassical phase. Charming watercolors of Gerald and Sara by Léger survive in the Murphy family collection.

But the major art to come out of the Villa America was by Gerald Murphy himself. He made only fourteen paintings in his career, seven of which survive and four of which exist only in reproductions. It appears that he made many of them at the Villa America, including *Cocktail* (1927). Yet, even though they were made in France, Gerald's paintings are quintessentially American, with their references to Precisionism, commercial sign painting, and billboards. As important precursors to Pop art, they can be considered masterpieces of American art.

The Murphys made little attempt to assimilate in France: they were resolutely and unapologetically American in terms of their customs and interests. Indeed, their very American-ness added to the cosmopolitan feeling of the Riviera. At the same time the Murphys were decidedly worldly in their outlook. They traveled extensively, between the Riviera and Paris on a monthly basis, around Europe, and frequently to the United States.

Beyond lending their villa an American flavor, the Murphys set their retreat apart from the other avant-garde residences on the Riviera through their devotion to family life. The dream world they created for their children included exercising on the beach, going on Easter egg and treasure hunts, putting on art exhibitions, and spending playtime with animals. Guests immediately found themselves in a warm and friendly environment. At times the Murphys assumed not just a familial but a parental

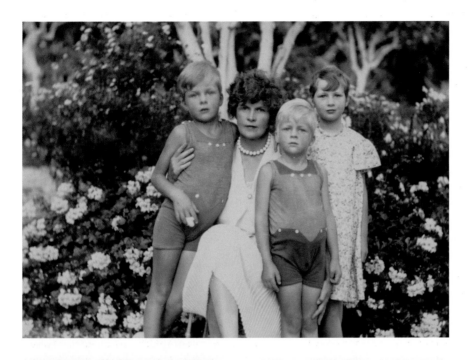

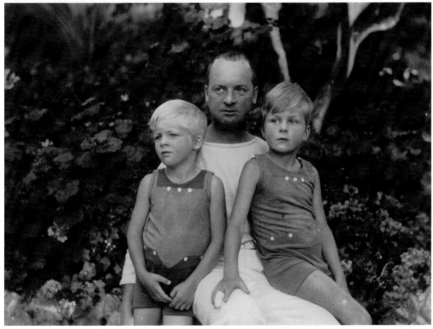

Man Ray, *Sara Murphy and Her Children*, c. 1926. Gelatin silver print, 6 ¾ × 9 in.

HONORIA MURPHY DONNELLY COLLECTION

Man Ray, *Gerald Murphy and His Sons Patrick and Baoth*, c. 1926. Gelatin silver print, 6 ¾ × 9 in.

MUSÉE NATIONAL D'ART MODERNE, CENTRE GEORGES POMPIDOU, PARIS

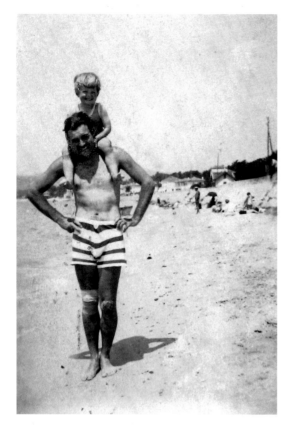

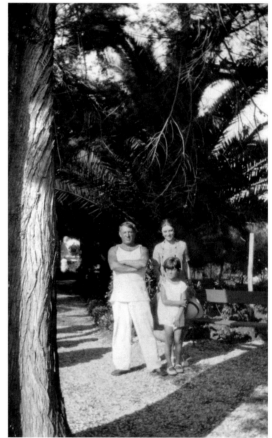

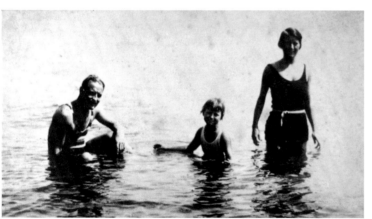

Ernest Hemingway with his son John (known as Bumby), La Garoupe beach, Antibes, 1924.

F. Scott Fitzgerald and his wife, Zelda, with their daughter, Scottie, bathing at La Garoupe beach, Antibes, c. 1926.

Pablo Picasso, his wife Olga, and their son, Paulo, Juan-les-Pins, 1925 or 1926.

role with their guests. This was especially true with Fitzgerald and Hemingway, who were, respectively, eight years and ten years younger than Gerald (and thirteen and fifteen years younger than Sara). When Hemingway separated from his first wife, Hadley, the Murphys wrote a touching letter of support, saying "somehow we are your father and mother."[13] Like parents, the Murphys provided financial, as well as moral, support to Hemingway in the 1920s and later, when he fell on hard times, to Fitzgerald in the 1930s. Gerald, for example, let Hemingway use his Paris studio. Gerald and Sara also had a supportive relationship with Léger, helping to arrange patrons for him and sponsoring several trips to the United States.[14]

The Murphys were the hub of their circle, with their friends becoming extended family members. Others wanted to share the Murphys' domestic, family-centered lifestyle: Ernest and Hadley Hemingway brought their son, Bumby; Scott and Zelda Fitzgerald brought their daughter, Scottie; and Pablo and Olga Picasso brought their son, Paulo. At Villa America, the Murphys replaced the bohemianism of Montparnasse—in which single, impoverished, carefree individuals experimented with drugs and drank to excess—with a robust celebration of children and family life. They demonstrated that the pursuit of earthly pleasures and an enjoyment of family life were not antithetical to avant-garde activity, but could be keys to extending it.

Together with the Château de Clavary, the Château de Mai, and Villa Noailles, Villa America served as a meeting point and a center for avant-garde artists during the 1920s, creating a vibrant artistic community on the Riviera. Yet its unique characteristics—its proximity to the ocean and the emphasis placed on family—set it apart from these other three locales. In addition, the exceptional art created at Villa America by Gerald Murphy, and the legendary writing that it inspired by F. Scott Fitzgerald and others, distinguished Villa America as a remarkable spot in Riviera history and, indeed, artistic history.

NOTES

1 See my chapter "Modigliani and Montparnasse," in Kenneth Wayne, *Modigliani and the Artists of Montparnasse* (New York: Harry N. Abrams, 2002), 16–29.

2 Quoted in Jimmie "The Barman" Charters, *This Must Be the Place: Memoirs of Montparnasse* (1934; reprint, New York: Collier Books/Macmillan, 1989), 100–1.

3 See my essay "Montparnasse Heads South: Archipenko, Modigliani, Matisse, and WWI Nice," in Kenneth Wayne, ed., *Impressions of the Riviera: Monet, Renoir, Matisse and Their Contemporaries* (Portland, ME: Portland Museum of Art, 1998), 26–37.

4 Mary Blume, *Côte d'Azur: Inventing the French Riviera* (New York: Thames and Hudson, 1992), 88.

5 For more on this, see the chapter "Intruders in the Landscape," in Kenneth E. Silver, *Making Paradise: Art, Modernity, and the Myth of the French Riviera* (Cambridge, MA: MIT Press, 2001), 83–99.

6 Richard David Cowan, diary entries, August 10, 11, and 12, 1934, Richard David Cowan Papers, in Stewart Mitchell Papers, Boston Athenaeum.

7 For more information on Clavary and many photos of Greeley and his visitors there, see my essay "Château and Villa Life on the Riviera during the Jazz Age: A Pictorial Essay," in Wayne, *Impressions of the Riviera*, 62–67. It has information and photos relating to the other three artistic locales as well.

8 Nina Hamnett, *Laughing Torso: The Reminiscences of Nina Hamnett* (New York: Ray Long and Richard R. Smith, 1932), 308–9.

9 Maintained by the Greeley heirs in Portland, ME. The author has a copy of the guest book. Many of the photos were published in my "Château and Villa Life on the Riviera during the Jazz Age."

10 See *Picabia et la Côte d'Azur* (Nice: Musée d'Art Moderne et d'Art Contemporain, 1991).

11 See Germaine Everling, *L'Anneau de Saturne* (Paris: Editions Fayard, 1970), esp. chapter 29, "Vie de Château," 165–79.

12 See Cécile Briolle, Agnès Fuzibet, Gérard Monnier, and Rob Mallet-Stevens, *La Villa Noailles* (Marseille: Éditions Parenthèses, 1990); and Dorothée Imbert, *The Modernist Garden in France* (New Haven, CT: Yale University Press, 1993).

13 Gerald and Sara Murphy, letter to Ernest Hemingway, [fall 1926], Ernest Hemingway Papers, John F. Kennedy Presidential Library and Museum, quoted in Amanda Vaill, *Everybody Was So Young: Gerald and Sara Murphy, A Lost Generation Love Story* (Boston: Houghton Mifflin, 1998), 185.

14 Sara's sister Hoytie Wiborg bought Léger's *Le Pot à Tisane* (1918) from the Paris dealer Léonce Rosenberg, as recounted in a letter from Rosenberg to Léger on January 16, 1926, in *Fernand Léger: Une Correspondance d'affaires* (Paris: Les Cahiers du Musée National d'Art Moderne, 1996), 109 (letter 306). On Léger's first trip to the United States, see Amanda Vaill, *Everybody Was So Young*, 261–63.

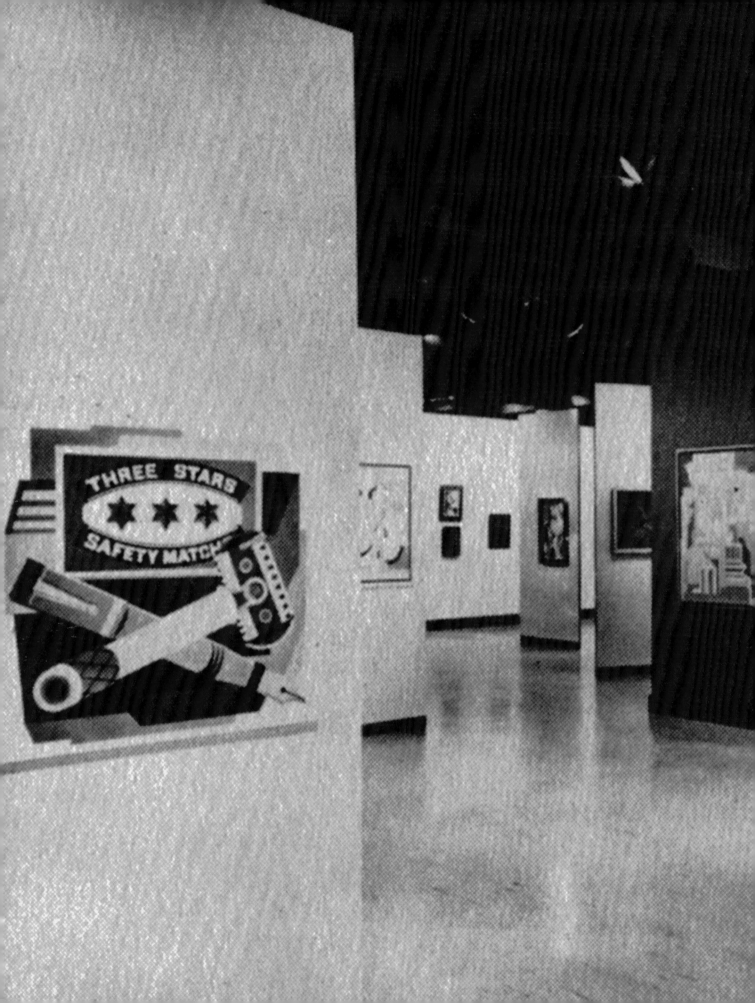

Considerable scholarship and biographical inquiry has examined Gerald Murphy in the 1920s with emphasis on the elegance of his stylish life in Paris and on the Riviera, and with his dozen or so paintings characterized as emblems of America, which was viewed by his contemporaries as the embodiment of modernity. There has been, in contrast, little curiosity about Gerald Murphy's sudden rediscovery about forty years later, after decades of obscurity, in the wake of personal tragedy, financial reversals, a definitive return to the United States, and the transformation of Europe through the political convulsions of fascism and war. This essay will illuminate his rediscovery during the final decade of his life, in 1960, in a small new museum of contemporary art in Dallas, Texas, as part of an aesthetic and intellectual program intended as a retort to the conservative cultural and political atmosphere that had convulsed that city and permeated much of the country in the 1950s (and would continue to do so through the 1960s).

AMURIKIN

Gerald Murphy's sudden appearance on the stage of avant-garde art exhibitions in Paris in the 1920s, no matter how brief, piqued the interest of prominent art critics, whose comments insisted on something quintessentially "American" in his work. Pablo Picasso, too, proclaimed him to be "Amurikin,—certainly not European," and Fernand Léger described him as "the only American painter in Paris."[1] Gerald exhibited annually at the Salon des Indépendants from 1923 through 1926, and his works were reproduced or discussed in a variety of journals, including *L'Art vivant, L'Art d'aujourd'hui,* and *Bulletin de L'Effort Moderne,* as well as in the Paris edition of the *New York Herald Tribune.*[2] Gerald's work on an "American ballet"—*Within the Quota* of 1923— commissioned by the Swedish impresario Rolf de Maré, would only have fostered this notion of nationalistic identity. The scenario, the décor, and the costumes (not to mention the music, by Gerald's college friend Cole Porter) were boldly satirical plays on American stereotypes. A flimsy plot provided the vehicle for an immigrant's encounters with a string of prototypical characters: the Heiress, the Colored Gentleman, the Jazz Baby, the Prohibition Agent, the Cowboy, the Sheriff, and so on. The backdrop, designed by Gerald, mimicked a giant tabloid, screaming parodistic headlines of the day: "Unknown Banker Buys Atlantic," "Rum Raid Liquor Ban," "Auto King Pledges Boom." The ebullient hyperbole of this production surely inspired the unusual scale (eighteen feet by twelve feet) of *Boatdeck,* which Gerald painted during 1923 and exhibited to great consternation at the Salon the following year. While his

Detail of photograph of *American Genius in Review No.1,* Dallas Museum for Contemporary Arts, 1960 (see p. 201).

earliest works focused on large-scale machinery, often related to modern travel—turbines, engine rooms, and ocean liners—later compositions depicted smaller-scaled objects of contemporary life—the Gillette safety razor, the Parker fountain pen, sulfur matches, and the Mark Cross railroad watch. These objects representing the world of merchandising and modern advertising surely had a personal resonance for the heir to Mark Cross, but they also appealed to his sensibility as emblems of something peculiarly American.[3]

It is understandable that Gerald's sense of Americanness should be accentuated by the experience of otherness while living abroad, in the mundane sense of anyone in that circumstance experiencing one's nationality—for better and worse—with heightened sensitivity through the lens of distance and difference. Gerald himself said: "Although it took place in France, it was all somehow an American experience. We were none of us professional expatriates, and Paris and the French seemed to relish it."[4] It is small wonder that Gerald later reminisced about his family's years in France as halcyon days: they had successfully evaded the pressures of the Murphy and Wiborg families and enjoyed—in financially privileged circumstances—the heady company of an extraordinary circle of cultural and social luminaries, while, moreover, Gerald discovered himself as a painter. But his personal experience coincided perfectly with the Roaring Twenties, a moment between the wars when the United States emerged as a superpower, when Americans traveled extensively, and when the nation's jazz and soaring skyscrapers were celebrated as the chic embodiments of modernity. Gerald embraced and accentuated his Americanness and, with his ebullient sense of style, played to his audience, offering Europeans exactly what they expected from the modern American. If his paintings were embodiments of Americanism, celebrating the functionality and power of the machine and partaking of the clarity of modern advertising, his modest artistic production was almost obscured by the power of his personal story, which inspired F. Scott Fitzgerald, Ernest Hemmingway, and Archibald MacLeish and subsequently became the focus of serious biographers whose works read like movie scripts. It seems to have been a life crafted with self-conscious intelligence, with an eye to what John Dos Passos later described as the French enthusiasm for everything "transatlantic chic."[5] Jacques Mauny, a minor artist, freelance writer, and advisor to the col-

lector A. E. Gallatin, captured the amalgam of artist and personality that Gerald exemplified, comparing his art to a stylish gentleman strolling down Park Avenue: "His art, impeccably dressed, is neat like a gentleman and explains the new American taste; just like a walk down Park Avenue, it shows us clearly the beauty of the instruments of daily life executed with perfection."[6] Mauny's 1926 article in L'Art vivant reads like a prose poem of admiration for the skyscrapers, billboards, and tabloids of New York. Aerial photographs of New York are juxtaposed with works by Gerald Murphy, Charles Sheeler, and Preston Dickinson. Yet despite its enthusiasm, the article reveals an unmistakable tone of superiority as Mauny describes "the beginnings of the American aesthetic."[7] It is not hard to imagine this avant-garde enthusiasm gradually eroding toward the end of the 1920s and early 1930s, eventually being supplanted by intellectual and political suspicion about the impact of Americanism and the transformation of national identity into a strident nationalism.[8] The world was wracked by the Depression, by the rise of fascism, and by the tumult of war. Gerald's personal idyll was irrevocably altered by the illnesses and deaths of his sons, by his return to the United States, and by his abandonment of painting in order to lead Mark Cross through years of financial reversal.

"I'VE BEEN DISCOVERED. WHAT DOES ONE WEAR?"

Almost forty years after his sudden success at the Paris Salon des Indépendants in the 1920s, Gerald Murphy was plucked from obscurity by the fledgling Dallas Museum for Contemporary Arts.[9] The museum's newly appointed director, Douglas MacAgy, included five of Gerald's paintings in a 1960 group exhibition entitled American Genius in Review No. 1, alongside works by Tom Benrimo, John Covert, Morgan Russell, and Morton Livingston Schamberg. This was not an exhibition of cutting-edge contemporary artists, but a historical project, resurrecting the work of artists whose careers had flourished decades earlier and whose work had fallen into obscurity. For instance, John Covert and Gerald Murphy had given up painting entirely, and Schamberg had died early. There was no readily apparent overriding theme to the exhibition, although four of the artists had trained or worked in Europe, and the impact of Cubism and abstraction was clear. To clarify MacAgy's intent is important, and so we need to pose several questions: Why did

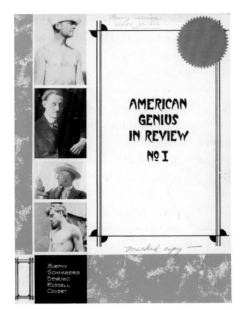
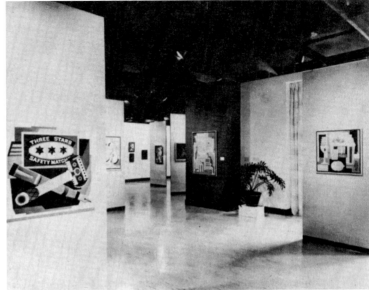

Cover of *American Genius in Review No. 1*, the catalogue to an exhibition of the same name at the Dallas Museum for Contemporary Arts, May 11–June 19, 1960.

American Genius in Review No. 1, Dallas Museum for Contemporary Arts, May 11–June 19, 1960.

BOTH IMAGES COURTESY OF DALLAS MUSEUM OF ART

MacAgy choose these artists? What did he intend to accomplish with the exhibition? How did this project reflect a broader program and agenda in Dallas? How did MacAgy come to know Gerald's work in the first place? Answering these questions will reveal the highly politicized nature of the cultural climate in Dallas at that time, which resonated with the McCarthyism that held the entire country in thrall. The founding of a new museum devoted to contemporary art was a response to the labels then being applied to modern art, which was accused of being "unpatriotic" or "communist." MacAgy, as we will see, was part of a national cadre of vanguard art historians and curators who championed modern art with sophisticated and compelling museum programs. Gerald Murphy, the embodiment of the modern American in Paris of the 1920s, was drawn into a fierce debate as to whether modern art was either American or un-American.

UN-AMERICAN?

The formation of the Dallas Society for Contemporary Arts in 1956, and the subsequent founding of the Dallas Museum for Contemporary Arts the following year, was a clear act of defiance against the cultural conservatism that buffeted the city in the 1950s. The Dallas Museum

of Fine Arts, the community's general museum, founded in 1903, had come under a series of virulent attacks from political conservatives, who accused it of "overemphasizing all phases of futuristic, modernistic and non-objective painting and statuary," of "sponsoring the work of communists," and of neglecting local artists "whose patriotism . . . has never been questioned."[10] Such charges simply repeated the McCarthyist coupling of art and patriotism that was fueling national debates at that time. One of the most frequently quoted congressional speeches in these debates was by Michigan representative George A. Dondero, entitled "Communist Conspiracy in Art Threatens American Museums."[11] In Dallas, the conservative Public Affairs Luncheon Club published a pamphlet entitled "Is There a Communist Conspiracy in the World of Art?"[12] Local newspapers followed the controversy surrounding the Museum of Fine Arts, where staff and trustees came under personal attack and specific artworks by Diego Rivera, Joseph Hirsch, and George Grosz were identified for removal. Conservatives not only sought to identify modern art with communism and anti-Americanism, but to taint the institutions that showed modernist works with accusations of misuse of public funds and the subversion of morality and order. The

Dallas Patriotic Council, a consortium of conservative clubs and associations, led the charge. One of the council's members, Florence Rodgers, wrote to the museum board and in a statement to the *Dallas Times Herald:* "The specific issue is whether the paintings of an artist who is a Communist or who is a known supporter of Communists or Communist party activities and who is supported by official Communist publications should be exhibited in a museum supported by Dallas taxpayers, thereby in turn giving support to the Communist Party itself and the Russian Communist government. . . . Let every fair-minded reader understand that the question to be answered is this: Shall art by Reds be exhibited at taxpayers' expense in our museum?"[13] Another article, "Art for Whose Sake? Some Modernists Are Peddling More Than Pictures," was first published by Esther Pels in the *American Legion Magazine* and then reprinted in *Facts Forum News.* Pels told "the sickening story of decadence, perversion, and revolutionary purpose behind the introduction of modern art to America" and how foreign artists "plotted to use art as a means of power over the masses."[14]

One project that emerged as the particular focus of controversy was the exhibition *Sport in Art,* organized by the American Federation of Arts, based in New York. The exhibition began its tour in Boston, traveled to Washington, DC, and after being shown in Dallas was scheduled to travel to Denver, Los Angeles, and San Francisco before culminating in Australia during the 1956 Olympic Games. In Dallas, the political affiliations of Yasuo Kuniyoshi, William Zorach, and Leon Kroll caused conservative critics to demand the exclusion of their artworks from the exhibition. Though the Dallas Museum of Fine Arts resisted this pressure, the controversy did result in the United States Information Agency withdrawing its sponsorship of the Australian presentation. In some national headlines, Dallas was to blame for this. An *Arts Magazine* editorial blared: "Dondero, Dallas and Defeatism."[15] The Sunday *New York Times,* however, lauded the museum's steadfast resistance to these pressures: "The courageous stand of the Dallas Art Association is a benefit not only to the Texas museum but also for every creative person in the land."[16] *Art News* published a thorough report by Charlotte Devree, and a rebuttal to Esther Pels written by René d'Harnoncourt, director of the Museum of Modern Art, was published in *Facts Forums News.*[17] Jerry Bywaters, director of the Dallas Museum

of Fine Arts, seemed to come away from these episodes a hero, lauded by his colleagues in a special resolution at the thirty-eighth annual meeting of the American Association of Art Museum Directors.[18] Nonetheless, passionate proponents of modern and contemporary art had lost confidence in the Dallas Museum of Fine Arts and doubted its ability to continue to resist governmental and community pressure. As recently as 2003, a former president of the Dallas Museum for Contemporary Arts expressed incredulity when recalling how the Museum of Fine Arts edited photos from its presentation of the Museum of Modern Art's *Family of Man* exhibition of *Life Magazine* photography in 1955.[19] The suspicions surrounding the Museum of Fine Arts were echoed in a 1959 *New York Times* article that celebrated Dallas's new contemporary arts institution. "The existing Dallas Museum of Fine Arts, dedicated to the whole history of art, is inhibited as a city-supported institution both overtly and subtly by vociferous anti-modern art groups and has become increasingly conservative."[20]

ABSTRACT BY CHOICE

The title of the new museum's very first exhibition, organized by the trustees themselves in 1957—*Abstract by Choice*—could not have been a clearer public rebuke of the conservatives' accusations and insinuations about modern art. The exhibition was, moreover, rife with foreign or foreign-sounding names—Lyonel Feininger and Max Weber, for example—that would surely have antagonized the fears of the critics (like Pels) who were so intensely suspicious of the intentions of foreign-born abstract artists. The new museum embraced an ambitious program of modern and contemporary art exhibitions, including a number of "firsts," among them the first U.S. presentation of the work of René Magritte, in 1960. Another exhibition, titled *1961* (though presented the following year), explored Pop art, including works by James Rosenquist, Roy Fridge, Joe Glasco, Robert Motherwell, and Robert Rauschenberg, as well as both the first objects from Claes Oldenburg's 1961 installation *The Store* and his first Happening to be seen outside New York. There was, as well, a clear emphasis on foreign art, as in the exhibitions *Contemporary Japanese Painting and Sculpture, Italian Sculptors Today,* and *Drawings by Ulfert Wilke,* all presented in 1960.[21]

The trustees' choice of a museum professional from outside the community to serve as the first director of

the new museum was also surely a conscious response to the parochialism that had fired the controversies in Dallas. Douglas MacAgy had trained at the Barnes Foundation, near Philadelphia, and that institution's innovative notions about art museums and education seem to have marked his career-long aspiration to transform the traditional museum into an interactive and outward-looking site. His career had unfolded in San Francisco, at the San Francisco Museum of Art and at the California School of Fine Arts, and subsequently in New York, at the Museum of Modern Art and at Wildenstein and Company. MacAgy's national professional network was evident in his work in Dallas. He brought the Museum of Modern Art's exhibition *Art of Assemblage* to the Dallas Museum for Contemporary Arts in 1962, and *Art News* publisher Alfred Frankfurter visited MacAgy at his new institution in 1960. Frankfurter's magazine had played a role in the Dallas cultural debates with the publication of the commentary by d'Harnoncourt, with whom MacAgy had worked at the Museum of Modern Art in his role as director of television. In this position, MacAgy had produced pilot programs, analyzed the evolution of national and commercial television systems from across the globe, and helped write *The Museum Looks in on Television: A Report on Art and Television,* commissioned by the Rockefeller Fund.[22]

In his introduction to the catalogue accompanying

Rudi Blesh, photographed by Bernard Davis, reproduced on the inside cover of Blesh's *Modern Art USA: Men, Rebellion, Conquest, 1900–1956* (New York: Alfred A. Knopf, 1956).

American Genius in Review No. 1, MacAgy reveals many of the most important figures in his circle. He acknowledges, for example, Andrew Carnduff Ritchie, who as director of painting and sculpture at the Museum of Modern Art, had included Morgan Russell, John Covert, and Morton Livingston Schamberg in a major group exhibition in 1951. (Covert and Schamberg would also have come to MacAgy's attention through the Katherine S. Dreier and Louise and Walter C. Arensberg collections at Yale, the Philadelphia Museum of Art, and the Museum of Modern Art.[23]) MacAgy also thanks Dreier's curator and advisor, Marcel Duchamp, for his "advice and assistance," and James Johnson Sweeney, curator at the Museum of Modern Art from 1935 to 1946, director of the Solomon R. Guggenheim Museum from 1952 to 1960, and subsequently director of the Museum of Fine Arts in Houston. It seems, however, that jazz historian Rudi Blesh had the greatest impact on the *American Genius in Review* project.[24] MacAgy writes: "In retrospect, it is possible to trace the glimmerings of the idea to conversations with Mr. Rudi Blesh when, five years and more ago, he was preparing his excellent account of American artists and art, *Modern Art USA.*"[25] The connection between Blesh and MacAgy is indicated in *Modern Art USA: Men, Rebellion, Conquest, 1900–1956* when Blesh explains that his project had begun as a television program he prepared at the Museum of Modern Art in 1954 (at which time, we recall, MacAgy was the museum's director of television).

Alfred Frankfurter, editor of *Art News;* Edward Marcus, president of the Dallas Museum for Contemporary Arts; and Douglas MacAgy, director of the Dallas Museum for Contemporary Arts at the museum's exhibition of sculpture by André Derain, January 28–March 6, 1960.

Modern Art USA is a history of modern art from the late nineteenth century through the date of its publication, in 1956, with an emphasis on the emergence of modernism in America. The most salient feature of the narrative, however, is its discussion of the *reception* of modernism—the interaction of artists with patrons, dealers, and curators, and the impact of exhibitions, museums, and galleries on the public. Along with the stories of such pioneers in the presentation of modern art as Dreier, the Arensbergs, Alfred Stieglitz, and Alfred H. Barr, Jr., Blesh also mentions admiringly the work of his friend MacAgy.[26] In fact, Blesh and MacAgy had known each other since the 1940s in San Francisco; while at the Museum of Art there, MacAgy had invited Blesh to present a lecture, titled "Hot Jazz and Its Origins," which evolved into an extremely popular series of concerts and lectures.[27]

It was Blesh who discovered Gerald Murphy and brought him to MacAgy's attention. As a critic for the *New York Herald Tribune* and host of a popular jazz radio program in New York, Blesh would have been familiar with the impact of American music on Paris in the 1920s. His deep knowledge of that milieu would most naturally have brought him into contact with Gerald, who had been living in New York since the early 1930s. Artist Roger Wilcox, in an interview with Linda Patterson Miller in 1982, revealed that he and his wife, Lucia Anavi-Christofanetti (a Surrealist painter and larger-than-life personality), introduced Blesh, along with Harriet and Sidney Janis, to Gerald.[28] Impressed by the one canvas hanging in Gerald's apartment—his 1927 painting *Cocktail* (p. 103)—Blesh attempted to convince Gerald to do a show with Sidney Janis. Though we know Gerald shared Blesh's passion for jazz,[29] he apparently did not like Blesh or the Janises.[30] Thwarted in his attempt to have Gerald show with Janis but still passionate about his painting, Blesh apparently prevailed upon Wilcox and Anavi-Christofanetti to introduce MacAgy to Gerald.[31] It was to MacAgy that Gerald revealed the story of the painting career about which he had not spoken for many years.

Not only did Blesh bring Gerald to MacAgy's attention, but in *Modern Art USA* he also inscribed the artist's life and career into a political framework that would speak most directly to MacAgy's Dallas project. In his discussion of Americans in Paris in the 1920s (Gertrude Stein's "Lost Generation"), Blesh paints a bleak picture of American culture: "Throughout nearly the whole decade of the 1920's, the abstract artist in America was a man almost without hope. He could not sell a painting; he could not even live by teaching. Throughout the land, scarcely one college or art school taught abstract art. . . . As one talks with these pioneer moderns today—those who are still alive—one gets the overwhelming impression of bereavement and rejection. Theirs is sorrow, not bitterness. They had hoped for better from their country."[32] Blesh presents Gerald Murphy, Schamberg, Russell, and Covert (four of MacAgy's "American geniuses") as victims of American philistinism. In fact, his book as a whole is a rebuke of the conservatism pervading the country throughout the first half of the twentieth century, whether in the 1920s or 1950s. Blesh concludes his text with a characterization of modernism as the expression of an inquiring mind, the search for and embrace of difficult questions, culminating with a defiant declaration: "We are not going to stop asking them."[33]

American Genius in Review No. 1 was an extraordinarily canny response to MacAgy's new post in Dallas. The exhibition extolled the importance of American artists—"geniuses"—and presented works that were not entirely abstract, many of which were seductively beautiful. Gerald himself described his paintings as "poised between abstraction and realism."[34] Moreover, the exhibition offered a historical perspective, excavating from obscurity works that had been executed nearly four decades earlier. At the same time, MacAgy and his colleagues, like Blesh, would have understood the sharpness of the rebuke to the cultural conservatism that had brought MacAgy to Dallas in the first place.[35]

ISMS

One might surmise that Gerald was blissfully unconcerned with the politics surrounding his discovery in 1960. However, this is probably untrue, as we know that he had helped bail Dashiell Hammett out of jail in 1951 after the author refused to testify in a trial of four accused of Communist activities and that he had testified on behalf of someone else who had been accused of being un-American.[36] There is also a handwritten note from Gerald to MacAgy in which Gerald expresses his admiration of MacAgy's courage in emphasizing modern art in Dallas in 1960.[37] Otherwise, the correspondence between Gerald and MacAgy provides basic information about the artist's biography and paintings—information that was vastly expanded upon in Calvin Tomkins's biography,



GERALD MURPHY
26:IV:60

After reading an account
of the picketing outside the Museum
of Modern Art, I had a strange dream
in which (as I walked thro' N.Y.C.)
I saw on all the Newstands banner
headlines reading ' Texas Curator
Honors Six Unknown Painters
of the Twenties.' ' DMCA
Revives ERA of Birth of Modern
Art in USA.' There was an
account of your haranguing a
city crowd in Dallas and
quoting Cocteau(!) ' Je suis le
poete le plus renommé et le
plus inconnu au monde.' A
great deal more was too garbled
to recall.

Gerald Murphy, letter to Douglas MacAgy, April 26, 1960.

Living Well Is the Best Revenge, published in 1962, just two years before Gerald's death. When the Museum of Modern Art presented an exhibition of Gerald Murphy's work in 1974, William Rubin's teleological analysis emphasized the painter's absorption of Cubist compositional formulae, meticulously correcting misinformation from the 1960 Dallas Museum for Contemporary Arts catalogue. Since that time, Gerald's work has been absorbed into a variety of art-historical contexts: Cubism, Precisionism, Purism, art of the Machine Age, Pop art, the modern still life, and the vernacular of advertising. In contrast to the art-historical literature, Gerald, in correspondence to MacAgy dated May 21, 1962, seems to insist that he worked independently in Paris and was rather impervious to influence: "There seemed to be little sense of there being 'schools' of painting at that time. . . . Artists seemed to have more than enough nourishment and were too busy and too intent on their own work."[38]

The political charge of Americans in Paris in the 1920s has been rediscovered, but the extraordinarily tense po-

litical environment of Gerald Murphy's rediscovery in Dallas has simply faded into obscurity. What seems consistent throughout the literature, however, is an insistence on the particularly American quality of Gerald's work. This would have pleased the artist, who in Blesh's 1956 book asserted the special quality of American painting: "We need real American artists. There is something to be painted by us that only we should do."[39]

NOTES

1 Quoted in William Rubin with the collaboration of Carolyn Lanchner, *The Paintings of Gerald Murphy* (New York: Museum of Modern Art, 1974), 30.

2 William Rubin's essay in *The Paintings of Gerald Murphy* focuses on unraveling contradictory evidence and establishing a reliable chronology of Murphy's painting and exhibiting activities.

3 Gerald Murphy, letter to Douglas MacAgy, May 21, 1962, Douglas MacAgy Papers, Archives of American Art, Smithsonian Institution, Washington, DC; transcribed in Rubin, *The Paintings of Gerald Murphy,* 46, n. 78.

4 Quoted in Rubin, *The Paintings of Gerald Murphy,* 9, n. 6.

5 John Dos Passos, *The Best Times; An Informal Memoir* (New York: New American Library, 1966), 153.

6 "Son art, tiré à quatre épingles, est net comme un gentleman et explique le goût américain nouveau; aussi bien qu'une promenade dans Park Avenue, il nous démontre avec précision la beauté des instruments de la vie prosaïque exécutés dans la perfection." Jacques Mauny, "New York—1926," *L'Art vivant* 2, no. 25 (January 15, 1926), 58.

7 Wanda M. Corn, *The Great American Thing: Modern Art and National Identity, 1915–1935* (Berkeley: University of California Press, 1999), 98.

8 Ibid., 132–33. See Corn's book for a thorough and insightful analysis of the rage for things American during the 1920s, and especially Murphy's response to this phenomenon. See also Wanda Corn, "Identity, Modernism and the American Artist after World War I: Gerald Murphy and Americanism," in Richard A. Etlin, ed., *Nationalism in the Visual Arts* (Washington, DC: National Gallery of Art, 1991); and Sophie Lévy, ed., *A Transatlantic Avant-Garde: American Artists in Paris, 1918–1939* (Berkeley: University of California Press, 2003), which accompanied a major traveling exhibition organized by the Musée d'Art Americain in Giverny.

9 Gerald's wry question that serves as the heading for this section, made in response to his "discovery" by MacAgy, was first reported by Calvin Tomkins in "Found Genera-

tion," *New Yorker*, July 22, 1996, 71; quoted in Amanda Vaill, *Everybody Was So Young: Gerald and Sara Murphy, A Lost Generation Love Story* (Boston: Houghton Mifflin, 1998), 343.

10 "Women's Group Protests Policy of Art Presentation at Museum," *Dallas Morning News*, March 15, 1955. See also Francine Carraro, *Jerry Bywaters: A Life in Art* (Austin: University of Texas Press, 1994), 251, n. 1. Carraro's chapter "Red, White, and Blue Art at the Dallas Museum" offers the most thorough investigation of the Red Art Scandal in Dallas and Douglas McAgy's involvement with the Dallas Museum for Contemporary Arts. It is an excellent source for primary material on these topics.

11 The speech was made on March 17, 1952; see Carraro, *Jerry Bywaters*, 176. See also the chapter on Fernand Léger in Katherine Kuh, *My Love Affair with Modern Art: Behind the Scenes with a Legendary Curator*, ed. Avis Berman (New York: Arcade Publishing, 2006), 95–112, esp. 107. The chapter recounts how, through the machinations of George Dondero, Léger was not allowed into the United States to see his major retrospective at the Art Institute of Chicago or the installation of his murals for the General Assembly building at the United Nations.

12 Carraro, *Jerry Bywaters*, 172–73. Ideas from this brochure were cited in the *Dallas Morning News* article "Women's Group Protests Policy of Art Presentation at Museum."

13 Quoted in Carraro, *Jerry Bywaters*, 190

14 Quoted in ibid., 184. Jerry Bywaters, director of the Dallas Museum of Fine Arts, and Stanley Marcus, president of the museum's board, effectively led the counter campaign to protect the independence of artistic expression, but also to carefully explain that no public funds were used for the purchase of art, an area of museum activity supported entirely by private funds through the Dallas Art Association.

15 Carraro, *Jerry Bywaters*, 200, n. 112. The controversy also prompted the USIA to withdraw a proposal to the American Federation of Arts to launch an exhibition of contemporary American art that was to tour European capitals.

16 Aline B. Saarinen, "Art Storm Breaks on Dallas," *New York Times*, February 12, 1956, Art, 15. Supportive words came also from the University of Texas in Austin and from the Texas Institute of Letters; see Carraro, *Jerry Bywaters*, 197. The *Texas Observer* reprimanded the Dallas Patriotic Council's stance with an angry editorial; see *Texas Observer*, February 15, 1956.

17 Charlotte Devree's report, "U.S. Government Vetoes Living Art," was published in *Art News* 55, no. 5 (September 1956), 34–35, 54–55. D'Harnoncourt's rebuttal to Pels, "Modern Art and Freedom," appeared in *Facts Forums News*, June 1956, 13. See Carrarro, *Jerry Bywaters*, 199. *Arts Magazine* also ran a rebuttal: Jonathan Marshall,

"Spectrum: An Answer to Miss Pels," *Arts* 30, no. 6 (March 1956), 13.

18 The cultural wars persisted in Dallas, however. Works by Pablo Picasso were removed from a textile exhibition at the Dallas Public Library in late 1956, because of the artist's political affiliations. Once again, the city found itself in the national spotlight, as the *NBC Today* broadcast on December 1, 1956, presented a story on the city's apparent hostility toward "controversial art." In the fall of 1955, the Dallas Public Library had already suffered embarrassment by ceding to objections from conservative voices and ordering the removal of a metal sculpture by Harry Bertoia that had been commissioned by the architect for its new building. Private money eventually came to the rescue, and the sculpture was restored to its spot. See Carraro, *Jerry Bywaters*, 202–4.

19 George and Schatzie Lee, "An Interview with Betty Blake: Dallas Needed a Gallery," in *Dallas Museum of Art: Celebrating 100 Years, 1903–2003*, no. 9 (brochure; Dallas: Dallas Museum of Art, 2003).

20 Aline B. Saarinen, "A Museum of Contemporary Art for Dallas," *New York Times*, November 22, 1959. The author also praised the work of guest curator Katherine Kuh, who organized the exhibition *Signposts of Twentieth Century Art*, and lauded the enlightened patronage of the Marcus and Murchison Dallas families.

The Dallas community itself was split, and tensions were high. In 2003 Paul Harris, an educator at the Dallas Museum for Contemporary Arts, recalled the animosity between the two camps: "I always went to the DMFA [Dallas Museum of Fine Arts]. The bad feeling was on their part. They hated the Contemporary. The Contemporary was taking thunder from the DMFA." *Dallas Museum of Art: Celebrating 100 Years, 1903–2003*, no. 19 (brochure; Dallas: Dallas Museum of Art, 2003). However, it can hardly be argued that the Museum of Fine Arts neglected modern art. For example, it presented the exhibitions *Mexican Art: Pre-Columbian to Modern Times* in 1959, *New Generation in Italian Painting* in 1960, and *Directions in Twentieth-Century American Painting* (which included works by Willem de Kooning and Jackson Pollock) in 1961.

21 The Dallas Museum for Contemporary Arts was, in the end, a short-lived venture, closing in 1963. During its six years of existence, it mounted thirty-three exhibitions, at least twenty-four of which originated in-house. Douglas MacAgy was brought on as director in 1959. David Beasley, *Douglas MacAgy and the Foundations of Modern Art Curatorship* (Simcoe, Ontario: Davus Publishing, 1998), 90.

22 On the role of the Rockefeller family at the Museum of Modern Art and their involvement in propagandistic activities for the government, see ibid., 55.

23 It seems likely that Ted Benrimo was included in *American*

Genius in Review No. 1 on the advice of Donald S. Vogel. A respected painter in his own right (and director of Betty Blake's Betty McLean Gallery in the 1950s), Vogel established the Valley House Gallery in Dallas in 1954. The gallery still exists today.

24 On Blesh's career as a jazz historian and art critic, see Jed Perl, *New Art City* (New York: Alfred A. Knopf, 2005).

25 Douglas MacAgy, *American Genius in Review No. 1* (Dallas: Dallas Museum for Contemporary Arts, 1960), unpaginated.

26 Rudi Blesh, *Modern Art USA: Men, Rebellion, Conquest, 1900–1956* (New York: Alfred A. Knopf, 1956), 234–36.

27 See Beasley, *Douglas MacAgy*, 16–17. MacAgy's commitment to music and lectures reflects his career-long desire to create an interdisciplinary, community-oriented art experience in the museum context.

28 Roger Wilcox, interview by Linda Patterson Miller, June 8, 1982. Lucia had met the Murphys in Paris, and they had helped finance her escape from that city in 1938; see Eric Ernst, "Lucia's Woods Bear Art Again," *East Hampton Star,* July 26, 2001, http://archive.easthamptonstar.com/DNN/Archive/ 2001/20010726/feat2.htm (accessed September 13, 2006). My thanks to Deborah Rothschild for bringing this to my attention.

Blesh had collaborated with Harriet Janis on a number of music- and art-related projects over the years. They established the Circle Records record label in 1946, coproduced the weekly radio show *This Is Jazz,* and wrote *They All Played Ragtime* in 1950. Maria Janis, "The Mississippi Rag," http://www.conradjanis.com/MississippiRag3.php (accessed September 13, 2006).

29 Douglas MacAgy, "Gerald Murphy, 'New Realist' of the Twenties," *Art in America,* no. 2 (1963), 52.

30 Wilcox, interview by Miller, June 8, 1982.

31 Ibid.

32 Blesh, *Modern Art USA,* 96.

33 Ibid., 295

34 MacAgy, "Gerald Murphy," in *American Genius in Review No. 1,* unpaginated.

35 MacAgy's aesthetic philosophy hinged on an all-embracing view of the arts that opposed the fetishization of the contemporary object in the sterile museum setting. He often worked with grand thematic concepts and included historical paintings and objects, which he installed cheek by jowl with modern and contemporary paintings and sculptures. MacAgy did not shirk from ambitious projects with broad intellectual bases in order to fulfill his didactic programs. Probably the most expansive project to embody this approach was *The Art That Broke the Looking Glass,* from late 1961, which focused on trompe l'oeil and illusionism, attempting to explore the complex and fluctuating importance of realistic depictions of the object in space.

36 My thanks to Deborah Rothschild for this information. Honoria Murphy Donnelly, interview by Lillian Hellman, c. 1980, Gerald and Sara Murphy Papers, Yale Collection of American Literature, Beinecke Rare Book and Manuscript Library, Yale University, New Haven, CT.

37 Gerald Murphy, handwritten note to Douglas MacAgy, April 26, 1960, in the object files of the Dallas Museum of Art.

38 Gerald Murphy, letter to Douglas MacAgy, May 21, 1962, Douglas MacAgy Papers, Archives of American Art, Smithsonian Institution, Washington, DC.

39 Gerald Murphy quoted in Blesh, *Modern Art USA,* 95.

EXHIBITION CHECKLIST FOR FINE ART

LÉON BAKST (1866–1924)
Costume design, c. 1914 *(fig. 1)*
Watercolor and pencil on paper, 10 ⅝ × 15 ⅝ in.
Honoria Murphy Donnelly Collection

GEORGES BRAQUE (1882–1963)
Still Life with a Violin, 1912 *(fig. 2)*
Charcoal and varnished "faux bois" paper on
handmade laid paper, sheet: 24 ⁷⁄₁₆ × 18 ¹³⁄₁₆ in.
Yale University Art Gallery, Leonard C. Hanna,
Jr., B.A. 1913, Susan Vanderpoel Clark, and
Edith M. K. Wetmore Funds

FANNY BRENNAN (1921–2001)
Weatherbird, 1999 *(fig. 3)*
Oil on composition board, 2 ¼ × 3 in.
Collection of Richard Lee Brennan

JEAN COCTEAU (1889–1963)
Sketch of Bronislava Nijinska, 1924 *(fig. 4)*
Ink on paper, 10 ¾ × 8 ½ in.
Howard D. Rothschild Bequest, Harvard Theatre Collec-
tion, Houghton Library, Harvard University
Williamstown only

1

2

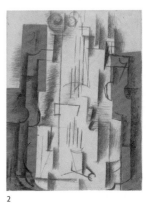

4

3

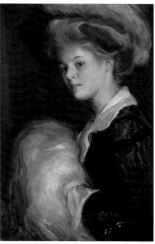

5

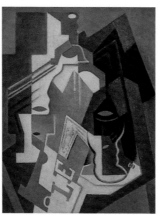

7

6

8

WILHELM FUNK (1866–1949)
Girl with Muff (Portrait of Sara Wiborg), 1904 *(fig. 5)*
Oil on canvas, 29 × 23 ¾ in.
Honoria Murphy Donnelly Collection

NATALIA GONCHAROVA (1881–1962)
Composition Cubo-Futuriste, c. 1916
Gouache on paper, 19 ⅝ × 12 ¾ in.
Mead Art Museum, Amherst College, Amherst, MA.
Gift of Thomas P. Whitney (Class of 1937)
Williamstown only
p. 33

NATALIA GONCHAROVA
Illustrations for *La Cité* (with text by Aleksandr Rubakin), 1920
Book, 10 × 6 ¼ in.
Amherst Center for Russian Culture, Amherst College,
Amherst, MA
p. 36

NATALIA GONCHAROVA
Les Noces **costume design (three male figures)**, 1923 *(fig. 6)*
Pen and ink and pencil on paper, 22 ¼ × 15 ⅜ in.
Howard D. Rothschild Bequest, Harvard Theatre Collec-
tion, Houghton Library, Harvard University
Williamstown only

NATALIA GONCHAROVA
Les Noces: **author's reproduction of costume design**, 1923
Pen and ink on tracing paper mounted on paper,
21 ⅝ × 17 ⅝ in.
Howard D. Rothschild Bequest, Harvard Theatre Collec-
tion, Houghton Library, Harvard University
Williamstown only
p. 125

NATALIA GONCHAROVA
Choreographic costume design for two of the women in
Les Noces, 1923
Ink on paper, 9 ¾ × 12 ¾ in.
Wadsworth Atheneum Musuem of Art, Hartford, CT,
The Ella Gallup Sumner and Mary Catlin Sumner
Collection Fund
Williamstown only

NATALIA GONCHAROVA
Design for the set: Part One, Scenes 1 and 3,
Les Noces (The Wedding), 1923
Graphite and tempera on paper, 26 ½ × 38 ¾ in.
Wadsworth Atheneum Musuem of Art, Hartford, CT,
The Ella Gallup Sumner and Mary Catlin Sumner
Collection Fund
Williamstown only
p. 42

NATALIA GONCHAROVA
Grand Bal de nuit (Travesti/Transmental), 1923
Color lithograph, sheet: 47 ¼ × 28 ⅞ in.
Lent by The Minneapolis Institute of Arts, The Modernism
Collection, gift of Norwest Bank Minnesota
p. 41

NATALIA GONCHAROVA
Ticket for *Bal banal*, 1924
Color lithograph, 8 ¼ × 5 ¾ in.
Private collection

JUAN GRIS (1887–1927)
Guitar and Pipe, 1913
Oil and charcoal on canvas, 25 ½ × 19 ¾ in.
Private collection
p. 144

JUAN GRIS
The Siphon, 1913
Oil on canvas, 31 ⅝ × 23 ⅝ in.
The Rose Art Museum, Brandeis University, Waltham, MA,
Gift of Edgar Kaufmann, Jr.
p. 32

JUAN GRIS
Still Life with Siphon, 1919 *(fig. 7)*
Oil on canvas, 77 ½ × 69 in.
Williams College Museum of Art, on temporary loan from
the Collection of the Sally and Eliot Robinson Family
Williamstown only

WILLIAM JAMES JR. (1882–1961)
Portrait of Mrs. Gerald Murphy, 1921
Oil on canvas, 60 ¼ × 50 ½ in.
Museum of Art, Rhode Island School of Design, Gift of
Mrs. Gustav Radeke and Mr. William T. Aldrich (22.099)
p. 28

FRANCES BENJAMIN JOHNSTON (1864–1952)
**Garden of the Wiborgs' Dunes Estate, East Hampton, Long
Island, c. 1912**
Gelatin silver print
Gerald and Sara Murphy Papers, Yale Collection of
American Literature, Beinecke Rare Book and Manuscript
Library, Yale University, New Haven, CT

MIKHAIL LARIONOV (1881–1964)
*Sketch of Serge Diaghilev, Igor Stravinsky, and
Serge Prokofiev*, c. 1918
Pencil on paper, 17 × 13 ⅛ in.
Howard D. Rothschild Bequest, Harvard Theatre
Collection, Houghton Library, Harvard University
Williamstown only
p. 31

MIKHAIL LARIONOV
Chout (scenic design for wooden houses), 1921 *(fig. 8)*
Watercolor on illustration board, 18 × 23 ¼ in.
Howard D. Rothschild Bequest, Harvard Theatre
Collection, Houghton Library, Harvard University
Williamstown only

MIKHAIL LARIONOV
Flyer for *Le Bal transvestimental*, 1923
Lithograph, 19 ¹¹⁄₁₆ × 5 ¼ in.
Mead Art Museum, Amherst College, Amherst, MA.
Gift of Thomas P. Whitney (Class of 1937) (2001.305)
Williamstown only

MIKHAIL LARIONOV
Program for *Le Bal transvestimental*, 1923
Lithograph, 15 × 10 in.
Private collection, courtesy A & C Projects

MIKHAIL LARIONOV

Ticket for *Grande Bal des artistes travesti/transmental*, 1923

Color lithograph, 13 ¼ × 15 ½ in.

Private collection

MIKHAIL LARIONOV

Serge Diaghilev and Dancers, 1924

Pen and ink and pencil on paper, 11 ⅛ × 17 ¾ in.

Howard D. Rothschild Bequest, Harvard Theatre Collection, Houghton Library, Harvard University

Williamstown only

MIKHAIL LARIONOV

Portrait of Serge Diaghilev, 1929 *(fig. 9)*

Pencil on paper, 15 ¾ × 20 ¾ in.

Howard D. Rothschild Bequest, Harvard Theatre Collection, Houghton Library, Harvard University

Williamstown only

LE CORBUSIER (CHARLES-ÉDOUARD JEANNERET) (1887–1965)

Still Life, 1920

Oil on canvas, 31 ⅞ × 39 ¼ in.

The Museum of Modern Art, New York, Van Gogh Purchase Fund, 1937

p. 35

FERNAND LÉGER (1881–1955)

Man with Hat, 1920

Oil on canvas, 21 ¾ × 15 in.

The Baltimore Museum of Art, Gift of Cary Ross (BMA.1940.63)

p. 39

FERNAND LÉGER

Costume design for "First Man," *La Création du monde*, 1923 *(fig. 10)*

Gouache and India ink on paper, 16 ½ × 9 ½ in.

Dansmuseet, Stockholm

Williamstown only

FERNAND LÉGER

"First Woman": figure study for *La Création du monde*, 1923 *(fig. 11)*

Graphite and India ink on paper, 13 ⅔ × 4 ½ in.

Dansmuseet, Stockholm

Williamstown only

FERNAND LÉGER

Set design with three god-like figures for *La Création du monde*, 1923

Graphite, watercolor, gouache, and India ink on paper, 16 ½ × 25 in.

Dansmuseet, Stockholm

Williamstown only

p. 42

FERNAND LÉGER

Flowers (Les Fleurs), 1926

Oil on canvas, 36 ⁵⁄₁₆ × 25 ¾ in.

Museum of Art, Rhode Island School of Design; Anonymous Gift (81.097)

Williamstown only

p. 64

FERNAND LÉGER

Large Comet Tails on Black Background (Grandes Queues de comètes sur fond noir; front), 1930

Oil on canvas (three panels), 79 × 106 ¼ in.

Galerie Maeght, Paris

p. 57

FERNAND LÉGER

Gerald Murphy, from *Weatherbird Portfolio*, summer 1934

Watercolor and pencil on paper, 12 ¾ × 9 ½ in.

Honoria Murphy Donnelly Collection

p. 70

FERNAND LÉGER

Sara Murphy, from *Weatherbird Portfolio*, summer 1934

Watercolor and pencil on paper, 12 ¾ × 9 ½ in.

Honoria Murphy Donnelly Collection

p. 70

FERNAND LÉGER

Murphy Children, from *Weatherbird Portfolio*, summer 1934

Watercolor and pencil on paper, 12 ¼ × 8 ⅝ in.

Honoria Murphy Donnelly Collection

FERNAND LÉGER

Parrot, from *Weatherbird Portfolio*, summer 1934 *(fig. 12)*

Watercolor and pen on paper, 12 ¾ × 9 ½ in.

William S. Donnelly, Sr.

FERNAND LÉGER

Abstract drawing, from *Weatherbird Portfolio*, summer 1934

Watercolor on paper, 12 ¼ × 9 in.

Courtesy of Straxwood

p. 71

FERNAND LÉGER

Abstraction, from *Weatherbird Portfolio*, summer 1934

Graphite and brown, blue, and gray watercolor,
12 ¾ × 9 ½ in.

Yale University Art Gallery, from the Collection of Frances
and Ward Cheney, B.A. 1922 (1971.121.1)

p. 71

FERNAND LÉGER

***Patrick Murphy in Bed, Saranac Lake*, 1935**

Colored pencil and crayon on paper, 12 × 18 in.

Honoria Murphy Donnelly Collection

p. 74

MAN RAY (1890–1976)

Igor Stravinsky, 1923

Gelatin silver print, 8 ⁹⁄₁₆ × 6 ⁹⁄₁₆ in.

Collection of Olivia Mattis and Kenneth Wayne

p. 168

MAN RAY

**Gerald Murphy in suit with black mourning
band, 1924**

Gelatin silver print, 6 ⅞ × 9 in.

Honoria Murphy Donnelly Collection

p. 34

MAN RAY

**Sara and Gerald Murphy at Comte Étienne de Beaumont's
Automotive Ball, 1924**

Gelatin silver print, 8 × 5 in.

Gerald and Sara Murphy Papers, Yale Collection of
American Literature, Beinecke Rare Book and Manuscript
Library, Yale University, New Haven, CT

p. 110

MAN RAY

Sara Murphy with pearls, 1924

Gelatin silver print, 9 × 6 ¾ in.

Honoria Murphy Donnelly Collection

p. 34

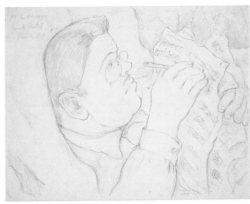

9

10

11

12

MAN RAY
Jean Borlin, c. 1924
Reproduction from archival photograph
Musée National d'Art Moderne, Centre Georges
Pompidou, Paris

MAN RAY
Mrs. Cole Porter: proof from the series
"Mrs. Cole Porter," c. 1924
Reproduction from archival photograph
Musée National d'Art Moderne, Centre Georges
Pompidou, Paris
p. 34

MAN RAY
Gerald Murphy and Vladimir Orloff on the *Picaflor*, 1925
Reproduction from archival photograph
Musée National d'Art Moderne, Centre Georges
Pompidou, Paris

MAN RAY
**Gerald Murphy and Vladimir Orloff with a dog
on the *Picaflor*, 1925**
Reproduction from archival photograph
Musée National d'Art Moderne, Centre Georges
Pompidou, Paris

MAN RAY
**Gerald Murphy nude sitting on the *Picaflor*
(half-length view), 1925**
Reproduction from archival photograph
Musée National d'Art Moderne, Centre Georges
Pompidou, Paris

MAN RAY
**Gerald Murphy nude sitting on the *Picaflor*
(viewed from side), 1925**
Reproduction from archival photograph
Musée National d'Art Moderne, Centre Georges
Pompidou, Paris
p. 113

MAN RAY
**Gerald Murphy nude standing against sail of the
Picaflor, 1925**
Reproduction from archival photograph
Musée National d'Art Moderne, Centre Georges
Pompidou, Paris
p. 113

MAN RAY
**Baoth, Honoria, and Patrick Murphy in sailor
suits, c. 1926**
Gelatin silver print, $6\,^3/_4 \times 9$ in.
Honoria Murphy Donnelly Collection

MAN RAY
Baoth Murphy, c. 1926
Gelatin silver print, $8\,^3/_4 \times 6\,^5/_8$ in.
Honoria Murphy Donnelly Collection

MAN RAY
*Gerald Murphy and His Sons Patrick and
Baoth*, c. 1926
Gelatin silver print, $6\,^3/_4 \times 9$ in.
Honoria Murphy Donnelly Collection
p. 195

MAN RAY
**Honoria Murphy in white dress with polka
dots, c. 1926**
Gelatin silver print, $8\,^1/_2 \times 6\,^1/_2$ in.
Honoria Murphy Donnelly Collection

MAN RAY
**Honoria Murphy wearing Paulo Picasso's harlequin
costume, c. 1926**
Gelatin silver print, $9 \times 6\,^3/_4$ in.
Honoria Murphy Donnelly Collection
p. 58

MAN RAY
Patrick Murphy, c. 1926
Gelatin silver print, $7\,^1/_2 \times 5\,^7/_8$ in.
Honoria Murphy Donnelly Collection

MAN RAY
Sara Murphy and Her Children, c. 1926
Gelatin silver print, 6 $\frac{3}{4}$ × 9 in.
Honoria Murphy Donnelly Collection
p. 195

JEAN METZINGER (1883–1956)
The Harbor (Le Port), 1916–17?
Oil on canvas, 33 $\frac{1}{2}$ × 39 $\frac{1}{2}$ in.
Dallas Museum of Art, gift of the Sara Lee Corporation
p. 32

LEE MILLER (1907–1977)
Baoth Murphy, c. 1928
Gelatin silver print, 11 $\frac{5}{8}$ × 9 in.
Honoria Murphy Donnelly Collection

LEE MILLER
Honoria Murphy, c. 1928
Gelatin silver print, 11 $\frac{5}{8}$ × 9 in.
Honoria Murphy Donnelly Collection

LEE MILLER
Patrick Murphy, c. 1928
Gelatin silver print, 11 $\frac{5}{8}$ × 9 in.
Honoria Murphy Donnelly Collection

GERALD MURPHY (1888–1964)
Razor, 1924
Oil on canvas, 32 $\frac{1}{16}$ × 36 $\frac{1}{2}$ in.
Dallas Museum of Art, Dallas, Foundation for the Arts
Collection, gift of the artist
p. 91

GERALD MURPHY
Villa America, 1924–25
Oil and gold leaf on canvas, 14 $\frac{1}{2}$ × 21 $\frac{1}{2}$ in.
Curtis Galleries, Minneapolis, MN
p. 93

GERALD MURPHY
Watch, 1925
Oil on canvas, 78 $\frac{1}{2}$ × 78 $\frac{7}{8}$ in.
Dallas Museum of Art, Dallas, Foundation for the Arts
Collection, gift of the artist
p. 95 (detail p. 88)

GERALD MURPHY
Doves, 1925
Oil on canvas, 48 $\frac{5}{8}$ × 36 in.
Curtis Galleries, Minneapolis, MN
p. 97

GERALD MURPHY
Still Life with Flowers, c. 1925–26
Gouache on paper, 11 $\frac{1}{2}$ × 9 in.
Private collection; courtesy of Gary Snyder Fine Art,
New York
p. 99

GERALD MURPHY
Bibliothèque (Library), 1926–27
Oil on canvas, 72 $\frac{1}{2}$ × 52 $\frac{5}{8}$ in.
Yale University Art Gallery, New Haven, Purchased with a
gift from Alice Kaplan in memory of Allan. S. Kaplan, B.A.
1957 and with the Leonard C. Hanna Jr., B.A. 1913, Fund
p. 101

GERALD MURPHY
Cocktail, 1927
Oil on canvas, 29 $\frac{1}{16}$ × 29 $\frac{7}{8}$ in.
Whitney Museum of American Art, New York, Purchase,
with funds from Evelyn and Leonard A. Lauder, Thomas H.
Lee, and the Modern Painting and Sculpture Committee
(95.188)
p. 103 (detail p. 132)

GERALD MURPHY
Wasp and Pear, 1929
Oil on canvas, 36 $\frac{3}{4}$ × 38 $\frac{5}{8}$ in.
The Museum of Modern Art, New York, Gift of Archibald
MacLeish, 1964
p. 105 (detail p. 180)

GERALD MURPHY
Potted Plant and Easel on Table, n.d.
Pencil on paper, 12 × 8 in.
Gerald and Sara Murphy Papers, Yale Collection of
American Literature, Beinecke Rare Book and Manuscript
Library, Yale University, New Haven, CT

GERALD MURPHY
Three Positions for Auratum, n.d.
Pencil on paper, 12 ½ × 10 ½ in.
Gerald and Sara Murphy Papers, Yale Collection of
American Literature, Beinecke Rare Book and Manuscript
Library, Yale University, New Haven, CT

GERALD MURPHY (WITH WATERCOLOR FIGURE BY
SARA MURPHY?)
The Immigrant (collage for *Within the Quota*), 1923
Watercolor, gouache, and collage on paper, 11 × 8 in.
Dansmuseet, Stockholm
p. 46

ATTRIBUTED TO GERALD MURPHY
Still Life with Curtain, Violin, and Flowers in Vase, c. 1936
Crayon on paper, 7 × 8 ¼ in.
Honoria Murphy Donnelly Collection
p. 67

SARA MURPHY (1883–1975)
Sketchbook, 1901
Pencil on paper, 9 × 5 in.
Gerald and Sara Murphy Papers, Yale Collection of
American Literature, Beinecke Rare Book and Manuscript
Library, Yale University, New Haven, CT
p. 20

SARA MURPHY
Self-Portrait, c. 1915
Crayon and colored pencil on paper, 6 ¾ × 5 ¾ in.
Gerald and Sara Murphy Papers, Yale Collection of
American Literature, Beinecke Rare Book and Manuscript
Library, Yale University, New Haven, CT
p. 24

SARA MURPHY
Baoth, c. 1920
Watercolor and pencil on paper, 13 × 10 in.
Gerald and Sara Murphy Papers, Yale Collection of
American Literature, Beinecke Rare Book and Manuscript
Library, Yale University, New Haven, CT

SARA MURPHY
**Costume design for "Sweetheart of the World" from *Within
the Quota*,** 1923
Graphite and watercolor on paper, 11 ¼ × 9 in.
Dansmuseet, Stockholm
p. 126

SARA MURPHY
Honoria, c. 1926
Pencil on paper, 7 × 6 ¾ in.
Gerald and Sara Murphy Papers, Yale Collection of
American Literature, Beinecke Rare Book and Manuscript
Library, Yale University, New Haven, CT
p. 34

SARA MURPHY
Still Life with Vase and Bowl, n.d.
Watercolor and pencil on paper, 12 × 8 in.
Gerald and Sara Murphy Papers, Yale Collection of
American Literature, Beinecke Rare Book and Manuscript
Library, Yale University, New Haven, CT

SARA MURPHY
Self-Portrait, n.d.
Pencil on paper, 3 ½ × 2 in.
Gerald and Sara Murphy Papers, Yale Collection of
American Literature, Beinecke Rare Book and Manuscript
Library, Yale University, New Haven, CT

SARA MURPHY
Self-Portrait in Red Turban, n.d.
Watercolor and pencil on paper, 16 × 13 in.
Laura Sara Donnelly

AMÉDÉE OZENFANT (1886–1966)
Still Life (Nature morte), 1926
Oil on board, 12 ¼ × 17 ½ in.
Grey Art Gallery, New York University Art Collection,
New York, Gift of Mr. and Mrs. Myles Perrin, 1958
p. 63

JULES PASCIN (1885–1930)
Hemingway at "Du Dôme," 1924 *(fig. 13)*
Ink on paper, 14 × 20 in.
James K. Moody

WALDO PEIRCE (1884–1970)
Plage La Garoupe, c. 1930
Oil on canvas, 26 × 33 in.
Lori and Art Benton
p. 191

FRANCIS PICABIA (1879–1953)
Transparence (F. Scott Fitzgerald?), c. 1930
Watercolor and ink on paper, 12 × 10 in.
James K. Moody
p. 193

PABLO PICASSO (1881–1973)
Segment of Pear, Wineglass and Ace of Clubs, 1914 *(fig. 14)*
Collage: pasted colored laid and wove papers,
distemper (gesso), gouache, and soft graphite, on
cardboard, 17 $^{15}/_{16}$ × 15 $^{3}/_{16}$ in.
Yale University Art Gallery, The John Hay Whitney,
B.A. 1925, Hon. M.A. 1956, Collection
Williamstown and New Haven only

PABLO PICASSO
Mother and Child, 1922
Oil on canvas, 39 $^{3}/_{8}$ × 31 $^{7}/_{8}$ in.
The Baltimore Museum of Art, The Cone Collection,
formed by Dr. Claribel Cone and Miss Etta Cone of
Baltimore, Maryland (BMA.1950.279)
New Haven and Dallas only
p. 53

PABLO PICASSO
**Cover sheet from Sketchbook 67, Cap
d'Antibes, 1923**
Ink on paper, 10 $^{1}/_{2}$ × 14 $^{1}/_{3}$ in.
Marina Picasso Collection (Inv. 8725), Courtesy Galerie Jan
Krugier & Cie, Geneva, Switzerland

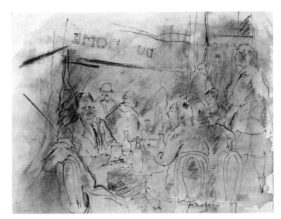

13

14

15

16

PABLO PICASSO

Femme allongée 1923

India ink on paper with Hôtel du Cap d'Antibes
letterhead, 8 1/4 × 10 1/2 in.
Marina Picasso Collection (Inv. 3178), Courtesy Galerie
Jan Krugier & Cie, Geneva, Switzerland
p. 53

PABLO PICASSO

Femme assise, 1923

Chinese ink on paper, 6 × 8 2/3 in.
Marina Picasso Collection (Inv. 3183), Courtesy Galerie
Jan Krugier & Cie, Geneva, Switzerland

PABLO PICASSO

Sheet of Studies: A Man, Hand, and Feet, 1923

Pen and ink on graph paper, 4 1/2 × 3 1/4 in.
Musée Picasso, Paris
p. 54

PABLO PICASSO

Sketch for *Woman in White*, 1923

Sketchbook 67 (page 11)
India ink on paper, 10 1/2 × 14 1/4 in.
Marina Picasso Collection (Inv. 8735), Courtesy Galerie
Jan Krugier & Cie, Geneva, Switzerland
p. 52

PABLO PICASSO

The Three Graces, 1923

India ink on paper with Hôtel du Cap d'Antibes letterhead,
10 5/8 × 8 5/8 in.
Marina Picasso Collection (Inv. 3171), Courtesy Galerie
Jan Krugier & Cie, Geneva, Switzerland
p. 51

PABLO PICASSO

Woman Seated in an Armchair, 1923 *(fig. 15)*

Oil on canvas, 51 1/4 × 38 1/4 in.
The Detroit Institute of Arts, Bequest of Robert H.
Tannahill
Williamstown only

PABLO PICASSO
Untitled (Pierrot and Harlequin), c. 1925 *(fig. 16)*
Hand-printed color stencil (pochoir), sheet: 12 1/16 × 9 3/16 in.
The Baltimore Museum of Art: The Cone Collection,
formed by Dr. Claribel Cone and Miss Etta Cone of
Baltimore, Maryland (BMA.1950.12.274)

LEOPOLD SURVAGE (1879–1968)
Montrouge, 1924
Pencil and watercolor on brown paper, 4 1/4 × 12 1/2 in.
Honoria Murphy Donnelly Collection

LEOPOLD SURVAGE
Beach scene (?), 1929
Ink on paper, 8 3/4 × 11 1/16 in.
Honoria Murphy Donnelly Collection

HENRI DE TOULOUSE-LAUTREC (1864–1901)
Au Concert, **poster for the Ault & Wiborg Co., 1896**
Color lithograph, sheet: 19 × 14 in.
Museum of Fine Arts, Boston; Bequest of Lee M.
Friedman, 1958.109
Williamstown only
p. 13

J. WEISS
**Photograph of Gerald Murphy taken in Basel, Switzerland,
with a hinged mirror, 1930**
Postcard, 3 1/2 × 5 1/2 in.
Gerald and Sara Murphy Papers, Yale Collection of
American Literature, Beinecke Rare Book and Manuscript
Library, Yale University, New Haven, CT
p. 160

Program for *Within the Quota*, **1923**
Printing ink on coated, wove paper stock, 32 × 24 1/2 in.
The Jerome Robbins Dance Division, Cia Fornaroli
Collection, The New York Public Library for the Performing
Arts, Astor, Lenox, and Tilden Foundations
Williamstown only

"Immigrant" costume from *Within the Quota*, **1923**
(re-created 1998)
Royal Swedish Opera, Stockholm

"Jazz Baby" costume from *Within the Quota*, **1923**
(re-created 1998)
Royal Swedish Opera, Stockholm

"Sweetheart of the World" costume from *Within the Quota*,
1923 (re-created 1998)
Royal Swedish Opera, Stockholm

Amherst Center for Russian Culture, Amherst College, Amherst, Mass.

Baltimore Museum of Art, Baltimore, Md.

Beinecke Rare Book and Manuscript Library, Yale University, New Haven, Conn.

Lori and Art Benton

Boston Athenaeum

Richard Lee Brennan

Chapin Library of Rare Books and Manuscripts, Williams College, Williamstown, Mass.

Curtis Galleries Inc., Minneapolis, Minn.

Dallas Museum of Art, Dallas, Texas

Dansmuseet, Stockholm, Sweden

Collection of Peter Davenport

Detroit Institute of Arts, Detroit, Mich.

Honoria Murphy Donnelly Collection

Laura Sara Donnelly

William S. Donnelly, Sr.

Galerie Maeght, Paris, France

Grey Art Gallery, New York University, New York, NY

Harvard Theatre Collection, Cambridge, Mass.

Hotchkiss School Archives, Lakeville, Conn.

William MacLeish

Collection of Olivia Mattis and Kenneth Wayne

Mead Art Museum, Amherst College, Amherst, Mass.

Minneapolis Institute of Arts, Minneapolis, Minn.

James K. Moody

Musée Picasso, Paris, France

Museum of Fine Arts, Boston, Mass.

Museum of Modern Art, New York, NY

New York Public Library, New York, NY

Marina Picasso Collection, courtesy Galerie Jan Krugier & Cie, Geneva, Switzerland

Private collection

Private collection, courtesy A&C Projects

Private collection, courtesy Gary Snyder Fine Art, New York, NY

Rhode Island School of Design Museum of Art, Providence, RI

Collection of the Sally and Eliot Robinson Family

Rose Art Museum, Brandeis University, Waltham, Mass.

Royal Swedish Opera, Stockholm, Sweden

Sawyer Library, Williams College, Williamstown, Mass.

Timothy and Marian Seldes

Straxwood

Yale University Art Gallery, New Haven, Conn.

Wadsworth Atheneum Museum of Art, Hartford, Conn.

Whitney Museum of American Art, New York, NY

Williams College Museum of Art, Williamstown, Mass.

WILLIAMS COLLEGE MUSEUM OF ART VISITING COMMITTEE

DOROTHY KOSINSKI is a distinguished scholar of modern French art and Senior Curator of European Painting and Sculpture at the Dallas Museum of Art. She is the author of several books, among them *Fernand Léger and the Rhythm of Modern Life; The Artist and the Camera: Degas to Picasso; Henry Moore: Sculpting the Twentieth Century; Dialogues: Duchamp, Cornell, Johns, Rauschenberg;* and most recently *Matisse: Painter as Sculptor*. Her expertise includes extensive work on Courbet, Moreau, Kupka, Léger, Picasso, Moore, and Duchamp.

OLIVIA MATTIS is a musicologist and a National Endowment for the Humanities fellow. She has served as curator for several exhibitions, including *Gershwin to Gillespie: Portraits in American Music*, which is touring nationally until 2008.

LINDA PATTERSON MILLER is a Professor of Literature at Pennsylvania State University. She specializes in early-twentieth-century American literature and art and has published several books on related topics. Her writing has also appeared in numerous publications, including *Mosaic, Renascence, American Transcendentalist Quarterly,* and the *Journal of Modern Literature*. Her book *Letters from the Lost Generation: Gerald and Sara Murphy and Friends* examines the personal and literary relationships between Sara and Gerald Murphy and their close friends F. Scott Fitzgerald, Ernest Hemingway, John Dos Passos, and Archibald MacLeish.

DEBORAH ROTHSCHILD is Senior Curator of Modern and Contemporary Art at the Williams College Museum of Art. Her dissertation on Picasso's use of popular imagery in his designs for the ballet served as the basis of her book *Picasso's 'Parade': From Street to Stage*. She has organized more than sixty exhibitions, including *Graphic Design in the Mechanical Age* and shows of such living artists as James Turrell, David Hammons, and Tony Oursler (International Association of Art Critics/USA [AICA] award). Her exhibition *Prelude to a Nightmare: Art, Politics, and Hitler's Early Years in Vienna 1906–1913* won Best Thematic Show of 2002–3 from the New England chapter of AICA.

KENNETH E. SILVER is a Professor of Modern Art at New York University. He is the author of *Making Paradise: Art, Modernity, and the Myth of the French Riviera* and *"Esprit de Corps": The Art of the Parisian Avant-Garde and the First World War, 1914–1925*. His most recent publication, *Sarah Bernhardt: The Art of High Drama*, co-written with Carol Ockman, appeared in 2005. His interest in style and the issues of modernism is illustrated in his essay "The Murphy Closet and the Murphy Bed" for the catalogue.

WILLIAM JAY SMITH is the author of more than fifty books of poetry, children's verse, literary criticism, and memoirs, and editor of several influential anthologies. He served as the Consultant in Poetry to the Library of Congress, a position now

called the Poet Laureate, and as Vice President for Literature to the American Academy of Arts and Letters. A former Rhodes scholar, Smith has lectured at the Salzburg Seminar in American Studies and has been a Fulbright Lecturer at Moscow State University. His translations have earned him honors from the French Academy, the Swedish Academy, and the Hungarian government. Additionally, he has received the Loines Award, the New England Poetry Club's Golden Rose, and an award from the New England Poetry Club's Golden Rose.

CALVIN TOMKINS has worked as a staff writer for the *New Yorker* since 1961. He is the author of numerous books, including *Living Well Is the Best Revenge* (a profile of Sara and Gerald Murphy), *Ahead of the Game: Four Versions of the Avant-Garde, The Bride and the Bachelors: The Heretical Courtship in Modern Art,* and, most recently, *Duchamp: A Biography.* His work has been published in *Newsweek, Harper's Magazine, Life,* and other publications. He is the recipient of numerous awards, including the 2006 Clark Prize for Excellence in Arts Writing.

AMANDA VAILL is the author of the best-selling biography about the life of Gerald and Sara Murphy, *Everybody Was So Young: A Lost Generation Love Story,* published in 1998; it was a finalist for the National Book Critics' Circle Award and named a *New York Times Book Review* Notable Book for the year. Her feature articles on arts and culture have appeared in numerous publications, including *ArtNews, Town and Country, Harper's Baazar, Esquire, New York* magazine, and *Architectural Digest*—where she has served as a contributing writer since 1999. Her latest book, *Somewhere: The Life of Jerome Robbins,* was published in November 2006.

KENNETH WAYNE is Chief Curator of Collections and Exhibitions at the Heckscher Museum of Art in Huntington, New York. He has organized many important exhibitions, including *Picasso, Braque, Léger and the Cubist Spirit, 1919–1939; Impressions of the Riviera: Monet, Renoir, Matisse and Their Contemporaries;* and *Modigliani and the Artists of Montparnasse,* which toured nationally and received significant acclaim.

TREVOR WINKFIELD exhibits his paintings at Tibor de Nagy Gallery, New York. A recipient of a Guggenheim Fellowship, he is also a Chevalier de l'Ordre des Arts et des Lettres. A book on his art, *Trevor Winkfield's Pageant,* with texts by John Ashbery and Jed Perl, was published in 1997, and another, *Trevor Winkfield's Drawings,* in 2004. He is co-editor of the art and literary magazine *The Sienese Shredder.* His article "From a Friend of Gerald Murphy" was published by *Modern Painters* in its spring 1998 issue.

Cross, Henri Edmond, 191

Cross, Mark W., 20–21

Cubism, 2, 3, 37, 133, 137, 146, 151, 200; ballet and, 123, 124; in garden design, 193; in Gerald's paintings, 63, 64, 68, 114, 187, 205; literary influences of, 143, 144, 148, 149; Léger on, 144, 161; Picasso and Braque as pioneers of, 35; Synthetic, 37

Dada, 30, 35, 37, 121, 133, 138

Dalí, Salvador, 139

Dallas Art Association, 202, 206n14

Dallas Museum for Contemporary Arts, 4, 63, 128, 200–205, 206n20, n21; *Abstract by Choice* exhibition, 202; *American Genius in Review No. 1* exhibition, 4, 8, 9, 68, 76, *198,* 200–201, *201,* 203, 204, 206n23; *The Art That Broke the Looking Glass* exhibition, 207n35; *Contemporary Japanese Painting and Sculpture* exhibition, 202; *Drawings by Ulfert Wilke* exhibition, 202; *Italian Sculptors Today* exhibition, 202; *Signposts of Twentieth Century Art* exhibition, 206n20

Dallas Museum of Fine Arts, 201, 202, 206n14, n20

Dallas Patriotic Council, 202, 206n16

Dallas Public Library, 206n18

Dallas Times Herald, 202

Damrosch, Walter, 165, 169

Davis, Bernard, photograph of Rudi Blesh, *203*

Davis, Stuart, 135

Debussy, Claude, *Le Cathédrale engloutie,* 166

de Kooning, Willem, 206n20

Delaunay, Robert, 41

Delaunay, Sonia, 39, 41

Demuth, Charles, 63; *The Figure 5 in Gold,* 83n133

Denham, Sergei, 3, 127, 128

Depression, 2, 68, 200

Derain, André, 33, 41, 123, 126, 139, *203*

Desnos, Robert, 193

Désormière, Roger, 173

Detweiler, Gill, 80n59

Devree, Charlotte, 202

de Wolfe, Elsie, *49*

Diaghilev, Sergei, 3, 7, 8, 18, 43, 49, 81n81, 123–24, 168, 169; in charity event for exiled Russian artists, 41; death of, 127; at Greeley's Château Clavary, 193; Larionov's sketches of, *31, 123;* Orloff and, 34, 69; set designs by modernist artists for, 18, 33, 81n81, 136

Dial, The (magazine), 40, 71

Dickinson, Preston, 200

Dockstader, Lew, 175

Dolin, Anton, *48, 49*

Dondero, George A., 201, 206n11

Dongen, Kees van, 192

Donnelly, Honoria Murphy (daughter), 39, 65, 72, 79–80n55, 85n200, 107, 128, 158, 166, *167,* 186; at Antibes, *48,* 50, *50,* 56, 58, *58,* 82–83n117, n119; birth of, 26; Hellman and, 75–76; infancy and early childhood of, *12,* 26–28, *26,* 79n38, 172; Man Ray's photographs of, *58,* 58–59, *195;* marriage and family of, 56; miniature letter to, from Gerald, *24;* on mother's fearlessness, 78n18; on parents' relationship, 55; on Patrick's illness and death, 73; Porter named godfather of, 174; references in Gerald's paintings to, 61, 63; sketch by Sara of, *34*

Doors, 166

Dos Passos, John, 2, 3, 8, 12, 71, 73, 116, 126, 146, 175, 184, 200; at Antibes, 47, 147, 194; ballet project declined by, 127; first meeting of Murphys and, 147; Hemingway and, 75, 109, 149, *153,* 162n33; at Murphys' Left Bank apartment, 40; Spanish Civil War documentary collaboration of, 176; Switzerland visit of, 69; WORKS: *The Best Times,* 41, 47; *The Big Money,* 127

Dos Passos, Katy, 73, 146, 163n23

Doucet, Jacques, 193

Draper, Paul, 4, 75

Dreier, Katherine S., 203, 204

Drew, John, 119

Duchamp, Marcel, 8, 133, 139, 160, 189, 193, 203; *Why Not Sneeze, Rrose Sélavy?,* 138

Duchamp-Villon, Raymond, 144

Duncan, Isadora, 193

Dunoyer de Segonzac, André, 192

Durante, Jimmy, 166

Durey, Louis, 165

Eastman, George, 166

École d'Arcueil, L', 173

Edison, Thomas, 176

Edward VII (king of England), 17

Ehrenweisen Rebay, Baroness Hilla von, 84n161

Eliot, T. S., *The Waste Land,* 146, 186

Éluard, Paul, 193

Ernst, Max, 63

Errazuriz, Eugenia Huici, 192

Esprit Nouveau, L', 4

Esprit nouveau, L' (magazine), 57

Euripides, *The Trojan Women,* 121

Everling, Germaine, *190,* 192, 193

exhibitionism: in painting, 137; sexuality and, 2, *106,* 112, *112–13,* 114, 115

Expressionism, 133

Exter, Alexandra, 123

Facts Forum News, 202

Falla, Manuel de, 123; *Le Tricorne, 33*

Fascists, 153

Faulkner, William, *The Sound and the Fury,* 146, 147

Fauvism, 133

Feininger, Lyonel, 202

Fels, Florent, 84n145, 186

Fergison, Drue, 80n78

Fitzgerald, F. Scott, 7, 29, 55, 110, 126, 147, 148, 158–59, 162n27, 200; at Antibes, 109, 144–45, 194, *196;* "lace-curtain Irish" back-ground of, 23; Murphys' financial and emotional support of, 75, 86n208, 197; and Patrick's death, 74; Sara's correspondence with, 54, 75, 155; in Switzerland, 69; Vidor introduced to Gerald by, 65, 175
 WORKS: *The Great Gatsby,* 145, 148, 194; *This Side of Paradise,* 194. See also *Tender Is the Night*

Fitzgerald, Scottie, 75, *196,* 197

Fitzgerald, Zelda, 69, 147, 155, 157, *196,* 197

Fokine, Michel, 123

Fontaine, Evan Burrows, 81n87

Fort, Paul, 144

Foster, Stephen, 175

Foujita, 41

Frankel, Stephen, 107, 108

Frankfurter, Alfred, 203, *203*

Franklin, Frederic, *129*

Franklin, Sidney, 73

Fratellinis (clowns), 121

Fredericks, Claude, 181

Fridge, Roy, 202

Funk, Wilhelm, *Girl with Muff (Portrait of Sara Wiborg),* 210

Futurism, 37, 124, 133, 137

Galerie de l'Effort Moderne (Paris), 35

Galerie La Boétie (Paris), 79n50

Gallatin, A. E., 200

Gardner, Isabella Stewart, 3, 29, 166, 172, 177n18, 178n52

Gellhorn, Martha, 151, 157

George, Yvonne, 193

George V (king of England), 17

Gershwin, George: *An American in Paris,* 174; *Porgy and Bess,* 175, 179n73; *Rhapsody in Blue,* 172

Ghost Town (ballet), 3, 128, *128, 129,* 176

Giacometti, Alberto and Diego, 194

Gibson, Charles Dana, 17, 77n12

gigantism, 135–36

Gill, Brendan, 11, 78n22

Giroflé-Girofla (opéra bouffe), 41, *122,* 123

Glasco, Joe, 202

Godebski, Jean, 192

Goethe, Johann Wolfgang von, 136

Golschmann, Vladimir, 172

Goncharova, Natalia, 8, *31,* 34, 35, 37, 41, 79n50, 169; Larionov's sketch of, *123;* set and costume designs by, 33, 42, *42,* 123, 124, *125,* 168, *210;* teaching approach of, 136
 WORKS: *Composition Cubo-Futuriste, 33;* costume designs for

Les Noces, 125, 210; Grand Bal de nuit poster, *41;* illustration in *La Cité, 36;* set design for *Les Noces, 42*

Gounod, Charles, 165

Gouy d'Arcy, François, 192

Graham, Mrs. William Miller, *19*

Grand Bal des Artistes Travesti/Transmental (Paris, 1923), 41

Granville-Barker, Harley, 121

Great War. *See* World War I

Greeley, Russell, 189, *190,* 192–93

Greenthal, Kathryn, 27–29

Gris, Juan, 33, 35, 41, 63, 68, 143, 184; *Guitar and Pipe, 144; The Siphon, 32; Still Life with Siphon,* 210

Grofé, Ferde, 172

Grosz, George, 201

Groupe des Six, Le, 30, 165

Guggenheim, Solomon R., Museum, 84n161, 203

Halffter, Rodolfo, 176

Hallelujah! (film), 174–75, *175,* 179

Hamblin, Stephen Francis, 79n34

Hamilton, Gordon, 170

Hammett, Dashiell, 4, 76, 204

Hammons, David, 77

Hamnett, Nina, 192

Handy, W. C., 175

Harnoncourt, René d', 202, 203

Harper's (publisher), 12

Harry's Bar (Montana-Vermala, Switzerland), *62, 69*

Hartford Assurance Company, 181

Harvard University, 172, 192; School of Landscape Architecture, 27, 29, 66, 79n34, 84n166, 172

Hayes, Daniel L., 175

Hedrick, U. P., *The Pears of New York, 66*

Heller, Harold, 74

Hellman, Lillian, 4, 75–76, 146

Hemingway, Ernest, 2, 3, 7, 54, 78n18, 126, 146, *150,* 151–53, 155–59, 200; at Antibes, 194, *196,* 197; in Austria, *153;* Cubist influence on, 143, 144, 149; first meeting of Murphys and, 149, 162n26, n27; Gerald's correspondence with, 8, 62, 148; homosexuality and, 109, 152; in Key West, Sara's visit to, 73, 152, 162n33; *Literary Birds* portrait of, 184, *184;* marriages of, 147, 149, 152, 157, 161, 197; in Pamplona, *142, 150;* and Patrick's illness, 69, 74; Sara as inspiration for, 11; Sara's correspondence with, 82n108, 148, 149, 151; Spanish Civil War documentary collaboration of, 176; suicide of, 129; in Wyoming, *151*
 WORKS: *For Whom the Bell Tolls,* 3, 146, 153, 155, 157; *In Our Time,* 144, 149; *A Moveable Feast,* 75, 129, 146, 149, 152, 153, 157, 162n29; *The Sun Also Rises,* 159, 163n70, 194; *The Torrents of Spring,* 149

Hemingway, Hadley, 109, 147, 149, *150,* 197

Hemingway, John (Bumby), *196,* 197

Herman, Simone, 86n207

Herrera, Hayden, 60

Hingle, Pat, *130*

Hirsch, Joseph, 201

Hodson, Millicent, 44, 81n89

Hohenlohe, Prince, 15

homosexuality, 2, 23, 72, 78n22, 86n203, 107–17, 120, 152; dress and, 110, 112; exhibitionism and, 112, 114; paintings and, 114–16

Honegger, Arthur, 165, 192

Honoria (sailboat), 69, 112

Hotchkiss School, 21–23

Hôtel du Cap d'Antibes, 47, *47*

House Un-American Activities Committee, 75–76

Houston Museum of Fine Arts, 203

Hoving, Walter and Mary Osgood, 192–93

Hugo, Jean and Valentine, 192

Immigrant (film), 44, *45*

Impressionism, 133

International Style, 55, 57, 193

Jacob, Maxime, 173, 193

James, William, Jr., 29; *Portrait of Mrs. Gerald Murphy, 28*

Janis, Harriet, 204, 207n28

Janis, Sidney, 204

Jarvis, Alan, 86n203

jazz, 4, 59, 165, 166, 175, 176; symphonic, 172

Jessye, Eva, 175, 179n73

Johns, Jasper, 2, 115–16, 117n24; *Pinion*, 115, *116*; *Target with Plaster Casts*, 115, *116*

Jolson, Al, 44

Joyce, James, 40; *Ulysses*, 146

Jungian therapy, 69

Kahnweiler, Daniel-Henry, 35

Kamerny Theater, 3, 41, 80–81n80, *121, 122*, 123, 124, 126

Kaprow, Allan, 77

Kay, Richard, 80n59

Keats, John, 22

Kennedy, John F., 108

Kennedy, Robert F., 108

Kiki, 192

King, Martin Luther, Jr., 179n73

Kisling, Moise, 191

Kochno, Boris, 33, 169

Koechlin, Charles, 172, 173

Kosinski, Dorothy, 4, 199–207

Krehbiel, Henry Edward, 177n18

Kroll, Leon, 202

Kuh, Katherine, 206n20

Kuniyoshi, Yasuo, 202

Kurtz, Efrem, 175

Laforgue, Jules, 186

Lambert, Gerard, 34

Larionov, Mikhail, 33, 34, 41, 81n81, 123, 124, 169; caricature of Sergei Diaghilev, Natalia Goncharova, and Igor Stravinsky, *123; Chout, 210; Portrait of Serge Diaghilev, 213; Sketch of Serge Diaghilev, Igor Stravinsky, and Serge Prokofiev, 31*

Lartigue, Jacques Henri, 191

Lauren, Ralph, 81–82n98

Laurencin, Marie, 192

Laurens, Henri, 49, 194

Lautréamont, Comte de, 138

League of Nations, 185

Le Corbusier, 35, 57, 60, 63; *Still Life, 35*

Lee, Alice, 40

Léger, Fernand, 2, 7, 9, 35, 37, 39, 56, *57*, 84n161, 126, 139, 145, 199, 206n11; at Antibes, 62, 71, 72, 192, 194; ballet collaborations of, 42, *42*, 47, 173; bisected compositions of, 64; in charity event for exiled Russian artists, 41; collaged postcard by, *68*; on Cubism as new way of seeing, 144, 161; Patrick's portrait of, *74*; Patrick's relationship with, 69, 74; at Picabia's Château de Mai, 193, 194; and postcard, with Patrick's painting, *68*, 69; United States trips of, 75, 86n207, 197; Villa America décor by, 57, *57*

WORKS: abstract drawing, *71*; abstraction, *71*; *Composition with Hand and Hats, 64; La Création du monde* designs, *42*, 213; *Flowers (Les Fleurs), 64, 64; Gerald Murphy, 70; Large Comet Tails on Black Background, 57, 57; Man with Hat, 39; Parrot, 213; Patrick Murphy in Bed, Saranac Lake, 74; Sara Murphy, 70; Le Pot à Tisane, 197n14; Weatherbird Portfolio, 70–71, 213*

Léger, Jeanne, 193

Leutze, Emanuel, *Washington Crossing the Delaware*, 119, 135–36

Lincoln, Abraham, 74

Lindbergh, Charles, 62

Lipchitz, Jacques, 194

Lippincott (publisher), 12

Lissitsky, El, 39

Livet, Jacques, 69

Loeffler, Charles Martin, 177n18

Lorca, Federico García, 183

Lowe, Rick, 77, 87n215

Lowell, Amy, 29

Luce, Maximilien, 191

MacAgy, Douglas, 4, 8, 9, 63, 68, 76, 200–201, *203*, 203–5, 206n21, 207n26, n35; letter to, from Gerald, *205*

Machine Age, art of, 35, *36*, 37–38, 205

MacLeish, Ada, 40, *52*, 73, 147, *147*, 162n23, 185

MacLeish, Andrew, 185

MacLeish, Archibald, 1–3, 12, 69, 109, 126, 128–29, *130*, 143–44, 146–48, 183, 200; at Antibes, 162n23, 194; ballet collaboration of, 175–76; Gerald's confessional letter to, 23, 60, 62, 83–84n140, 107, 108, 116, 117n6, 148–49, 151, 163n25; on League

CREDITS

Artist Copyright and Photo Credits:

Georges Braque—*Still Life with a Violin* (p. 209): © 2007 Artists Rights Society (ARS), New York/ADAGP, Paris.

Jean Cocteau—*Sketch of Bronislava Nijinska* (p. 209): © 2007 Artists Rights Society (ARS), New York/ADAGP, Paris.

Natalia Goncharova—All artwork by Natalia Goncharova (pp. 33, 36, 41, 42, 125, 210) © 2007 Artists Rights Society (ARS), New York/ADAGP, Paris.

Juan Gris—All artwork by Juan Gris (pp. 32, 144, 210) © 2007 Artists Rights Society (ARS), New York/ADAGP, Paris.

William James Jr.—*Portrait of Mrs. Gerald Murphy* (p. 28): photography by Erik Gould.

Jasper Johns—All artwork by Jasper Johns © Jasper Johns/Licensed by VAGA, New York, NY. *Target with Plaster Casts* (p. 116): photo courtesy Castelli Gallery; *Pinion* (p. 116): photo courtesy Universal Limited Art Editions, Inc., Bay Shore, NY.

Le Corbusier—*Still Life* (p. 35): © 2007 Artists Rights Society (ARS), New York/ADAGP, Paris/FLC. Digital image © The Museum of Modern Art/Licensed by SCALA/Art Resource, NY.

Mikhail Larionov—All artwork by Mikhail Larionov (pp. 31, 123, 210, 213) © 2007 Artists Rights Society (ARS), New York/ADAGP, Paris.

Fernand Léger—All artwork by Fernand Léger © 2007 Artists Rights Society (ARS), New York/ADAGP, Paris. *Large Comet Tails on Black Background* (p. 57): front photo © Galerie Maeght; back Réunion des Musées Nationaux/Art Resource, NY; additional images on pp. 39, 42, 64, 68, 70, 71, 74, 213.

Man Ray—All photographs by Man Ray © 2007 Man Ray Trust/Artists Rights Society (ARS), New York/ADAGP, Paris. Gerald nude sitting on the *Picaflor* (p. 113): photo CNAC/MNAM/Dist. Réunion des Musées Nationaux/Art Resource, NY; Gerald nude standing against the sail of the *Picaflor* (p. 113): photo CNAC/MNAM/Dist. Réunion des Musées Nationaux/Art Resource, NY; *The Murphy Family: Sara and Gerald Murphy* (p. 34): photo CNAC/MNAM/Dist. Réunion des Musées Nationaux/Art Resource, NY; *Mrs. Cole Porter* (p. 34): photo CNAC/MNAM/Dist. Réunion des Musées Nationaux/Art Resource, NY; *Gerald Murphy and His Sons Patrick and Baoth* (p. 195): photo CNAC/MNAM/Dist. Réunion des Musées Nationaux/Art Resource, NY; *Sara Murphy and Her Children* (p. 195): photo CNAC/MNAM/Dist. Réunion des Musées Nationaux/Art Resource, NY; additional images on pp. 58, 110, 168.

Jean Metzinger—*The Harbor (Le Port)* (p. 32): © 2007 Artists Rights Society (ARS), New York/ADAGP, Paris.

Gerald Murphy—*Wasp and Pear* (p. 105): digital image © The Museum of Modern Art/Licensed by SCALA/Art Resource, NY. *See also* above and pp. 46, 91, 93, 95, 97, 99, 101, 103.

Amédée Ozenfant—*Still Life* (p. 63): © 2007 Artists Rights Society (ARS), New York/ADAGP, Paris.

Francis Picabia—*Transparence* (p. 193): © 2007 Artists Rights Society (ARS), New York/ADAGP, Paris.

Pablo Picasso—All artwork by Pablo Picasso © 2007 Estate of Pablo Picasso/Artists Rights Society (ARS), New York. *Glass, Guitar and Bottle* (p. 32): digital image © The Museum of Modern Art/Licensed by SCALA/Art Resource, NY; *Paulo as Harlequin* (p. 58): photo Réunion des Musées Nationaux/Art Resource, NY; *The Pipes of Pan* (p. 55): photo Réunion des Musées Nationaux/Art Resource, NY; *Sheet of Studies: A Man, Hand, and Feet* (p. 54): photo Réunion des Musées Nationaux/Art Resource, NY; *Study of Three Graces* (p. 51): photo Réunion des Musées Nationaux/Art Resource, NY; *Three Modern Graces* (p. 51): photo Réunion des Musées Nationaux/Art Resource, NY; *Three Musicians* (p. 60): digital image © The Museum of Modern Art/Licensed by SCALA/Art Resource, NY; *Woman in White* (p. 52): photo © 1994 The Metropolitan Museum of Art; *Woman Seated in an Armchair* (p. 218): photo © 1987 The Detroit Institute of the Arts; additional images on pp. 51, 52, 53, 217, 218.

Vladimir and Violette Polunin working on *Le Tricorne* backdrop (p. 33): photo Réunion des Musées Nationaux/Art Resource, NY.

Le Train bleu photographs (pp. 48, 49) from Bibliothèque Musée de l'Opéra, Paris are courtesy Bibliothèque Nationale de France.

Alexandr Vesnin—Arikeia, costume design to Racine's *Phaedra* (p. 121): photo Erich Lessing/Art Resource, NY.

Worker bee's foreleg (p. 66), used by permission of Cornell University Press.

SPONSORING EDITOR
Deborah Kirshman

ASSISTANT EDITORS
Sigi Nacson, Eric Schmidt

PROJECT EDITOR
Sue Heinemann

EDITORIAL ASSISTANT
Lynn Meinhardt

COPYEDITOR
Jennifer Knox White

INDEXER
Ruth Elwell

DESIGNER
Nicole Hayward

PRODUCTION COORDINATOR
Anthony Crouch

TEXT
9.75/13 Verlag Book

DISPLAY
Verlag family

COMPOSITOR
Integrated Composition Systems

PRINTER AND BINDER
Friesens